PALGRAVE Studies in O.

Series Editors: Linda Shopes and Bruce M. Stave

Editorial Board

Oral History and Photography

Oral History and Photography

Edited by

Alexander Freund and Alistair Thomson

First published in hardcover in 2011 by PALGRAVE MACMILLAN® in the United States—a division of St. Martin's Press LLC, 175 Fifth Avenue, New York, NY 10010.

Where this book is distributed in the UK, Europe and the rest of the world, this is by Palgrave Macmillan, a division of Macmillan Publishers Limited, registered in England, company number 785998, of Houndmills, Basingstoke, Hampshire RG21 6XS.

Palgrave Macmillan is the global academic imprint of the above companies and has companies and representatives throughout the world.

Palgrave® and Macmillan® are registered trademarks in the United States, the United Kingdom, Europe and other countries.

ISBN: 978–1–137–28062–6

Library of Congress Cataloging-in-Publication Data is available from the Library of Congress.

A catalogue record of the book is available from the British Library.

Design by Newgen Imaging Systems (P) Ltd., Chennai, India.

First PALGRAVE MACMILLAN paperback edition: October 2012

D 10 9 8 7 6 5 4 3 2

Contents

Figures

Series Editors' Foreword

"One picture is worth a thousand words" resonates as a familiar cliché. For the historian, however, a picture is worth a great deal of analysis. It provides a snapshot of a certain point in time. It is a piece of evidence to be interpreted. It evokes memories. As Alexander Freund and Alistair Thomson, the editors of this volume, suggest, in tandem with oral history, photography intersects at points of evidence, memory, and storytelling. Yet there is something more to understanding this intersection than the use of a photo as a mnemonic device.

The contributors to this volume understand that using photos during an oral history interview helps to *construct* the past as well as reveal, recover, or retell it. Photography and oral history involve two essential senses, sight and sound. Together they can enhance our understanding of past events or complicate and obscure the same. A happy image may invoke the opposite in the words of a narrator, who offers a back story that provides surprising information. Smiling family photos sometimes mask tension and trauma. Interviews often provide new meaning to photographs. An individual's revisiting photos over long periods of time can contribute to conflicting interviews by the same person. The complexity of uniting photography and oral history is substantial and the union is not neutral. As the editors point out, the "gap in meaning between photograph and oral narrative...is a focus of most essays in this collection." Such a focus adds to the methodological understanding and practice of oral history, which this series encourages. Other volumes such as Della Pollock's *Remembering: Oral History Performance* and the forthcoming, *Place, Writing, and Voice in Oral History* emphasize significant methodological approaches, but method and theory are important to all of the more than two dozen volumes that comprise the Palgrave Studies in Oral History series to date. Our goal, however, in addition to encouraging methodological rigor, is to offer our readers the best that oral history provides in vital narrative, significant substance, and topical relevance.

Bruce M. Stave
University of Connecticut

Linda Shopes
Carlisle, Pennsylvania

Acknowledgments

Photographs are more than simply illustrations of past lives, but they are also not that at all. They are historical documents and triggers of memories and stories, but they often fail to be either, and often they can be much more. Oral history and photography are interconnected in complex and until now largely unexplored ways. We came to the topic of oral history and photography through two different oral history projects on two different continents but with the same questions: How can oral historians best use photographs in their work? What do we make of our interviewees' often perplexing responses to photographs? In particular, why did family snap shots of smiling people so often evoke tears of sadness and tales of pain? Why did narrators not talk about what *we* saw in the photographs, and instead seemed to go off on "tangents"? And why have oral historians, who have used photographs from the beginning of their practice, written so little about their work with images? A response to these questions was overdue.

In designing this essay collection, we strove, as much as was possible without funding for translation, to gather perspectives and experiences from around the world. We believe we have succeeded, at least to some degree. Our contributors are from Australia, Brazil, Canada, Germany, the United Kingdom, and the United States. As is typical of the field of oral history, this is also a multi-disciplinary collection. Our authors hail from the fields of art history, communications, cultural studies, education, fine arts, history, social anthropology, and sociology. They include freelancers, teachers, and artists as well as junior and senior scholars. They report on diverse experiences and answer not only our own questions but also many others: how do people use photographs to perform their life stories? What is the role of political photographers in repressive regimes? How do photographs construct, support, and undermine identity? What is the difference between using photographs pulled out of a shoebox, and photographs in carefully assembled albums? Can photographs preserve memories? How do our bodies respond to images? What are the politics of using photographs in oral history?

An essay collection such as this is the work of many people, not only that of the authors and editors. On behalf of our contributors, we thank, first of all, our many interviewees from around the world who gave so generously of their time, their lives, and their often prized and most intimate possessions—their stories

and their photographs. As always, without the voluntary efforts of our narrators, there would be no book. On behalf of our contributors, we also thank the many colleagues who for the past two years have been drawn into discussions and asked to read drafts of essays.

We thank our contributors for their enthusiasm and cooperation, and for expanding our views on oral history and photography in ways we could not have imagined. We also thank Linda Shopes and Bruce Stave for their enthusiastic support of this project and the insightful advice along the way; Samantha Hasey and Sarah Whalen, editorial assistants, and Chris Chappell, editor, at Palgrave, for their support and gently keeping us on track. We thankfully acknowledge a print subsidy by the Chair in German-Canadian Studies at the University of Winnipeg.

Alex thanks Andriy Nahachewsky and his other research partners as well as Leslie Hall, Christine Kampen, Matt Scalena, Angela Thiessen, and other research assistants in the *Local Culture and Diversity on the Prairies Project*, who first drew him to the question of photography in oral history; Angela Thiessen for pursuing a compelling case study; Ron J. Grele, Alexander v. Plato, and Penny Tinkler for early discussions; Ian Keenan for probing questions; and Catherine-Lune Grayson for new perspectives and insights on photography projects around the world. I thank my mother, and my sister and her family for fun times, good food, interest, and love on my visits to Hamburg and via mail, phone, email, and Skype.

Al thanks the four women in our Moving Stories project (Phyl Cave, Gwen Good, Joan Pickett, and Dorothy Wright) for sharing their photographs and memories and helping me to see the connections between memories, stories and images. Thanks too to members of the Melbourne Life Writing Group and my Monash History Department Research Group for their comments on drafts of my writing, and especially to Katie Holmes, Jim Mitchell, Dorothy Sheridan, and Siân Edwards.

Introduction: Oral History and Photography

Alexander Freund and Alistair Thomson

But photographs cannot tell stories. They can only provide evidence of stories, and evidence is mute; it demands investigation and interpretation. Looked at in this way, as evidence of something beyond itself, a photograph can best be understood not as an answer or an end to inquiry, but as an invitation to look more closely, and to ask questions.

—Phillip Gourevitch[1]

We have all heard it said that one picture is worth a thousand words. Yet, if this statement is true, why does it have to be a saying? Because a picture is worth a thousand words only under special conditions—which commonly include a context of words in which the picture is set.

—Walter J. Ong[2]

This book is about the "photographic turn" in oral history. Historians' interest in photographs—their "discovery of old photographs"—dates back, according to Raphael Samuel's observations in Great Britain, to the early 1960s.[3] Historians back then evaluated their visual evidence much less critically than their traditional textual sources, treating photographs, as Samuel criticized, as "transparent reflections of fact."[4] Cultural and family historians as well as archivists seized on photographs in the 1970s, concentrating on their assumedly self-evident informational value.[5] Over the last two decades, the use of photographs has come under greater critical scrutiny. In turning the object of its research into a category of analysis, the discipline of history has moved toward a "pictorial turn," a "visual turn," an "iconic turn," or, more focused, a "turn to photography."[6]

Oral history, as Samuel noted, was from the beginning intertwined with photography—not methodologically, but in the historians' belief that without oral history, as without photography, "history was dead."[7] This belief was most obviously expressed in a "flood of 'We-Remember' books which poured out of the local and community presses" in Great Britain during the 1970s.[8] Popular oral history often, and rather nostalgically, used the family album "as a device for family reconstitution and opening up memory lanes."[9] Schools, too, seized on photographs and oral histories for their "graphic representation of otherness."[10] This was an international phenomenon. In the early 1970s, Lil McIntosh, a librarian in British Columbia, Canada, "had a lady come into a classroom with me...and I taped her speaking about the pictures that were in front of us all. They were her pictures of her life when she had come to Fraser Lake, in 1910, when she was four years old. There wasn't a lack of interest at all; she was a good subject to bring to the classroom."[11] Similarly, the Foxfire project in the Appalachians in Georgia, United States, taught high school students to explore their local culture and community through oral history and photography.[12] In several European countries, history workshops interviewed contemporary witnesses and collected local photographs. The Oral History Centre at the National Archives of Singapore used photography extensively in several projects documenting vanishing trades or communities of Singapore. In New Zealand the History Group of the Ministry for Culture and Heritage has produced many books and, more recently, web-based publications that combine recorded memories and both official and personal photographs.[13]

Thus, it has long been common practice in oral history to use photographs. This is not surprising. Oral history and photography intersect at important epistemic points: evidence, memory, and storytelling. Both are used as forms of evidence; both require "memory work"; and both are forms of storytelling. Despite these intersections, oral historians find little guidance in their literature on the use of photographs in oral history. All of the major English-language oral history guides and handbooks mention photographs only in passing, if at all. Photographs, these guides suggest, should be sought out from interviewees as further documentation and they may be used as memory triggers. The guides are silent on how exactly oral historians should go about using photographs to stimulate memories and they do not suggest other understandings of photographs beyond that of social documentation.[14] Beyond guides, there are few case studies that explore the theoretical and methodological implications of using photographs in oral history work.[15]

This lack of reflection and discussion on the systematic use of photographs in oral history may explain why oral historians' use of photographs has been sporadic and narrow. Most oral history publications do not include photographs, and if they do, they often serve only as illustrations.[16] When oral historians use photographs as memory triggers, they seldom reflect on this practice in their

publications. In the few cases that oral historians have integrated photographs into their analysis, they have done so mostly by understanding photographs as a historical source of further information about the past. In this quest for more historical facts, oral historians have used photographs in two ways: as documents of social history and as mnemonic devices.

First, oral historians have read photographs like other sources as documents of social history, that is, as containers of facts about past events and experiences. The interview can help in "discovering," as Paul Thompson writes in *The Voice of the Past*, "written documents and photographs which would not have otherwise been traced."[17] This discovery would take place after the interview: "Do not rush away after the recording session," Thompson counsels, "be prepared to chat about the family and photographs."[18] Thompson stresses the fruitfulness of "combining" testimonies with photographs, and he warns that "social images of 'respectable' or 'happy families' determine what photographs are taken, just as a similar decision is made about what is kept for the album."[19] Linda Shopes advised in 1980: "Sensitively interpreted, [family photographs] can suggest much about 'what life was like' years ago."[20] And Samuel wrote in 1994: "Deconstruction, using photographs in conjunction with oral testimonies and written documents, splicing together different classes of evidence, or using one to expose the silences and absences of the other, is one procedure which historians can bring to bear on the explication and interpretation of old photographs."[21] Oral historians have also been advised to bring a camera to the interview to take pictures of the interviewee, material objects, and living surroundings, or, better still, to bring along a photographer to take a series of photographs that can then be matched with the interviews.[22]

These have been fruitful suggestions, but they are far from the concrete advice that oral historians need for a systematic and reflexive use and interpretation of photographs. The essays in this collection provide, through their case studies, a number of approaches to using photographs as social documents. At the same time, however, the authors in this book go beyond this traditional use of photographs by questioning the epistemic status of photographs—at least as they are used in oral history—as historical documents. Thus, they are interested not only in *what* is depicted in the picture, but also in *how* the producer depicted it, and how the interviewee as well as the interviewer use it in the context of oral history.

Second, oral historians have used photographs to "stimulate the narrator to remember," to trigger recall, as Valerie Raleigh Yow, Donald A. Ritchie, and many others write.[23] From the beginning, oral historians were alert to the complexity of recall through photographs. Sherna Gluck counseled in 1977 to view photographs early on in the project and "to let the tape recorder run as [the interviewee] comments on her photo album...Although the material should be recorded again later, in the context of the period in which it took place, the second version of the

story might be quite different from the first rendition—which could become a lost gem were we not to record when the memory spontaneously surfaced."[24] Paul Thompson warned: "Experiments have shown that it is relatively easy to generate false memories by feeding people with a mixture of genuine and misleading stimulants to memory such as photographs."[25]

Again, this has been valuable advice, but—despite Yow's sample questions about the content and provenance of photographs—insufficient to help oral historians use photographs more systematically. This essay collection offers a number of approaches to using photographs as memory triggers, ranging from various forms of visual life-story telling (Freund and Thiessen, Thomson, Schiebel and Robel) and thematic photo-review (Ryan, Thompson, Mauad) to photo-album review (Tinkler) and anthropological photo-elicitation (Mannik), to commemorative photographing (Wilton), repatriation of photographs (Payne), and presentation in exhibits and online (Bersch and Grant, Marles). The essays move beyond the use of photographs as mnemonic devices to a reflection on how differently memories are evoked by different methods and how memories may either not be stimulated at all or may be so overwhelming that they cannot be expressed.

Certainly, using photographs as documents and as mnemonic devices has served oral historians well. Countless oral history interviews include more and richer detail about life in the past because photographs stimulated memories. There are fine publications that have included both historical photographs and photographs taken alongside oral histories. The best are the results of cooperation between oral historians and photographers. Milton Rogovin and Michael H. Frisch's *Portraits in Steel* is an example of the combined power of photography and oral testimony. In some cases, the visual and oral documents were mounted as exhibitions.[26] Tamara Hareven and Randolph Langenbach reported that Langenbach's exhibition of photographs dramatically changed the interviewing process, because it was only after seeing historical photographs and portraits of themselves that townspeople and workers understood the historical significance of their lives and the necessity to tell their stories.[27] In their study of Homestead, Pennsylvania, United States, Judith Modell and Charles Brodsky developed an interviewing method that (reversing Gluck's method) asked first for an oral narrative and then for a response to archival photographs, photographs taken by Brodsky, and family photographs. They then analyzed the relationship between oral narrative and "visual story."[28] Marjorie L. McLellan interviewed members of a Pomeranian immigrant farming family in Wisconsin, United States, to understand the regional and family history in the context of which the family had produced several thousand early-twentieth-century photographs and accompanying artifacts and documents.[29]

Rather than brushing aside this fine work, this essay collection seeks to extend the inquiry into the relationship between image, oral narrative, and

memory. Gourevitch and Ong have pointed out, as quoted at the beginning of our introduction, that images need stories to create meaning—or rather, in order to imbue images with meaning, we tell stories about them, whether silently to ourselves as we view a picture and speculate on what happened before the depiction of a scene, or out loud to others. But the opposite is also true: we tell narratives through imagery. Images and stories, Ricoeur argues, are linked to time and thus to the past and to memory.[30] If we want to understand the people we interview—people who grew up in a visual world—we need to know their images, or at least a few of them. And if we want to understand how they were shaped by images, we have to ask them to tell us about them. This is no easy task. This book attempts to provide a few answers.

Photography critics have approached this task by pointing to the complex relationship between photographs and language. Photographs do not say more than a thousand words and they do not speak for themselves. As James C. Curtis argues, photographs are mute: "It is as if the image provides a fact, but the word provides the meaning."[31] Words invest photographs with meaning, and oral historians must be alert to the multiple narratives that are ascribed to the images they discuss with their interviewees. As H. Porter Abbott argues, each image is already invested with narrative. When we look at an image, our "narrative consciousness" is automatically activated: "We want to know not just what is there, but also what happened." And if the story is not explicitly stated in the image, we will make one up by drawing on the "many narrative templates in our minds."[32] Another narrative told through pictures is generated by their arrangement, for instance, the order of photographs in an album.[33] Often, photographs and albums come with captions, thus providing yet another narrative. As Jacquelyn Dowd Hall reminds us, there is also the story of the photograph's production, a story that may be quite mysterious if the relationship between the photographer and the photographed person is intimate yet characterized by the photographer's absence from the images: "She is behind the camera, which secretly evokes her presence yet hides it from history's prying eyes."[34] In interviews, we can collect our interviewee's narratives about the photographs and their production as well as about our interviewees' lives—two often separate and even contradictory stories that may tell of happy images and sad experiences. And then there are the stories we as historians tell about the photographs and our interviewees' use of them.

Multiple meanings and the in-between gaps are evidence that the narratives woven around photographs are not merely additions to the stories told in "traditional" oral history interviews. Rather, they often run counter to what we could call "master life stories"—the life stories we feel comfortable telling ourselves and others. Memories evoked by photographs are not simply memories in addition to those recalled through narrating. These are often repressed or suppressed—rather than simply "forgotten"—memories that undermine and contradict personal "master memories" as often as they enhance or nuance them. As several

authors in this collection demonstrate, photography-evoked memories come as often with silences as with words.

Most of our contributors explore the relationship between image, oral narrative, and memory through their practice as oral historians, albeit from various disciplines, rather than as photographers or photography critics (although Carol Payne is a photo studies scholar and Al Bersch and Leslie Grant are also photographers). The authors explore the multiple layers of meaning different viewers invest in photographs before, during, and after the oral history interview. They also investigate the complex ways in which photographs not only trigger but also shape memory and how photographs are in turn seen or read through memory. Thus, this essay collection offers readers approaches to using photographs as more than social documents and mnemonic devices.

We have decided to focus on photographs and to leave out other forms of images, including video. Video recording in oral history is commonly used as an alternative to audio recording and as such poses very different questions about the relationship between image and narrative. The use of historical video or film footage—in a way that parallels the use of photographs discussed in this collection—is explored in archivists' oral history interviews with donors of films or in social-psychological inquiries into the influence of film on memory.[35] These practices await further investigation.

Another major gap is that of digital imaging and the creation of "mediated memories."[36] Digital photography changes how we take pictures, how we interact with pictures and picture-taking, how we use pictures, and how it changes the pictures themselves. Increasingly, people have their family "albums" on their computers instead of or in addition to the hard copy albums. More and more people scan and digitize their analog memory objects, such as diaries and letters, music and other sound recordings, photographs, and home movies.[37] What challenges will these changes present to oral historians using photographs? How will oral historians respond to this new digital image interaction? Alistair Thomson gives a glimpse of how digital technology changes oral historians' use of photographs: he digitized the photographs that the interviewees had loaned him and then together they looked at the pictures on his laptop. This was more than simple convenience. The pictures were blown up, much bigger—new and important details could be seen and commented upon. Digital technologies also affect how people use photographs. Ian Keenan writes, "The simple abundance of digital images has altered, in my family, the way in which photographs are used as material, ritual objects." Think of the digital photo frame: instead of one iconic family photograph on the mantelpiece, we can now show dozens or thousands of photographs in an endless loop. Keenan concludes, "While the photographic medium remains important in our self-portrayal, the role of individual images is lessened."[38] Moreover, further individualization is, as van Dijck (following Barbara Harrison) argues, another result of digital photography: "Self-presentation—rather than family

re-presentation—has become a major function of photographs" over the last two decades.[39] At the same time, while not new to the digital age, pictures can be more easily manipulated and it is harder to detect such manipulation.[40] We also need to be concerned about preservation. As with all digital files, digital photographs' duration of survival is unclear. With each missed step in migrating images to the next software and hardware, will we lose billions of pictures? And will this spread evenly across populations, or affect especially those who cannot afford to continually upgrade, who do not have the skills to transfer, or who do not have the time to preserve their digital albums? At the same time, a certain number of pictures are uploaded to various Internet sites such as Flickr or Facebook. This is a new form of sharing photographs with wider circles of family and friends, and even strangers. This dramatic change in visual culture changes how we remember the past through photographs. It is not yet clear, however, what the changes will be. In 50 years will we still be able to ask interviewees to select their ten most memorable photographs, and then sit down with them to browse through their albums? Although we do not tackle these questions in this collection, oral historians will eventually have to address them.

Indeed, our focus is to some extent even narrower: Half of the essays deal with family photographs, another five with photographs that were either originally shot or later reinterpreted as private or personal photographs. The essay collection was not designed in this way, but, we believe, the preponderance of family and personal photographs is intrinsic to current oral history practice.

It is tricky business to define a photograph as a personal or family photo. Milton Guran's pictures of the Brazilian military government (discussed by Ana Mauad) were taken as press photographs of public events, but, as Martina Schiebel and Yvone Robel show, people may well reframe press photographs of themselves as family photos, thus blurring or even erasing the boundary between public and private photos. Similarly, Kathleen M. Ryan demonstrates that propaganda photos find their ways into family albums. As Al Bersch and Leslie Grant show, private photographs become public when mounted in exhibitions or, as Janet Elizabeth Marles did, when they are published online.

There is a category of photographs, however, that is largely missing from this book and that is seldom classified as family photographs. Those are the pictures that Susan Sontag writes about in *Regarding the Pain of Others*.[41] There are no photographs of violence or war in this collection. Oral history investigates atrocities and human rights violations as much as photographers do. Yet, we seldom ask people to talk about the photographs that confront them and us in the news media every day (and survivors of violence rarely have their own photographs of persecution to share and discuss in interviews).[42] These "media icons" and "key pictures" of "violence, war, and genocide; revolution and transition; gender and generation; mobility (national, geographic, social); medialization (politics, propaganda, advertising); science and technology" have shaped, according to

some historians, the "image canon of cultural memory."[43] Whether or how this is actually so is open to debate. Oral historians have a distinct vantage point for launching this inquiry, because they can ask people directly how they make sense of such images and how such images shape their lives. At the same time, the lack of atrocity photographs in our research points in another direction as well, namely, the scarcity of oral history research on perpetrators. The postcards of Jim Crow-era public lynchings, as well as soldiers' snap shots of the German army's mass killings in Poland during World War II, and the U.S. Army's crimes in Abu Ghraib prove that atrocity photos have been part of family albums for a long time.[44]

This is not to say, however, that the photographs in this collection are all happy images. It is true, as Marjorie L. McLellan writes, that "[p]rofound emotions of loss, death, anger, and bitterness are expressed in stories rather than in the trite photographs of funeral bouquets."[45] But as several authors demonstrate, "happy-memory"-photographs can evoke painful memories. Furthermore, as Penny Tinkler shows in this book, photographs torn out of albums leave material traces of "profound emotions of loss, death, anger, and bitterness." Publicly instrumentalized happy photographs—be it a wedding photo hung on a dining-room wall or propaganda photos used by a government at war—that cover up stories of pain, abuse, and humiliation are, as this collection shows, widespread. It is often this insidious abyss between meanings that oral historians wish to understand.

In their quest to make sense of personal and family photos, oral historians look to the pioneering work of Marjorie L. McLellan. "[P]hotographs and stories, the stuff of family nostalgia," McLellan writes about her case study, "offered dramatic windows on both the history of rural immigrant life and the processes by which a family constructed its identity."[46] She shows that just like oral narratives, photographs are subjective, and may be fictive, even to the point that photographs are intentionally fabricated as evidence. "[T]he photographer and his subjects imaginatively construct images in a picture-taking event," McLellan writes.[47] In her case study, the family had dressed up in period costumes and used old farm equipment to display, like in a tableau vivante, scenes of their ancestors' farming life. Few of us go to the same extent of designing photographs, but when we pose, often smiling, with a babe in arms, on a voyage to a new country, in front of a new car, or surrounded by friends, we similarly perform a scene as our life. Most family photographs, even those called snap shots, are posed.

The darkroom fixer does not fix the photograph's meaning. Different viewers, as McLellan alerts historians, bring "personal experience and associations to the image"[48] and thus affix different meanings to the same image. Meanings also change over time. "Family photographs gather meaning from the way families use them," McLellan writes. With changing needs, photographs gain new currency. Initially, photographs may be used to recall birthdays, weddings, and picnics.

Later, it may become "more important to know how someone looked when they were young than it is to recall particular events."[49] Similarly, the authors in this collection, familiar, as oral historians, with the performative aspects of interviews, analyze photographs as a rhetoric of memory.

Two scholars in particular have advanced our thinking about the relationship between oral narratives and photographs, about performance, rhetoric, and images. They too have focused on family photographs and family albums. Martha Langford investigates the "striking" "parallels between orality and photography." She argues that even if we cannot interview anyone about a family album, we can nevertheless discover oral tradition that originally accompanied the album in its contents and structure: "the organization of photographs into albums," she writes, "has been one way of preserving the structures of oral tradition for new uses in the present." She alerts oral historians to the fact that posing does not only happen at the time of releasing the shutter, but every time the photograph is presented: "The showing and telling of an album is a performance."[50] This means that while orality and visuality are related, stories about photographs are structured in a different way than other kinds of oral narratives. Thus, the authors in this book also examine what one could call the oral-visual performance during the interview.

Marianne Hirsch also looks at family photographs, including those of her own family, as well as the stories woven around those photographs, which constitute, as she says following W. J. T. Mitchell, "imagetexts." Photographs and albums, she argues, create a "familial gaze" that "frame" and thus make families, but in an ideological fashion: "photographer and viewer collaborate on the reproduction of ideology." The stories, however, serve to undermine ideology: "The composite imagetexts...both expose and resist the conventions of family photography and hegemonic familial ideologies."[51] Like Langford, Hirsch suggests that imagetexts' power to constitute individual subjects lingers on beyond the generation of the depicted and depicters. "Postmemory" is the term Hirsch uses to describe these powerful lingering effects of memory on succeeding generations—a memory rooted in a family's oral tradition rather than lived experiences.

That so much analysis of photographs and oral narratives should focus on private and family photographs is not surprising. Oral historians are interested in private and family life. Within oral history this is an imbalance that needs to be addressed (but not in this volume). Yet, the focus on private life is also a political stance vis-à-vis a dominant history that eschews private life, be it in the form of life stories or family photographs. One need only look to historical surveys and textbooks to see historians' disinterest in family and private imagetexts.

Oral history's "photographic turn" happens at an important moment in time. History's turn to the image is, according to Doris Bachmann-Medick, a reaction to the dominance of the word in the social sciences and humanities. The pictorial turn is also a reaction to the "picture revolution" since the second half

of the nineteenth century and particularly the increasing circulation of images through mass media and now through the Internet.[52] Photography was among the first visual media to be mass produced and circulated.[53] It was so from its very inception in 1839.[54] The "carte-de-visite" (invented in 1854), a small photograph mounted on a slightly larger card, "was the first attempt at a form of mass production of popular photographs." Collecting visiting cards of family as well as royalty and celebrities became a craze among the middle classes, who organized them in albums, sent them to relatives, and traded them with friends.[55] Other forms of mass images certainly preceded family photography, for example in the form of pictures on billboards or magazines such as *Illustrated London News*. In the twentieth century, new kinds of visual images, especially moving images, and new forms of mass distribution—cinemas, television, the Internet—increased our exposure to and focus on visual representations of the world.

What exactly is this turn to the visual and how does it affect oral history? What marks this development as a "turn"? Historians' increasing interest in and use of photographs alone does not constitute a "turn." Rather, the image—in our case, the photograph—is turned, as Bachmann-Medick explains, from an object of investigation into a category of analysis.[56] Hence, in recent historical investigations, as Jennifer Tucker explains, "the photograph serves not only as a historical document or source, but also as a reflexive medium that exposes the stakes of historical study by revealing the constructed nature of what constitutes historical evidence."[57] Turning the object of study into "a reflexive medium" rings true to many oral historians, who since the 1970s have "turned" their oral sources into a category of analysis.[58]

It is easy enough for historians to understand that photographs, just like other pictures, are not self-evident, do not speak for themselves, and need to be understood not as objective depictions of past reality but rather as artifacts produced by people with interests and agendas at a certain time and place, artifacts that are shaped as much by aesthetic conventions as by social norms. Yet, historians—not trained in the use of images—find it difficult to put this realization into practice. Oral historians in particular find themselves in an ironic situation. They have traditionally battled prejudice against oral sources as "subjective," fraught with problems of memory (i.e., recall), and thus unreliable. In using photographs, oral historians must now battle the popular assumption that photographs are objective because "the camera never lies."[59]

The authors in this collection offer a path out of the dead-end street of the objectivity-subjectivity dichotomy. They explore the photograph in the context of the oral history interview as a reflexive medium—photographs and oral narratives playing on each other during the interview construct rather than simply reveal, recover, or retell the past. Our contributors begin with the proposition that photographs, just like the memories evoked in oral narratives, are not timeless and fixed in their meanings. Although they draw on a variety of theories

coming out of photography criticism, our authors base their arguments on the empirical case studies at hand. While an extensive review of photo theory is not necessary here because the authors explain the concepts they use, Annette Kuhn and Kirsten Emiko McAllister's classification of this theory may be a useful guide to some of the fundamental questions asked in the wake of the photographic turn.

Photography theory has drawn on "three strands of analysis," according to Kuhn and McAllister. The first, following Foucault and postcolonial theory, asks how photography is implicated both "in the production of modern knowledge, where sight operates as the foundation of a system of classification and control" and in the production of "colonial knowledge structured by the desire and the gaze of the coloniser." The second, based on feminist theory and Holocaust Studies, investigates how scholars, "in the process of analysing the discourses deployed through photography," are invested "in the images they study." The third "draws on earlier phenomenological studies of photography by Roland Barthes, Walter Benjamin and Siegfried Kracauer." This strand asks "how photography can become implicated in our knowing the world." Barthes's concept of the "punctum," for example, is used in several essays to get a grip on how photographs affect viewers emotionally. Freund and Thiessen use punctum to indicate the jarring effect on the historian of the gap between a happy image and its horrid story, while Tinkler uses it to indicate how a photograph triggers an emotional response. Ryan understands punctum as an "after-image" that lingers in memory even after the photograph is put away, and, like Freund and Thiessen, posits that punctum may be enriched or even generated by a story about a photograph that may otherwise be forgettable. More generally, photography critics "consider how meanings in photographs may be shifted, challenged and renewed over time and for different purposes, from historical inquiries to quests for personal, familial, postcolonial and national identities."[60]

The oral historians in this collection draw on all three strands of theory to investigate not only photographs' past meanings but also the meanings developed and ascribed during the interview. Just as our narrators, in collaboration with oral historians, make sense of their lives through the stories they tell, they make sense of their lives by weaving stories around and inscribing meanings into photographs in the situation of the interview. These meanings, like the oral narratives, are constructed through language, emotions, and body movements. They are constructed dialogically and interactively—oral historians are implicated in the construction of the photographs' meanings as they, in turn, then use photographs for their own research goals.

Penny Tinkler and Alistair Thomson, for example, ask in their respective essays how photographs and photographic albums were implicated in producing knowledge about being a "modern" Briton in the post–World War II period, be it as teenage girls or overseas migrants. Oral history helps these authors understand

how identities and meanings shifted over time and continue to emotionally affect people who volunteer to revisit old photographs in an oral history interview. Casting back a longer historical glance, Maris Thompson also looks at families' understanding of their modernization, in the form of Americanization, in their photographs. Carol Payne investigates the ramifications of the Canadian colonial gaze of Inuit in the 1950s and asks how Inuit youth nowadays find positive ways of using the same photographs to reconstruct their elders' and their own identities and histories.

Several authors explore how they are invested in their interviewees' photographs. Payne found that photographs initially devised for increasing white Canadians' pride in their country, and which scholars trained in postcolonial theory see as evidence of "cultural disruption," were used half a century later by the Inuit for creating a sense of "intergenerational continuity." Janis Wilton asked herself and her relatives to talk about photographs in order to explore the meanings of her mother's passing. Photographs included those the family took of the interior of her mum's house to create an inventory before everything was dispersed among the family. Janet Elizabeth Marles embarks on a similar journey with her mother, who uses photographs to reconstruct her life experiences as an orphan. Oral historians have been invested not only in their own family photographs, as Al Bersch and Leslie Grant demonstrate in their examination of photographs and oral history in exhibitions. Alert to their own voice in constructing an exhibit, "to undermine any possibility of a single overriding perspective, author, or narrative" they included not only the photographs they had taken of their interviewees but also those their interviewees had given them. Similarly, Kathleen M. Ryan investigates her own role in inscribing meanings into photographs of women in the U.S. military during World War II.

Most authors draw on phenomenological studies of photography—considering oral history's affinity to phenomenology (the study "of what we perceive and how we perceive it"), this is perhaps not surprising.[61] Thus, Ana Mauad lets the Brazilian photographer Milton Guran revisit his political photography during the last phase of the military government. On the basis of his narrative, she explores photography's "capacity...to organize the meanings of contemporary history." As several authors point out, photographs' meanings shift not only over historical time; multiple meanings are being attached to photographs during the interview process. These multiple meanings create fissures and gaps. It is these varied discrepancies of meaning that are the focus of several essays. Alexander Freund and Angela Thiessen explore the gap between the apparent meanings of a "happy-memory" wedding picture, and the stories of hardship told about this photograph. Lynda Mannik similarly explores the silences and sensory memories of post-World War II refugees who looked at photographs of their arduous and stressful overseas passage.

All of these essays show that the use of photographs in oral history interviews is not neutral. In an interview, photographs are reframed and re-presented in new and potentially disturbing ways. Photographs in the oral history context become powerful signifiers of a significant past, that is, of history. Martina Schiebel and Yvonne Robel state this perhaps most clearly, arguing that oral history fixes photographs' meanings in two ways. First, a photograph acquires a fixed meaning as it is used to illustrate a specific biographical context. Second, a narrative implies that the photograph always had a particular and intended biographical meaning. This understanding has implications for oral historians' analysis and interpretation of photographs and the stories that their interviewees tell about them. It also has implication for the actual interview. That personal photographs, hitherto stored away in albums and shoe boxes, may also be "historical evidence" and the objects of public interest may be startling and even difficult to accept for our interviewees. Thus, oral historians asking for photographs, Mannik warns, "need to be sensitive to the dramatic effect they may have." We are part of the process by which interviewees make meanings with photographs and memories, and thus we need to pay attention to how photographs are introduced and used in interviews.

Remembering with Images

The 12 essays in this book move from a focus on method, that is, how we remember with images (Part I), to a focus on interpretation and presentation, that is, how we make histories (Part II), although most essays address both aspects. Alexander Freund and Angela Thiessen open Part I with a case study that explores some fundamental questions about the use of photographs in oral history. Beginning with the assumption that photographs help interviewees remember and narrate their life stories, they asked rural Canadians who came of age on the Canadian prairies before World War II to choose photographs to tell the story of their early life. Photographic theory helped Freund and Thiessen prize open some of the manifold meanings interviewees and interviewers together inscribed into the photographs in the interview setting. They argue that rather than simply enhancing an orally remembered and narrated life story through added memory details, photographs may allow people to tell a different kind of life story, or may silence them or maneuver them into a situation of depicting themselves at the margin of their lives. The photographic life story unravels past and present social norms and cultural values that can then be subtly undercut by counter memories. Thus, the main interviewee in their case study counterpointed her "happy memory"– wedding photograph with complex stories of both hardship and fulfillment. Alert to the meanings created in the interview process, Freund and Thiessen also write this as a story of young interviewers expecting a wedding photograph to forecast

a "happy story" and being quickly confronted with a narrative that troubles their own expectations and values.

Indeed, it is this gap in meaning between photograph and oral narrative that is a focus of most essays in this collection. Family and personal photographs tend to depict smiling faces, but not necessarily happy moments. As Penny Tinkler's research documents, this gap between diametrically opposed meanings, while not evident in the photographs as such, can be evident in photo albums. Tinkler interviewed British women about the albums they had created as teenagers in Britain during the 1950s and 1960s. The jealous husband of one of her narrators had ripped out photographs from his wife's teenage album. Large blank spaces, smears of old glue, and torn paper are the scars left behind in the album and are traces of the different meanings the husband had inscribed in the photographs. For the women, returning to the albums half a century later revealed other gaps between happy pictures and narrated memories. Photographs they had not looked at for decades put them in a position of discomposure that compelled them to integrate a long-forgotten youthful counter-memory into their well-honed adult life story. That photographs represent lived experience differently from oral narratives is not surprising, although until now has not been systematically studied by oral historians.

Janis Wilton used oral history and photography to deal with the loss of her mother. Taking photographs of the inventory of her mother's house—creating new material memory objects (photographs) of old material memory objects (for example, a toaster)—allowed her to find out about the manifold meanings her relatives attached to the relationships with their mother, grandmother, or aunt. As Wilton says, "We decided to photograph memories." Rather than using photographs only as triggers of memory, the need to remember also triggered the need to photograph. Family members' memories were stirred by material objects; this stimulated the desire to create photographs as durable, portable material memory objects. Material objects and memories create—and in turn transform—each other. The photograph of Wilton's mother's old toaster is a different kind of material memory object than the toaster itself. Wilton's research shows that photographs and memory stories cannot be thought of as a one-way street. The photograph-memory relationship is not linear and unidirectional. In this photographic age, photographs are intrinsically linked with memories; they generate each other.

Lynda Mannik used anthropology's photo-elicitation method in her interviews. She collected an archive of photographs taken by Estonian displaced persons who traveled on a small ship from Sweden to Canada in 1947. She presented the pictures on large boards to the former passengers. Perhaps because this was a more "confrontational" introduction of photographs—photographs most interviewees had never seen, brought in from the outside rather than pulled from the kitchen cupboard or night stand drawer—the interviewees' emotional

bodily reactions were more palpable, leading Mannik to explore different sensory memories evoked by the images. Photographs helped narrators remember and tell stories in diverse ways. The dangerous journey had been traumatic for many of the passengers. Naming people in the photographs and using photographs as historical evidence became important strategies in the interviews to deal with difficult experiences. Creating nostalgic memories through "happy" photographs helped narrators sustain narratives and identities. Forgetting was an important form of silence that interviewees found to be both surprising and healing.

Naming people in photographs was also an important strategy for constructing individual and group identity in Carol Payne's research. The Canadian federal government had taken photographs of Inuit during the 1950s. In the 2000s, in a process of repatriation of the photographs, Inuit youth were given copies of the photographs and they interviewed their elders about them. Naming or identifying the people in the photographs became an important part of creating a historical sense of identity across the generations. For the youth, however, working with the photographs did not stop at the emotional response they shared with their grandparents. Interviewing the young people about their photo-interviews, Payne found that the emotional response was often transformed into a political engagement.

While Payne interviewed young people just setting out to become politically engaged, Schiebel and Robel interviewed men looking back at difficult lives as communists in West Germany. Their interviewees actively used media photographs and other documents to structure their life stories in the interaction with the interviewers. Schiebel and Robel encountered interviewees who by themselves had selected a number of photographs and decided to begin their life stories by presenting these photographs as supporting evidence, in part to "link their personal narratives to the collective memory of their group." Schiebel and Robel argue that their narrators' memories are "structured by pictures" and conclude that "photographs and oral accounts are interrelated in a way that influences the structure and content of narratives as well as the reception of photographs."

Although the essays in the second part of the book are less concerned with interview methodology, it will be useful to briefly add their approaches to using photographs in interviews. Kathleen M. Ryan, like Freund and Thiessen, asked her interviewees to select photographs from a specific time period—the narrators' time in the military—and, like Mannik, also brought other photographs to the interviews. Maris Thompson asked her interviewees for photographs and albums that stretched far back to a time before her interviewees' own life stories to explore photographic genealogical memories. Alistair Thomson scanned photographs from his interviewees and then returned to discuss the photographs, now blown up on his laptop computer screen. Ana Maria Mauad selected photographs together with her narrator, a professional photographer, and then asked about the creation and intended meaning of each image. Al Bersch and Leslie Grant as

well as Janet Marles worked with the photographs their interviewees gave them; Bersch and Grant also took photographs, both of their interviewees and of their material artifacts. This diversity of approaches to introducing photographs in oral history interviews demonstrates that this needs to be a reflective practice that is carefully planned before the interview.

Making Histories

The essays in Part II deal more concretely with the making of histories. Before discussing the essays in Part II, a few words about how the first six essays deal with history making. Freund and Thiessen explain that history, a loaded term, shapes people's understanding of what constitutes a "historical" photograph—this has implications for the photographs selected by the interviewees and the stories they tell. Tinkler shows how people participate in the making of histories by producing photographic archives. Albums seldom make their way into archives and it is up to the oral historian to ensure they enter the historical record. Wilton documents how families create informal family histories by taking photographs and conducting interviews while Mannik shows that sometimes oral historians have to be more active in the creation of archives. Payne as well as Schiebel and Robel explore, in different ways, the role of photographs and narratives in the formation and representation of historical consciousness.

Making histories is the focus of essays in Part II. Kathleen M. Ryan interviewed female navy recruits who served in World War II and asked them about photographs the women had kept from the period as well as propaganda photographs produced by the U.S. Navy. Ryan explores the interplay of values, memories, and images in the women's self-presentation vis-à-vis their public image as it was created by navy photographs. She uses Barthes's notion of the "punctum"—that aspect of a photograph that catches one's eye, that touches one personally, that gets under one's skin—to better understand the meaning gap opened by, on the one hand side, glorious, liberating oral narratives and, on the other, mundane photographs. But punctum also helps her analyze how she participates in the construction of the WAVES' history.[62] It is the punctum that allows her to establish a link between the past and the present, between the women and history, between the imagetexts and herself.

Maris Thompson used family photographs and interviews with second-, third-, and fourth-generation German Americans in Illinois, United States, to explore their memories and post-memories of discrimination during the two world wars and the lingering legacy of Americanization: "Oral testimonies and family photographs uniquely highlight how traumas experienced during the first half of the twentieth century are still very much at work in the stories from these communities." While the oral testimonies revealed memories of anti-German

sentiment, language restrictions, and the need to keep a "low profile," the photo albums served as more positive anchors of family lore, helping German American families to ground their identities in their ethnic history and the American landscape. Such gaps between meanings, Thompson writes, are "productive spaces for analysis of social history."

The fault lines of migration are also at the center of Alistair Thomson's study of British migrants to Australia who sent photographs, letters, and audio tapes back home during the 1950s and 1960s. He uses the productive spaces produced by the juxtaposition of image and narrative to explore photographs' "complex and even contradictory relationship to memory." Behind the smiling photos of immigrant success linger the memories of unhappiness, disappointment, and family conflict. Placing photographs and oral stories next to each other exposes the crevices between myth and reality. Yet, neither the happiness of photos nor the lack of unhappy photos can suppress memories of hardship. Indeed, happy photographs have the power to evoke contradictory memories. Thomson in particular draws our attention to the production history of photographs: "the contemporary photograph is highly selective, influenced by technology...cultural expectations of what to photograph and how to pose, and the social relationships within which photos were taken, disseminated, and discussed." Thus, while the photographs themselves depict smiling faces, their use during the interview may point to past and possibly still reverberating tensions created by social expectations and individual desires.

While print publications have been a dominant medium for oral historians to publish their research, Janet Elizabeth Marles created a website through which visitors can explore photographs in more detail, while Al Bersch and Leslie Grant mounted an exhibition of photographs and oral narratives (also accessible online) that aimed to challenge our understanding of historical representation. Bersch and Grant question the possibility of documentary as a social practice and seek to "undermine expectations for authority and truth in oral histories and photographs." Thus introducing the notion of a "documentary turn,"[63] they argue that the presentation of oral history and photographs as evidence of "authentic" experience of hardship and oppression does "more to maintain existing conditions than...to promote social change," because these representations deflect attention from systemic oppression and imply that oppression is an individual's personal misfortune. The three projects they discuss provide alternative approaches that nevertheless accept the possibility of saying something meaningful about experience. In their own project, Sugar House, they worked with former workers at a closed-down sugar refinery to assemble diverse materials that they "treated as collage elements rather than revelatory mediums." History, as a result of such a process, is not conclusive but open to multiple readings.

Similarly, Janet Marles created a history of her mother's (and her own) search for family roots by constructing a website that can be explored in multiple

directions and that reflects "the fragmentary nature of Heather's memory story." Heather was born in Australia and was 72 years old when she received a shoebox full of mementos from her childhood. This led her on a search through archives, cemeteries, and memorials around the world. Marles's essay and her website take us along on Heather's "journey of discovery," demonstrating, along the way, the fragile and fragmentary nature of memory and the power of narrative to assemble such fragments into a whole. Photographs were at the centre of this exploration, used both to document the past and to help remembering. Marles looks at this from the perspective of the documentarian. Her website is an example of Bersch and Grant's proposal to look for alternative ways of presenting documentary that undercut authenticity by refusing, in Marles' case, linearity. The website presents elements of a life story, but the website visitor is given the opportunity to put them together in different ways. Just like Bersch and Grant, however, Marles does not wish to reject the veracity of her mother's lived experience.

The commitment to truth as a political stance is also evident in the photographs of Milton Guran, whom Ana Mauad interviewed about the role of the photographer in Brazil during the military dictatorship. Political engagement, Mauad writes, is "a form of authorship." Guran's photos and Mauad's essay hark back to the notion that the twentieth century is the century of images.[64] As Mauad writes: "The photographic experience of the twentieth century redefined the forms of access to historical events and their registration in the social memory to the extent that we can tell the story of the twentieth century through its images." The photographer's "committed eye" is important in documenting this history, but the images have often taken on a life of their own, shaping our collective memory in ways unanticipated and perhaps even unintended by the photographer. Mauad's essay therefore takes us away from the focus on the individual to questions about the role of photographs in societies and about the stories of the photographs that we tell collectively. The final three essays, then, while considering ideas that all essays share such as the oral-visual gaps and the constructedness of photographs as historiographical representation, force us more insistently to investigate the creative aspects of oral history and to consider in greater detail (oral) history as documentary posing and performance.

This book is not written as a guide or handbook for oral historians seeking concrete advice on using photographs in their practice, but it nevertheless provides readers with guidance. Rather than prescribing best practices, it showcases them. The 12 case studies demonstrate how some oral historians have used photographs. This will allow readers to become more conscious in their own use of photographs. Readers will appreciate that rather than leaving it up to happenstance, they can and must make choices about the kinds of photographs to be used, the diverse forms of their presentation (pulled singly from a shoebox, presented in an album, stored online), and the questions to be asked about the photographs and their history,

Historians are moving with force into the field of visual history; oral historians risk becoming disconnected. This essay collection seeks to remedy this situation by encouraging oral historians to consider a variety of methodological strategies, critical approaches, and interpretive frameworks for working with photographs. We wish to begin and stimulate a discussion that is needed in a world that has become increasingly visual—not least thanks to photography, "the first truly revolutionary means of reproduction"[65]—over the last one and one half centuries. As a result, oral historians, rather than trailing behind, may take the lead in history's photographic turn.

Notes

1. Phillip Gourevitch and Errol Morris, *The Ballad of Abu Ghraib* (New York: Penguin Books, 2009), 148, cited in Jennifer Tucker, "Entwined Practices: Engagements with Photography in Historical Inquiry," *History and Theory*, Theme Issue 48 (Dec. 2009): 1–8, 1.
2. Walter J. Ong, *Orality and Literacy. The Technologizing of the Word* (London: Routledge, 2003 [1982]), 7.
3. This discovery of old photographs was a social phenomenon in which historians participated alongside "connoisseurs and collectors, totters and dealers, museum curators and local librarians, historians (especially local historians) and archivists, school officers and county education committees, community arts groups and WEA branches." Raphael Samuel, *Theatres of Memory: Past and Present in Contemporary Culture Vol. 1* (London: Verso, 1994), 343; the same point was made by participants in a 1979 workshop on family history and photography in the United States; see Joan R. Challinor, Jonathan Garlock, Judith Mara Gutman, Amy Kotkin, Catherine Hanf Noren, Amalie Rothschild, Jamil Simon, William Stapp, Elisabeth Weis, "Family Photo Interpretation," *Kin and Communities: Families in America*, ed. Allan J. Lichtman and Joan R. Challinor (Washington, D.C.: Smithsonian Institution Press, 1979), 239–263.
4. Samuel, *Theatres of Memory Vol. 1*, 320, 328–330.
5. Lorraine O'Donnell, "Towards Total Archives: The Form and Meaning of Photographic Records," *Archivaria* 38 (Fall 1994): 105–118; Joan Schwartz, "Negotiating the Visual Turn: New Perspectives on Images and Archives," *American Archivist* 67/1 (Spring-Summer 2004): 107–122. We thank Ian Keenan for bringing this literature to our attention.
6. Justin Kestenbaum, "The Photograph: A 'New Frontier' in Cultural History," *Journal of American Culture* 4 (Spring 1981): 43–46; Neal Curtis, "'As if': Situating the Pictorial Turn," *Culture, Theory and Critique* 50/2-3 (2009): 95–101; Peter Burke, *Eyewitnessing: The Uses of Images As Historical Evidence* (Ithaca, NY: Cornell UP, 2001); Tucker, "Entwined Practices"; Gerhard Paul, ed., *Visual History. Ein Studienbuch* (Göttingen: Vandenhoeck & Ruprecht, 2006); Doris Bachmann-Medick, *Cultural Turns: Neuorientierungen in den Kulturwissenschaften*, 3rd ed. (Reinbek bei Hamburg: Rowohlt, 2009), 25–27, 329–377.

7. Samuel, *Theatres of Memory Vol. 1*, 317; Canadian oral historian Imre Orchard made a similar point in 1975, arguing that after photography and film had "showed the ordinary people," the tape recorder "has come and has penetrated our lives to a far greater extent than anything else has." "Historians Panel (Roundtable)," *Sound Heritage* 4, 1 (1975): 20–31, 30–31.

8. Samuel, *Theatres of Memory Vol. 1*, 321; for a similar phenomenon in the United States during the late 1970s and early 1980s, see Michael Frisch, "'Get the Picture?': A Review Essay," in Michael Frisch, *A Shared Authority: Essays on the Craft and Meaning of Oral and Public History* (Albany: State University of New York Press, 1990), 203–214.

9. Samuel, *Theatres of Memory Vol. 1*, 351.

10. Samuel, *Theatres of Memory Vol. 1*, 322.

11. "Aural History in Primary and Secondary Schools (Roundtable)," *Sound Heritage* 4, 1 (1975): 16–19, 19.

12. Eliot Wigginton, ed., *The Foxfire Book* (Garden City, NY: Anchor Books, 1972).

13. For Singapore, see *Reflections and Interpretations: Oral History Centre 25th Anniversary Publication* (Singapore, National Archives of Singapore, 2005). For New Zealand, see Alison Parr, *Home: Civilian New Zealanders Remember the Second World War* (Wellington, Ministry for Culture and Heritage, 2010); and http://www.mch.govt.nz/.

14. Paul Thompson, *The Voice of the Past: Oral History*, 3rd ed. (New York: Oxford University Press, 2000); Donald A. Ritchie, *Doing Oral History: A Practical Guide*, 2nd ed. (Oxford: Oxford University Press, 2003); Valerie Raleigh Yow, *Recording Oral History: A Guide for the Humanities and Social Sciences*, 2nd ed. (Walnut Creek: Altamira Press, 2005); Beth M. Robertson, *Oral History Handbook*, 5th ed. (Unley, South Australia: Oral History Association of Australia [South Australian Branch], 2005); Donna M. DeBlasia et al., *Catching Stories: A Practical Guide to Oral History* (Athens: Swallow Press, 2009); David K. Dunaway and Willa K. Baum, eds., *Oral History: An Interdisciplinary Anthology*, 2nd ed. (Walnut Creek: Altamira Press, 1996); Robert Perks and Alistair Thomson, eds., *The Oral History Reader*, 2nd ed. (London: Routledge, 2006); Thomas L. Charlton, Lois E. Myers, and Rebecca Sharpless, *Handbook of Oral History* (Lanham: Altamira Press, 2006).

15. Marjorie L. McLellan, *Six Generations Here: A Farm Family Remembers* (Madison: State Historical Society of Wisconsin, 1997); Judith Modell and Charles Brodsky, "Envisioning Homestead: Using Photographs in Interviewing (Homestead, Pennsylvania)," in *Interactive Oral History Interviewing*, ed. Eva M. McMahan and Kim Lacy Rogers (Hillsdale, NJ: Lawrence Erlbaum Associates, 1994).

16. Ritchie, *Doing Oral History*, 100.

17. Thompson, *Voice of the Past*, 6.

18. Thompson, *Voice of the Past*, 240.

19. Thompson, *Voice of the Past*, 105, 125.

20. Linda Shopes, "Using Oral History For a Family History Project," in *Oral History: An Interdisciplinary Anthology*, originally published in *Technical Leaflet* 123 (Nashville: American Association for State and Local History, 1980).

21. Samuel, *Theatres of Memory Vol. 1*, 330.

22. Ritchie, *Doing Oral History*, 108; Frieder Stöckle, "Zum praktischen Umgang mit Oral History," in *Oral History: Mündlich erfragte Geschichte*, ed. Herwart Vorländer (Göttingen: Vandenhoeck & Ruprecht, 1990), 131–158, 139–140.

23. Ritchie, *Doing Oral History*, 99; Yow, *Recording Oral History*, 264–265.

24. Sherna Gluck, "What's So Special About Women? Women's Oral History," *Frontiers: A Journal of Women's Studies* 2, 2 (Summer 1977 Special Issue on Women's Oral History): 3–13, 9.

25. Thompson, *The Voice of the Past*, 134.

26. Michael Frisch and Milton Rogovin, *Portraits In Steel* (Ithaca: Cornell University Press. 1993); see also Steven High and David W. Lewis, *Corporate Wasteland: The Landscape and Memory of Deindustrialization* (Ithaca, NY: ILR Press, 2007).

27. Tamara K. Hareven and Randolph Langenbach, *Amoskeag: Life and Work in an American Factory-City* (Hanover, NH: University Press of New England, 1978)

28. Modell and Brodsky, "Envisioning Homestead," 142–145.

29. McLellan, *Six Generations Here*.

30. Paul Ricoeur, *Memory, History, Forgetting*, trans. Kathleen Blamey and David Pellauer (Chicago: University of Chicago Press, 2006 [2004]), 44–55.

31. James C. Curtis, "Documentary Photographs as Texts," *American Quarterly* 40, 2 (June 1988): 246–252, 246.

32. H. Porter Abbott, *The Cambridge Introduction to Narrative*, 2nd ed. (Cambridge, Cambridge University Press, 2008), 6–10.

33. Challinor et al., "Family Photo Interpretation," 260–263; Martha Langford, *Suspended Conversations: The Afterlife of Memory in Photographic Albums* (Montreal: McGill-Queen's UP, 2001).

34. Jacquelyn Dowd Hall, "'To Widen the Reach of Our Love': Autobiography, History, and Desire," *Feminist Studies* 26, 1 (Spring 2000): 230–247, 236.

35. Caroline Forcier Holloway, "Giving a Voice to the Doug Betts Silent Home Movie Collection: Making a Case for the Donor Interview," paper presented to "Oral History in Canada," International Workshop-Conference at the University of Winnipeg, Winnipeg, MB, Canada, 18–20 August 2005; for the latter, see Harald Welzer, Sabine Moller, and Karoline Tschuggnall, *"Opa War Kein Nazi": Nationalsozialismus und Holocaust im Familiengedächtnis* (Frankfurt am Main: Fischer, 2002). On the broader question of image and text/narrative, see Richard Candida Smith, ed., *Text and Image. Art and the Performance of Memory* (New Brunswick: Transaction Publishers, 2006).

36. José van Dijck, *Mediated Memories in the Digital Age* (Stanford, CA: Stanford University Press, 2007),

37. Van Dijck, *Mediated Memories*, xii.

38. Ian Keenan, "A Few Random Thoughts on Digital Cameras and the Social Rituals of Photography," unpubl. mss. [no date (April 13, 2010)], in possession of the editors.

39. Van Dijck, *Mediated Memories*, 113.

40. On the ideological and commercial implications of this digital manipulability, see Jerome S. Handler and Michael L. Tuite, Jr., "Retouching History: The Modern Falsification of a Civil War Photograph," online at http://people.virginia.edu/~jh3v/retouchinghistory/essay.html.

41. Susan Sontag, *Regarding the Pain of Others* (New York: Picador, 2003).

42. Nor do oral historians often account for newer uses of photography as political and social activism and as participatory action research. See, for example, projects with children and teenagers in Africa and South America who were given cameras to photograph the world around them. Some projects include video films or books that show them. Catherine-Lune Grayson, *Once Upon a Time on a Sunny*

Continent. Pictures by Refugee and Displaced Teens From Somalia (Horn of Africa: Danish Refugee Council, 2009); see also the accompanying website: http://www. drc.dk/dk/news/news/artikel/once-upon-a-time. Another project is Photovoice, online at http://www.photovoice.org. Eric Green and Bret Kloos, "Facilitating Youth Participation in a Context of Forced Migration: A Photovoice Project in Northern Uganga," *Journal of Refugee Studies* 22, 4 (2009): 460–482; Alba Lucy Guerrero and Tessa Tinkler, "Refugee and Displaced Youth Negotiating Imagined and Lived Identities in a Photography-Based Educational Project in the United States and Columbia," *Anthropology & Education Quarterly* 41, 1 (2010): 55–74. For a critique of Photovoice, see The Rights Exposure Project: http://therightsex-posureproject.com/2009/08/05/participatory-photography-%E2%80%93-jack-of-all-trades-master-of-none. We thank Catherine-Lune Grayson for bringing these projects and the literature to our attention.
43. Reinhard Wendler, "Visuelle Kompetenz und das Jahrhundert der Bilder," *Neue Politische Literatur* 54, 2 (2009): 181–189, 181–182.
44. James Allen, *Without Sanctuary: Lynching Photography in America* (Twin Palms Publishers, 2000); Hamburg Institute for Social Research, *Crimes of the German Wehrmacht: Dimensions of a War of Annihilation 1941–1944. An Outline of the Exhibition* (Hamburg: Hamburger Edition, 2004), online at http://www. verbrechen-der-wehrmacht.de/pdf/vdw_en.pdf; Mark Danner, *Torture and Truth: America, Abu Ghraib, and the War on Terror* (New York: New York Review of Books, 2004).
45. McLellan, *Six Generations Here*, 110–111.
46. McLellan, *Six Generations Here*, 3–4.
47. McLellan, *Six Generations Here*, 57.
48. McLellan, *Six Generations Here*, 72
49. McLellan, *Six Generations Here*, 75–76.
50. Langford, *Suspended Conversations*, viii, 5, 21.
51. Marianne Hirsch, *Family Frames: Photography, Narrative and Postmemory* (Cambridge, Massachusetts: Harvard University Press, 1997), 3, 7, 8, 11, 22.
52. Bachmann-Medick, *Cultural Turns*, 329.
53. Patricia Anderson, *The Printed Image and the Transformation of Popular Culture* (Oxford: Oxford University Press, 1991). Thanks to Ian Keenan for this reference.
54. For a critical assessment of the history of photography, see Derrick Price and Liz Wells, "Thinking About Photography: Debates, Historically and Now," in Liz Wells, ed., *Photography: A Critical Introduction*, 3rd ed. (London: Routledge, 2004), 9–63, here 48–55.
55. Patricia Holland, "'Sweet It Is to Scan'...Personal Photographs and Popular Photography," in Wells, *Photography*, 113–158, 128.
56. Bachmann-Medick, *Cultural Turns*, 25–27.
57. Tucker, "Entwined Practices," 3.
58. See, for example, Ronald J. Grele, "Movement Without Aim," in Ronald J. Grele, *Envelopes of Sound: The Art of Oral History*, 2nd rev. and enlarged ed. (Chicago, IL: Precedent Publishing, 1985); Paul Thompson, "Chapter 4: Evidence," in *The Voice of the Past*, 118–172; Luisa Passerini, "Work Ideology and Consensus under Italian Fascism," *History Workshop* 8, 1 (1979), 82–108; Alessandro Portelli, "The Peculiarities of Oral History," *History Workshop* 12, 1 (1981): 96–107.

59. Steve Edwards, *Photography: A Very Short Introduction* (Oxford: Oxford UP, 2006), 68.

60. Annette Kuhn and Kirsten Emiko McAllister, *Locating Memory: Photographic Acts* (New York: Berghahn Books, 2008 [2006]), 4–5.

61. R. Kenneth Kirby, "Phenomenology and the Problems of Oral History," *Oral History Review* 35, 1 (2008): 22–28, quote from 22.

62. Roland Barthes, *Camera Lucida: Reflections on Photography*, trans. by Richard Howard (New York: Hill and Wang, 1982), 27.

63. Stella Bruzzi, *New Documentary*, 2nd ed. (New York: Routledge, 2006). We thank the anonymous reviewer for this reference.

64. Gerhard Paul, ed., *Das Jahrhundert der Bilder*, 2 vols. (Göttingen: Vandenhoeck & Ruprecht, 2008–2009).

65. Walter Benjamin, "The Work of Art in the Age of Technological Reproducibility (Third Version)," in Walter Benjamin, *Selected Writings, Vol. 4: 1938–1940* (Cambridge, MA: Belknap Press of Harvard University Press), 251–283, 256.

Remembering with Images

Mary Brockmeyer's Wedding Picture: Exploring the Intersection of Photographs and Oral History Interviews

Alexander Freund with Angela Thiessen

Historian Alexander Freund and teacher Angela Thiessen argue that photographs do not simply trigger more detailed life memories in an oral history interview. Rather, photographs allow narrators to tell alternative life stories. Such visual life story telling may uncover or generate conflicted feelings and understandings of one's life choices and experiences. While photographs may stimulate remembering they may also silence narrators or maneuver them into depicting themselves at the margin of their lives. The photographic life story unravels past and present social norms that may be subtly undercut by counter memories. The main interviewee in their case study counterpointed her "happy memory" wedding photograph with complex stories of both hardship and fulfillment. This is also a story of young interviewers expecting a wedding photograph to forecast a "happy story" and being quickly confronted with a narrative that troubles their own expectations and values. Freund and Thiessen's study demonstrates that the introduction of photographs into oral history interviews fundamentally alters the dynamics of the interview situation and the resulting narratives. Freund and Thiessen's focus on the gap between image and oral memory speaks to several other essays in this collection, most notably Lynda Mannik's, who similarly explores the silences and sensory memories of her narrators. These often unexpected responses turn Freund and Thiessen, like Tinkler and Ryan,

to Roland Barthes's notion of "punctum" to understand the emotional rather than the mnemonic response. Punctum also helps them explore the connection between interviewee and interviewer as joint viewers of the photographs, and their disconnection as they read different meanings in the images.

Nothing can be so deceiving as a photograph.

Franz Kafka

"The theory of the photo as an *analogue* of reality has been abandoned," Umberto Eco wrote in 1982, "even by those who once upheld it—we know that it is necessary to be trained to recognize the photographic image."[1] Photography theorists Victor Burgin, John Tagg, and Allan Sekula made the same point and suggested a number of critical approaches to "reading" photographs. They argued that although photography in itself was not a language it was nevertheless embedded in codes.[2] Marianne Hirsch and Martha Langford refined this connection between photography and language by pointing to the narrative and "oral" qualities of photography. Hirsch argues that photographs are embedded in narratives and must therefore always be read as "imagetexts"; Langford argues that family photo albums may be interpreted by exposing their "oral structure."[3] Thus, a picture does not say more than a thousand words, but rather holds the potential to evoke multiple meanings.

This is not how (oral) historians have commonly understood and used photographs.[4] Our notion of photographs as "memory prompts" does not sit easily in a (post-)structuralist understanding of photographs, because this notion is based on the assumption that photographs are "windows on the world" (Burgin) that are simply further opened through the elicitation of details and stories about a past reality "captured" in the photograph. This chapter attempts to develop an approach that goes beyond the use of photographs as mnemonic devices and investigates the complex interaction between oral narrative and photograph.

The approach to using photographs in interviews seeks to help interviewers and interviewees with constructing and re-evaluating life stories in a way that differs from the classic oral history interview. We argue that a systematic use of photographs allows interviewees to tell a different kind of life story. The photograph is a form of signification that is always in need of contextual decoding, and therefore we also caution oral historians to be alert to the possibility that photographs may obstruct rather than enable memory and narrative.

After describing the use and objectives of the "photo-interview" method and the project in which this method was used, this chapter discusses methodological implications that emerged from our research. In particular, it evaluates, exemplified through one case study, the photo-interview's opportunities and limitations for a narrator to tell her life story. The case study raises questions of class, gender, and place in the use of photographs in everyday life and in oral history projects. From an ethical perspective, this chapter concludes that a photo-interview has

the potential to enable "shared authority" between interviewer and interviewee, because it allows the interviewee to transform from spectacle to spectator and thus to "return the historian's gaze."[5]

In a three-year interdisciplinary project, "Local Culture and Diversity on the Canadian Prairies," a group of historians and folklorists from the Universities of Alberta and Winnipeg interviewed some 600 men and women who before 1940 had lived in one of the three prairie provinces of Manitoba, Saskatchewan, and Alberta. One of the project's major objectives was to document local or vernacular culture and traditions; another was to learn about cultural diversity and ethnic identity; and a third was to better understand the prairies as a particular region.

We used three interview methods: a survey questionnaire, a life story interview, and the so-called photo-interview. For the photo-interview, interviewees were asked to look through their family albums, photo boxes, and room displays (photographs hung on walls or set on mantelpieces) and select about ten photographs from the period before World War II.[6] During the interviews, we asked for descriptions of the photographs. The interviews were audio-recorded and the pictures digitally photographed.[7]

The folklorists in the project saw "historical photographs [as] an unusually rich medium for researchers of vernacular culture" and as "complementing" verbal images and narratives.[8] In addition to this conception of photographs as documents of social life, they also understood photographs as memory prompts. The project partners agreed that photo-interviews would "elicit more complete and detailed information on physical objects and settings in addition to the narratives," "sharpen the memory and may remind of experiences, activities, events or details otherwise forgotten or poorly remembered," and "encourage the respondent to expand on subjects that had been touched on very briefly." Perhaps most importantly, though not fully understood before or even during the fieldwork, the cooperative examination of photographs by researchers and respondent could function as the "focus of the discussion and [thus] help to establish a friendly, relaxed rapport by *relieving the respondent of the role of 'subject of interrogation.'*"[9] In other words, we assumed that people would be more used to telling stories about photographs than to narrating their life story or responding to oral historians' questions. This hypothesis was reinforced by assumptions that interviewees' selection of photographs gave them control over the structuring of the interview, and that chronology was less constraining than in a life story interview.

Our belief that the photo-interview would generate rich descriptions, anecdotes, stories, and reflections was also founded on previous research both in visual anthropology[10] and oral history. We believed that, like Judith Modell and Charlee Brodsky who interviewed the people of a steel town, we would "[duplicate] a way of telling history that was familiar to our informants" and that the photo-interview would "[resemble] the kind of 'do-you-remember' exercise that ordinarily accompanies a display of photographs."[11]

An analysis of 25 photo-interviews calls into question this hypothesis, at least for the group of people we interviewed: rural prairie Canadians in their 70s, 80s, and 90s.[12] In our experience, the photo-interview did not partake, as Modell and Brodsky had found, "of the composite creation of history people from time to time engage in." Like Modell and Brodsky, we too "became part of a conversation about the past,"[13] but in our experience, the photographs played a different role in interviewers' and interviewees' negotiation of memory and history.

A typical response to the question "tell me about this photo" was not the full and detailed story we had imagined, but rather a hesitant, cursory description of a few words or a sentence or two. Follow-up questions were successful only with some photographs. Interviewees often seemed to feel helpless and frustrated when confronted with questions for details. When asked questions about when and where the photographs were taken or how they had got into their possession, typical responses were either guesses or a simple "I don't know." The question "what does this photo remind you of?" was often answered with general observations that were not rooted in personal experiences. Few stories were told. In many cases, people did not remember the occasion or experience of the photograph being taken. The confidence and ease with which Modell and Brodsky's respondents used photographs were largely absent from our interviews.[14]

Three explanations for this "dilemma" of the photo-interview emerged. First, interviewees found the setting of interviewers asking them to reminisce about family photographs artificial and estranging, because the interviewers knew nothing about the photographs and had no personal connection with them. Although most interviewees quickly understood the interviewers' interests and soon anticipated their questions, responses did not become much more elaborate. We began to understand that photos, just like oral and written sources, were neither "self-explanatory" nor "self-evident." We also learned that photographs' meanings were not fixed, but changed with the context. As Alan Sekula writes, "the meaning of any photographic message is necessarily context-determined . . . [T]he photograph, as it stands alone, presents merely the possibility of meaning. Only by its embeddedness in a concrete discourse situation can the photograph yield a clear semantic outcome."[15] A photo-interview could not imitate the intimate sharing of memories among friends and family. This was a new context, and interviewees learned only during the interview which meanings the interviewers were interested in, and which meanings were safe and useful to inscribe in the photos in this particular context.

Second, experiences may be remembered in the form of images, but not necessarily in the form of images as they are represented in family photographs.[16] Modell and Brodsky found that just mentioning that they would show photographs later in the interview made interviewees shift to a visual storytelling mode. At the same time, however, once the interviewees were looking at photographs, they often found that the photos contradicted their narratives. Thus, photographs

"preserve" different memories, and in a different way, than oral narratives. Hence, the interaction of oral history and photographs may lead, as in the case of Modell and Brodsky, to more complex narratives,[17] but it may also lead, as seems to be the case in our project, to a mutual blocking or obstruction.

Third, it seems that several interviewees themselves had only a tenuous connection to the photographs. Some had inherited the images they were showing half a century after the event. Others had not looked at the photographs in several decades, if ever. Some photography theorists distinguish between "users" and "readers" of photographs.[18] Users are usually the owners of photographs who bring a plethora of memories and knowledge to the photograph. They usually know the persons and things depicted in the photograph, and also have a sense of who took the picture, when it was taken, perhaps even why it was taken, and what had happened to it (where it had been) since then; over time, they may have looked at the photograph from time to time, by themselves or together with others. In so doing, they had constructed new meanings, altered others, and forgotten others yet. Readers, on the other hand, are people who do not know anything about the photographs but can attempt to tease meanings out of them with the help of historical contextualization as well as photography theory. Thus, we assumed that our interviewees would be the users of photographs while we would be the readers.

But several interviewees had not "used" the photos or built a repertoire of anecdotes about them. In a way, they were readers of the photographs at the same time as they were users. They tried to make sense of the photos in ways similar to historians. For example, interviewees tried to date a photograph by guessing the age of people in the picture or attempting to date their fashion style. This blended into ways in which "users" would date pictures, that is, by drawing on personal memory rather than historical knowledge; for example, they figured out dates by recalling when an addition to their farm had been built and which was absent from the image, or by recalling the year the family bought its first car and which was depicted in the photograph.

These blurred boundaries between "users" and "readers" of family photographs require us to re-think our assumptions about the historically contingent use of family photographs. Photographic use is a historical process. Some of this historicization of photographic use has been accomplished by the literature in photography theory, but there seem to be blind spots in this analysis. Much of this literature is based on photographs produced and consumed by upper and middle classes or urban populations. Victor Burgin and his colleagues consider the (urban) class struggle by examining the work of professional photographers (whose products may be consumed as art, advertising, or documentary). Roland Barthes, Marianne Hirsch, and Martha Langford focus on urban, middle-class family photography. Even Marjorie L. McLellan's *Six Generations Here* shows photographs taken by a family that, although rural, was (unlike their neighbors)

deeply engaged in photography. None of these authors raise the question to what degree photographic production and consumption are activities mostly of the urban and middle classes. Thus, at least for our project, we needed to reconsider our potentially urban, middle-class assumptions about the "universal" use of family photographs. It seems that rural, farming-class, prairie Canadians composed and used photographs more sporadically.

Our interviewees found it difficult to tell stories about the photographs they had selected. Nevertheless, they told stories of their lives in pre–World War II rural Canada. Together, these indirectly connected photographs and stories—or "imagetexts" as Hirsch, following W. J. T. Mitchell, calls them—allow us to investigate some of the narrative structures and interpretive patterns (for example, nostalgia, belief in progress, "history repeats itself," great-men-history) underlying the overall story, the selection of photographs, and their viewing and narrating in the context of an oral history interview.

For the Local Culture project, an analysis of photo selection could be done only cursorily, because we did not anticipate the information we needed (and ask of our interviewees) to document parts of this selection process; we therefore have only limited knowledge of how and why photographs were chosen; we also know nothing about the photos that were not selected. Despite such shortcomings, we would like to suggest an approach to interpreting the imagetexts created in photo-interviews on the basis of one photo-interview, that with Mary Brockmeyer.[19]

In July 2004, undergraduate students Angela Thiessen and Christine Kampen, and graduate student Leslie Hall conducted a photo-interview with Mary Brockmeyer and her daughter, Fran Hrynkiw, in the town of Humboldt, Saskatchewan. Brockmeyer was born into a poor Russian-German immigrant family in Saskatchewan in 1919. Her father died young and her stepfather was abusive. When he died in 1935, Brockmeyer's mother moved into the town of Humboldt. Similarly, when Brockmeyer's husband died in 1987, she sold their farm and moved to Humboldt. For the interview, mother and daughter had rummaged through one box of photographs and selected seven pictures for the interview.

Three of the seven photos depicted Brockmeyer, along with others: Figure 1.1 shows her with her brothers, sister-in-law, and parents, in a photograph taken around 1929 outside of their rented farm. Figure 1.6 is a color-tinted wedding photograph of Mary Brockmeyer, dated 1935. Figure 1.7 depicts Mary Brockmeyer with her two children, Eddie and Fran, around 1939.

The other four photographs depicted men and "male" activities such as hunting, slaughtering, and harvesting. Figure 1.2 shows a group of people at work, thrashing wheat. Brockmeyer explained that it was taken "before my time," which probably referred to the time before she got married (rather than to the time before she was born), because her later husband was depicted in the photograph. Figure 1.3 shows three men—all brothers of Mary Brockmeyer—at work,

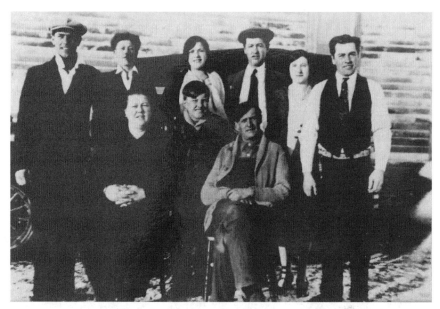

Figure 1.1 Mary Brockmeyer (second from right) with her parents, brothers, and sister-in-law, no date (*ca.*1929) (Brockmeyer collection).

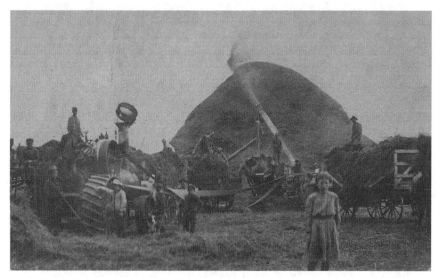

Figure 1.2 "Taken before my time." Mary Brockmeyer's husband and his brother (unidentified), bringing lunch to field workers, no date (Brockmeyer collection).

slaughtering a cow. Figure 1.4, again taken "before my time," shows her later husband and five neighbors loading hay onto wagons. Figure 1.5 shows her husband and two other men grouped around a car, and holding rifles and their catch of fowl of the day.

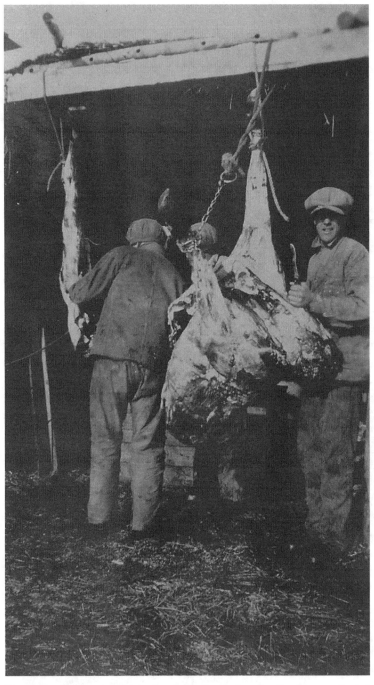

Figure 1.3 Mary Brockmeyer's brothers butchering beef, no date (Brockmeyer collection).

Figure 1.4 Neighbors at threshing, possibly including Brockmeyer's husband, no date (Brockmeyer collection).

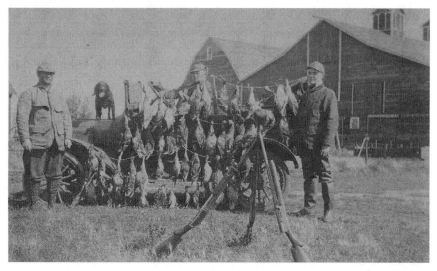

Figure 1.5 "They had easy hunting." Mary Brockmeyer's husband (right) and neighbors, no date (Brockmeyer collection).

Thus, as a response to a call for family photographs from early life, Brockmeyer chose photographs that either did not depict her at all, or depicted her in a family setting. If we compare this "visual narrative" to the oral narrative often told in an oral history interviews, the interviewee, rather than situating herself in the middle of her life story, seems to place herself at the

margin and, in the majority of pictures, even outside of her life story. How can we explain this highlighting of men and male accomplishments, and the female self-marginalization? As we know from oral history, life stories are gendered and, at least in some cultures, women are more prone to situate themselves in social groups and at the margin, while men's stories tend to be more individualistic, with them taking center stage. The visual narrative would thus be gendered in the same way that oral narratives are.

The gendering of the visual narrative could, on the other hand, be specific to photographs as a medium for story telling, at least in the context of the photo-interview: Brockmeyer may have selected the photographs on the basis of their "historical significance" with "history" understood to happen in the male public domain.[20] The Brockmeyer case supports, albeit in an unexpected way, our hypothesis that photo-interviews "relieve the respondent of the role of 'subject of interrogation,'" but it also calls into question our assumption that the photo-interview may be an empowering venue for telling one's life story.

Yet, if we listen to the stories that Brockmeyer told about the photographs, a very different reading of this visual narrative becomes possible. These stories were almost all stories of women's hard labor and men's abuse of their domestic power. The emerging imagetexts highlighted the contradiction between lived experiences and their visual representations, shaped, as they were, by social conventions. For example, Brockmeyer used a picture of her husband showing off his catch from a hunting trip (Figure 1.5) to comment: "But they [the men] had easy hunting—when they come home with a load like that, they'd throw it in the door, and they'd be gone. They'd be gone and get drunk...But I didn't think it was fair that they just took and threw them at ya. 'Now clean 'em.'"[21] Brockmeyer's selection of family photographs, then, carved a space for her to tell stories of hardship, abuse, and resistance.

As we know from oral history, interviews are dialogic and shaped by the interviewer-interviewee relationship. And so it is with photo-interviews, but with a new and additional focus: the photograph. Based on British art critic John Berger's observation, "In every act of looking there is an expectation of meaning,"[22] we can posit that interviewers and interviewees look at photos in different ways, expecting—and in the process inscribing—different meanings.

How, then, can we best analyze photographs and the stories our interviewees tell about them? While using oral history theory to interpret the stories, oral historians should also draw on photo criticism for an initial external "reading" of photos. This enables us to complicate the photograph by inquiring about its relationships with its subject matter, photographer, user, and reader, as well as the different contexts that produce meaning.

Mary Brockmeyer's "happy memory" wedding photograph (Figure 1.6) and the painful story behind it may illuminate interpretation strategies that make

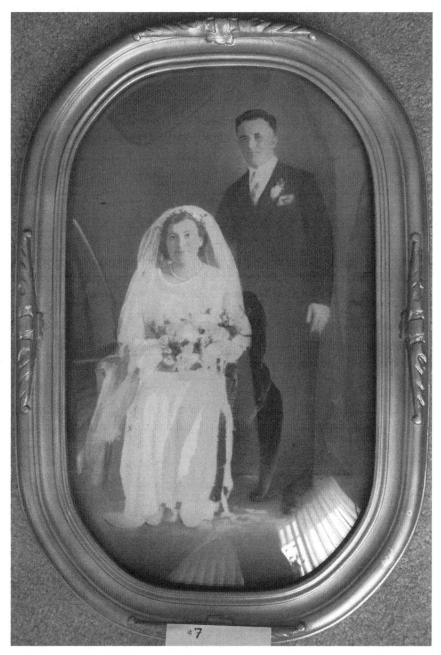

Figure 1.6 Wedding photograph: Mary and Henry Brockmeyer, March 4, 1935 (Brockmeyer collection).

sense of the complex relationship between photograph, oral narrative, and the diverse viewers during the photo-interview.

Before the interview, as Thiessen was setting up the digital photo camera in the living room, Brockmeyer's daughter, Fran Hrynkiw, came in and took her parents' framed wedding photo from the wall. She proudly showed it to Thiessen, who asked whether it would be included in the interview. Hrynkiw nodded and said, "She's only 15 in this picture!" Taken aback by that information, Thiessen said she was interested in hearing the story. "It's not a nice story," Hrynkiw replied and left.

The wedding photo was taken before the ceremony at Humboldt Church on March 4, 1935. Their neighbour "had a good camera" and photographed Mary and Henry Brockmeyer in Henry's parents' house. They had the portrait enlarged and tinted at the Humboldt Photo Studio and set in a gold coloured frame. In the picture, Brockmeyer is seated in a chair wearing, as was fashionable at the time, a simple white gown with long sleeves, and a round neckline. Like the wedding fashion of glamorous Hollywood stars and royalty, her long veil cascaded down to the floor. Flowers are at the top of the veil where it is attached to her hair, worn in the fashion of the day—wavy and longer than the bobbed hairstyles of the 1920s. She wears a pearl necklace, and is holding a large bouquet of pink-tinted flowers. Art Deco called for such pastels.[23] Henry, in a dark suit, is standing behind Mary, slightly leaning toward her. Both are smiling demurely and looking straight at the camera (although it is difficult to make eye contact with Henry).

The photograph is intended to document an event, to prove that they were indeed married. As with all photographs, however, this is not a simple reflection of reality, but rather an aesthetically and socially constructed image, "a practice of signification," a make-belief.[24] It is arranged to show what a wedding was supposed to be, what the viewing public would expect: the record of a joyous event of two lovers pledging loyalty "until death do us part." According to filmmaker Patricia Holland, "the more ceremonial the occasion…the more important it is that certain rules are followed in the production of the photograph that mark the event."[25] In a wedding photo, then, we can see more than individual taste. Through careful photographic analysis, we can tease out contemporary social values that are expressed through the rules of production. Gender roles are clearly visualized in the arrangement: The man stands watchfully over his wife, who is femininely fragile and weak and therefore must sit. The husband is in control, but also has responsibilities to his wife. The clothes and flowers, the photograph's "professional" studio look and exquisite coloration, and the golden frame suggest material security and thus an embracing of middle-class values. This is reinforced by the modernist urban style of fashion, which was preferred to traditional "ethnic" folk dress, and by the romanticization of marriage, which glosses over its underlying socio-economic conditions.

The photograph is more than an artefact. It is, in the words of photo critics Derrek Price and Liz Wells, a "densely coded cultural object" that has been "collected, stored, used and displayed" in specific, "interested" ways.[26] It is thus part of a performance that continued after the picture was taken. We did not ask and therefore do not know how the picture was displayed at the Brockmeyers' farmhouses between 1935 and 1987, but it is probable that it was in an equally public space as it was in her apartment, where it was hanging on the living-room wall, for all visitors to see. Brockmeyer was proud of what the photograph symbolized: her marriage. But the decision to include this picture in the interview was complex. It is unclear to what degree this was Hrynkiw's decision. Her excitement over the wedding stories, evident when presenting the picture to Thiessen, as well as her involvement during the interview, indicate that she believed the image to be significant to her mother's and possibly her own identity. As her mother began to tell the story behind the photograph, however, its meanings became increasingly complex, contradictory, and obscure. In the ensuing cooperative construction of meaning, the fieldworkers were about to find out the truth of Franz Kafka's comment, "Nothing can be so deceiving as a photograph."[27]

Less than one minute into Brockmeyer's story about the photograph, her daughter redirected the discussion by asking, rhetorically, "And you were how old?" "15!" Brockmayer exclaimed, but did not go into any more detail until interviewer Leslie Hall asked: "Tell us more about what this picture reminds you of. I bet there are lots of good stories." Here, then, we see the power of images: Although Hrynkiw had reframed the wedding picture to make the audience aware of the "bad" story that was about to follow, Hall brought her own expectations to the photograph that, as they were formed by powerful social conventions, were not easily broken. And yet, we also see the potential of the interview to break through these conventional frames. To Hall's prompt for "good stories," Brockmeyer replied, "No! I was scared, scared out of my wits. I really was. I didn't know where we were going to live or nothing. So we lived with his folks till we found a farm and rented it. And then the fun began (sighs)." She then described her dilapidated house and husband's preference for whiskey over decent furniture.

As the photo-interview continued, Brockmeyer revealed more about her husband's character and the conflicted feelings she had toward him. When asked how she met her husband, her reply startled not only the fieldworkers, but also her daughter. After a long pause, she explained: "I went with his brother to that dance, and for some reason or another I went home with him (laughter). Went there with Uncle John." Her daughter responded, "I didn't know that." Brockmeyer said: "You didn't know that? Sure, I went to that dance with Uncle John and went home with Pop."

Although Hrynkiw was familiar with the story of her parents' marriage and eager to have her mother talk about it, she did not know this crucial part of the

story. Brockmeyer did not discuss how John reacted to her leaving the dance with his brother, nor could she remember why she was attracted to Henry: "I don't really know. He probably knew how to schmooze me more, or whatever you want to call it." She then revealed Henry's age at the time: "Yup, there were five boys, and the youngest brother was older than I was. Yeah, well, he was 30 and I was 15." Asked about her parents' reaction, she said: "They didn't say too much about it. But I was just a little too young. He got me into trouble and then we had to get married, that's all there was to it. It's lucky that he did, you know?"

The wedding photo, and the story woven around it in the interview make a complex imagetext with multiple meanings. Although Henry had impregnated a girl half his age and decided to marry her, Mary, even after looking back on "a hard life," nevertheless felt "lucky." Why did she feel lucky? In the interview, Brockmeyer pointed to her daughter, implying that otherwise she would not have had her two children, whom she loved deeply. Perhaps she also felt lucky, because at the time it seemed better to marry than to deal with the consequences of being a single mother with an illegitimate child in 1930s rural Saskatchewan. Brockmeyer also claimed that her situation was not out of the ordinary. Asked whether it was common that girls married at such a young age back then, she explained: "Oh yeah, that was more or less the style, or whatever you want to call it. Tradition or whatever. If the girl got pregnant they automatically got married, eh? So, that's a lot of them, a lot of them did that."

Brockmeyer thus situated herself in a broader social experience and culture she claimed to be common and therefore socially accepted. Hence, her experience could not be seen as abnormal or shameful. Arguing that it was not her decision, that her marriage was "tradition" and "automatic," she submitted that society dictated a shotgun wedding unless she wanted to face unmentioned, but certainly dire social consequences. This contextualization also allowed Brockmeyer not to answer the question whether marriage *at that age* was also common.

Brockmeyer's fear on the wedding day and her ironic comments on married life are evident neither in the 1935 photograph nor in its 2004 public display. Clearly, then, it is the interview that uncovers the great gap between the make-belief photo and its display on the one hand side and the narrated harsh reality of lived experience on the other. It is the oral history that allows us to go beyond an external "reading" of the photograph's subject matter and composition, to unearth a context that is otherwise restricted to the memories of the few people who know the story behind the photograph.[28] At the same time, however, it is the photograph that allows for the specific telling of the story. In an oral history interview, Brockmeyer may have told the story quite similarly, but it may have had a less dramatic character. Two aspects of the photograph make this photo-narrative more compelling. First, Brockmeyer draws on the "currency" of the

photograph, namely its "privileged status as a guaranteed witness of the actuality of the events it represents."[29] Second, and more importantly, neither the oral narrative nor the photograph by themselves, but rather the clash between seeing and hearing acts as the "punctum"[30] of the imagetext.

Documenting this punctum, this tension within the imagetext, however, is not sufficient. We need to attempt to explain it. Price and Wells argue that "original motives" for taking a photograph "may disappear, leaving it accessible to being 'reframed' within new contexts." This new context is the photo-interview. As Canadian art historian Martha Langford has argued, people include demystifying and embarrassing photos in albums in order to humiliate and place blame on others, or so that other viewers of the photograph give praise.[31] Although the picture in itself is mystifying rather than demystifying, Brockmeyer (and Hrynkiw) knew that they would also tell the story behind the image. Both photograph and story, make-belief and experience, were inseparably linked. It was by telling about her husband's inability and unwillingness to fulfill the duties of a husband and father that she demystified him. Sometimes, Brockmeyer made generalizations about men on the basis of her experiences with her husband and stepfather, which could be seen as a feminist critique of patriarchy. That her three interviewers were young women, and that no men were present during the interview, perhaps contributed to her frankness.

Brockmeyer also wanted her audience to know that she was a survivor of the Great Depression and of a brutal marriage. Perhaps Brockmeyer was looking for praise from her audience for the strength and resilience she had shown throughout. She was proud of her accomplishments: "I'm real proud of my kids, both of them, very proud," she said. This is best exemplified by her choice of the last photograph, depicting her with her two children, but without her husband and the children's father (Figure 1.7).

Including the wedding picture in the photo-interview gave Brockmeyer an opportunity to tell a complex story. This does not explain, however, why she had the picture on her living-room wall. There, it may have served several purposes. It may have served as a defence against any speculations about immorality. It was there to document to everyone that she had indeed been married. This may have also been important to her daughter. Furthermore, her relationship with her husband was complicated. She may have wanted a reminder of him. At the very least, she may have wanted a reminder of what she may have seen as his only decent act: to marry her when she was pregnant.

Few of the photographs in our project showed similarly great tensions between image and text. The punctum of all photo-interviews, however, was indeed the gap between "happy" photos and countless stories of poverty, hard work, illness, violence, abuse, and death.

The photo-interview can be seen as yet another method in our arsenal of methods. But in conclusion, we would like to argue that it places a responsibility

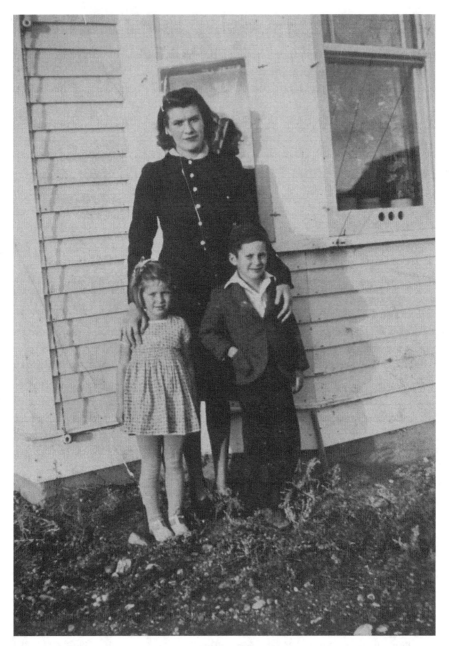

Figure 1.7 Mary Brockmeyer with her two children, Eddie and Fran, *ca.*1939 (Brockmeyer collection).

on the historian. Historians are often not trained in interpreting photographs. They often use them simply for illustration. For the people depicted in photographs, however, this raises the problem of "being looked at without being able to return the look."[32] The photo-interview allows the "viewed" to return the

historian's voyeuristic or probing gaze, offer their interpretation, give meanings to a memory that is otherwise coldly exhibited, or even reject the public use of the photograph.

Notes

1. Umberto Eco, "Critique of the Image," Victor Burgin, ed., *Thinking Photography* (London: Macmillan, 1982), 33.
2. Victor Burgin, "Looking at Photographs," in Burgin, *Thinking Photography*, 143.
3. Marianne Hirsch, *Family Frames. Photography, Narrative, and Postmemory* (Cambridge, MA: Harvard UP, 1997), 3–4; Martha Langford, *Suspended Conversations: The Afterlife of Memory in Photographic Albums* (Montreal: McGill-Queen's UP, 2001), 122–123.
4. On historians' recent critical engagement with images, see Peter Burke, *Eyewitnessing. The Uses of Images as Historical Evidence* (Ithaca, NY: Cornell UP, 2001); Gerhard Paul, ed., *Visual History. Ein Studienbuch* (Göttingen: Vandenhoeck & Ruprecht, 2006); the theme issue "Photography and Historical Interpretation" of *History and Theory* 48 (December 2009).
5. See Michael Frisch, *A Shared Authority: Essays on the Craft and Meaning of Oral and Public History* (Albany: State University of New York Press, 1990).
6. The project recorded 57 photo-interviews with a median of nine photos per interview.
7. Carrying a camera rather than a flatbed scanner to an interview allowed for greater mobility in the field. The digitized recordings and photographs will be made publicly available through the website <http://www.arts.ualberta.ca/local_culture>.
8. Local Culture and Diversity on the Canadian Prairies, Methodology <http://www.arts.ualberta.ca/local_culture/Methodology.htm> (accessed November 30, 2009).
9. Local Culture and Diversity on the Canadian Prairies, Photograph Interview <http://www.arts.ualberta.ca/local_culture/Method3.htm>. Emphasis added (accessed November 30, 2009).
10. See Lynda Mannik's chapter in this collection.
11. Judith Modell and Charlee Brodsky, "Envisioning Homestead: Using Photographs in Interviewing (Homestead, Pennsylvania)," in: Eva M. McMahan and Kim Lacy Rogers, eds., *Interactive Oral History Interviewing* (Hillsdale, NJ: Lawrence Erlbaum Associates, 1994), 144.
12. This analysis is based on interviews with descendants of German-speaking immigrants.
13. Modell and Brodsky, "Envisioning Homestead," 145.
14. Modell and Brodsky, "Envisioning Homestead," 159.
15. Allan Sekula, "On the Invention of Photographic Meaning," in Burgin, ed., *Thinking Photography*, 85, 91.
16. Paul Ricoeur, *Memory, History, Forgetting*, transl. Kathleen Blamey and David Pellauer (Chicago: University of Chicago Press, 2006 [2004]), 44–55.
17. Modell and Brodsky, "Envisioning Homestead," 149.

18. This analysis was first suggested and applied by Angela Thiessen, "Hidden Inside the Frame: Photo-interviews and Their Usefulness to Researchers," unpublished research paper prepared for History 29.3560/6 The German-Canadian Presence in Canadian History (Fall/Winter 2004–5), April 2005.

19. The following is based, in part, on Thiessen, "Hidden Inside the Frame."

20. Modell and Brodsky similarly found that interviewees tended to show "public" rather than "private" photographs, that is, images of events they thought were "historically significant" or that looked "official," such as wedding photos. "Old pictures" were also seen as important. "Envisioning Homestead," 155.

21. Mary Brockmeyer, interview by Leslie Hall, Christine Kampen, and Angela Thiessen. Humboldt, Saskatchewan, July 17, 2004. LC 2004_4065–4067.

22. John Berger and Jean Mohr, *Another Way of Telling* (New York: Vintage, 1982), 117.

23. Bellaby, Allysa, "A Swinging Affair," *Modern Bride Magazine*, no date, <http://www.modernbride.com/styles/?ww_swingmbcsp01.html,> (accessed January 28, 2005); Vaughan, Roger, *Roger Vaughan Picture Library*, "20th Century British Photographs" <http://homepages.tesco.net/~patio?20thc/photo20.htm,> (accessed March 20, 2005).

24. Victor Burgin, "Introduction," in Burgin, ed., *Thinking Photography*, 2; Marilyn F. Motz, "Visual Autobiography: Photograph Albums of Turn-of-the-Century Midwestern Women," *American Quarterly* 41/1 (March 1989): 63–92, 82.

25. Patricia Holland, "'Sweet it is to scan...' Personal Photographs and Popular Photography," in Wells, ed, *Photography*, 113–158, 151.

26. Derrick Price and Liz Wells, "Thinking About Photography: Debates, Historically and Now," in Liz Wells, ed, *Photography: A Critical Introduction*, 3rd ed. (London: Routledge, 2004), 9–63, 60.

27. From: Paul Martin Lester: <http://commfaculty.fullerton.edu/lester/writings/others.html> (accessed February 25, 2006).

28. Linda Haverty Rugg, *Picturing Ourselves: Photography & Autobiography* (Chicago: University of Chicago Press, 1997), 67.

29. John Tagg, "The Currency of the Photograph," Burgin, ed., *Thinking Photography*, 117.

30. Roland Barthes, *Camera Lucida: Reflections on Photography, trans. Richard Howard* (New York: Hill and Wang, 1982 [1980]), 27.

31. Langford, *Suspended Conversations*, 144.

32. Rugg, *Picturing Ourselves*, 89.

"When I Was a Girl...": Women Talking about Their Girlhood Photo Collections

Penny Tinkler

Sociologist Penny Tinkler argues that photo albums introduce a specific dynamic into the oral history interview that is fundamentally different from the use of single photographs or photographs in other arrangements. Tinkler interviewed British women about the albums they had created as teenagers in Britain during the 1950s and 1960s. Like Alistair Thomson in his essay in this volume, she asks how photographs and photographic albums were implicated in producing knowledge about being a "modern" Briton in the post–World War II period. Tinkler argues that photo albums do not speak for themselves; yet, even retrospective interviews with the creators of the albums do not simply open windows onto the ways in which these albums had once been meaningful to them. For the women, returning to the albums half a century later revealed other gaps between happy pictures and narrated memories. Albums also reveal silences and violence that photographs in shoeboxes or on living-room walls do not: The jealous husband of one of Tinkler's narrators had ripped out photographs from his wife's teenage album, leaving material traces of "profound emotions of loss, death, anger, and bitterness." Thus, photographs and albums they had not looked at for decades put the narrators in a position of discomposure that compelled them to integrate a long-forgotten youthful counter-memory or suppressed memories of domestic violence into their well-honed adult life story. Tinkler, like Freund and Thiessen and Ryan, employs Barthes's notion of "punctum" to get a grip on her narrators' and her own emotional response to the photographs.

In 1955, aged 15, Carol started a photograph album. Not having a camera of her own, Carol collected photographs taken by other people, including her parents, older sisters, and friends. She also included pictures she had taken using her mother's camera. This magpie collection was added to for a couple of years and then put away. In 1965, 17-year-old Irene similarly began compiling a photograph album. This focused on two summer holidays. Having a camera of her own, a gift for her 14th birthday, Irene's collection contained mainly photographs that she had taken. Irene and Carol were not unusual in collecting photographs and making albums; these were common practices amongst middle-class girls growing up in England in the 1950s and 1960s.

Two teenagers and two representations of girlhood interests and concerns—studied in isolation, however, photograph collections do not usually reveal how their form and content were meaningful for the young album-makers. Yet, over 50 years later, can Irene's and Carol's reflections shed light on the teenage experiences and priorities that shaped their girlhood collections?

In this chapter, I consider what happens when women talk to an interviewer about their girlhood albums. How do photograph collections contribute to memory? What is distinctive about this method compared to interviews focused on a number of individual photographs? To address these questions I draw on a study of the photographs that five middle-class British women, born between 1938 and 1946, collected during their youth in the 1950s and 1960s. The photograph collections were looked at in the context of extended interviews (usually two interviews of around two hours each) with the women who, in their youth, had compiled them. Following a brief personal history, which included answering questions about the role of cameras and photography in their youth, we moved between periods of intense work on the albums to the women talking, without visual prompts, about being a teenager in the 1950s and 1960s. Before concentrating on women's talk about their girlhood photograph collections I consider briefly the theorization of memory in oral history and how photographs contribute to this.

Remembering with Photos

In interviews it is useful to keep in mind a distinction between a "youth-subject perspective" and an "adult-subject perspective." In other words, we need to distinguish between the subject's experience and views when they were young, for example 40 or more years ago ("youth-subject perspective"), and how the subject in adulthood now represents their past youth experience ("adult-subject perspective"). Whereas the photograph collection was embedded in the youth-subject's present, it is now part of the adult-subject's distant past; to make sense of their collection the adult-subject draws heavily on memory.

Cultural historians argue that oral histories do not tell us simply about the past, but the complex interweaving of past and present. Memories are reworked over time in light of subsequent experiences and the meanings attached to these. They are also shaped by the cultural context in which the interview takes place; "people do not simply remember what happened to them, but make sense of the subject matter they recall by interpreting it."[1]

Whilst there is debate about how much emphasis should be placed on cultural factors, it is widely accepted that people's recollections are complex constructions.[2] The concept of "composure" is used by some cultural historians to explain the processes involved in remembering in an oral history interview. "Composure" refers both to the composition or construction of memories and the subject's composition of a self. Although historians theorize composure in different ways, the outcome is similar; people try to compose stories that contribute to a version of themselves with which they feel comfortable.[3]

There are, however, instances where recalled matter is difficult for the subject to compose or live with. Acknowledgment of this has led Summerfield to coin the term "discomposure"; this is the result of "an uncomprehending or unsympathetic audience or a particular terrain of memory" that produces "personal disequilibrium, manifest in confusion, anger, self-contradiction, discomfort, and difficulties of sustaining a narrative."[4]

But how do photographs contribute to the process of remembering? Scholars agree that photographs can be a powerful stimulus to memory, although they are less sure as to why. There seem to me to be two aspects to a photographic encounter that are, in practice, interwoven: the memory response and the processing of recalled matter. The first aspect, the *memory response,* can take two forms; some photographs elicit both. In some instances the memory experience is initially one of *reaction* to the photograph. It seems first and foremost to be an emotional response, akin to Barthes' "punctum" (the part of an image that is poignant, that "pricks" the viewer) though this is often entangled with vivid recollections of sounds, sights, touch, and smell. More commonly, the response seems to be one of *consideration.* The subject applies herself or himself to the photograph, considering it in a manner akin to Barthes' "studium" (an interested reading), and recalling people, places, events, and experiences.[5]

The memory response to a photograph—both consideration and reaction—is not just about image, but also the photograph's materiality. As Edwards and Hart explain, drawing on Barthes, "image and referent are laminated together" like a "landscape and the window pane" through which it is viewed; meaning is constituted by the relationship between the two. The material form can influence the status consciously or unconsciously given to the content of an image; most notably it can shape assessments of the photograph's authenticity and indexicality (that is to say, the idea that a photograph represents a physical trace of its subject—like a footprint in sand). The memory response may also involve a

reaction to the photo-object and its history as, for example, when a photograph is a valued gift. The memory reaction also has a material component. As Rose notes, Barthes' punctum—the "prick" of a photo, which is akin to my memory reaction—produces an embodied response.[6]

Recalled matter can consist of visual and other sensory fragments, flashbacks, knowledge, meanings, and feelings. Memories of past experiences are not stored in aspic and are often overlaid with the effects of subsequent experiences, dreams, imaginings, media representations, and the meanings we attach to these. Some recalled matter is, however, relatively unmediated by history and biography. For example, some photographs can prompt the recollection of feelings that would have occurred in looking at the photograph around the time it was taken. Kuhn experienced something similar when, as an adult, she reviewed a film that had profoundly affected her as a child.[7]

Stage two of the photographic encounter involves the *processing* of recalled matter. Memory fragments, facts, and meanings are interpreted, classified, synthesized, and arranged into a coherent account that is articulated to self and others. This process is shaped, but not determined, by contemporary cultural resources, including language, dominant discourses, and collective memories. It is also influenced by the perspectives and interests of the subject and the recall context that includes the dynamics of the interview, and the subject's perceptions of their audiences. The "psychic effects" of past experiences that include "enduring unconscious conflicts" can, according to Roper, also shape this process. The objectives, conscious or otherwise, of this process are to compose memories that make sense to self and others and that present and position the self in ways that one can live with.[8]

Photos sometimes bolster the processes of composure in that their content seems consistent with the subject's recollections and can be used as visual evidence of them, or they support a particular version of the past that she or he is comfortable with. But the process of composing memories is not always successful and can result in discomposure. Discomposure occurs particularly when a photo elicits a punctum-like memory reaction, as the often intense, complex and sometimes intimate emotional/sensory recollections can be difficult to tame, name, interpret, and organize into a coherent and comfortable account. The subject may also resist this processing. Discomposed by the photographic encounter, the subject may be rendered speechless or left struggling to find the right words to convey his or her recollections.

Talking About a Photograph Collection

Talking about individual photographs is, however, different from talking about a photographic collection for two main reasons.

First, unlike talk-alone interviews or those focused on a selection of photographs, in interviews about photo-collections the subject is compelled to address visual and material evidence of one of their childhood agendas. During the period of their formation, albums are often added to, but as girls become adults, and particularly after "settling down" into long-term relationships, often with children, teen collections tend to be put away, rarely looked at or revised. Although collections bear the marks of selectivity, it is a youthful selectivity rather than one determined principally by adult sensibilities. Whilst it is the case that most girls relied on photographs taken by other people (especially parents and sometime friends) girls still had authorial power. The subject decided which photographs to include in their albums, how these were arranged, and what captions they required. The photographs that were included in albums were the product of childhood choices, initiatives, and activities. Thus, the photographic albums I looked at represent childhood agendas, that is, what was meaningful and important to young people in the 1950s and 1960s.

A childhood photograph collection confronts the adult-subject with a range of images and objects that the youth-subject deemed important. These often do not correspond to the people, events, or relationships that adult-subjects recall without this prompt or recall as meaningful; they are often unmemorable and insignificant. In addition, photograph collections often contain features that, either wholly or partially, anchor meanings that were once important. These anchoring devices include the organization of photographs as well as captions and details scribbled on the front or back of a picture. Working with collections also brings to light absences and raises questions about the significance of these; albums typically present material traces of missing photographs—gaps, captions, corners—and prompt the adult-subject to account for what has been removed from their collection. While it is tempting to focus only on what is visible in collections, accounts of what is excluded are important for contextualizing what is included and refining the interpretation of the childhood agenda. Absences do not equate with unimportance.

Different sorts of photographic material facilitate different memory experiences; the specificity of photographic prompts is therefore an important consideration in photo-interviews. For an interviewee, remembering with a childhood photograph collection is, for example, a different experience than reflecting on a few photographs they have selected to speak about.[9] In the latter, the selection is a choice dictated by concerns at the time of the interview rather than when the pictures were produced or acquired. These selections represent present-day adult agendas such as the interviewee's assessments of the purpose of the interview; the impressions about their past and present selves they want to project to the interviewer and the audience of the research; how they want to see their past self and its relation to their present self; or adult assessments of what is a "good" photograph. Given that meanings and memories change over time, the

selection fits a current version of the past. Selected photographs are also likely to be those that have remained in use and have long-term relevance rather than those with ephemeral and child-specific significance, typically photographs of the self and key family members rather than pictures of childhood friends and sweethearts. Of course, photographic images portray more than the interviewee's "photographic memory stories" and this facilitates explorations that go beyond the scene depicted, enriching and disrupting the initial account.[10] In contrast to talking about a collection, a selection necessarily involves the exclusion of some, if not many, personal photographs. Some old photographs are regarded as unrepresentative, uninteresting, or inconsistent with recollections; these pictures are unlikely to be selected. Research points to the disjuncture that can occur between memories and the "evidence" of photographs, particularly when adults revisit photographs of themselves when children that were taken by their parents.[11] Whereas scholars may use these pictures as opportunities for "contesting that construction, of rewriting the present by way of revising the past," interviewees may prefer the easier option of ignoring or discounting them.[12] However, what is excluded may be as revealing as what is included, as Walkerdine realized when she confronted her own efforts to suppress a reviled self-portrait.[13]

The second distinctive feature of looking at and talking about photograph collections is that it involves the subject composing two inter-connected sets of accounts—about individual photographs and the collection as a whole. Talk about a childhood collection is more than a stringing together of discreet accounts about photographs and is not reducible to these; the aggregate is more than the sum of its parts.

Scholars agree that photograph albums contain narrative structures. According to Chalfen, they have a "visual narrative style developed to deliver culturally significant tales and myths about ourselves to ourselves." Although photographs are seen typically as "keys to memory" in that only insiders know the detailed stories that the photographs speak to, some argue that the main features of an album's narrative can be reconstructed by an outsider. As Walker and Moulton explain, "every photo album is constructed on the basis of some implicit narrative" and if the genre is identified it is possible to "begin to imagine the structure of a narrative which would reasonably accompany it." Although narrative structures are typically attributed to literary and visual conventions, Langford argues that a photograph album is organized around verbal narration conventions. It is a "mnemonic device for storytelling" and only comes to life through talk; "speaking the album is not merely the supplement of photographic and textual reading, but the discovery of the album's ordering principle…The contents, structure and presentation of a photographic album are the vestiges of its oral scaffolding." When the compiler is not available to narrate their album, the original "conversation" is "suspended," but this "conversation" can be reactivated by an outsider's empathic oral performance of the album.[14]

In my research, albums are narrated by their compilers. Interestingly, in light of the emphasis placed on people's usual practices of talking about their albums, none of my interviewees recalled doing this with their girlhood collections (although it is possible that they told stories to themselves or anticipated oral storytelling).[15] Reviewing an album did not lead to a simple resurrection of an original girlhood story; stories change over a lifetime. Moreover, childhood photograph collections were often unfamiliar terrain; it had been many years since most of my subjects had studied theirs. And when, as sometimes happened, women literally deconstructed their childhood albums to make new ones for their own children, this process did not lead to a retracing of the collection's story, but merely the mining of it for evidence to fit a different one—that of their children's family history. In all cases there was not a rehearsed account, but one that was generated in the interview. However, although albums do have narrative structures (this is often overstated because albums also serve as a means merely of containing and tidying away loose photographs that people do not feel comfortable discarding), the talk that emerged in interviews was the result of more complex processes than is usually acknowledged. So how did women produce accounts of their childhood photograph collections?

Talk about an album is, in part, the product of engagement with the collection as a whole; photograph collections are material and visual objects in their own right that people engage with in distinctive ways. Interviewees introduce, explain, and frame their collections by what they say and do. Albums also require navigation. Through what is talked about at length, merely commented on, or ignored, the subject navigates a visible path through their collection. This path is shaped not only by what is present; sometimes interviewees also recalled missing photographs. Though the interviewer can ask the interviewee to explain what is ignored, preferred pathways are still revealed. This navigation process also includes verbal and nonverbal commentary that occurs between photographs, relating to what is visible and invisible in the collection.

Subjects worked out the detail of their collections, identifying people, places, events, relationships, and dates. Irene, for example, could not always rely on her memory or on written clues in her albums; often she had to work out what her photographs depicted. Her memory of the events portrayed was sometimes based on her recollection of their meaning or the feelings associated with them, from which she then worked out what was likely to have happened, as indicated by phrases such as "I imagine" and "I think I was trying to." Like all my interviewees, Irene is best seen as an "expert co-analyst" rather than an authority on her collection.

The women also wove accounts as they navigated their collections. Visual and material evidence from the girlhood collection is not simply reported on. Women also drew on memories of girlhood formed prior to, and independent of, looking at their childhood collections. These were not always consistent with

the photographic evidence. As Holland notes, photograph collections "force us to negotiate with our personal memories." Memories about the collection—such as why and how it was started and what happened to it over time—were folded into the composition. Accounts also drew on recollections prompted by individual photographs; these contradicted, confirmed, or added new dimensions to pre-existing memories and the emerging account of the collection. Women's current needs and interests added a further layer of complexity to their compositions, as did their attempts to engage with the demands and dynamics of the interview.[16]

The unfolding account of an album was not usually a neat narrative, but an account interspersed with facts, stories, comments, asides, subtle or unsubtle directions on how to proceed through the collection, and nonverbal reactions and expressions. The richness of the account is best appreciated by standing back from the specifics of the interview. Akin to an impressionist painting, the responses of the interviewee appear as fragments when looked at closely, but narrative threads can often be detected when the interview is viewed holistically.

Women's Accounts of Their Girlhood Photograph Collections

To illustrate the interweaving of processes involved in talking about a photograph collection I now look at two women's accounts, first Irene's, then Carol's.

In my first meeting with Irene we concentrated on an album she had compiled in 1965 and 1966 when she was 17 and 18. This focused on two holidays, one in the Lake District, the other in Wales. Irene had her own camera, but though she had been taking photographs since she was 14, this was her first album. The photographs in this album were taken mainly by Irene, but some also by her mother and friends using Irene's camera. A few photographs given to her by other people were also included.

The collection is evidence of some of Irene's youthful concerns and agenda. Whilst the inclusion of photographs indicates that their subject matter was important to Irene, their significance is not always clear to the outsider. The youth agenda emerged, however, as Irene clarified her relationships with people and explained what was happening in photographs. In a nutshell, Irene's album was preoccupied with herself, her friends, especially her cousin Liz with whom she went on holiday, and activities that included walking, photography, and "copping off" with boys.

The album presents Irene with prompts that she may not have spoken to without the album; photographs and events that are now deemed inconsequential, or which have been forgotten or even blocked from memory. Of course, Irene hones in on some photographs and photographic details rather than others, but each photograph requires some sort of explanation. This is not always a comfortable process. In Irene's collection there are several small group photographs

that feature "Colin." His name is written into the album so he was clearly worth a mention at the time it was produced. Looking at these photographs Irene feels she has to explain him, but she is clearly uncomfortable with this memory. She refers to him rather dismissively as "the builder" and explains that she does not know what she saw in him, "God knows why I got off with him. He was a builder. He was horrible. We had nothing in common." Irene's reaction is one of discomposure. Colin was a boyfriend Irene preferred to forget. Her recollections of him were incompatible with the versions of her teenage and adult selves that she now cherishes.

Irene weaves a narrative through what she says and the way she guides my viewing of her album. Her account produces a different story to the one that emerges from talk alone. This is partly because the album focuses principally on holidays. It is also because Irene sees in her album evidence of an important relationship with her cousin Liz.

Liz is in many of the photographs. There are 42 photographs in the album. Liz is identifiable in 14, and mentioned in 10 of the photograph captions. Liz is clearly central to Irene's girlhood agenda. However, the importance of Liz is not just a product of the album's content, but is generated by the way Irene navigates her collection. The relationship between Irene and Liz is central to Irene's account of her album and of the life she sees represented there. In the very first photograph Irene identifies both herself and her cousin in a group picture. After this, Irene routinely identifies both herself and Liz as we proceed through her collection:

> That's my cousin
> There's me and cousie
> There's me and cous
> That's us

Looking at one particular photograph, Irene commented, "nobody in there that we know." This is a revealing and important point; the people in this photograph were not central characters in Irene's story.

Irene talks at length about the photographs in which she appears with Liz. She adds color to black-and-white photographs, fills in details that are not visible to the eye, and tells stories about Liz and what they got up to in their youth. Even if Liz is not central to a photograph, the photographs that generate stories frequently feature Liz. One photograph of a group of young people resting during a walk features a man smoking. I pointed this out and Irene proceeded to talk at length about her smoking career, which was precipitated by Liz, "We were heavily into smoking. My cousin led me astray. It was her fault."

Irene's account also draws on memories of her collection, including absent photographs. One photograph that Irene was at particular pains to talk about

was actually missing from the album. This absent photograph nevertheless left material traces:

> This is a really great one of me and Liz... It's obviously pouring with rain and I'm wearing my souwester, but we're in little shorts. And the rain gear was so dreadful that the water went straight through it. I remember we ended up having to wade through streams because a small group of us got lost. And I can distinctly remember one of the party standing in a stream and saying "it's alright, it only comes up to here."

Subsequently, Irene emailed me a scanned copy of the photograph. She had removed the photograph from her album fairly recently to show to her cousin.

Irene's account of her album sheds light on the significance of Liz for Irene. When Irene viewed her album she commented that she had not realized how much of her youth she had spent with her cousin. Liz is not, however, a prominent figure in the talk-alone interview which covers life outside of holidays, and the album only accounts for four weeks of Irene's teenage years. Irene's comment about being with Liz seems exaggerated, but it is perhaps suggestive of Liz's influence which extended beyond holidays.

The narrative about Irene and Liz is in response to the album's youth agenda, but Irene's account contributes emphasis that cannot be explained solely by the youthful significance of this relationship. Irene's focus on Liz may also be a product of the interview. To Irene I am a historian researching teenage girls and their photographs from the 1950s and 1960s; I do not have a personal interest in Irene's youth. Given this, it is not surprising that Irene concentrates on the two most prominent teenagers in her photograph collection. However, the focus on her cousin is also a means by which Irene locates herself in relation to a "typical teenager," a construction that draws on dominant discourses about youth in this period. Repeatedly Irene presented herself as having had an old-fashioned upbringing in contrast to her cousin, whose youth conformed more to the dominant image of a teenage girl (at least, according to the adult Irene). Though the talk-alone interview provided evidence of this old-fashioned upbringing, it is in her discussion of photographs of Liz that Irene offers this self-assessment. The first photograph featuring Liz and Irene prompted this comment (see Figure 2.1):

> Liz was always with it, should we say. I mean, she was a bit of a raver. She must have given her mother nightmares... I was veering much more towards the, sort of, Beatnik style. But I made that suit, that was khaki. Some dreadful fabric I got from somewhere or other. And it also had a pair of flared trousers that went with it. But this [pointing to Liz's outfit] was a very smart suit. She, Lizbeth, always had her hair fashionably cut. I never go near a hairdresser's, never did.

Figure 2.1 Liz and Irene (on the right), ready to leave for their holiday together in 1965 (private collection).

Confirming the impression that the adult Irene did not see her young self as a proper "teenager," at several points, and often after mentioning Liz, Irene described herself as "rather boring."

Carol experienced her teenage years ten years earlier than Irene, but she too compiled an album. She started it in 1955, when 15. Although the album begins with a collection of photographs of a younger Carol, the album is not arranged in strict chronological order. Photographs of Carol at 11 appear opposite ones of her at 16.

The most striking feature of the album is the focus on photographs from 1956 and 1957 when she was 16 and 17 (Carol left school at 17). There are five sets of photographs from this period, and each relates to change and growing up. Whereas photographs from pre–1956 portray Carol principally as a daughter, photos from 1956 and 1957 present Carol in relationships outside the nuclear family, as an aunt and, in particular, as a friend. Whilst the focus on 1956 and

1957 could be explained in terms of the availability of photographs, which is not insignificant, Carol's recollections confirm and expand on the importance of this period. As Carol explained, "Life started for me at 16." Carol had little to say about most of her early photographs, but accounts of later ones were colorful and lively. The relationships featured were meaningful and sometimes intense, as suggested by Carol's passionate account of her holiday with Christine, "On our last. Our *last* summer [said in semi-humorous mock of her words] we went to Ireland together to stay with her relatives. We just had really *loads* and *loads* of good fun together. It was absolutely fantastic. A *hell* of a summer."

Carol's account of her album draws out the youthful agenda and the importance for the teenage Carol of growing up and gaining independence. However, this narrative jostles uneasily against another, a narrative of loss, Carol's loss of independence on marriage when she was 24 which involved the distancing of previously close friends and the loss of her position as "Daddy's girl" as she became a woman, wife, and mother.

The narrative of loss relating to the father-daughter relationship emerges in part from how Carol framed my viewing of her album. Although there are no photographs of Carol's father affixed in her album, he is central to this narrative thread. As Carol passed the album to me, she extracted from the front cover a small, loose, black-and-white photograph of her parents that was sent to her when she left home for university. Although both parents are featured, Carol points out her father and describes how his hair went white when she left home, apparently because of his sadness at losing his daughter. She then picks up the photograph and reads the words her father pencilled on the back. It seems that the memories evoked by this photograph are less about the image than the photograph's materiality and material history. The photograph provides Carol with a material link to her father, not just because of the image's indexicality, but because her father wrote on the back and physically handled the photograph. Indeed Batchen would argue that by writing on the photograph the father successfully transformed it into a more "effective memory object"; moreover, Carol's father transformed the photograph from an object that could be just looked at to one that required handling. Although Carol's handling of the photograph could be explained as a practicality, touch did seem intrinsic to the process of remembering. Whereas I was allowed to photograph the visual image, I was not permitted to photograph the words; the prohibition suggests Carol's need to preserve the exclusivity of this photo-object and the intimacy it embodied.[17]

Having introduced her father so poignantly, the father-daughter relationship is then woven through the narration of the collection. It is central to the meaning and significance of a portrait of Carol taken by her father in 1951 when she was 11. Carol describes how much she loved, and still loves, this photograph of herself sitting on the grass. In her account of the photograph, Carol says, "We went out on the hills on a beautiful, beautiful day. And I think my Dad and I

were just trailing out the back … There's a feather in my hair. A big bird's feather." Carol pieces together a colorful memory fragment about the day, the knowledge that she was with her father and mother, and a desire possibly then and definitely now to read this photograph as evidence of her relationship with her father. The specifics of this image are not what are most significant to Carol. Rather, it is that this photograph was taken by Carol's father, and to Carol it represents her father's adoration of his daughter. Carol's account is shaped less by the image than by her memories of the material history of this photograph, namely the conditions in which it was made. But as her recollections unfold the assumptions are revealed. Carol does not have a clear memory of the photographic event; she admits, she "think[s] my Dad and I were just trailing behind" and the photograph could have been taken by her mother.

The interview story is not limited to what is featured in the album, but also embraces absences. Absent photographs can sometimes be detected by material clues in an album, they may also, and only, leave memory traces. Absent images are not only those that once had a place in a collection, but also those photographs that the subject thinks should be present. This is the case with a photograph that Carol no longer has, but which she feels is important to her story, "It's me and my father rolling on the floor fighting for a stick … I was 15 and my father was old enough to know better. And we had this stick and we were fighting for it … I'm in a coat I know I had when I was 15." The timing of this photograph and its subject—Carol and her father involved in childish intimate play—become particularly meaningful in light of changes that were soon to happen in Carol's life.

The second narrative of loss focuses on Carol's relationship with Christine and revolves around Carol's unhappy marriage at 24 to a jealous and controlling husband. It is a story shaped by the material evidence of her collection and its biography as well as her memories of one particular photograph.

Carol says little about her husband, but in a different way to her father, he figures in her album's story. His presence in her collection is almost palpable to Carol as it is his hands that vandalized her album by tearing out photographs leaving corners and scraps of photographic paper. These lost photographs are of Carol's friends, including Christine. There is only one photograph of Christine in the album; the inclusion of Carol's nephew in the photograph may be the reason it was not destroyed (see Figure 2.2). This photograph stirs up powerful feelings for Carol, but the effect of this picture is difficult to separate from its material context—a page where there are visible traces of violence. Significantly, Carol does not talk about the detail of the missing pictures. Perhaps the photographs cannot be separated from the violent relationship that led to their destruction.

The muting of the story about marriage relative to that of Carol's growing up is, in part, a result of the interview because Carol did not perceive her marriage to be relevant to my research. I think it is also because Carol did not want to

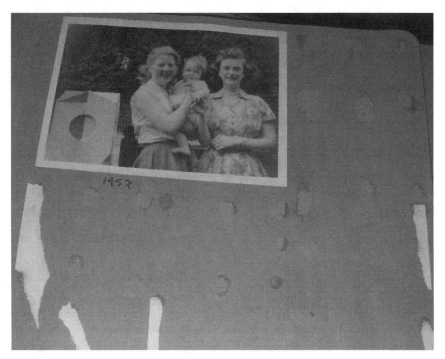

Figure 2.2 Carol, holding her baby nephew, is photographed in 1957 with her friend Christine. Other photographs of Christine were removed from the album in the 1960s (private collection).

think or talk about her marriage. In spite of this, the story struggles to the surface because of the powerful feelings generated by the material evidence of the album and the photograph of Christine, but it does so in asides, coded comments, and barely suppressed emotion. The story leads to Carol's discomposure because it is painful and sits uneasily with how she wants to see herself. Throughout the interview, Carol kept her distance from me and rarely handled her album. She seemed to be literally keeping the photographs and at least some of her memories at bay.

Talking to people about their photograph collections seems an obvious way to understand photographs and their personal and historical significance. Detailed recollections and complex stories are generated by looking and talking. Moreover photograph collections prompt people about matters that are not otherwise obvious to the researcher or the adult-subject. These memories are products of considerable work on the part of interviewees, but historical insight comes only from teasing these apart.

To do this it is necessary to understand how photographs contribute to remembering. But remembering with photograph collections is different to remembering without photographs or with only a selection of pictures. In interviews that address photograph collections, the collection confronts the

adult-subject with a range of images that the youth-subject deemed important. The subject is therefore compelled to address their childhood agenda. However, this is not a simple process. As I have demonstrated, from an adult perspective, and in a particular interview context, women weave accounts about their photo collections. These accounts draw on the "evidence" of their albums, preexisting narratives of their youth, knowledge of the biographies of their collections as well as recollections prompted by looking at, and handling, individual photographs and albums.

The process of weaving an account is not simply an intellectual activity. Seeing and remembering are embodied activities. Women touch their photos and albums, and their memory responses, especially their memory reactions, produce physical sensations from intense pleasure and feelings of comfort, to anxiety, dislike, and pain, sometimes simultaneously. Processing these responses or attempting to ignore or suppress them, generates its own feelings and physical responses, manifest, for instance, in Carol's reluctance to touch her album and her obvious physical discomfort when confronted with the vandalized page.

Women strive for composure in talking about their photograph collections, but this is sometimes elusive because of the complexities involved in processing memories into coherent and comfortable accounts. The potential for discomposure is heightened because the album sets the agenda for discussion, each photo requiring an explanation irrespective of the interviewee's sensibilities.

Notes

1. Penny Summerfield, "Culture and Composure: Creating Narratives of the Gendered Self in Oral History Interviews." *Cultural and Social History* 1, no. 1 (January, 2004): 67. I would like to acknowledge the generosity of my interviewees and the helpful feedback of readers and conference audiences.
2. Michael Roper, "Remembering the Soldier Hero: The Psychic and Social Construction of Memory in Personal Narratives of the Great War." *History Workshop Journal* 50 (Autumn 2000): 181–204.
3. Graham Dawson, *Soldier Heroes: British Adventure, Empire and the Imagining of Masculinities* (London: Routledge, 1994); Alistair Thomson, *Anzac Memories: Living with the Legend* (Melbourne: Oxford University Press, 1994); Summerfield, "Culture and Composure," 65–93.
4. Summerfield, "Culture and Composure," 69–70.
5. Roland Barthes, *Camera Lucida: Reflections on Photography* (London: Vintage, 2000), 27.
6. Elizabeth Edwards and Janice Hart, eds., *Photographs, Objects, Histories: On the Materiality of Images* (London, Routledge, 2004), 2; Gillian Rose, "'Everyone's Cuddled Up and It Just Looks Really Nice': An Emotional Geography of Some Mums and Their Family Photos," *Social & Cultural Geography* 5, 4 (December, 2004) 549–564.

7. Annette Kuhn, *Family Secrets: Acts of Memory and Imagination* (London: Verso, 1995)

8. Roper, "Remembering the Soldier Hero," 200.

9. See Freund and Thiessen in this collection.

10. See Freund and Thiessen, and Thomson, in this collection.

11. Valerie Walkerdine, "Behind the Painted Smile," in *Family Snaps: The Meanings of Domestic Photography*, ed. Jo Spence and Patricia Holland (London: Virago, 1991), 35–45; Diana Gittens, *The Child in Question* (London: Macmillan, 1997).

12. Marianne Hirsch, *Family Frames: Photography, Narrative and Postmemory.* (Cambridge, Massachusetts and London: Harvard University Press: 1997), 193.

13. Walkerdine, "Behind the Painted Smile," 35.

14. Richard Chalfen, *Snapshot Versions of Life.* (Bowling Green, Ohio: The Popular Press, 1987), 142; Christopher Musello, "Family Photography," in *Images of Information: Still Photography in the Social Sciences*, ed. Jon Wagner (London: Sage, 1979), 112; Andrew L. Walker and Rosalind Kimball Moulton, "Photo Albums: Images of Time and Reflections of Self," *Qualitative Sociology* 12, 2 (June 1989): 165, 175; Martha Langford, "Speaking the Album: An Application of the Oral-Photographic Framework," in *Locating Memory: Photographic Acts*, ed. Annette Kuhn and Kirsten Emiko McAllister (Oxford: Berghan Books, 2006), 224.

15. For example, see: Martha Langford, *Suspended Conversations: The Afterlife of Memory in Photographic Albums.* (London: McGill-Queen's University Press, 2001); Langford, "Speaking the Album"; Chalfen, *Snapshot Versions of Life*; Annette Kuhn, "Photography and Cultural Memory: A Methodological Exploration." *Visual Studies* 22, 3 (December 2007): 283–292; Deborah Chambers, *Representing the Family* (London: Sage, 2001).

16. Patricia Holland, "Introduction: History, Memory and the Family Album," in *Family Snaps: The Meanings of Domestic Photography*, ed. Jo Spence and Patricia Holland (London: Virago, 1991), 9.

17. Geoffrey Batchen, *Forget Me Not: Photography and Remembrance.* (New York: Princeton Architectural Press, 2006), 48.

Imaging Family Memories: My Mum, Her Photographs, Our Memories[1]

Janis Wilton

Oral and public historian Janis Wilton used oral history and photography to deal with the loss of her mother, just as other essays, by Marles and Mannik for example, consider the therapeutic potential and challenges of such projects. Taking photographs of the inventory of her mother's house—creating new material memory objects (photographs) of old material memory objects (e.g., a toaster)—allowed her to find out about the manifold meanings her relatives attached to the relationships with their mother, grandmother, or aunt. As Wilton says, "We decided to photograph memories." Rather than using photographs only as triggers of memory, the need to remember also triggered the need to photograph. Family members' memories were stirred by material objects; this stimulated the desire to create photographs as durable, portable material memory objects. Material objects and memories create—and in turn transform—each other. The photograph of Wilton's mother's old toaster is a different kind of material memory object than the toaster itself. Wilton's research, like that of most essays in this collection, shows that photographs and memory stories cannot be thought of as a one-way street. The photograph-memory relationship is not linear and unidirectional. In this photographic age, photographs are intrinsically linked with memories, they generate each other. And, like Bersch and Grant in a later essay, Wilton points to the value of oral historians creating their own photographs alongside those provided by interviewees.

My Mum, Edna Wilton, died in July 2009. It was unexpected. She had been living independently. It's true, she was short of breath, had a heart condition, a cracked pelvis and had had a fall—but she was rallying; getting better. Then, after four weeks of slow recovery, her body suddenly shut down. She was 90. The medical staff, friends, relatives; we all kept talking about a long life, a good life. It didn't compensate. She was gone. As so often at times like this, my brothers, my sister, myself, our families, our relatives, our friends started to share memories. Her life, our father, our childhood. Her memorial service was full of memories. An oral history interview I had conducted twenty years before, complemented by her exquisitely eccentric diary of significant events from across her life, shaped the memory-picture we used to provide a framework for all of our other memories. Her mass of loose photographs and photograph albums offered up images and memories that could be shared through the wonders of modern technology. As we talked and remembered, there was Mum as a child, a Girl Guide, a young mother, a grandmother, a volunteer at the Royal Far West Children's School,[2] and so much more. Someone photographed the service. This mixing of photographs and memories continues to shape the ways in which we are coming to terms with our Mum's absence; we are sharing stories and building a bank of family images that can be passed on to children, grandchildren, great grandchildren, cousins, and friends.

The photographs we are using come from different sources. There are myriad photographs documenting our family from around 1900 to the arrival of Mum's most recent great-grandchild in 2009. Some of these are sorted in albums; others are jumbled in boxes and envelopes. Then there are the photographs my brother is taking now. Before we began the emotionally draining task of sifting, sorting, and dispersing the contents of my Mum's house, we decided to photograph the house as it was; the photographs on the walls, the furniture, the room full of her wonderfully creative soft toys and other creatures. And we decided to photograph individual items as stories were shared—and sometimes recorded—about the use of particular objects, their significance, the memories they provoked.

In this imaging of family memories and in starting to sort and connect family photographs to family stories we are creating a conversation about the ways in which photographs shape memories and memories inform photographs and, indeed, photographs become memories. We make use of the oral history interviews with Mum, of her bundles of reflective and creative writing, and we are interviewing each other and sharing our stories. The process is cathartic, warming, and affirming. In being shared here in this public forum, it offers reflections on the relationships between oral history, memory, and photographs, and draws on some of the rich literature that can inform our understanding of those relationships. It is shaped and informed by writers and commentators who, confronted by the death of a family member, especially a parent, have contemplated the meaning of the things—including photographs—left for them to sort.[3] It is also located within my own ongoing interest in objects and memories.[4]

Insider/Outsider

I have spent my professional life recording other people's community, family, and individual stories.[5] I have had the luxury of distance. I have experienced the familiarity and friendship engendered by the process of oral history interviewing, piecing together other people's lives, asking for their assistance, their commentary, their objects, and their photographs but always from a safe position and with the gaze of the outsider. This time, it is my family, my mother, my brothers, my sister, my children, and all of our relatives. I am caught within the emotions of the exercise, within the knowledge that I am writing, viewing, and talking about my own family and how that can blur the edges. As Martin Bashforth has eloquently expressed it, this process is not "simply an exercise of the intellect, but a struggle with emotions."[6] An advantage is that I can tap into silences and, significantly, into my own memories as well as the stories and memories shared over years with siblings, and with my Mum. This tapping adds to the oral history interviews already recorded and opens doors on other questions to ask, other topics to pursue, and other moments on which to reflect as I conduct the next oral history interview and uncover or take the next photograph. It is a reminder of the exercise I always encourage my students to do before they start interviewing: reflect on your own memories, think how they are constructed, think what they tell you, contemplate what and how you might censor those memories for outsiders, and think about the different ways in which things (including photographs) and places trigger and shape those memories. Reflecting on and evaluating one's own processes of remembering can enrich expectations of what and how other people may remember and what they may be willing to share.

Memory Photographs

Like so many families, we have inherited a wealth of photographs from among my Mum's things; some people and places we can identify, know a little about, or have found out about, and some we can't identify and whose stories have faded and disappeared. These are the kind of memory photographs that a number of commentators have analyzed and written about. Of particular relevance here are explorations of the ways in which familiar family photographs evoke memories and stories that differ from family member to family member. It is an approach well represented in Annette Kuhn's "Remembrance".[7] Also of relevance are discussions of the ways in which a photograph can trigger or even shape a memory shared through an oral history interview, and the ways in which it can evoke memories and stories that extend or challenge the narrative suggested by the photographic images. These are issues taken up by other chapters in this book.[8] As well, concerns with the materiality, contexts, and biographies of photographs

are of significance. Geoffrey Batchen's focus on elaborate and decorated frames; Albert Chong's construction of still-life images using family photographs; Martha Langford's exposure of the power of photographic albums, especially when their creator is known; and Elizabeth Edwards and Janice Hart's edited collection of essays exploring photographs as objects, provide reminders to document and question the material features of a photograph (its frame, its size, its form), and the stories and meanings revealed by analyzing where and how photographs are displayed and who has owned and shown them.[9] I want to explore these various threads through a focus on a particular photograph from among the many in my Mum's collection.

The photograph (Figure 3.1) is a hand-coloured portrait of William Odewahn (1871–1941), my maternal grandfather. His age, the style of photograph, and its wooden frame with curved glass date it from his later years, probably in his 50s. My first memories of it are from my childhood, from the visits paid to my grandmother's house in Albury, a rural town in southern New South Wales, Australia. The portrait hung in the guest bedroom in which my brother and I often slept. Grandfather sternly looked down on us, imprinting in my young mind an image of a very formal man, serious, respected, in his business suit. It was a first impression that remained for some time. He was an unmet member of the family. It was my grandmother who dominated, and her conversations rarely mentioned her deceased husband.

My brother Greville's memories of the portrait locate it in the same room but the context is slightly different. For him, the portrait marked the end of our drives from Sydney to the town in which my grandmother lived. We were both children, playing on the back seat of the family car. It was a long day's drive. On arrival, as my brother remembers, Nan (our name for our grandmother) was always sitting at the table in the dining room and, insistently if not sternly, she would direct the two of us to have a lie down. Greville recalls his frustration, "It was the last thing we wanted to do after sitting all day in the car. We'd have to lie down. Lie on a bed each and sleep for an hour—which we never did—with grandfather hanging over us in that dark room."[10] The portrait, for Greville, became strongly associated with his memories of this frustrating childhood experience, and with his resistance to our grandmother's domineering ways.

With my grandmother's death in 1978, the portrait passed into my mother's collection of things. It moved to the wall in the living room of her new home, and it was still there at the time of her death. On the back she had inscribed the details of her father's name, date and place of birth, and date and place of death. Her much loved father was watching over her, her house, and her family and his portrait was labeled so that, when there were no longer people who remembered this man, the back of the image would name and place him. The photograph had moved from the less public space of her mother's spare bedroom to the more public space of her lounge room. The move—and the labeling—was perhaps an

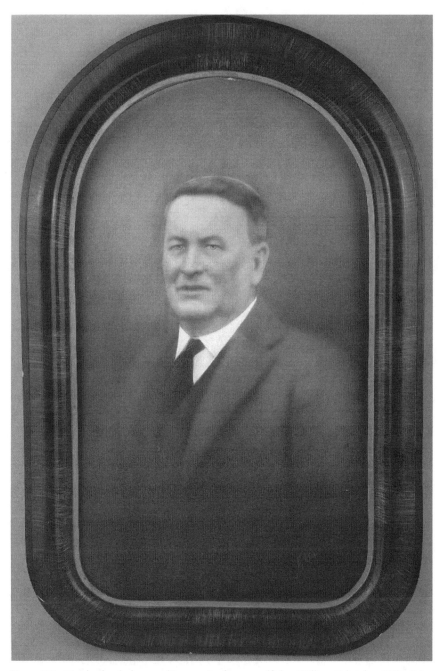

Figure 3.1 Hand colored photographic portrait of our grandfather, William Odewahn, 1920s (Edna Wilton collection).

indication of the different attitudes of the women to this man in their lives; there was tension between husband and wife, but admiration by the daughter of her father.[11] What I do not know because it is now too late to ask—Mum was the last of her siblings to pass away—is where the portrait was hung in their family home, back on the land, when my grandfather was alive. Why was it taken? Was there also one of grandmother? Or, indeed, was this portrait created after grandfather's death? Was it his memorial? What might this biography of the origin and original location of the portrait suggest about the man and his place in the family and in the memories and emotions of his wife and children? And, indeed, who is the F. Lewellyn whose name is inscribed in the bottom right hand corner of the photograph? Was he a local photographer or the colorist? Was he from Sydney?

What I do know is that when, in 1986 and again in 1991, I interviewed my Mum about her family background, childhood, and adolescence, and used photographs—including this and another earlier formal portrait of her father—as triggers for memories, descriptions, and a sense of people and places, the images I had formed of my grandfather were challenged. I knew he had been a farmer, but I had an image of him as a businessman farmer, sitting in his office in the house (a room I knew as a child), attending meetings in town, managing business and family. I also knew that Mum had great love and admiration for her father, but I hadn't really thought about it nor had I thought much about his physical presence or his personality. From the interviews, I learnt—and you can hear my surprise—that he wore glasses, that he was "a big man—16 stone...about five feet ten inches...[but not] a big fat man," that he "liked to go out with his horse and sulky rather than the car all the time," and that

> he had a good voice and he was very musical but he never learned and of course he had big fat farmer's fingers and he'd sit down at the piano and he'd play a tune by ear without any problem. Of course he'd hit more than one note at a time—he had a concertina which he could play really well, a tin whistle—he played the violin but he had to give up the violin because he broke—that's right I think he was learning violin and he broke his little finger. So he couldn't play violin. The piano and music he loved that—and poetry—he could recite all sorts of things—that's why I think I learned a lot of Australian poetry because I used to say it to my father. He used to like all that.[12]

Mum's love of iconic Australian poets—Banjo Paterson and Henry Lawson—fell into place. She could still recite Paterson's "Clancy of the Overflow" until late in her life. And, through her memories, my image of my grandfather had to break away from the formality conveyed through the familiar photographic portrait.

At the time of the interview, Mum's remembering and describing her father sent her searching through her memories, albums, and scattered photographs for other images. Here he was sitting on his favorite horse, "Doctor," here he was

bringing gifts back for his children from trips away, here he was dressed informally at a family picnic, here he was on horseback or driving a sulky (Figure 3.2). These photos and memories became a focus of a booklet Mum and I produced about her childhood for family members.[13] Yet, it is the formal portrait, the framed and hand colored photograph, which remained prominent in her home.

And that portrait—along with Mum's other photographs and things—has now moved into the next stage of its own biography; it now hangs in my brother's home, back on a rural property though one at the other end of the state to where Mum grew up. In explaining why he was happy to be custodian of the photograph, Greville unhesitatingly says that it was because of its association with that memory of the frustrations of our grandmother's insistence on us having to rest on arrival. He emphasizes, "I have consciously made sure that I don't tell people who come to visit here (in his home in the bush) that, when they get here, they need to have a rest. Maybe having it is about trying to resolve an unpleasant memory. And, of course, it's also because it's grandfather." The other three of us—myself, my sister, and my other brother—were unsure where we could hang a portrait like this. It didn't fit with our homes and, I guess, we were not particularly attached to the image of a man we had only met through the photographs and memories passed on by my Mum and other members of her family, and we didn't have Greville's strong association with it, his desire to be reminded how not

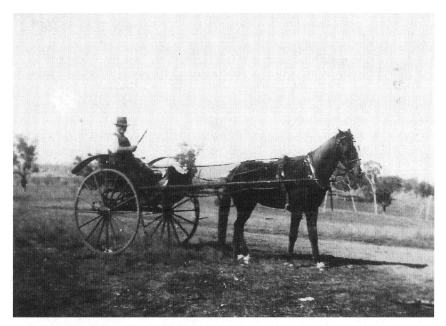

Figure 3.2 Grandfather in his sulky with "Snip," the horse, 1923. Original is an 8 × 6 cm snapshot (Edna Wilton collection).

to behave. As well, the new technologies mean that we can all have copies of the portrait—in forms and sizes more palatable to our own collections, and we can continue to share the stories and memories. We have photographed the photograph, and we have photographed much more.

Photographing Memories

Mum's collection included lots of photographs. As we packed her things we talked about some of them, and that talking and sharing will continue. There were so many photographs—along with her papers and memorabilia—that we simply boxed them as we packed her house. The boxes sit in my cupboard, waiting for my time and skills—I am, after all, the historian in the family. There will be time to pursue further the memories and stories they evoke among family and friends.

The packing, however, also meant dismantling her house; the framed photographs on the walls had to be taken down and find new places to hang, the bric-a-brac on the mantelpiece and sideboard distributed, the contents of her cupboards sorted, the objects anchoring different bits of her life story were to be displaced, moved on, take on new meanings in new hands. This was unnerving, finite, challenging. We talked about the power of objects to tell stories, the need to remember things and their stories, the risk of forgetting, and a later desire to retrieve the forgotten. So, we decided to photograph the house and its contents before anything was moved. We decided to record stories and memories associated with different items. We decided to photograph memories.

My older brother, Noel, took the photographs. He began with a series that led from the street into the house and then through each room. These photographs include one (Figure 3.3) that locates the familiar portrait of our grandfather hanging on the wall in the lounge room—its context for the past 30 years and an image whose impression on grandchildren and visitors could be revealing. Indeed, it is possible that these photographs will generate memories or indeed create memories. I asked my daughter about her memories of her Nan's lounge room, what objects and things could she remember. Her memories brought in Mum's "armchair with the sewing everywhere," other chairs and the lounge room suite, the television, the "two giant elephants at the fireplace," "the window to the room with the toys in it" and, on the walls, just "the weird pictures—old paintings and landscapes." I asked about the photograph of her great grandfather: "I don't remember it at all!"[14] I wonder whether, when my daughter has a set of photographs capturing her Nan's house, she might start to remember that portrait. We might discover, as psychologists Maryanne Garry and Matthew Gerrie among others have demonstrated, that the visual power of a photograph

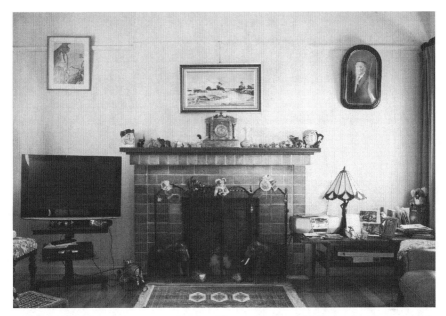

Figure 3.3 Mum's lounge room, August 2009. The portrait of grandfather can be seen on the right hand side of the fireplace (Noel Wilton).

can intrude and create a memory that, without that prompt, was previously not a familiar memory or not a memory at all.[15]

Among the newly taken photographs there is a snapshot (Figure 3.4) I took of the assemblage of items that sat on an inside windowsill, shrine-like. Here was an acknowledgment of our father—a wedding photograph, him in uniform, Mum as bride, and army mates as guards of honor. Next to it are Dad's World War II medals. These items are now distributed among family members. The assemblage captured in the photograph, however, provides a poignant starting point for some of the silences and sadnesses in our family story. Our father was damaged by war. He was a Rat of Tobruk.[16] Our parents' marriage was fraught with difficulties. They separated and, after separation, had very little contact with each other. Yet, after my father died in 1984 his estate came to my mother. His possessions were few but, as with Martin Bashforth's focus on his father's work-shed with its secreted tin of items,[17] those few possessions said a great deal about our Dad: they mostly related to his war service. Mum kept his possessions. At some stage she created this small shrine to his memory and pulled out his war medals to put on display. On top of the display cabinet in the dining room she also put his army portrait photographs; this handsome young man in uniform. Her status had changed from deserted wife to war widow and the new setting of the photograph and medals reflected this. Some of the bitterness and silences that had previously enveloped her memories of her husband and our father softened.

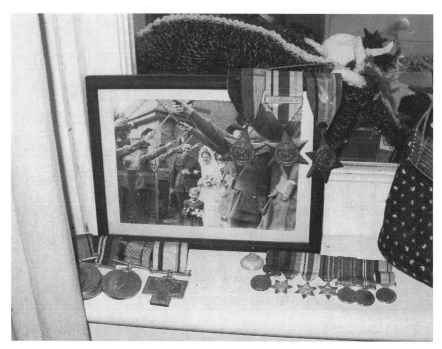

Figure 3.4 Wedding photographs and medals as a memorial to our father, Maurice Wilton (Janis Wilton).

In my oral history interview with her in 1986, she offered faintly fond memories of their first meeting:

> When he came to Walla,[18] I met him there. First day he landed in Walla, he came by train—it was virtually a city fellow coming to a little country town and he went in the Koehlers' shop...Her parents had the stationery shop, the newsagents in Walla. I was in there and your father used to always say he remembered I was buying a cabbage...Anyhow I was in the Koehlers' shop and he went in there to have a cup of coffee or tea because it was in the morning and he didn't know where he was going to stay. He went up and lived in a hotel and...he noticed particularly because I had the little red Oldsmobile that was Hube's[19] car, the day I was in town.[20]

And, in passing, she adds details that place her wedding photograph, the one that sat at the centre of her shrine, in a wider context. We were talking about some of the military training and service photographs and snapshots she had inherited from Dad. I asked about them and about when he joined up.

> *JW: Did he join the army as soon as war broke out?*
> No, it was about six months after...
> *JW: And these photos, can you say something*

Well — he got into the officers' training school at Puckapunyal. He just really graduated as lieutenant when we were married. His uniform hadn't come through—he was waiting on his uniform to come through, he thought he could have been married in his uniform.[21]

And when she turned to talk about the photograph itself, she found a companion photograph (Figure 3.5)—the guard of honor created by the local Girl Guides. She had been an active leader in the Girl Guides and, like her new husband's army mates, the local Girl Guides gathered to celebrate her wedding. And she talked about her wedding clothes: the veil that had previously been worn by her mother at her wedding and by other members of the family before and since, and the dress she had borrowed from her sister-in-law. It was wartime, after all.

We found the veil stored safely in a camphor box. That is now with my sister waiting for the next family member who wants to wear it. And the memories are strong for her—it was the veil she wore for her own wedding so it is there also in my sister's wedding photographs.

In this process of photographing memories, of capturing Mum's house and its contents as it was before we started to dismantle, disperse and dispose, there were many other images waiting to prompt the memories we shared around them and perhaps the memories we will create: Mum's chair with her sewing table still littered with the last items on which she was working; her sideboard with its collection of gifts, photos, and memorabilia; her bedroom; her collection of toys and

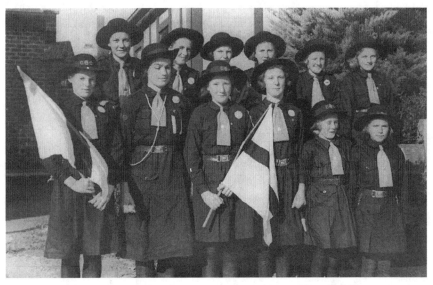

Figure 3.5 Girl Guide guard of honour at our parents' wedding in Albury, NSW, July 1940 (Edna Wilton collection).

creations made by her. Her spaces, with her things still there. These photographs are anchors for children, grandchildren, relatives, friends to share memories of moments in the house with my Mum, of the stories she shared and, especially, of the things she made.

The photographing of memories, however, did not stop with photographing the house as it was. We decided that, in sharing Mum's possessions, we wanted to record the memories and stories associated with particular items before those items went to their new homes. My brother kept photographing. This time individual items: in context and out of context. And now the stories and memories can be attached to photographs that can share items and memories: the photographs become anchors for all who want to have a tangible item, a visual representation of particular stories, associations and things. There may only be one item but the modern technologies of digital photography mean there can be many images of each item, of each of these windows to memories and stories.

Photographs of Mum's toaster provide an example. In *Objects of Death*, Margaret Gibson notes that among the people she interviewed about the items they treasured in the collections of deceased family members, they rarely, if ever, sought to keep or own domestic utilitarian items like fridges, irons, or toasters as mementos. These were useful items that, at most, went to family members who needed them or to charity. As Gibson observes, they "*do not* trigger feelings of attachment, or specific memories or stories."[22] This was not the case within our family.

We asked family members if there was a particular item belonging to Mum that they would like as a memento. My 28-year-old nephew Ry put in a request for Mum's "magic toaster" and for the fairly tired and battered stool that she had in her kitchen. The stool was of the kind that had a small set of steps that folded out when you wanted to climb up it. My older brother and sister were a little perplexed. They didn't know why the toaster was "magic" or why Ry would want it. The younger of my brothers, Ry's Dad, and I smiled. We understood. Ours were the families that lived outside Sydney. We used to visit and stay with Mum. Breakfast involved conquering her "magic toaster." It was a particular style of toaster: it operated by the pressure of the bread being dropped into the toaster slot. It was supposed to make the bread descend to be toasted. However, Mum's toaster would only do this if you put the slice of bread in a particular slot and then jiggled it in a particular way. Mostly, we all failed. Ry wanted this memory of his grandmother and of visits to her house. And he added the stool. He explained that, as a small child he used to pull the stool and steps out, climb up so that he could sit at the kitchen window and look down on the main road that could be seen from the window and that the "bendy buses" went along. He was a country kid, after all, and this was the big city. Here are memories that talk of the dispersal of families with some children living in rural areas and visiting, and others remaining city bound and in closer proximity. Here also are memories that talk of

my Mum, like so many of her generation, being unable to throw things out and keeping them functioning even when they were falling apart. Any suggestion to replace the toaster or the stool met with dismissal. She was a recycler well before the term and ideas became an imperative, but she would never have regarded herself as an environmentalist in today's sense. For her, it was about using, reusing, mending, recycling. She didn't throw things out. She mended, she patched, she reused. Those are memories that warrant photographs.

Here is a snapshot (Figure 3.6) of the toaster in situ, in its context in the kitchen, breadcrumbs scattered on the benchtop, microwave settling above the toaster and kettle, the place where we knew it fitted and was right. The power was always switched off—that could trick you at first. Mum always switched off the electricity—saving power—and we often sat in darkening rooms until someone was brave enough to suggest that the lights should go on. The toaster and its photograph in situ trigger those memories too.

Then there is a photograph (Figure 3.7) of the toaster disembodied, as it might appear in a museum collection and here, some extra research—the internet is amazing—revealed another context, another story, an excursion into the materiality of the item. This was a particular style of toaster, a special toaster, a Sunbeam Radiant Control Toaster! There is an American who collects and is

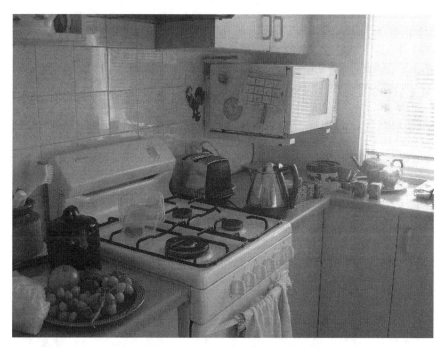

Figure 3.6 Mum's Sunbeam Radiant Control toaster in situ in her kitchen, August 2009 (Janis Wilton).

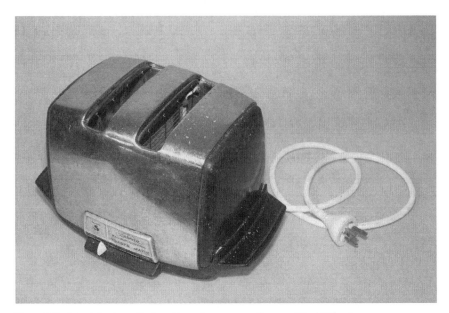

Figure 3.7 Mum's Sunbeam Radiant Control toaster out of context (Noel Wilton).

passionate about these toasters. On his website he declares: "From the late 1940s to 1997, the upscale toaster market was dominated by this classic from Sunbeam. Its sophisticated lines, art deco styling, and consistent toasting quality made it a pleasure both to the eyes and the palate."[23]

The website is full of photographs of different versions of the toaster. And, in telling this story and in showing this photograph to a gathering of local historians in late 2009, a number of heads started to nod. They knew this toaster. There was one in their kitchens or in their mothers' kitchens. They started to remember their breakfasts, their toast magically making its way down and up with a gentle movement, no clicking, pressing, or popping. And the memories of toasters moved to memories of people, places, and kitchens.[24]

Mum's apparently very ordinary toaster took on meaning as memories were attached to it, and those memories and meanings can now be shared as the memory photographs and the stories they tell circulate and multiply. The family will have multiple images of Mum's toaster and the memories that flow around it. And perhaps other families are now also photographing memories, capturing things as ordinary as domestic appliances in their place, with their stories, to keep as a part of a family archive and a focus for remembering.

This is only a beginning. A series of thoughts and moments, of photographs and memories, of excursions into family secrets and stories, and of the ways in which this emotionally charged reflective exercise has built on the established scholarship about the connections between photographs, memories, and oral history interviews. In particular, it has highlighted the importance of

thinking beyond the visual narratives and asking for memories and stories of the materiality of photographs—their own biographies alongside the memories and stories evoked by the images themselves. It has illustrated the power of photographing memories, of seeking memories of objects, places and spaces and then photographing those objects, places and spaces, in context and out of context, and recording and sharing the memories associated with these new family photographs. The process has reinforced for me the power of oral history and the need to keep thinking laterally, to think of other questions, other memories and to think of the ways in which photography and oral history can complement, challenge, and shape each other. The process, most importantly, is honoring my Mum, my family's memories of her, and the conversations we will continue to have that will connect her life, her photographs, her things to our lives, our photographs, and our things.

Notes

1. With thanks to my brothers, Noel and Greville Wilton, sister Lyn Loveday, and other family members for sharing their memories and for their willingness to participate in this exercise. Thanks also to Glenda Kupczyk-Romanczuk and Joe, Daniel, and Rachel Eisenberg for their thoughtful feedback and suggestions.
2. This is a school in Sydney catering for ill or disadvantaged children from country areas who needed to spend time in Sydney for treatment.
3. Roland Barthes' iconic *Camera Lucida* (London: Flamingo, 1984) is a eulogy to his mother as well as a treatise about photography, and there are many other writings whose initiation came at least partly with the death of a near relative. Those with particular impact for me include Martin Bashforth, "Absent fathers, present histories," in *People and their Pasts: Public History Today,* ed. Paul Ashton and Hilda Kean (Basingstoke Hampshire: Palgrave Macmillan, 2009), 203–223; Margaret Gibson, *Objects of the Dead: Mourning and Memory in Everyday Life* (Melbourne: Melbourne University Press, 2008); and Mary Palevsky, "Questioning history: personal inquiry and public dialogue," *Oral History Review,* 29, 2 (2002): 69–74. Hilda Kean's readable and inspiring family history *London Stories* (London: Rivers Oram Press, 2004) is stimulated and shaped by her encounters with her mother's things—although the moment for her is when her mother goes into residential care.
4. See, for example, Janis Wilton, "Telling objects: material culture and memory in oral history interviews," *Oral History Association of Australia Journal,* 30 (2008): 41–49, and Janis Wilton, "Belongings: oral history, objects and an online exhibition," *Public History Review,* 16 (2009): 1–19.
5. For example, Janis Wilton, *Golden Threads: The Chinese in Regional NSW 1850–1950* (Sydney: Powerhouse Museum, 2004); *Different Sights: Immigrants in New England* (Sydney: NSW Migration Heritage Centre, 2009) and online database at http://hfrc.une.edu.au/heritagefutures/neimmigrants; and *Maitland Jewish Cemetery: A Monument to Dreams and Deeds* (Maitland: Maitland Regional Art Gallery, 2010).

6. Bashforth, "Absent fathers, present histories," 206.
7. Annette Kuhn, "Remembrance," in *Family Snaps: The Meaning of Domestic Photography,* ed. Jo Spence and Patricia Holland (London: Virago Press, 1991), 17–25.
8. Notably the chapters by Freund, Thompson and Thomson.
9. Geoffrey Batchen, *Forget Me Not: Photography and Remembrance* (New York: Princeton Architectural Press, 2004); Albert Chong, "The photograph as a receptacle of memory," *Small Axe,* 29 (2009), 128–136; Martha Langford, "Speaking the album: an application of the oral-photographic framework," in *Locating Memory: Photographic Arts,* ed. Annette Kuhn and Kirstin McAllister Emiko (New York: Bergahn Books, 2006), 223–246; and Elizabeth Edwards and Janice Hart, *Photographs Objects Histories: On the Materiality of Objects* (New York: Routledge, 2004). On the materiality of photographs and how to read them, see also Marcus Banks, *Visual Methods in Social Research* (London: Sage, 2001) and Richard Chalfen, "Interpreting family photography as pictorial communication," in *Image-Based Research: A Sourcebook for Qualitative Researchers,* ed. Jon Prosser (London: Falmer Press, 1998), 190–208.
10. Greville Wilton talking to Janis Wilton, phone conversation, February 19, 2010.
11. These sentiments are clearly expressed in oral history interviews conducted with my Mum in 1986 and 1991, and the tensions between husband and wife surface in other family history accounts.
12. Edna Wilton interviewed by Janis Wilton, August 22, 1986. Recording in author's possession.
13. Edna Wilton, "Hill and Dale: My Recollections," 1995. Hill and Dale was the name of the family farm where Mum spent her childhood and adolescence.
14. Rachel Eisenberg talking to Janis Wilton, phone conversation, February 18, 2010.
15. Maryanne Garry and Matthew P. Gerrie, "When photographs create false memories," *Current Directions in Psychological Science,* 14, 6 (December 2005): 321–325.
16. Rats of Tobruk was the name given to the Allied soldiers who held the Libyan port of Tobruk against the German Afrika Corps during World War II.
17. Bashforth, "Absent fathers, present histories," 212–214.
18. Walla refers to Walla Walla, the small town closest to the family farm.
19. Hube was Mum's brother.
20. Edna Wilton, August 22, 1986.
21. Edna Wilton, August 22, 1986. Note: Dad's army records indicate that he was promoted to lieutenant in October 1940. The wedding was in July 1940.
22. Margaret Gibson, *Objects of Death,* 5.
23. *Automatic Beyond Belief!,* http://www.automaticbeyondbelief.org/ (accessed February 2010).
24. The occasion was the annual conference of the Royal Australian Historical Association.

Remembering, Forgetting, and Feeling with Photographs

Lynda Mannik

Social anthropologist Lynda Mannik uses anthropology's photo-elicitation methods in her interviews and argues that photographs not only evoke diverse mnemonic responses, but also, potentially, a range of strong emotions. The participants in Mannik's study were Estonian displaced persons who traveled on the HMS *Walnut* from Sweden to Canada in 1948; over half a century after the event she talked with them about photographs taken during that harrowing journey. While looking at photographs that several interviewees had never seen, taken by four of the passengers, the narrators' emotional bodily reactions were palpable. Mannik warns oral historians incorporating photographs that depict traumatic experience "to be sensitive to the dramatic effect they may have." We are part of the process by which interviewees make meanings with photographs and memories, and thus we need to pay attention to how photographs are included in the interview process. Mannik helps us move forward in describing and interpreting our interviewees' diverse responses to images. Naming people in the photographs and using photographs as historical evidence became important strategies for the former refugees to deal with difficult memories. The elicitation of nostalgic memories through photographs depicting camaraderie helped narrators sustain narratives and identities. Forgetting and silence were spontaneous and thoughtful as well as emotionally poignant. Mannik, like all of the authors in Part I, demonstrates the importance of the way in which photographs are introduced into interviews and emphasizes the link between mnemonic and emotional reactions to images.

Photo-elicitation is just one of many methods employed in anthropological fieldwork. John Collier introduced this methodology in the mid-1950s. In initial experimentations he juxtaposed the identical interview settings, where, in one, photos were introduced and discussed and, in the other, only verbal questions were asked. He found that looking at photographs while reminiscing sharpened memories, reduced misunderstandings, and created longer and more comprehensive interviews. In 1986, John Collier and Malcolm Collier outlined in detail the importance of this method for anthropologists. In *Visual Anthropology: Photography as a Research Method* (1986) they argued that sharing and viewing photographs creates an immediate point of access, encourages interviewees to take the lead in enquiries, but also leads to discussions about "unfamiliar, unforeseen environments and subjects."[1] The prevalence of emotional reactions induced by photography was brought forward as an important, yet delicate issue, for researchers. They claimed that when photos were used in the interview process the emotional value and significance was clearly made evident, even though the visual content may not provide personal or subjective insights. In this context, Collier and Collier found that "Photographs are charged with unexpected emotional material that triggers intense feelings."[2] To date, scholars have frequently commented on the ways this method encourages emotional responses.[3] However, there has yet to be a study that focuses exclusively on the breadth and depth of emotions elicited. This chapter will explore this aspect of photo-elicitation interviews through conversations about private photographs taken by Estonian refugees during their migration to Canada by boat in 1948. These photographs elicited myriad emotions complicated by the dramatic nature of this voyage.

In 1948 the HMS *Walnut* was purchased by a small group of Estonian refugees who were living in Sweden. They had fled along with approximately 70,000 other Estonians in the fall of 1944 to escape Stalin's violent regime. All had suffered tremendous trauma and loss throughout World War II. Under the threat of repatriation, 40 shareholders pooled their resources to outfit this old British minesweeper so that it would be capable of carrying over 300 passengers across the Atlantic to Canada. The *Walnut* remained in Göteborg harbor for several months while it was refitted and plans were made for its departure. By late October it was ready to set sail. A total of 352[4] people left Sweden on November 17, 1948 to brave a dangerous winter crossing. Three hundred and five of them were Estonian refugees and the rest were originally from Latvia, Lithuania, Poland, Austria, and Finland. There were 70 children and 123 women aboard. They were all without passports and knew they faced illegal entry into Canada, yet risked what little security they had acquired in Sweden in order to find a safe haven.

Passengers boarding the *Walnut* were allowed to take only one small suitcase. The ship was designed to sleep 18 crew members, so small, wooden boxes, commonly referred to as "cubbyholes," were built. These sleeping compartments

were approximately 2 feet (61 cm.) wide, 2 feet (61 cm.) high, and 6 feet (1.8 m.) long and stacked in three tiers. The passengers could not sit up in them and had to crawl in feet first. These cramped areas were where they spent most of their time throughout this 32-day voyage. All other accommodations were primitive as well. There were only two makeshift toilets and a mock–dining room (a simple tent-like enclosure on the deck). The little minesweeper survived several treacherous winter storms while on the North Sea and in the Atlantic. Waves pounded the deck and washed away anything that was not tied down. Many passengers were seasick throughout and for them it seemed as though the end of each storm was followed by the beginning of another. The decision to board this ship had meant giving up all recently acquired domestic comforts and leaving friendships, jobs, and sometimes family members behind.

Despite the allowance for only sparse belongings, several of the *Walnut's* passengers did bring cameras with them and they took photographs of the voyage. The photographic images that comprise the *Walnut* collection of over 200 photos do not visually depict trauma, even though they were taken during a month-long voyage that was described by the photographers, and other passengers, as traumatic on many levels. One of the most outstanding features of this collection is that the majority of photographs show the *Walnut's* passengers physically active and happy. Small groups are seen standing or sitting together, seemingly in social poses, smiling, and looking directly into the camera (Figure 4.1). As Richard Chalfen explains, in "home mode photography" or amateur photography, subjects are generally posed with a smile on their face.[5] An outside viewer

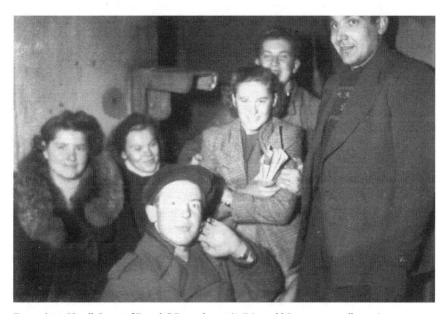

Figure 4.1 "Small Group of Friends," December 1948 (Manivald Sein, private collection).

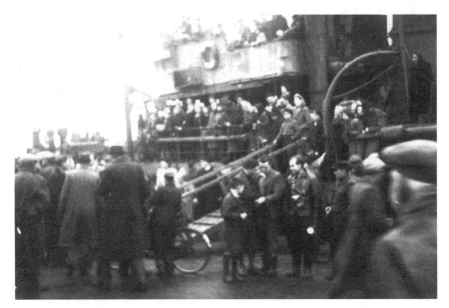

Figure 4.2 "Waiting to Depart," December 1948 (Manivald Sein, private collection).

would never be able to imagine the particulars of the passengers' experience through these photographic images. The second most common theme depicted in the *Walnut* collection are large groups (40–100 people), often huddled together, waiting in harbors. Most often there is a partial view of a dock or parts of the ship. They are not staged shots, but random depictions of the group's activities (Figure 4.2). The third predominant theme revolves around various views of the ship. A large portion of the collection's photographs shows activities within interior spaces of the ship—families in their sleeping bunks (Figure 4.3), men working onboard, (Figure 4.4) or small groups eating together. There are no images depicting the passengers' memories of freezing temperatures, massive waves washing over the deck, injured or ill passengers, or their fears or anxiety throughout.

Photographs cannot narrate experience, only individuals can do that. Photographs are simply a tool for remembering with, even though they provide the illusion of transcription or a trace of reality.[6] Yet, when we look at photographs and talk about what we see, they often become "like a mirror of us."[7] Photographs often make it easier to delve into ideas, topics and emotions; they provoke a depth and fluency to feelings and meanings.[8] Nevertheless, Roland Barthes explains that the experience of trauma is rarely depicted photographically because social rhetorical codes work to "distance, sublimate, and pacify" the photographs' meanings.[9] If trauma is depicted, for example, in images of natural disasters or catastrophes, future viewers have little to say about these photographs because there is no socially appropriate way to verbalize trauma, therefore, "the

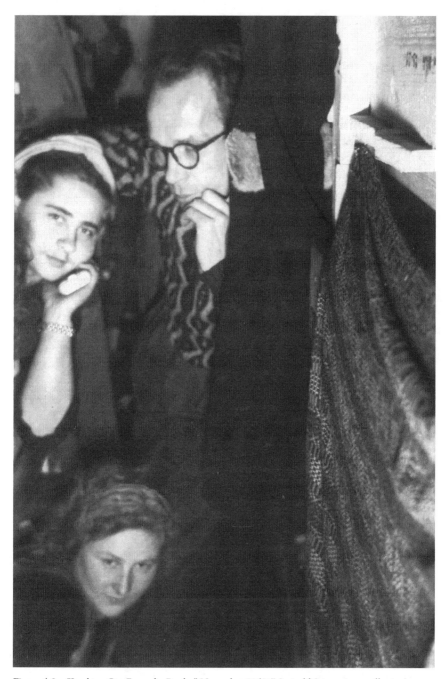

Figure 4.3 "Looking Out From the Bunks," November 1948 (Manivald Sein, private collection).

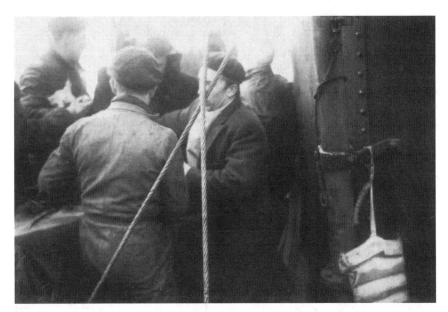

Figure 4.4 "Men Working on the *Walnut*," December 1948 (Manivald Sein, private collection).

more direct the trauma, the more difficult is connotation."[10] As well, as Ernest Van Alpen states, language often falls short of enabling a memory of a traumatic experience due to severe confusion over the actual events, events that cannot be understood in a logical way.[11] This chapter will delve into the ways photographs that were taken during a traumatic experience can be considered catalysts for verbal renditions of a range of emotional memories. Within a dominant narrative about loss, trauma, and victimization, a complex interweave of counter narratives emerged. Five characteristics of oral communication will be brought forward to provide an ethnographic account of "performative viewing," a phrase coined by Martha Langford in relation to storytelling that takes place while looking at photo albums.[12] In this instance, a collection of photographs armed the *Walnut's* passengers as tellers with the ability to remember and express—or to forget and repress—positive and negative experiences and the emotions associated with them. These five characteristics include naming; talking about trauma; remembering happy moments alongside traumatic experiences; silences and forgetting, and sensory memories.

In 2006 I began interviewing surviving passengers who were then between the ages of 65 and 95. Working with those in the senior years of their life was rewarding. There were fewer time constraints, and I always felt that my interest was welcomed. Most offered to meet me in their homes where I was often greeted with a meal or coffee. These in-home sessions were conducive to quiet and uninterrupted viewings of photographs and photo-albums. Each interview began with a conversation about their flight from Estonia in 1944 and the incidents

that led to boarding the *Walnut* in 1948.[13] Throughout, my intention was to create a relaxed atmosphere where sharing photographs and information about the voyage set the stage for remembering. Together we looked at large photo-boards, where I arranged a collection of 55 images in collage fashion with approximately ten photos on each board. My sorting criteria were based on eliminating repeated images to create a collection that was comprehensive, yet small enough to facilitate a two-to-three-hour interview. During each meeting there was also an exchange of photographs, newspaper articles, and government documents between the participants and myself. In the end, a collection of over 200 photos about this voyage were amassed.

In general, looking at photographs deepened, brightened, or colored the memories elicited. They induced emotional responses and added credibility to storytelling due to their material proof of experience.[14] As Jeffrey Samuels explains, when photographs are bought into the interview process, oral narratives become richer; "very concrete descriptions" are grounded in "lived and affective experience."[15] Photographic evidence added to the ease and confidence with which the *Walnut's* passengers conveyed their memories, almost as if these 60-year-old images were giving them permission to retell the events of their passage to Canada. Negative or sad memories were told in hushed, dramatic tones. Positive, happy memories were told with vigor and excitement. However, the emotional impact of these images was demonstrated most clearly by those who did not want to look, or who physically moved away from photographs of this voyage, which I will explain later in the chapter.

Naming

The naming process was a critical component of the *Walnut's* passengers' response. At first glance, interviewees scanned each photograph for recognizable faces. Naming a family member or friend brought the deceased or the absent into present time, which confirmed a connectedness to them. As Gaynor Macdonald argues, confirming relationships is a primary motive for naming.[16] The inability to name faces could in some way suggest that one had never been, or had ceased to be, a functioning member of this group. Barthes says that what we identify in a photo attests to the legitimization of past events.[17] For this group, naming legitimized relationships and their participation in the *Walnut's* voyage. It was proof of having gone through this experience: I was there. The quantity of names known legitimized the depths of each individual's connection to this group as well as the importance this voyage has had on their identity over time.

Throughout our interviews a definite feeling of camaraderie was repeatedly expressed. This was based on having gone through a dramatic, life-threatening, and life-altering experience together. As one passenger put it, "We were all

together like a family."[18] Even as time had gone by, this feeling remained. When asked about the sense of bonding that was experienced another interviewee replied:

> Oh yes definitely! Even if I meet someone that I didn't know they would be my friends automatically because you had the same experience, the same horrible experience.[19]

Every person I spoke with said that they had found out about the trip either through a family member or friend. Therefore, many were closely related prior to the voyage, albeit in a variety of ways. It is important to remember that original family units had often been completely destroyed when these individuals fled Estonia in 1944. Consequently, friends from Estonia or relationships that were formed in Sweden were often considered to be family or "just like family." The critical nature of these relationships was repeatedly confirmed throughout the photo-elicitation portion of the interview process, and this was precipitated by naming.

Talking about Trauma

For many of the survivors interviewed, the only memories they had of the actual voyage revolved around the physical trauma of severe seasickness. In general, for these passengers the photographs held little meaning, except for the images of themselves or others lying in the bunks or "cubbyholes" as they called them because this is where they literally spent all of their time. Figure 4.5 is an example. Even though the individuals depicted look calm, these types of photographs would enliven dramatic details about the experience of seasickness along with associated feelings of anxiety, pain, and distress, which often lasted for the duration of the voyage. While looking at Figure 4.5, Mrs. Berendson remembered:

> For one month we were just in a space where we couldn't sit up. We were either lying down or sitting like that. I didn't eat more than twice. I was sick. If you went upstairs there were very few people eating. and it was so crowded you hardly had any air, you hardly had any air. There was one door upstairs, and you would go, I don't know how many stairs up … I didn't go.[20]

Similar photos were accompanied by distinct memories of the fear and physical distress associated with violent winter storms, cramped quarters, rotting food, unsanitary toilet facilities, and generally feeling panicked throughout the entire month on the Atlantic. Occasionally, photographs of small groups socializing, as

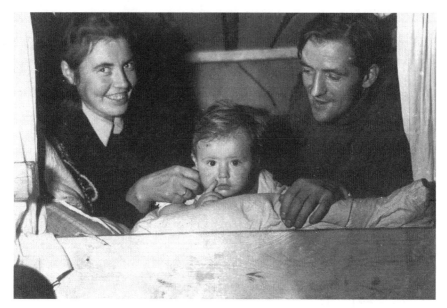

Figure 4.5 "Resting in the 'Cubbyholes'," December 1948 (Manivald Sein, private collection).

shown in Figure 4.6, would also inspire the telling of emotion-packed memories. In the process of identifying a friend Mr. Alle recalled:

> Oh yes [pointing to someone in a photograph] this is Mr. Veske. And he was so sick that we were afraid he wasn't going to make it. He was a friend of ours in Sweden, and Manny and I dragged him out of his bunk when the sea was rather calm. We dragged him out onto the deck. He was white in his face. Well, he was vomiting for about a month! Yeah, he was probably the sickest guy on the boat.[21]

The content of this image did not denote the effect it could have in terms of eliciting sad or negative memories. This ability of photos to elicit seemingly random memories or memories that might have otherwise remained dormant has been noted by Marisol Clark-Ibáñez.[22]

Negative or sad memories are invaluable in understanding the experience of forced migration. They allow individual voices to surface. I was told that memories of the *Walnut's* voyage were rarely brought up in conversation with outsiders because disbelief was the usual response. Although members of this group can be considered part of a massive postwar migration, it was the way they arrived, illegally in a decrepit, overcrowded minesweeper as opposed to a government-sanctioned ocean liner, which still created feelings of shame for some. Also, this voyage represents only one leg in a lengthy journey to find freedom and safety following three successive occupations of their homeland between 1940 and

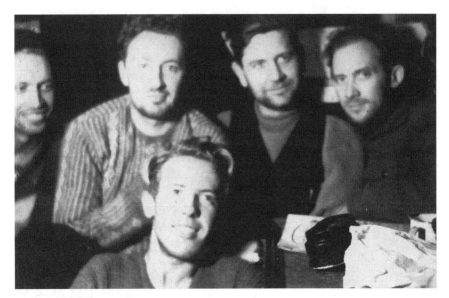

Figure 4.6 "Friends Socializing," December 1948 (Manivald Sein, private collection).

1944.[23] Hastings Donnan and Kirk Simpson explain how survivors of traumatic experiences often feel that no one wants to listen, so they either retreat into silence or struggle to find ways to tell stories so that people will believe them. Often the difficulty is not in remembering, but in communicating traumatic experiences as a reality.[24] Photographs from the *Walnut* collection seemed to open up discussion, or give permission, to express sad, unusual, and difficult recollections. In this way they served as a buffer or as a tool to speak through while remembering traumatic experiences.

Positive and Negative Memories

Conversely, the same photographs that inspired negative memories also inspired positive memories. The polysemic nature of photographs and their ability to generate multiple meanings has been discussed by other scholars using this method.[25] While looking at a photograph of a family lying in their sleeping quarters, Adele Nyman, who was 16 in 1948, spontaneously remembered a charming story about her father.

> AN: There were three levels and next to me there were two men and my father said, "You are not going to sleep next to these men." So he built a wall (laughs).
>
> *LM: How did he build a wall?*
>
> AN: A piece of plywood or something. These men were just laughing!

There was little space for moving around the boat and few places to sit or stand. However, looking at images of "cubbyholes" inspired several passengers' fond memories of playing cards, telling stories, or singing in their bunks to pass the time. Peter Alle stated:

> Yes, some people played cards, but I can't remember if I played cards. Oh yes, some people were playing 21, Black Jack, for cigarettes. We had lots of duty free cigarettes on the boat and so they were playing for cigarettes. They were mostly Camels; and the cost, $1.00 a carton.[26]

The memories about this voyage told in conjunction with photographs tended to be ambiguous. In some cases, the same speaker would simultaneously recall distressing or frightening incidents alongside more cheerful or amusing occurrences.

There are three issues that can be considered in relationship to the fact that images elicited both positive and negative memories in a somewhat random fashion. First, myriad emotions were experienced throughout this voyage. Even though many of the passengers suffered extreme physical distress and psychological trauma, there were moments of happiness and comfort that sustained them. Second, talking about positive, everyday experiences normalized oral narratives about this voyage. The strong emotional content of stories and memories about traumatic events can marginalize individuals because there is no socially acceptable way to communicate the depths of these experiences.[27] Extremely emotional memories were often couched in everyday topics in order to make them more believable in contemporary renditions.[28] Third, there is a certain amount of nostalgia incorporated into all remembering, and in the case of traumatic or distressing memories, nostalgia can serve an important psychological function. Nostalgia has been described as a positive emotional "reservoir that people delve into to deal with existential threats."[29] It is a coping mechanism that serves to protect and affirm identity. In this way it can also serve as a type of forgetting. Several of the *Walnut's* passengers, who were young children in 1948, remembered the voyage simply as an adventure.

Silences and Forgetting

Silences and forgetting are both important components of memory. Donnan and Simpson note that the language of suffering, which includes punctuations of silences and recognized forgetfulness, has become a significant theme in anthropology. These moments add to the ambiguity of memory work and expand on notions about knowledge, agency, and power. "Silences uphold the dominant order or can be used to subvert it."[30] Forgetting plays a crucial

role in the ongoing dynamic of remembering. Janet Carsten states that "social memory and shared knowledge are constructed as much from things which are untold, or left implicit, as from what is recorded."[31] Maria-Luisa Achino-Loeb claims that silence has been used as an overt political tool for both victims and victimizers and therefore, practices of silence are at the heart of strategic identity formation.[32] Often it is impossible to tell the difference between a purposeful silence, forgetting, and amnesia—particularly when dealing with memories of a highly emotional nature. While looking at photographs of the *Walnut's* voyage, silences occurred on a verbal level, but also through the physical act of turning away from the photographs. Generally, forgetting was verbally acknowledged by those interviewed with a comment such as, "I forget where that photo was taken."

The potential of photographic images to rekindle unwanted memories was made clear during the interview process when passengers would pause for an extended period of time over a single image. It was obvious they were thinking about things they did not want to talk about or were not sure they should talk about. In other instances, interviewees would tell me directly that certain topics were not to be spoken about. A total of 5 out of the 32 passengers interviewed did not really want to look at photographs of the voyage at all. They glanced at them quickly as I passed around the collage boards, and made few comments during or afterwards. When asked if they wanted copies they said, "no," and when asked how they felt about looking at the photographs they told me that these images made them feel too emotional. In general, they were physically agitated and resisted focusing any deliberate attention on these images. This reaction seems to run counter to Collier and Collier's insistence that photographs always elicit deeper levels of memory, yet their silences may have also meant that the memories being elicited were just too powerful to talk about.

The responses of these particular individuals were spontaneous and emotional, even though they had agreed to look at the photographs during the interview process. Their silence was not precipitated by any form of intention—their silence had a visceral quality. The photographic potential to elicit powerful feelings was understood by those who did not want to look. Looking at photos became risky due to the threat of "being caught up again in strong feelings" and also, possibly, the intensification of past experiences.[33] Engaging with the photos meant engaging with their past experiences on the *Walnut*. The visual content of these images conjured up memories that were too difficult to talk about.

Throughout the interview process incidents of forgetting differed from silences in that they were acknowledged by those interviewed. As Paul Connerton explains, we generally feel obligated to remember and so the inability to remember is marked by comments such as, "I forget."[34] There were many times when individuals struggled to remember an event and were upset, embarrassed or surprised when they could not remember. One particular part of this voyage,

disembarking in Halifax, was forgotten by over 70 percent of the passengers, and age was definitely not a factor.[35] Several interviewees made similar statements in response to my question: "Do you remember getting off the boat when it landed?"

> HL: At that moment, I do not remember! I have no memory of it at all.[36]
> AH: Not in detail. I remember being very tired.[37]
> EP: I don't remember too much about it, other than once we got settled, I believe it was at a hospital or a school or something like that.[38]

Aet Lige tried to remember their arrival at Halifax harbor while looking at a photograph of arriving in Halifax Harbor (Figure 4.7), but was unsuccessful and obviously distressed about her loss of memory.

> *LM: What do you remember arriving in Halifax?*
> AL: That I don't remember anything about. Not one thing. I have looked at the pictures, but I can't remember anything. I think they took some of us on little boats, but I don't remember anything about how I got off. I don't know anything about that.

These interviewees had no problem remembering other parts of the journey, and in many cases their memories were jogged by photographic images of the trip. It is clear from their comments that this lack of memory surprised them and was disheartening.

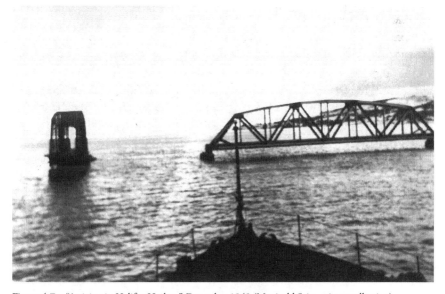

Figure 4.7 "Arriving in Halifax Harbor," December 1948 (Manivald Sein, private collection).

It is impossible to know whether they were repressing particular memories or just feeling uncomfortable about communicating them. I do not think their forgetting was a fact of old age because articulated memories were very clear. I would argue against Stanley Cohen, who claims that victims or survivors are unable to shut out traumatic memories. For the *Walnut's* passengers, the "repressed trauma model" that Cohen dismisses carried weight.[39] In most instances of forgetting, interviewees gave me the impression that they thought there should be a memory. Their forgetting was not just about consciously refusing to articulate memories, but was a product of traumatic experience where blocking or numbing occurs. As one interviewee stated, "That is one thing that I must have done but it is erased from my memory."[40]

In another interview this type of forgetting was explicitly described:

> I think that I have the kind of memory or ability to just forget. Like if I don't want to remember something I think I put it out of my mind, I don't think about it. I start to forget these things because I don't—I think this is something people do when there is something awful that you try to put it out of your mind. Actually that is what it is, you put it out of your mind and try not to think about it and then it doesn't seem so bad.[41]

Remembering can be extremely painful—forgetting can alleviate this pain.

Sensory Memories

Another characteristic of the oral narratives that was expressed by the *Walnut's* passengers, while looking at old photos of their voyage, was sensory memory. Barbara Myerhoff initiated a discussion about "sensory events" as part of the act of remembering. She claims that for her informants, elderly Jewish people who had migrated to the United States following World War II, recollections were often triggered by physical movements such a dancing and singing as well as tastes, smells, and touch. Myerhoff claims that these types of remembering were common because "[t]he body retains experiences that may be yielded, eventually and indirectly, to the mind."[42] Elizabeth Edwards elaborates on the relational nature of photographs in her recent article, "Photographs and the Sound of History," by drawing attention to the ways laughter and tears, body language, hand gestures, and tonal variations are incorporated in performances of memories elicited by photographs.[43] She emphasizes photography's agency in affecting emotions, bodily reactions, and subsequently social processes, and thus inserts new ways of thinking about the sensory. C. Nadia Seremetakis' work in *The Senses Still* adds another layer of meaning and power to our understanding of memory. She reminds us that "memory is internal to each sense, and [that] the

senses are as divisible and indivisible from each other as each memory is separable and intertwined with others."[44] Sensory memories speak to unconscious bodily experiences including trauma. They are also embodied in objects, which in turn have the ability to provoke "the awakening of [the] layered memories"[45] in physical manifestations. Some of the *Walnut's* passengers' responses suggest that there is another dimension concerning sensory aspects of remembering and photography that needs to be developed. Their memories were not only expressed more fully through bodily actions, as suggested by Myerhoff and Edwards, but photographs elicited recollections of smells, tastes, and body movements experienced in 1948.

During our interviews the *Walnut* collection triggered spontaneous, unrelated, and lengthy memories about sensory experiences, which I was told had not been previously articulated. Memories of smells and of tasting food were common. When Elmar Peremees looked at a photo of the deck of the *Walnut* (Figure 4.8), he remembered the strong smell of oranges rotting on the deck. He also remembered the taste of those oranges and that he had not been able to eat oranges for five years afterwards. Memories of physical sensations were accompanied by body language that further expressed the sensation. Comments about feeling seasick, cold, hungry, or suffocated were accompanied by grimaces, gasps, or shrugs. Positive sensory memories of warmth or sunshine on the face were expressed with a smile. The memory of fresh air was accompanied by a deep

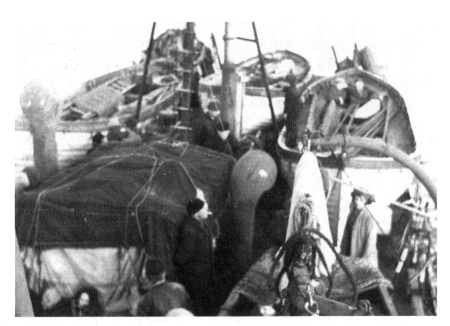

Figure 4.8 "Deck of the *Walnut* while it crosses the Atlantic," December 1948 (Manivald Sein, private collection).

breath. Similarly, comments about remembering the physical sensations of being on the ocean were simulated and repeated for effect. Leho Jovega was near the stern of the *Walnut* during a storm. "That is the worst place to be: Up and down, up and down, I couldn't take it," recalled Jovega. As he told the story, he lifted his body and motioned with his hands to physically show me how he was moving and feeling at that time. Memories of sounds were also elicited and mimicked. While looking at photographs of the voyage Mr. Seero remembered hearing "the anchor chain that was in a metal tube that kept banging all night, bong, bong."

My reading of these memories contradicts Barthes' argument that the power of visuality replaces full or total memory, which includes smells, sounds, and touch, and that photographs block the things we feel by allowing us to remember the things we see so distinctly.[46] Sensory memories, which were accompanied by some sort of physical expression or demonstration, confirm the ability of photographs to distinctly elicit physical feelings or sensations. The physical performance of these memories expresses their powerful sensory impact, while alerting the listener to the innate visceral importance of this type of memory. Interviewees' body language indicated that they were physically captured by these memories. While looking at photographs, odors were smelled again and sounds heard again. Interviewees gasped when remembering a lack of fresh air. Scientists have found through empirical data that visual imagery is "well remembered," while complex odors in olfaction memories are "indefinitely remembered."[47] Rachel Herz and Trygg Engen also found that there were direct links between emotions and memories evoked by odors. When "salient emotion is experienced during encoding with an odor" the effectiveness of that sensory memory is enhanced.[48] Perhaps this is why sensory memories were brought to mind so spontaneously and so powerfully after 60 years. The *Walnut* collection had a powerful visceral affect on those who experienced this traumatic voyage.

The emotions associated with memories often enrich the breadth and density of oral narratives when photographs are brought into the interview process. As has been discussed in terms of Collier and Collier's original findings, the photo-elicitation method allows for open expression while providing concrete contexts where research participants can take the lead, tell their own stories, and express subjective meanings and feelings throughout. As has been demonstrated by the *Walnut* collection, photographs can elicit emotional and sensory memories that were felt 60 years ago, yet also reignite feelings associated with traumatic experience that can shut down communication. The random and visceral way blocked memories surface while looking at photographs can have negative repercussions, surprise researchers, and perhaps cause emotional distress or confusion, or both, for the people they are interviewing. The potential of photography to redefine the research relationship and allow for the joint exploration of meanings, emotions, and memories can become elusive territory when overwhelming emotions enter the interview arena. According to Maurice Halbwachs, the past is not filed

away waiting to be resurrected, but "reconstructed on the basis of the present."[49] If remembering through photographs creates a collision between the past and the present due to strong blocked or forgotten emotions then connections are difficult to make. These memories can become too intrusive—not negotiable with contemporary realities. Photo-elicition interviews that use photographs taken during past traumatic experiences push reflections of current identities while maximizing the boundaries of emotional and sensory memory. Researchers need to be sensitive to the dramatic effect they may have.

Notes

1. John Collier and Malcolm Collier, *Visual Anthropology: Photography as a Research Method* (Albuquerque: University of New Mexico, 1986): 99.
2. Collier and Collier, *Visual Anthropology*, 131.
3. Several scholars have emphasized the ways photographs trigger emotions and likewise, when memories are trigger by them, how interviewees claim that they are reliving feelings and even sensations. See Collier and Collier, *Visual Anthropology*; Jeffery Samuels, "Breaking the Ethnographer's Frame: Reflections on the Use of Photo Elicitation in Understanding Sri Lankan Monastic Culture," *The American Behavioral Scientist*, 47, 12 (August 2004): 1528–1549; Marisol Clark-Ibáñez, "Framing the Social World with Photo-Elicitation Interviews," *The American Behavioral Scientists*, 47, 12 (August 2004): 1507–1526 and T.A. Loeffler, "A Picture is Worth…Capturing Meaning and Facilitating Connections Using Outdoor Education Students Photographs," Paper for International Outdoor Education Research Conference. Latrobe University, Bendigo (as seen April 10, 2010 on http://www.latrobe.edu.au/education/assets/downloads/2004_conference_loeffler.pdf).
4. Although 352 individuals left Sweden on the *Walnut*, only 347 arrived in Canada. The rest stayed for various reasons in Ireland during a brief stopover.
5. Richard Chalfen, *Snapshot Versions of Life* (Bowling Green, Ohio: Bowling Green State University Press, 1987).
6. Marianne Hirsch, *Family Frames: Photography, Narrative and Postmemory* (Cambridge: Harvard University Press, 1997): 7.
7. This comment was made in an photo-elicition interview conducted by Jeffrey Samuels (in "Breaking the Ethnographer's Frame," 1540), when he asked one of his participants, a child monk living in Sri Lanka, what he thought the difference was between photo-elicitation interviews and word only interviews.
8. Collier and Collier repeatedly stress this factor in the chapter titled, "Psychological Overtones of Visual Imagery," in *Visual Anthropology* (1986): 117–132.
9. Roland Barthes, *Image, Music, Text*, trans. Stephen Heath (New York: Hill and Wang, 1977): 30.
10. Barthes, *Image, Music, Text*, 31.
11. Ernest Van Alpen, "Symptoms of Discursivity: Experience, Memory, and Trauma," in *Acts of Memory: Cultural Recall in the Present*, ed. Mieke Bal, Jonathan Crewe, and Leo Spitzer (Hanover/London: University Press of New England, 1999): 32.

12. Martha Langford, *Suspended Conversations: The Afterlife of Memory in Photographic Albums* (Kingston, ON: McGill-Queen's University Press, 2001): 102

13. Gabriele Rosenthal makes note of the fact that there needs to be a certain structure to questions concerning emotionally stressful events in order to encourage disclosure and to avoid feelings of exclusion concerning certain topics. Gabriele Rosenthal, "The Healing Effects of Storytelling: On Conditions of Curative Storytelling in the Context of Research and Counseling," *Qualitative Inquiry*, 9, 6 (2003): 915–933. 925.

14. Theorists and researchers have made this same assertion, that looking at photographs enhances and adds depth to remembering, including: Roland Barthes, *Camera Lucinda*, trans. R. Howard (London: Fontana, 1984); Collier and Collier, *Visual Anthropology*; John Berger, *About Looking* (New York: Vintage International Editions, 1991); Sarah Pink, *Doing Visual Ethnography* (London: Sage, 2001) and Douglas Harper, "Talking About Pictures: A Case for Photo-elicitation," *Visual Studies*, 17, 1 (2002):13–26.

15. Samuels, "Breaking the Ethnographer's Frame," 1533.

16. Macdonald, "Photos in Widadjuri Biscuit Tins," 233.

17. Barthes, *Camera Lucinda*, 85.

18. Aet Lige, interview with the author, Toronto, Ontario, January 23, 2007.

19. Adele Nyman, interview with the author, Toronto, Ontario, November 21, 2006.

20. Lydia Berendson, interview with the author, North York, Ontario, February 15, 2007.

21. Peter Alle, interview with the author, Don Mills, Ontario, November 13, 2006.

22. Marisol Clark-Ibáñez, "Framing the Social World with Photo-Elicitation Interviews," 1513.

23. In 1940 the Soviet army occupied Estonia. In June of 1941 over 12,000 Estonians were sent to concentration camps in Siberia. In July 1941, Estonia was overtaken by German occupation. There was a new wave of persecution. As well, all Jewish people and Estonian gypsies were annihilated. In 1944 the Soviets occupied Estonia once more. Approximately 70,000 people fled and there was a new wave of mass arrests and executions. It is estimated that during this period Estonia lost over one-third of its original population (approximately one million Estonia citizens). For statistics and details about the impact World War II had on Estonia see, Estonian State Commission, *The White Book: Losses inflicted on the Estonian Nation by Occupation Regimes, 1940-1991* (Republic of Estonia: Multiprint Ltd., 2005).

24. Hastings Donnan and Kirk Simpson, "Silence and Violence among Northern Ireland Border Protestants," *Ethnos*, 72, 1 (March 2007): 5–28.14, 24.

25. Other scholars who have discussed how multiple meanings are elicited from photographs include: H.S. Becker, *Doing Things Together: Selected Papers* (Evanston, IL: Northwestern University Press, 1986); D. Schwartz, "Visual Ethnography: Using Photography in Qualitative Research," *Qualitative Sociology*, 12, 2 (1989): 119–153; Harper, "Talking About Pictures"; Pink, *Doing Visual Ethnography*; Laura Peers and Allison Brown, *'Pictures Bring Us Messages' Sinaaksiiksi aohtsimaahpihkookiyaawa: Photographs and Histories from the Kainai Nation* (Toronto: University of Toronto Press, 2006); Clark-Ibanez, "Framing the Social World" (2004); and Samuel, "Breaking the Ethnographer's Frame" (2004).

26. Peter Alle, interview with the author, Don Mills, Ontario, November 13, 2006.

27. Donnan and Simpson, "Silence and Violence among Northern Ireland Border Protestants," 7.
28. Gay Becker, Yewoubdar Beyene, and Pauline Ken, "Memory, Trauma and Embodied Distress: The Management of Disruption in the Stories of Cambodians in Exile," *Ethos,* 28, 3 (2000): 320–345. 341.
29. Constantine Sedikides, Tim Wildschut, and Denise Baden, "Nostalgia: Conceptual Issues and Existential Functions," in *Handbook of Experimental Existential Publications,* ed. Jeff Greenberg. (New York: Guilford Publications, 2004): 200–213. 206.
30. Donnan and Simpson, "Silence and Violence among Northern Ireland Border Protestants," 6.
31. Janet Carsten, "The Politics of Forgetting: Migration, Kinship and Memory on the Periphery of the Southeast Asian State," *Journal of the Royal Anthropological Institute* 1, 2 (June 1995): 317–336. 344.
32. Maria-Luisa Achino-Loeb, *Silence (The Currency of Power)* (Oxford: Berghahn Books, 2005): 9.
33. Kathy Charmez, "Stories and Silences: Disclosures and Self in Chronic Illness," *Qualitative Inquiry* 8, 2 (2002): 302–328. 311.
34. Paul Connerton, "Seven Types of Forgetting," *Memory Studies* 1, 1 (2008): 59–71.59.
35. There was a wide age range for the interviewees that specifically stated that they did not remember anything about getting off the *Walnut.* In 1948 some had been 12 years old and some were 28 years old, so I do not see a correlation between being too young to remember the voyage or being too old to remember when interviewed.
36. Helmi Lible, interview with the author, Toronto, Ontario, December 5, 2006.
37. Anna Himmist, interview with the author, North York, Ontario, February 27, 2007.
38. Elmar Peremees, interview with the author, Richmond Hill, Ontario, November 22, 2006.
39. Stanley Cohen, *States of Denial: Knowing About Atrocities and Suffering.* (Cambridge: Polity Press, 2001): 131.
40. Lia Arens, interview with the author, Toronto, Ontario, January 10, 2007.
41. Adele Nyman, interview with the author, Toronto, Ontario, November 21, 2006
42. Barbara Myerhoff, *Number Our Days: Culture and Community Among Elderly Jews in an American Ghetto* (New York: Touchstone, 1982): 110.
43. Elizabeth Edwards, "Photographs and the Sound of History," *Visual Anthropology Review* 21, 1 and 2 (2006): 38.
44. Nadia C. Seremetakis, *The Senses Still* (Chicago: University of Chicago Press, 1994): 9.
45. Seremetakis, *The Senses Still,* 10–11.
46. Barthes, *Camera Lucinda,* 85.
47. Rachel Herz and Trygg Engen, "Odor Memory: Review and Analysis," *Psychonomic Bulletin & Review* 33, 3 (1996): 304.
48. Herz and Engen, "Odor Memory: Review and Analysis," 308.
49. Maurice Halbwachs, *On Collective Memory,* trans. Lewis A Cosar (Chicago: University of Chicago Press, 1992): 40.

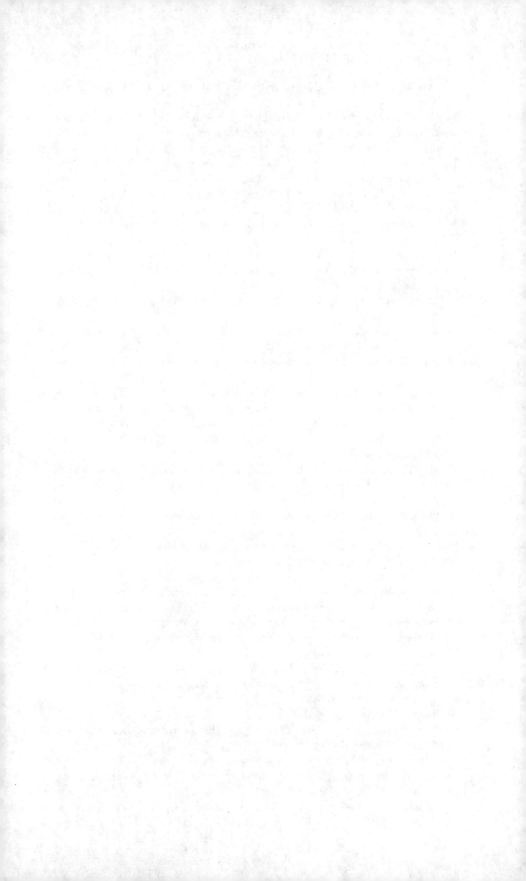

CHAPTER 5

"You Hear It in Their Voice"[1]: Photographs and Cultural Consolidation among Inuit Youths and Elders

Carol Payne

Photo Studies scholar Carol Payne argues that young people's emotional responses to historically and politically charged photographs may result in political engagement and activism. Payne researched the repatriation of photographs of Inuit taken by the Canadian federal government in the 1950s and 1960s. In the 2000s, Inuit youth were given copies of the photographs and interviewed their elders about them. Naming or identifying the people in the photographs became an important part of creating a historical sense of identity across the generations. For the youth, however, working with the photographs did not stop at the emotional response they shared with their grandparents. Interviewing the young people about their photo-interviews, Payne found that the emotional response was often transformed into a political engagement. Payne, like several other authors in this volume, explores how she herself became invested in her interviewees' photographs. She found that photographs initially devised for increasing white Canadians' pride in their country, and which scholars trained in postcolonial theory saw as evidence of "cultural disruption," were used half a century later by the Inuit for creating a sense of "intergenerational continuity." Payne's work converses quite powerfully with that of Schiebel and Robel; both studies explore, in different ways, the role of photographs and narratives in the formation and representation of historical consciousness. In addition,

like Marles and Bersch and Grant, Payne undermines the distinction between private and public photography by showing how official photographs can become part of a family album.

In April 2009, 19-year-old Inuk student Natasha Mablick recounted to me her experiences conducting interviews with Inuit elders in her community of Pond Inlet, in Nunavut, the Canadian central arctic territory established in 1999. Like all of the case studies discussed in this volume, the interviews that Natasha conducted centered around photographs as memory prompts and sites of social engagement (see Figure 5.1). Natasha recalled:

> Some [of the interviews] really make me want to get involved in politics . . . I have a feeling of just wanting to fix absolutely everything but I know that's impossible . . . And I'm kind of finding myself juggling a bunch of mixed emotions. A part of me is kind of mad at the government [for] moving my ancestors into communities . . . taking my parents away from their homes and putting them into schools and in some cases breaking up some families and their relationships with their family members but on the other side, I know that if this didn't happen, these people wouldn't be who they are today. So it's just juggling and what I believe is right and wrong.[2]

Like that of several of her classmates, Natasha's experiences conducting interviews with elders over archival photographs prompted a response that was at once emotionally charged and politically engaged.

This chapter explores photo-based oral history's potential for political advocacy and cultural consolidation. My case study centers on an ongoing "visual repatriation" project in which Natasha and several other students participated.[3] While I will provide an overview of that research program as a whole, I particularly want to explore the perceptions of the interviewers, a group of youths personally implicated in the oral histories that unfolded with the aid of photographic images. This initial discussion of student reaction is based on a series of follow-up interviews I conducted with six of the students; I thank Natasha, as well as Siobhan Iksiktaaryuk (Baker Lake), Kathleen Merritt (Rankin Inlet), Paulette Metuq (Pangnirtung), Marvin Atqittuq (Gjoa Haven), and Kevin Iksiktaaryuk (Baker Lake) and the elders they interviewed for their participation and for permission to quote from them.[4] Drawing on Marianne Hirsch's concept of "postmemory" and discussions of Inuit cultural experience, this paper examines how the photographic encounters in those oral history interviews provide a site for the transformation of emotional response to political engagement and the assertion of Inuit culture.

The visual repatriation project—in which Natasha Mablick and the other students participated—has been developed in collaboration with the Ottawa-based

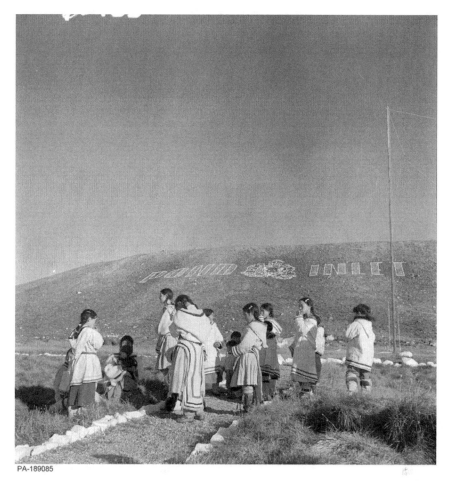

PA-189085

Figure 5.1 "Eastern Arctic Inuit at Pond Inlet," Mittimatalik/Tununiq, Nunavut, July 1951 (Wilfrid Doucette, National Film Board of Canada, Still Photography Division, Library and Archives Canada, PA-189085).

Inuit post-secondary school Nunavut Sivuniksavut. Translated into English from the Inuktitut as "The Future of Our Land," Nunavut Sivuniksavut (hereafter NS) was founded in 1985 by the Tungavik Federation to teach Inuit youth about their cultural heritage.[5] Initially, the school was established in order to prepare youth to participate in and be informed about land claims negotiations with the federal Canadian government. Those negotiations, which had been undertaken actively since the 1970s, sought title to land and self-government for Inuit; they resulted in the largest land claim settlement in Canadian history, with the establishment in 1999 of the Territory of Nunavut.[6]

With a land mass of some 2 million square kilometers, the Territory of Nunavut is vast and ancient but with a population that is surprisingly small and

youthful. There are only about 32,000 Nunavummiut or less than one-tenth of 1 percent of Canada's total population; their median age in 2008 was just under 24. Approximately 85 percent of the population is Inuit.[7] Most live in the territory's 26 small, isolated communities spread across three time zones and regions: Kivalliq (west coast of Hudson's Bay), Kitikmeot (far west areas of the territory), and Qikiqtaaluk (Baffin Island and north including the capital Iqaluit).[8]

National and international discussions of Nunavut are generally dominated by reports of various devastating social and environmental concerns ranging from the immediate effects of global warming to endemic poverty and substance abuse as well as staggering sexual assault and suicide rates. Between 1999 and 2008, the suicide rate in Nunavut fluctuated between 111 and 119 per 100,000 people or about ten times that in the rest of Canada. Most suicides in Nunavut are committed by young men in their teens and 20s, the same demographic group represented in much of NS's enrollment.[9] As I was told by Morley Hanson, one of NS's founding faculty members, none of the students are untouched by these tragedies.[10] Partly in response, the school today has developed a curriculum that emphasizes Inuit culture and history as well as the development of practical life skills as means to regain cultural pride and economic agency. In this way, the teachers hope to stem the tide of those widespread social ills.

In this the school reflects the Government of Nunavut's own emphasis on *Inuit Qaujimajatuqangit*, which is widely known across Nunavut by the acronym "IQ." An indigenized play on intelligence quotient, IQ is defined and systematized by the territorial government as a set of "Inuit traditional knowledge and values" summarized by six key concepts: Pijitsirarniq (Serving), Aajiiqatigiingniq (Consensus–Decision Making), Pilimmaksarniq (Skills and Knowledge Acquisition), Qanuqtuurungnarniq (Being Resourceful to Solve Problems), Piliriqatigiingniq (Working in Collaborative Relationships toward a Common Purpose), and Avatimik Kamattiarniq (Environmental Stewardship).[11] In turn, these values inform some of the practice of governance in Nunavut.[12] IQ principles are based on community life and skills developed by Inuit hunter-gatherers as they were understood to be before European contact.[13] In this respect, IQ is arguably an exercise in "strategic essentialism." A concept coined by Gayatri Spivak and closely associated with second wave feminism, strategic essentialism describes the subversive tactic of referencing broad (even stereotypical) cultural characteristics in an attempt to foster group cohesion while simultaneously critiquing the effect of essentializing stereotypes themselves.

As part of these strategies of traditional knowledge, NS faculty regularly bring Inuit elders and students together, at times around photographs. In 2001, for example, the school established "Project Naming," an innovative initiative with the Library and Archives Canada (hereafter LAC).[14] For that program, NS students research archival photographs in the collection of the LAC depicting what is now the Territory of Nunavut and work with elders to name individuals

in the photographs. Before the advent of Project Naming, most Inuit depicted in the LAC's collection were presented as anonymous types. In one example from Pond Inlet, Natasha Mablick's home community, a photograph dated from 1923 (see Figure 5.2) was identified simply as "Native woman, Pond

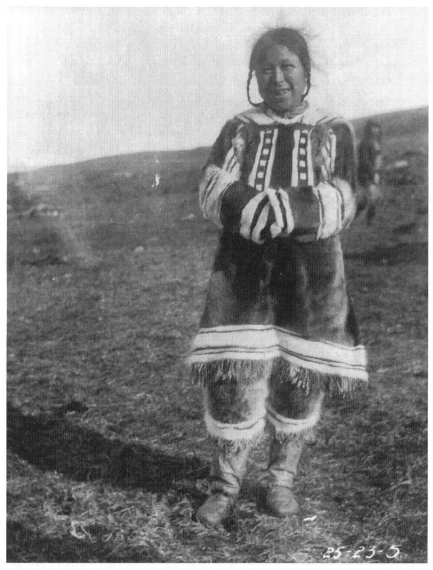

Figure 5.2 "Native woman, Pond Inlet, Baffin Island, N.W.T.," Mittimatalik/Tununiq, Nunavut, 1923; retitled under Project Naming: "Miali Aarjuaq wearing an 'amauti' (a woman's hooded caribou parka). This photograph was taken near the R.C.M.P Detachment." (Joseph Dewey Soper, Library and Archives Canada, PA-101840).

Inlet, Baffin Island, N.W.T." With the help of elders, the LAC archive record now describes the image as depicting "Miali Aarjuaq wearing an 'amauti' (a woman's hooded caribou parka). This photograph was taken near the R.C.M.P. [Royal Canadian Mounted Police] Detachment." In this way, NS and the LAC have been able to identify and acknowledge hundreds of Inuit among their photographs collection.[15]

The research program discussed here, in which I have been involved since 2005, extends Project Naming's emphasis on identifications to include oral histories based on or prompted by archival photographs. In this it reflects the central place of orality within Inuit cultural heritage. It also reflects other oral history initiatives in the north including the LAC's Inuit Land Use and Occupancy Project (ILUOP) and the extensive oral history work of Julie Cruikshank, John Bennett and Susan Rowley, among others.[16] The methodology that guides this project is termed, by Elizabeth Edwards and other visual anthropologists, visual repatriation, the recovery and recontextualization of photographs depicting Aboriginal peoples by the same Aboriginal groups or in collaboration with outside researchers. In effect it adapts and indigenizes aspects of conventional anthropological "photo elicitation," the use of photographs in anthropological field work to prompt memory, but uses it in order to reclaim Aboriginal subjectivity.[17]

For this program, NS students are hired as researchers to interview elders, who are also paid, each in his or her own home community about archival photographs depicting that same community. Each participating student is supplied with digital audio recording equipment and instructions in its use, a binder of archival photographs depicting his or her home community, and guidelines for the interviews. This material is taken home over the students' extended Christmas and New Year's break, and they are asked to interview an elder at that time.

The students are not only key participants but are also central to the development of the methodology for the interviews. Each year in November or December, I organize a workshop with NS students on conducting oral history interviews. The workshop was initially developed with the help of Caroline Forcier Holloway, an Archivist at the LAC, who has worked on Aboriginal oral history projects for that federal agency.[18] At every step, we engaged the students in developing protocols for the interviews. For example, in discussion with students and Leslie Macdonald-Hicks, Carleton University's Research Ethics Coordinator, a culturally sensitive ethics clearance procedure was developed, in which elders, who often are not able to read or have little knowledge of English or French, Canada's two official languages, can give their approval of the procedure orally. Students were also central in developing questions; this often meant a purposeful limitation on questioning. Within Inuit culture as understood by many of the students, interrupting an elder—to ask further questions, for example—is considered disrespectful; accordingly, students are now encouraged to introduce the project as a whole

and let the photographs in the albums guide the elders' recollections without unnecessary interruptions. Students themselves are responsible for finding people to interview; typically, they approach a grandparent, parent, another relative, or a neighbor. In our workshop discussions, several students have encouraged their classmates to bring the elder interviewed a gift of "country food" (game) or sea ice. As Forcier Holloway notes, "this visual type of natural 'material culture' may have also helped to elicit some strong memories on the part of the elder, as the story is retold to a younger face, shared, recorded, serving as a connection or a link to the past."[19] The familiarity of subjects and interviewers, enhanced by such exchanges and archival photographs of their home communities, has resulted in a series of encounters that are highly engaged, warm, and intimate.

The archival photographs at the center of the interviews were made during the 1950s and 1960s, later than many Project Naming images, and all under the auspices of The National Film Board of Canada's Still Photography Division, a federal agency mandated to promote Canadian nationalism through photographs, which often deployed images of the north and Inuit as key markers of the national identity.[20] These governmental images document a devastating period in recent Inuit history. At that time, the federal Canadian government relocated several Inuit family groups to the High Arctic from Arctic Québec and the settlement of Pond Inlet in northern Baffin Island; established settled communities for most other Inuit; and supported residential and day schools for their children.[21] Churches and the Canadian government encouraged the settlement of Inuit into permanent communities following the collapse of the fur trade. While arguably prompted by fears for the physical welfare of Inuit, this period witnessed the demise of Inuit traditional life as semi-Nomadic hunters.[22] The establishment of settlements effectively marked an effort to assimilate Inuit into southern Canadian life, as Frank Tester, Peter Kulchyski, and Shelagh Grant have shown.[23] This pivotal period, although five to six decades in the past, has continued to haunt Inuit, with many arguing that today's devastating poverty, sexual assault, and suicide rates as well as widespread loss of cultural heritage, are rooted in those changes.[24]

Ironically, the tragedies of the 1950s and 1960s are rarely evident on the surface of the NFB archival photographs used in this project. While there are numerous contemporary photographs depicting the grim conditions of life in the north at the time, the NFB Still Photography Division, as a promotional agency, instead depicted Inuit assimilation in glowing terms (see Figure 5.3). Made for a southern Canadian viewership, and commissioned by a federal government deeply engaged in promoting the north for economic gain, they feature the clean lines of newly constructed housing, health facilities brought to the north, and dozens of smiling Inuit faces. Among Inuit, the thousands of still photographs depicting the north from the NFB archive were simply never seen at all.

In returning these photographs to the north, this research program attempts to support intergenerational Inuit connections, and enter into the public record

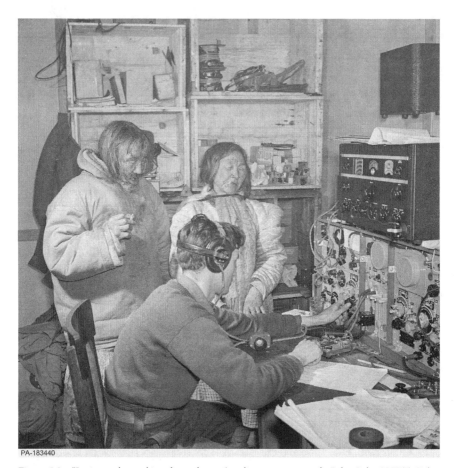

PA-183440

Figure 5.3 "Inuit couple watching the settlement's radio operator at work, Baker Lake, N.W.T., Baker Lake (Qamanittuaq), Nunavut," March 1946 (George Hunter, National Film Board of Canada, Still Photography Division, Library and Archives Canada, PA-183440).

the voices and interpretations of a group often erased or subjugated by official institutional histories of Canada. I came to this project from my research on the NFB's Still Photography Division and its model of a normative Canadian national identity told through photographs.[25] Rather than simply critiquing that federal institution, I wanted to open a space for other voices to use that photographic archive to tell their own stories. With resources that are available to western or southern researchers—access to archives, grant funding, and technology—I have been able to disseminate those narratives among non-Inuit and Inuit. To reach their most important audience—Inuit in Nunavut—images and the conversations they prompt will be disseminated through the web, that celebrated Inuit filmmaker Zacharias Kunuk has recently termed "the most important media tool of the twenty-first century to protect Inuit language and culture."[26] To that

end, the components of this research will be carried on a web-based interactive, cybercartographic atlas developed by Carleton University's Geomatics and Cartographic Research Centre.[27]

In this project, students and elders use the "visual economy"[28] of the NFB archive against the grain of its original intent.[29] When students and elders sat down to look at images of the north from the NFB archive, they rarely saw the same scenes that I perceived. I saw visual evidence of subjugation, othering, and enforced cultural assimilation dressed up in the cheerful colors of jingoistic nationalism. They saw family members, long lost neighbors, hunting techniques, social gatherings, and old friends. Where I witnessed cultural disruption, they experienced intergenerational continuity. That disconnect between now conventional colonial critiques, and the actual uses of historic images by those they depict has fascinated and perplexed me. As I have argued in previous writing, in repatriating and reframing these nationalist images, elders and youth together write their own "counter-narratives of the nation."[30]

Elders, who are encouraged to keep photographic prints, have identified a number of locations and people in the images; they particularly drew in the students by providing anecdotes about the students' family members. In addition, elders discuss their communities' histories, and—in the most enthusiastic parts of the interviews—provided detailed discussions of "traditional" Inuit life including hunting, dog teaming, and handcrafts. The photographs launch the discussion that tends to meander into various corners of community life. The experience of being interviewed seems to renew the elders' place in community life, and confirm cultural respect for them. The students consistently report that elders are enthusiastic to sit down and talk.[31]

But the project is as much about the students' experiences as the elders'. This visual repatriation research program has been developed as a project in memory work and, accordingly, reflects Memory Studies' characterization of memory as a form of representation that recasts the past through today's experience.[32] The specific concept of "postmemory" is central to the project. Developed by Marianne Hirsch to address second-generation experience of the Holocaust, and extended to other trans-generational effects, postmemory describes the powerful effect of past events that the individual did not experience directly, but have nonetheless dominated their lives. The children and grandchildren of Holocaust survivors, for example, although they did not face the horrific events of World War II themselves, often also live in a state of post-traumatic anxiety.[33] Hirsch singles out photographs as potent "agents of postmemory."[34] For her, the photographic image can at once signal trauma while it also can "make present, rebuild, reconnect, bring back to life."[35] Postmemory, which is predicated on conventional western notions of an autonomous self, aptly describes encounters with the past undertaken by the students as well as many other Inuit today. In one current example, the Inuit response to the Canadian Truth and Reconciliation Commission on

residential schools employs the critical and reconstructive strategies at the core of postmemory by revisiting past events to build community strength today.[36] At the same time, by bringing young people and elders together to discuss their community's history, the project discussed here reflects Inuit conceptionalizations of identity in terms of an extended social network that includes but is not limited to kinship groupings.[37]

Indeed, when students spoke to me in follow-up interviews about their conversations with elders, the idea of reconnecting became something of a leitmotif. All of the students remarked about how they had been intimidated to approach elders in the past. This was largely the result of a generational language gap: many elders primarily speak Inuktitut, Inuinnaqtun, or another dialect of Inuktitut, while the prime language of most Inuit youth in Nunavut is English. The youths I work with, for example, almost consistently felt that their limited Inuktitut language skills would not be sufficient to speak with elders, or would be a sign of disrespect. With intense Inuktitut language instruction at NS, they are able to speak more comfortably and confidently with elders. As Siobhan Iksiktaaryuk of Baker Lake explained:

> I was able to ask questions because I'm not too strong in my language but [the interviews] kind of pushed me to force it out of me, because when it was just me and Kevin interviewing an elder we had to struggle, but we helped each other, so that kind of helped us improve our Inuktitut by asking questions. And the elders were surprised. They said, oh, I never knew you could speak Inuktitut. That kind of got me happy and kind of sad at the same time.[38]

Kathleen Merritt, too, felt that Inuktitut language instruction, as well as a broader knowledge of Inuit cultural heritage changed her perspective and relation to elders:

> I guess for 20 years of my life I can't say that I embraced my own culture, or that I cared one day just to stop and talk to an elder made me like for various reasons because I can't speak Inuktitut because in my 20 years of life before coming and realizing the things that Inuit did, I didn't really care about that stuff.[39]

The photographs also helped to bridge that generational divide. As researchers have long recognized, photographs put the individual being interviewed at ease by prompting memories, and directing discussion toward specifics seen in the images.[40] But for the young people and elders, the photographs at times seemed to offer a pretext for conversations. As Natasha Mablick explained, the interviews "lead to a lot of regular conversations that we [could] have had, but we probably wouldn't have had if we didn't have the pictures."[41] Natasha's observations reflect Elizabeth Edwards' compelling argument that photographs are "social objects,"

with an "affective tone" that is activated through active sensory experience, and orality. As a result, as Edwards contends, photographs activate social bonds.[42]

Beyond a sense of intergenerational connection, the students were moved by the specific stories they heard about the past. They noted that they learned more than they had known before about their home communities, and family members. All of the students saw images of and heard stories about relatives and neighbors, some closely connected, and others long gone. Natasha Mablick, for example, learned whom she was named after, and how her parents met, through the interviews; and Paulette Metuq gathered information about traditional regional clothing in Pangnirtung.[43]

The painful episodes of the 1950s and 1960s were a part of the photo-centered interviews, too, though at times they were only obliquely referenced. Students heard allusions to or direct information about their relatives' experiences in residential schools, and the often disruptive establishment of settled communities. Siobhan Iksiktaaryuk of Baker Lake recounted her own family's experience with one of the most notorious strategies for forcing Inuit to settle in communities—shooting dog teams:

> My mom said that [our family] used to live around the Kazan River area south of Baker and my mom remembers that the RCMP came and they told them that they had to move into Baker Lake and grandpa had no choice because the RCMP shot our dogs. So my mom said that that was the first time she saw her dad really startled...I never even knew that our dogs were shot. I didn't even know that we had a dog team because now we just have like two dogs and men don't talk about dog teams. And so it hit her, too, because she doesn't really want to talk about how her dogs were shot because...the lead dog was her dog.[44]

The widespread killing of dogs in the 1950s and 1960s remains a controversial and distressing topic today. In turn, reticence to narrate these painful episodes—as in Siobhan's observation that her mother did not like to talk about the shootings—also became a feature of the encounters.

If a sense of cultural continuum was animated through photographs and conversations, trauma was articulated through silence. Students reported several times that their families did not talk about these events; in others, students reported guiding the conversation away from such potentially distressing subjects. Kathleen Merritt of Rankin Inlet, for example, noted that she "didn't ask [the elders] about the things that have been a bad period in their time... [b]ecause I know that Inuit are kind of quiet about that stuff sometimes, older Inuit at least."[45] The students' use of the Inuktitut language may have been limited, but they were all fluent in the complex idiom of familial and cultural silence. In this they reflect the pervasiveness of silence in second generation experiences of postmemory as discussed by Hirsch and Nadine Fresco.[46]

When elders did elect to discuss the dramatic changes of the 1950s and 1960s explicitly, the conversation turned to questions of power and the students were often jolted. Kathleen Merritt recalled:

> One of the things [the elder I interviewed] said had an impression on me because he was somebody that I see to be very strong and, you know, from a huge family, and he is the grandparent of a huge family. But he said to me, I remember seeing a policeman and being afraid. And for someone [like him] to say something like that…to be afraid of an outside figure, it just showed me how [things] really are bad, they had no authority, no real powerful place when people from the outside came into their world. It was like, we learn about this throughout the school year, but for someone to say it in real life to me…The things we learned in the textbook are stories from Inuit so they are just as personal, but to put a face to the story, it really opened my eyes to say, ok, you learn about these things and you say, they happened, but when someone tells you their own personal experience, you say, yes, they really did happen. And you understand it almost at a different level. You hear it in their voice. You see it in the way they speak to you almost.[47]

Here Kathleen articulates her own embodied experience of encountering the past through an elder's response to archival photographs—experiences she not only heard and saw but felt intensely, at a "different level." In turn, the "affective tone" of those encounters, as well as Kathleen's and the other students' educational experiences at NS generally have prompted many of them to identify themselves more fully in terms of Inuit heritage. As student Kevin Iksiktaaryuk told me:

> It's shed a new light on my life for me to embrace my culture…when I went back home and I viewed things a whole lot different. And I came to appreciate things like elders. I spoke to elders and actually listened to them what they were saying, how it actually related. Before I came to NS I didn't know anything about IQ principles and learning about them and then actually putting them in to play in my head.[48]

Encounters with elders over photographs have indeed "shed a new light" on Inuit culture for Kevin Iksiktaaryuk, and his classmates (see Figure 5.4). They have illuminated dark spaces of silence while helping students see their families and communities anew. Within the charged atmosphere of Inuit culture in Nunavut—a culture wounded by the intergenerational trauma of acculturation that is revisited with alarming regularity in widespread suicides, domestic violence, and substance abuse—these seemingly modest, routine conversations have fostered a sense of cultural consolidation and heightened social engagement through the politics of memory. In their often emotional responses to photo-based oral history interviews with

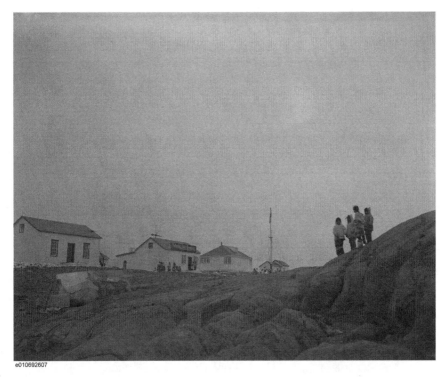

e010692607

Figure 5.4 "Hudson's Bay Company Post at Pangnirtung," July 1951 (Wilfrid Doucette, , National Film Board of Canada, Still Photography Division, Library and Archives Canada, e010692607).

elders, Kevin, Siobhan Iksiktaaryuk, Kathleen Merritt, Paulette Metuq, and Marvin Atqittuq, and other NS students, have claimed positions as active agents in Inuit cultural reclamation. The interviews have allowed them to revisit a traumatic period in recent Inuit history, which, although before their time, has shaped much of their experience as Inuit and in relation to non-Inuit. In turn, these postmemory encounters have allowed them to reframe representations of that past from a new position informed by the tenets of IQ, the Government of Nunavut's strategy of rendering government policies, procedures, and values in terms of Inuit culture. In this way, photographs and the oral histories they have sparked have transformed affect into cultural and political engagement not only for the elders but also for the youth interviewers.

Notes

1. Kathleen Merritt in conversation with Carol Payne, April 17, 2009, Ottawa.
2. Natasha Mablick in conversation with Carol Payne, April 14, 2009, Ottawa.

3. Visual anthropologist Elizabeth Edwards has defined visual repatriation as Aboriginal (or Aboriginal collaborative) recovery and recontextualization of photographs focusing on Aboriginal peoples. Elizabeth Edwards, "Talking Visual Histories: Introduction," in *Museums and Source Communities: A Routledge Reader,* ed. Laura Peers and Alison K. Brown, (London and New York: Routledge, 2003), 83–99; Elizabeth Edwards, "Photographs and the Sound of History," *Visual Anthropology Review* 21, 1–2 (2006): 27–46.

4. Next to the participation of those students, I gratefully acknowledge the participation of the elders they interviewed and Nunavut Sivuniksavut faculty members Murray Angus and Morley Hanson. Frank Tester, Caroline Forcier Holloway, Mitchell Frank, and Randi Klebanoff provided invaluable editorial advice to earlier drafts as did audience members at the "Feeling Photography" conference at the University of Toronto (October 2009) and the Visual Culture Colloquium at Carleton University (November 2009). Finally, for help in various aspects of the research project, thanks to Hellin Alariaq, Rosalie Favell, Cortney Crewe Murray, Laura Schneider, Suzanne Crowdis, and Clare McKenzie. Finally, thanks to Fraser Taylor and Amos Hayes of Carleton University's Cartographic and Geomatics Research Centre.

5. Nunavut Sivuniksavut website http://www.nstraining.ca/history.php, accessed January 30, 2010.

6. Keith Crowe, with files from Marion Soublière and Greg Coleman, "The Road to Nunavut," *Nunavut '99* http://www.nunavut.com/nunavut99/english/road.html, accessed January 30, 2010.

7. According to Statistics Canada, the country's total population in 2009 was 33,739,900. Statistics Canada, Population by year, by province and territory http://www40.statcan.gc.ca/l01/cst01/demo02a-eng.htm, accessed May 17, 2010. Statistics Canada estimated Nunavut's median age on July 1, 2008 as 23.8 years of age; it has Canada's youngest population. Statistics Canada, Table 1 Population, age distribution and median age by province and territory, as of July 1, 2008. http://www.statcan.gc.ca/daily-quotidien/090115/t090115c1-eng.htm Statistics Canada, Aboriginal Population Profile, 2006. http://www12.statcan.ca/census-recensement/2006/dp-pd/prof/92-594/details/page.cfm?Lang=E&Geo1=PR&Code1=62&Geo2=PR&Code2=01&Data=Count&SearchText=Nunavut&SearchType=Begins&Search PR=01&B1=All&GeoLevel=&GeoCode=62, accessed January 30, 2010.

8. Government of Nunavut, "Our Land," http://www.gov.nu.ca/english/about/ourland.pdf, accessed January 30, 2010.

9. The Working Group for a Suicide Prevention Strategy for Nunavut, *Qaujijausimajuni Tunngaviqarniq. Using knowledge and experience as a foundation for action: A discussion paper on suicide prevention in Nunavut.* Appendix 1: Statistical Deaths by Suicide in Nunavut 1960–2008 http://www.gov.nu.ca/suicide/SP%20WG%20discussion%20paper%20E.pdf, accessed January 30, 2010.

10. Morley Hanson, conversation with the author, May 2006.

11. Government of Nunavut, Department of Human Resources, "Inuit Qaujimajatuqangit (IQ)" http://www.gov.nu.ca/hr/site/beliefsystem.htm, accessed January 30, 2010.

12. Annis Mae Timpson, "Stretching the Concept of Representative Democracy: The Case of Nunavut," *International Review of Administrative Sciences* 72, 4 (2006): 517–530.

13. Edmund Searles, "Anthropology in an Era of Inuit Empowerment" in *Critical Inuit Studies: An Anthology of Contemporary Arctic Ethnography*, ed. Pamela Stern and Lisa Stevenson (Lincoln and London: University of Nebraska Press, 2006), 92.

14. Library and Archives Canada, Project Naming. http://www.collectionscanada. gc.ca/inuit/index-e.html accessed November 10, 2009.

15. For a more detailed discussion of Project Naming as an alternative to governmental photographic archives, see: Carol Payne, "Lessons with Leah: Re-Reading the Photographic Archive of Nation in The National Film Board of Canada's Still Photography Division" *Visual Studies* 21, 1 (April 2006): 4–22.

16. Library and Archives Canada, Department of Indian Affairs and Northern Development fonds, RG85M 77803/16, "Inuit land use and occupancy maps [cartographic material, sound recording]" series (Mikan 3677893); John Bennett and Susan Rowley, compilers and editors, *Uqalurait: An Oral History of Nunavut* (Montreal: McGill-Queen's University Press, 2004); Julie Cruikshank, *Do Glaciers Listen? Local Knowledge, Colonial Encounters and Social Imagination* (Vancouver: University of British Columbia Press, 2005); Julie Cruikshank, *The Social Life of Stories: Narrative and Knowledge in the Yukon Territory* (Lincoln: University of Nebraska Press, 1998); Julie Cruikshank, *Dän Dha Ts'edenintthe'é / Reading Voices; Oral and Written Interpretations of the Yukon's Past* (Vancouver and Toronto: Douglas and McIntyre, 1991); Julie Cruikshank, *Life Lived Like a Story* (Lincoln: University of Nebraska Press, 1990).

17. Edwards, "Photographs and the Sounds of History"; John Collier, *Visual Anthropology: Photography as a Research Method* (New York: Rinehart & Winston, 1967); Judith Binney and Gillian Chaplin, "Taking the Photographs Home: The Recovery of a Maori History," in *Museums and Source Communities: A Routledge Reader*, ed. Laura Peers and Alison K. Brown (London and New York: Routledge, 2003), 100–110; Gaynor Macdonald, "Photos in Wiradjuri Biscuit Tins: Negotiating Relatedness and Validating Colonial Histories," *Oceania* (June 2003): 225–242; Benjamin R. Smith, "Images, Selves, And The Visual Record: Photography and Ethnographic Complexity in Central Cape York Peninsula," *Social Analysis: The International Journal of Cultural and Social Practice* 47, 3 (2004): 8–26; Chris Wright, "Material and Memory: Photography in the Western Solomon Islands," *Journal of Material Culture* 9, 1 (2004): 73–85; Evelyn Wareham, "From Explorers to Evangelists: Archivists, Recordkeeping, and Remembering in the Pacific Islands," *Archival Science* 2, 1–2 (2002): 187–207.

18. Donald A. Ritchie, *Doing Oral History: A Practical Guide*, 2nd ed. (New York: Oxford University Press, 2003); Thomas L. Charlton, Lois Ed. Myers, and Rebecca Sharpless, eds. *Handbook of Oral History* (Lanham, MD, and New York: AltaMira Press, 2006).

19. Caroline Forcier Holloway, email correspondence with Carol Payne, January 18, 2010.

20. Carol Payne, "How Shall We Use These Gifts?" Imaging the Land in The National Film Board of Canada's Still Photography Division," in *Beyond Wilderness*, ed. John O'Brian and Peter White (Montreal: McGill-Queen's University Press, 2007), 153–160; Carol Payne, "A Land of Youth": Canadian Citizenship and the Image of the Child in the NFB's Still Photography Division," in *Depicting*

Canada's Children, ed. Loren Lerner (Waterloo: Wilfrid Laurier University Press, 2009), 85–107.

21. As Frank Tester has reminded me, the specific circumstances of settlement were distinct in each community. Erik Anderson, ed. *Les Relations du Canada avec les Inuit: Histoire de l'Élaboration des politiques et des programmes* (Ottawa: Affaires indiennes et du Nord Canada, 2006).

22. I thank Frank Tester for clarifying this information for me. Among the most notorious incidents of settlement were the relocations of several Inuit family groups from Inukjuak on Hudson's Bay and Pond Inlet on Baffin Island to two areas in the remote High Arctic: Resolute Bay on Cornwallis Island and an area on southern Ellesmere Island around Grise Fiord, *Royal Commission on Aboriginal: The High Arctic Relocations : A Report on the 1953–55 Relocations* (Ottawa: Minister of Supply and Services Canada, 1994).

23. Frank Tester and Peter Kulchyski have demonstrated that the quest for Canadian Arctic sovereignty was central to the government's motivation in the resettlements. Frank Tester and Peter Kulchyski, *Tammarniit (Mistakes): Inuit Relocation in the Eastern Arctic, 1939–1963* (Vancouver: University of British Columbia Press, 1994), 123; Shelagh D. Grant, "A Case of Compounded Error: The Inuit Resettlement Project, 1953, and the Government Response, 1990," *Northern Perspectives* (Canadian Arctic Resources Committee) 19, 1 (Spring 1991): 3–29; Morris Zaslow, *The Northward Expansion of Canada 1914–1967* Toronto: McClelland and Stewart, 1988), 332; Sherrill E. Grace, *Canada and the Idea of North* (Montreal and Kingston: McGill-Queen's University Press, 2002), 64.

24. Paul Okalik, "What Does Indigenous Self-Government Mean?" Lecture given at Brisbane, Australia on August 13, 2001. Reprinted on the Government of Nunavut website http://www.gov.nu.ca/english/premier/press/2001/isg.shtml, accessed September 21, 2007; Valerie Alia, *Names and Nunavut: Culture and Identity in Arctic Canada* (New York: Berghahn Books, 2006).

25. Carol Payne, *The Official Picture: The National Film Board of Canada's Still Photography Division and the Image of Canada* (forthcoming); Payne, "A Land of Youth"; Payne, "How Shall We Use These Gifts?"; Carol Payne, "Through a Canadian Lens: Discourses of Nationalism and Aboriginal Representation in Governmental Photography," ed. Sheila Petty, Annie Gérin, and Garry Sherbert, *Canadian Cultural Poesis: An Anthology.* (Waterloo: Wilfrid Laurier University Press, 2006), 421–442; Carol Payne, *A Canadian Document: The National Film Board of Canada's Still Photography Division*, Ottawa: Canadian Museum of Contemporary Photography, 1999.

26. Zacharias Kunuk, Keynote Address, Inuit Studies Conference, Winnipeg, October 2008.

27. For information on cybercartographic atlases as discussed by D.R.F. Taylor, the founder of Carleton University's Geomatics and Cartographic Research Centre, see: D.R.F. Taylor and S. Caquard, eds. Special Issue on Cybercartography, *Cartographica* 41, 1 (2006).

28. Deborah Poole, *Vision, Race and Modernity: A Visual Economy of the Andean Image World* (Princeton: Princeton University Press, 1997).

29. Edwards, "Photographs and the Sound of History," 27–46; Alison K. Brown and Laura Peers with members of the Kainai Nation, *'Pictures Bring Us Messages':*

Photographs and Histories from the Kainai Nation (Toronto: University of Toronto Press, 2006); Rosanne Kennedy, "Stolen Generations Testimony: Trauma, Historiography, and the Question of 'Truth'," in *The Oral History Reader,* ed. Robert Perks and Alistair Thomson, 2nd ed. (London and New York: Routledge, 2006), 506–520; Christopher Pinney and Nicholas Peterson, *Photography's Other Histories* (Durham and London: Duke University Press, 2003); Cruickshank, *The Social Life of Stories.*

30. Payne, "Lessons with Leah"; Homi Bhabha, "DissemiNation," in Homi Bhabha, *Nation and Narration* (New York and London: Routledge, 1990), 300.

31. Indeed, in a follow-up interview student Siobhan Iksiktaaryuk of Baker Lake recounted: the elders she and two other students spoke with were interested in "talking and talking and talking and that's good but it can get pretty tiring at times…!" Siobhan Iksiktaaryuk in conversation with Carol Payne, April 17, 2009, Ottawa.

32. Annette Kuhn, *Family Secrets: Acts of Memory and Imagination.* (London: Verso,1995), 107–108; Susannah Radstone, "Introduction," in *Memory and Methodology.* ed. Susannah Radstone (Oxford and New York: Berg, 2000), 12; Marita Sturken, *Tangled Memories: The Vietnam War, the AIDS Epidemic and the Politics of Remembering* (Berkeley: University of California Press, 1997).

33. Marianne Hirsh, *Family Frames: Photography, Narrative and Postmemory.* (Cambridge: Harvard University Press, 1997), 22; Marianne Hirsch, "Surviving Images: Holocaust Photographs and the Work of Postmemory," *The Yale Journal of Criticism* 14, 1 (2001): 5–37.

34. Hirsch, *Family Frames,* 249.

35. Hirsch, *Family Frames,* 243.

36. Inuit Tapiriit Kanatami (ITK), "ITK/TRC Truth and Reconciliation Commission and Inuit Leaders Agree in Principle to an Inuit Subcommission," July 16, 2009. http://www.itk.ca/media-centre/media-releases/itktrc-truth-and-reconciliation-commission-and-inuit-leaders-agree-princ, accessed January 30, 2010.

37. Peter Kulchyski, "Six Gestures," in *Critical Inuit Studies,* ed. Stern and Stevenson, 167; Nobuhiro Kishigami, "Inuit Social Networks in an Urban Setting," in *Critical Inuit Studies,* ed. Stern and Stevenson, 214.

38. Siobhan Iksiktaaryuk in conversation with Carol Payne, April 17, 2009, Ottawa. All of the students spoke of the language barrier. Another touching statement about this came from Siobhan's cousin Kevin Iksiktaaryuk, with whom she had conducted interviews: "I grew up in a house that did kind of speak Inuktitut but it was mostly English and I was brought up in English because I was put in an English kindergarten all the way up. So I didn't develop my Inuktitut as well as my other friends did but now that I've come to Nunavut Sivuniksavut and kind of gotten in touch with my cultural side again through performing and just learning." Kevin Iksiktaaryuk in conversation with Carol Payne, April 20, 2009, Ottawa.

39. Kathleen Merritt in conversation with Carol Payne, April 17, 2009, Ottawa.

40. Collier, *Visual Anthropology.*

41. Natasha Mablick in conversation with Carol Payne, May 14, 2009, Ottawa.

42. Edwards, "Photographs and the Sound of History," 27, 29.

43. Natasha Mablick in conversation with Carol Payne, May 14, 2009, Ottawa; Paulette Metuq in conversation with Carol Payne, May 14, 2009, Ottawa.

44. Siobhan Iksiktaaryuk in conversation with Carol Payne, April 17, 2009, Ottawa.
45. Kathleen Merritt in conversation with Carol Payne, April 17, 2009, Ottawa.
46. Nadine Fresco, "Remembering the Unknown," *International Review of Psychoanalysis* II (1984): 417–27, quoted in Hirsch, "Surviving Images," 28.
47. Kathleen Merritt in conversation with Carol Payne, April 17, 2009, Ottawa.
48. Kevin Iksiktaaryuk in conversation with Carol Payne, April 20, 2009, Ottawa.

Using Press Photographs in the Construction of Political Life Stories

Martina Schiebel and Yvonne Robel

Sociologist Martina Schiebel and cultural studies researcher Yvonne Robel interviewed men looking back at difficult lives as communists in West Germany. Their interviewees actively used news media photographs and other documents to structure their life stories and interaction with the interviewers. Some of these men had selected a number of photographs and decided to begin their life stories by presenting these photographs as supporting evidence, in part to "link their personal narratives to the collective memory of their group." Schiebel and Robel argue that their narrators' memories are "structured by pictures," and conclude that "photographs and oral accounts are interrelated in a way that influences the structure and content of narratives as well as the reception of photographs." Like other essays in this collection, such as those by Payne and Mauad, Schiebel and Robel explore, in different ways, the role of photographs and narratives in the formation and representation of historical consciousness. In particular, like Mauad, and also Ryan, they consider the interaction between personal histories and the public images of photojournalism or propaganda.

Markus Hulsberg[1] was not only the youngest communist member of a West German state parliament in the 1950s, he also had to face one of the longest prison terms imposed on members of communist organizations in the Adenauer era. His sentence, five years of imprisonment for violating the 1951 ban of the Freie Deutsche Jugend (Free German Youth; FDJ) in West Germany, was widely publicized, and

his case became known far beyond the communist movement. The press in East and West Germany reported on his first arrest in 1953 and on his wider political history, including his activity for the Kommunistische Partei Deutschlands (Communist Party of Germany; KPD) before and after its ban in 1956, which led to further arrests; his escape to the German Democratic Republic (GDR) in 1962; and his work for the newly formed Deutsche Kommunistische Partei (German Communist Party; DKP) after its formation in West Germany in 1968. To this day, Markus Hulsberg has remained a political activist, participating, for instance, in demonstrations and speaking at rallies as a member of the DKP.

A booklet accompanying an exhibition on the "forgotten victims of the Cold War" refers to Markus Hulsberg as a "model defendant."[2] It is not surprising, therefore, that some communists named him as an interesting potential interviewee we should include in our study of the political activity, sanctions, and imprisonment experienced by people of two generations between 1945 and 1968 in East and West Germany.[3] Markus Hulsberg immediately agreed to be interviewed, and we made an appointment to meet at his home.

As with our other interviewees, we planned to conduct a narrative biographical interview with Hulsberg. Such an interview begins with a "main introductory narrative" the interviewee creates autonomously, following an open initial question—in our case, the request to tell his or her life story.[4] Markus Hulsberg is well prepared for the interview. On the table there is a considerable stack of documents, booklets, press clippings, and DVDs. Before the interviewer can ask the introductory question, Hulsberg seizes the initiative, asking her consent to start with his documents because "if I show you what I have got, it'll make things easier."[5] He is eager, it seems, to approach "things" in an unproblematic manner.

What are the difficult things he wants to make "easier"? One possibility is that his biographical experience holds problematic and stressful memories for him that he can control by concentrating on his documents. This not being his first interview, he knows that these interviews can be time-consuming. Thus another possible reading is that, with the aid of the prepared documents, he aims to limit the duration of the interview. At the time of the interview, Hulsberg is 84 years old and has some medical problems. This supports the assumption that he may be trying to limit interview time. However, time-saving here may mean concentration on the essential. If this were the case, Hulsberg would speak about those experiences that are especially important to him, leaving the interviewer to gather further information from the relevant sources. However, he could also be aiming to make things easier by using the documents to create a certain thematic focus that is important for his self-representation. In this case, the documents would be intended to structure his biographical narrative thematically and make the interviewer see a specific connection, thus making it easier for her to follow the course of the narrative. This would afford the interviewee a system by which

to order and select his biographical experiences. It becomes clear that there are many possible interpretations as to why including the documents in the interview might make things "easier" for Hulsberg. These readings are not mutually exclusive but may complement each other.

Composing life stories requires selection from biographical experiences.[6] It is not surprising, therefore, when interviewees make selections and put things in a temporal or thematic order. However, it is remarkable how frequently members of the group under consideration here, West German communists who faced sanctions in the 1950s and 1960s, resort to the help of documents to structure and tell their life stories. These aids frequently include photographs, many of which appeared in press articles or in the "gray literature" of political movements. The photos can serve very different functions in the interview. We have to ask how the narratives and the documents, including the pictures, interact. How does the use of these documents influence the narrative structure? Can particularities be explained by the interview context or by our research questions and our sample of interview partners? In what way do the uses of photographic sources, for example, correspond with collective narrative patterns? In a first step, therefore, we ask how this combination of told life story and written or visual documents affects narrative patterns. In a second step, we ask what the use of documents in our interviews might mean for the pictures shown. What does it mean for the photographs to be used in the telling of a political biography? Which readings of the pictures does that generate?

Narrative Patterns

If the story and the documents interact, we may assume that the way in which the latter are used affects the narrative pattern of the former. In order to make clear what we mean by this, let us go back to the interview with Markus Hulsberg. After the interviewer agrees to Hulsberg's suggestion to structure the main introductory narrative with the help of the documents he had prepared, Hulsberg presents two DVDs. The first was prepared by a journalist as a historical documentary on the persecution of communists in the Federal Republic in the 1950s and 1960s. It uses film clips, photographs, and excerpts from interviews with communists who appear as witnesses, among them Markus Hulsberg. The second DVD is a biographical film portrait of Hulsberg.

Limiting, Shortening, and Legitimizing the Story

What does this beginning of the interview mean? First, by making these introductory remarks and presenting these documents, Hulsberg emphasizes an important theme. His focus is on the postwar years and on the political and legal persecution of communists in West Germany, and he presents himself as a part

of this history. For example, Markus Hulsberg hands the interviewer neither his school diploma nor other documents pertaining to his childhood and youth, nor any photographs taken at family occasions. He leaves these biographical threads out of his main introductory narrative entirely, addressing them only when answering the interviewer's later questions. The words and visual documentation he does use in his initial, self-directed narrative are interwoven in such a way that, together, they constitute the gestalt[7] of his life story. Second, Markus Hulsberg thus stresses the importance of his own biography for understanding the anticommunism of those times. He seems to have internalized the label of a "model defendant." Immediately after the main introductory narrative he hands over booklets on the persecution of communists and on his own trial, which support this interpretation.

In the next interview sequence Hulsberg deals with his arrests. This topical shift to his own experiences is accompanied by a turn to new documents. After remarking that he is "moving on to other things now," Hulsberg presents his 1953 arrest warrant. Remarkably, he does not narrate his arrest at this point of the interview.[8] Rather, he presents an argument trying to prove that arresting him in spite of his immunity as a member of the state parliament amounted to a violation of the constitution on the part of the *Generalbundesanwalt* (Attorney General). Thus the new document serves a dual function: Hulsberg uses the warrant of arrest not only to shorten his narrative but also to press his point about the violation of law.

The narrative is different when Hulsberg jumps to his second arrest in 1962. He had been arrested again for continuing to work for the KPD after its ban in 1956. After the introductory evaluation—"and I was dead set on escaping as soon as the opportunity presented itself"—he talks at length about his successful escape after an appearance before the investigating judge. He managed to escape by slipping out of his handcuffs. The escape story is the first *story* in the interview, which until then has been dominated by argumentation and brief reports as well as the presentation of written and visual documents. This prominent position of the story already hints that the event is of special biographical importance to Markus Hulsberg. Furthermore, it is remarkable that he does not resort to presenting a press article on his second arrest at this point, and hands over a pertinent article from *Der Spiegel*[9] only after the main introductory narrative when he talks about the press coverage of his case and of the FDJ. When he tells the story of his successful escape—which resulted in his relocation to the GDR—it is a climactic event that does not need corroboration through documents. Here the story stands by itself in order to stress his cleverness and success in escaping. When, later, Hulsberg hands over the article—which includes a photograph of him showing his slim wrists[10]—he does so only for the sake of completeness. The article and the accompanying picture now serve to confirm the escape story previously told in the interview.

The remainder of the interview alternates between narration and argumentation. Hulsberg presents his further biographical experiences as scenic narratives,

and after each story hands over pertinent legal documents as historical and legal legitimization. This structure, which Markus Hulsberg sustains for the remainder of his main introductory narrative, marks a departure from his earlier use of documents. Whereas before, the documents served to focus, delimit, or shorten the narrative, Hulsberg now draws upon them merely to confirm experiences previously told in stories.

Enriching Memory

The structure of Hulsberg's interview reveals another possible benefit of using documents, namely to add further perspectives to the narrative. For example, when Markus Hulsberg begins to tell how he was arrested in the street, he shifts to scenic narration, recalling from memory the words he used to defend himself against this threat. Then he adds some background information drawn from the subsequent press coverage of the event. He enriches his own memories of the event with details from the press that account for the actions of others—passers-by who called the police—and the reaction of the police. Thus Markus Hulsberg presents the interviewer not only with his own view but also with the perspectives of other actors who witnessed the event. Similarly, in his account of the search of his home and his office—witnessed by his wife—that took place while he was being arrested, he refers to things he learned from a newspaper article. The newspaper articles enrich Hulsberg's biographical story by providing further details that complete the picture. It seems important to Hulsberg to present not only his personal perspective on past events and his own memories, but to enrich his personal account with other forms of knowledge.

Constructing Traditions

At the end of the interview sequence on his arrest and the search of his home, Markus Hulsberg hands the interviewer another press article, written by himself. In this article, he deals with the arrest in almost exactly the same words he used in the interview. This, together with other aspects of the interview's narrative structure, indicates that Hulsberg is not recounting this experience spontaneously in an impromptu narrative. Rather, the story has been told and written down several times previously, and shows the signs of "tradition building."[11]

How important are the documents for this construction of tradition? In order to explore this question, let us turn to another case, Dieter Petzold, who became a member of the FDJ and the KPD in 1946. Petzold worked for a communist newspaper until 1956, illegally served on a state board of the KPD after its ban, ran as an "independent" candidate for a West German state assembly, and faced several searches of his home as well as court trials. In 1963, he was arrested for working for the banned KPD and went to prison for two years.

Dieter Petzold prepared for our interview in a similar way to Markus Hulsberg. From his statements it is clear that on the day before our interview he reviewed the legal documents, letters, newspaper clippings and photographs, as well as his written memories, all of which he prepared for us to look at. However, in the interview he not only uses the documents as a mnemonic aid, but also frequently quotes them in his narrative. At times, narrated and read passages merge seamlessly.

Unlike Markus Hulsberg, Dieter Petzold takes written documents and pictures only as starting points, from which he elaborates situations in his very detailed initial life story narrative and in the question-based interview that follows it. He proceeds in this way even when referring to a picture he is then unable to find in his unsorted stack of documents, for example when he is talking about the search of his home by the police. Therefore, we assume that he uses photographs to recount situations that, had it not been for the pictures, may not have been included in his biographical account. It seems his memory is structured by these pictures. Referring to a very similar observation from interviews, Harald Welzer et al. have asserted that visual images and the telling of autobiographical experiences may become enmeshed in such a way as to be indistinguishable. The force of the pictures is explained by their "incessant reenactment."[12] Their reproduction in booklets and press articles allows for repetitions and thus contributes to the construction of the fixed tradition. Even though, as we have seen, the two cases of Marcus Hulsberg and Dieter Petzold differ in the way photographs and other documents influence the main introductory narrative, they are similar in that in both cases the documents help to consolidate the stories.

Condensation of Memories

The fact that, for Dieter Petzold, the photographs also stimulate a detailed elaboration of the narrative confirms that pictures here function as *condensations* of memory. This is also shown by the example of Wilfried Rabe, a member of the KPD since 1948, editor of a communist newspaper until 1956 and "independent" candidate in a 1961 state election. Rabe tells us about the trial against him for using his candidacy to violate the ban on the party. As Rabe at times has difficulties keeping up the thread of his narrative unaided, he falls back on a booklet written and published by himself, reading some sections aloud and incorporating them in his narrative. The booklet contains a political portrait of Wilfried Rabe and his codefendants as well as a description of the court case. Also included is the reproduction of a photograph showing Rabe, with a bouquet of carnations in his hand, in a group of men and women leaving a large building (Figure 6.1).

The caption "Leaving the court house" identifies the building. The open mouths of the people in the picture suggest that they are shouting or singing.

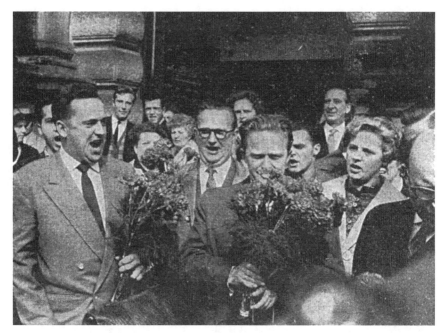

Figure 6.1 Leaving the court house.

To Wilfried Rabe, the meaning of the depicted scene is unquestionably clear. With the help of his self-written booklet, he talks about the court case right at the beginning of the interview, and explains the actions of the group outside the court house. "Most influential," he insists, was the collective singing of the *International* by those "attending the court trial." For Wilfried Rabe, this situation constitutes the key scene of his political biography because, he argues, it decisively strengthened his political beliefs and the activism as a member of the KPD that had fulfilled and "shaped [his] life in the time from 1945 to this day." To him, the photograph of the accused and supporters singing together in front of the court house symbolizes solidarity and adherence to collective political goals. The picture has a meaning to Rabe that is rooted in his political biography. It serves as a condensation of his memory of a longer time span. Roswitha Breckner has shown how photo albums can structure biographical experiences and provide a frame for memory.[13] In the case of Wilfried Rabe, a photograph also supports a condensed memory. This condensation of memory is reinforced by the fact that the picture was published in almost identical form in several media, including a press article.[14]

Passing on Collective Knowledge

In the cases discussed above, the narrative construction of tradition and the condensation of memory correspond with *collective* patterns of meaning. Our

respondents address the sanctions they faced as a central aspect of their political biographies. In doing so, they consider their own experiences to be representative of the persecution of communists in that time. This collective representation influences the narrative structure of the interviews, as the example of Wilfried Rabe shows. He says in the interview: "so I have the entire time you want to report about, learned about anticommunism the hard way because what I do I do thoroughly, and so I was an active member of the Party." He assumes we merely want to "report" on a particular phase of history, the West German Adenauer era of the 1950s and 1960s characterized by anticommunist tendencies. With this expectation, he likens the interviewers to journalists or chroniclers wanting to report on a particular time.[15] At the same time, what he says conveys his assumption that the interviewers are interested only in those experiences that have to do with "anticommunism." However, this focus is his choice; the interviewers' had clearly stated the biographical focus of the interview in their initial question. Thus, the limitation of the main introductory narrative to his political biography, and the focus on his experiences after 1945, reflect what he considers relevant. At the same time, Rabe embeds his own biographical experiences into collective memory, and presents himself as a vehicle of a tradition representing the collective story of postwar West German communists.

The cases of Hulsberg, Petzold, and Rabe, as well as other interviews, also show traces of a homogenization of personal experience. Their stated reasons for political activism, and the accounts of political persecution are remarkably similar. This "discursive homogenization" can be explained as follows. The persecution of communists in the 1950s and 1960s, and the fact that they are still waiting for political rehabilitation, strengthened ties within this group, and fostered its closing in on itself. This retrospectively creates a "collective narrative of cold war victims." Five topics dominate explanations of political activism and political persecution throughout, namely discourses of anti-militarism and anti-fascism, a reference to the lingering influence of national socialism in the (legal) administration of the Federal Republic, an emphasis on the anticommunism of the early Federal Republic, and an all-German perspective. This collective discourse dominates the individual life story and levels out differences of biographical experience. For example, Hulsberg's political carrier started after 1945, whereas Petzold looks back on a communist family tradition. Nevertheless, they both use the same topics to tell their political life story.

The individual narratives thus highlight the collective which our respondents feel part of, and thereby recapitulate the social knowledge of this group. Peter Alheit has described those parts of biographical memories where people take stock and interpret, as "higher-order predicative" forms of knowledge. They are linked to "dominant structures of social behavior and expectations."[16] Accordingly, these forms of knowledge express the collective memory of a group

and not only the experiences of a single person. In the context of our study, the narrators use press articles and booklets to place their experience in a larger historical and social context. The example of Wilfried Rabe shows that this is accompanied by a self-image as a witness to history testifying from his own experience of a certain time. The other West German communists we interviewed shared this self-image.

Having first-hand knowledge of a particular time and passing it on to posterity constitutes the figure of the juridical, historical, or moral witness.[17] The witness's experiences aim to represent the fate of a certain group and to embed it into collective memory.[18] Through its presence in memorials, historical exhibitions, popular historical documentaries, and journalistic contributions, the figure of the witness as living proof has become so dominant that when people are requested to do a biographical interview they expect to be interviewed as witnesses to history. The knowledge imparted by witnesses is, on the one hand, part of an emancipatory historiography aiming to tell the story of "ordinary people".[19] On the other hand, the knowledge that the witness imparts is, in this view, imbued with greater authenticity than the everyday narratives of others.

The dominant self-image and self-presentation as witnesses to history plays an important role for the West German communists because they are trying to pass on a knowledge that is excluded from today's hegemonic view of history. As witnesses, they also expect to be recognized as victims in a legal, social, and moral sense. In this context, frequent recourse to articles and pictures from the "bourgeois press" has additional meaning. For example, when Dieter Petzold, referring to a political action in which he participated, stresses that "some newspaper, I think the *Berliner* or the *Illustrierte, Neue Berliner Illustrierte,* they even had a piece on this," he considers articles and photographs not merely as factual evidence but as a means of making actions and some kind of counter history public. Markus Hulsberg, too, remarks that he "succeeded" several times in making it into the news in the noncommunist press, thus bringing, in his view, not only his own story but also West German communist political goals to public attention.

Interpreting and Placing the Photographs

As we have shown, the documents and the photographs serve different functions in the interviews. They are used to limit, shorten, and legitimize what is told, as well as to enrich and to add additional perspectives to memory. They not only influence the narrative structure but also contribute in important ways to the transmission and condensation of experiences into social or collective memory. Adopting a different perspective, we now ask what these uses of the documents, and their different effects on narrative structure, might mean for the pictures themselves.

Biographical Framing of Photographs

Let us take a closer look at the photograph that Markus Hulsberg handed over with a press article on his escape (Figure 6.2). We see in it a man, maybe in his mid-30s, with his hand raised.

Figure 6.2 Hulsberg's hand.

In itself, this portrait does not reveal the political orientation of the man, for it lacks all political symbols. The raised hand could mean several things: a gesture of admonition, a greeting, or even the showing of an aching limb at a medical examination. In the interview situation, these possible meanings are irrelevant to us. We now see Markus Hulsberg proudly showing his slim wrist that enabled him to escape. The interview narrative and the text of the article initially only let us adopt this reading of the photograph. The photograph here becomes the vehicle of an interpretation that the photo, in turn, now corroborates. Embedded in the biographical self-representation, the picture gains a fixed meaning. It can be assumed that, to Hulsberg, the only meaning of the photograph is the one it has in the context of his biography. The picture itself, by being set in biographical context, is disconnected from other possible meanings.

The following picture (Figure 6.3) of Markus Hulsberg with his wife and daughter is a good case in point. It was included in one of the booklets he handed over to the interviewer. Even though Hulsberg did not tell her about the event described there—his rearrest shortly after he had been released from remand because he was running as a communist candidate in the state election—when he gave her the booklet the connection between the oral narrative and the booklet's written account is immediately clear to those who know both. Here, too, the text of the booklet together with the picture serves to corroborate the biographical narrative and its interpretation. Markus Hulsberg had said in the interview that his daughter suffered greatly from her father's repeated arrests, and his absence from the family; so much indeed that she was diagnosed with diabetes. The family picture and the accompanying text underline this interpretation.

Viewed independently of Hulsberg's biographical self-representation and of the booklet's account, Figure 6.3 reveals nothing of this drama. It could have been taken at a happy occasion, such as the girl's birthday, or it might be a picture of the young family vacationing. For the narrator, however, the photograph serves a biographical function, and gains specific meaning. The combination of biographical theme and photograph suggests that the "family happiness" shown was impaired by the anticommunist measures directed at Hulsberg. Thus, alternative meanings of the picture are excluded in two ways: the photograph not only acquires a fixed meaning as it is used to illustrate a specific biographical context, but Hulsberg's narration also implies that it was originally taken in that context. Hulsberg's biographical self-presentation and the booklet do not merely place the picture in a political context, but claim that it never was anything but a political picture in the first place.

Blurring the Lines

Without these framings of narration and publication, the photograph showing Hulsberg's family could be taken as a private situation. Accordingly, it would

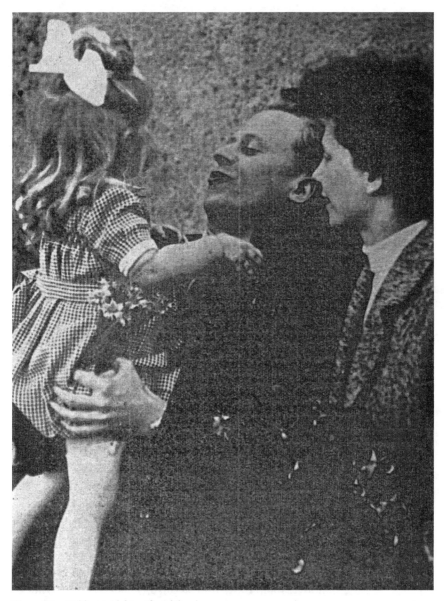

Figure 6.3 Hulsberg with his wife and daughter.

be possible to find the same type of picture in one of Hulsberg's family photo albums. However, as pointed out above, by his narration Hulsberg constructs a *political* and thus *public* context of production of the photograph. What does this mean with regard to the analysis of photographs like the one discussed here? Research concerning the interpretation of photographs often distinguishes

between "private" and "public" photographs. This distinction is usually based on assumptions about the context of production of these photographs.[20]

In the case of the photograph showing Hulsberg's family, we do not know whether an existing "private" picture was used for the booklet or whether the photograph was taken to illustrate the booklet. We just know that Hulsberg's narration constructs a political context. Because of this ill-defined knowledge, pictures like this can not easily be classified as either private or so-called professional photography. The use of photographs shows a blurring of the lines between "private" and "public." This blurring effect is due to the fact that in our research we are dealing with accounts of the *political* biographies our respondents consider relevant. This is intensified by the fact that the photographs appeared in semipublic booklets.

Furthermore, it seems, by placing that family picture in a clearly political and thus *collective* context it functions like a part of a "collective family photo album"; the booklets act as a reservoir for the collective memories of the "family" of communists. The selection is similar to that of family photo albums in that both present ideal images of a certain social group[21]—a family or the collective of "victims of the Cold War." Marita Krauss has pointed out that both family photographs and public photographs have the same potential for being taken out of context (of the initial production) and becoming symbolic images that carry new meanings.[22] Nevertheless, the selection of photographs in the interviews also differs from what is usually included in family photo albums, which often show pictures, in chronological order, of transitions in social status.[23]

To sum up, what is distinctive about the interviews with West German communists is how they try to link their personal narratives to the collective memory of their group. Because they aim to find a place in the hegemonic history of the Federal Republic as "victims of the Cold War," communists do not consider their life stories as "private," but rather as representative of a shared experience.

With their self-image as witnesses, in the interviews they draw upon press photographs not merely to legitimize narrations, as one might think. Rather, photographs and oral accounts are interrelated in a way that influences the structure and content of the narratives as well as the reception of photographs. To be sure, in the biographical interviews the communists at times use photographs to corroborate their narratives and their implicit interpretations. This usage is facilitated by the still common idea that photographs "represent reality."[24] In addition to the documentary function, however, the photographs presented in the interviews take on specific biographical *meanings*.

Furthermore, in this interview context, the documents and photographs afford our respondents the opportunity to integrate the views of other actors, such as the courts, the media, or the political "enemy," and, at the same time, to distance themselves from these views. With the help of the documents, they present the legal and administrative persecution of communists in the Federal

Republic in a seemingly neutral way while, at the same time, making their own interpretations seem more plausible. The use of the legal documents, newspaper articles, press photographs, and booklets in the biographical narrations also suggests a fixed context of their production. Our case studies highlight the importance of attending to the interrelatedness of written documents, photographs, and narrative interviews. They show how we need to examine the social, generational, historical, and biographical constructions of meaning in these different but interconnected forms of self-representation.

Notes

1. Names of all interviewees and places have been made anonymous.
2. Ver.di, ed., *Die vergessenen Opfer des Kalten Krieges. Begleitheft zur Ausstellung: Hier besteht Handlungsbedarf. Die vergessenen Opfer des Kalten Krieges. Erinnerungsarbeit gegen den Trend* (Berlin, 2005). The exhibition and the accompanying booklet were prepared cooperatively by ver.di MedienGalerie, the magazine *antifa* published by the VVN-BdA and the "Initiativgruppe für die Rehabilitierung der Opfer des Kalten Krieges".
3. This research is funded by the Deutsche Forschungsgemeinschaft (2008–2010) and is located at the Department of Cultural Sciences at the University of Bremen. Whereas the study as a whole follows a comparative approach, this chapter concentrates on the older generation of West German communists.
4. During this "main introductory narrative," interviewer activity is limited to active listening. This is followed by the interviewer asking, first, questions pertaining to aspects addressed in the main introductory narrative (internal questions) and, second, questions related to topics or biographical threads raised by the interviewer (external questions). The main objective of the narrative interview is to elicit and sustain narrative sequences focusing on the respondent's actions and experience (see Fritz Schütze, *Die Technik des narrativen Interviews in Interaktionsfeldstudien—dargestellt an einem Projekt zur Erforschung von kommunalen Machtstrukturen. Arbeitsberichte und Forschungsmaterialien Nr. 1* (Universität Bielefeld, Fakultät für Soziologie, 1977), 10). In this method, based on the theory of narration, the narrative is of greater importance than the schemes of description and argumentation. The narrative is thought to be especially informative with regard to the actions recounted. This does not, however, imply a homology between experience and narrative, as some critics have argued. For an English-language description of the method, see for example, Fritz Schütze, "Pressure and Guilt: War Experiences of Young German Soldiers and Their Biographical Implications", *International Sociology* 7 (1992): 181–208; Gerhard Riemann, "A Joint Project Against the Backdrop of a Research Tradition: An Introduction to 'Doing Biographical Research'," *Forum Qualitative Sozialforschung/Forum Qualitative Social Research*, 4 (2003): [http://www.qualitative-research.net/index.php/fqs/article/view/666]. Accessed May 6, 2010.
5. Dialectal color, pauses and paraverbal phenomena included in the interview transcripts are omitted in the passages quoted here for sake of readability.

6. See, for example, Gabriele Rosenthal, *Erlebte und erzählte Lebensgeschichte. Gestalt und Struktur biographischer Selbstbeschreibungen* (Frankfurt a.M.; New York: Campus, 1995); Gabriele Rosenthal," Reconstructions of Life Stories. Principles of Selection in Generating Stories for Narrative Biographical Interviews," *The Narrative Study of Lives* 1 (1993): 59–91; Martina Schiebel, *Wechselseitigkeiten. Lebensgeschichtliche Institutionalisierungen ostdeutscher Frauen in Führungspositionen der Wohlfahrtspflege* (Bremen: Donat, 2003).

7. The use of this term comes from Gabriele Rosenthal (see note 6), who stresses the gestaltness of biographical self-descriptions.

8. See note 4.

9. "Dünnes Gelenk" (Slim Wrist), *Der Spiegel,* 10 (1969): 57.

10. See Figure 6.2.

11. According to Alheit, biographical representations at this early stage of constructing traditions are characterized not only by the fact that they are told repeatedly, and that their telling requires a social frame in which they are expected (e.g., a company party or a family celebration), but also by weakening ties to the event recounted, and by their being enriched with interpretive knowledge from daily social life (see Peter Alheit, *Zivile Kultur. Verlust und Wiederaneignung der Moderne* (Frankfurt a.M.; New York: Campus, 1994), 116f).

12. Harald Welzer, Sabine Moller, Karoline Tschuggnall und Olaf Jensen, *"Opa war kein Nazi". Nationalsozialismus und Holocaust im Familiengedächtnis* (Frankfurt a.M.: Fischer, 2002), 105.

13. See Roswitha Breckner, "Abgelegte Erinnerungen? Was Fotoalben verraten," *Der blaue Reiter: Journal für Philosophie* 18 (2004): 64.

14. "Prozesse. Kommunisten—als Menschen untadelig" (Trials. Communists— Personally Irreproachable), *Der Spiegel,* 40 (1962): 54–56.

15. The research project aims to reconstruct the biographical meaning of the experience of political imprisonment and other sanctions, and to assess its consequences for political activity. Therefore, the focus is on the biographical constructions of the interviewees and not on any specific phase of contemporary history.

16. Alheit, *Zivile Kultur,* 114f.

17. For the typology of witnessing see Aleida Assmann, "Vier Grundtypen von Zeugenschaft," in *Zeugenschaft des Holocaust. Zwischen Trauma, Tradierung und Ermittlung,* ed. Michael Elm and Gottfried Kößler (Frankfurt a.M.; New York: Campus, 2007), 33–51.

18. See Maurice Halbwachs, *Das kollektive Gedächtnis* (Stuttgart: Ferdinand Enke, 1967).

19. Dorothee Wierling, "Oral History," in *Neue Themen und Methoden der Geschichtswissenschaft. Aufriß der Historischen Wissenschaften,* ed. Michael Maurer (Stuttgart: Reclam, 2003), 81–151.

20. See for example Marita Krauss, "Kleine Welten. Alltagsfotografie—die Anschaulichkeit einer 'privaten Praxis'," in *Visual History. Ein Studienbuch,* ed. Paul Gerhard (Göttingen: Vandenhoeck & Ruprecht, 2006), 57–75.

21. See Marianne Hirsch, *Family Frames. Photography, Narrative and Postmemory,* (Cambridge, MA: Harvard University Press, 1997 and 2002).

22. See Krauss, "Kleine Welten," 59.

23. See Roswitha Breckner, "Abgelegte Erinnerungen? Was Fotoalben verraten," *Der blaue Reiter: Journal für Philosophie* 18 (2004): 63.

24. See, for example, Roswitha Breckner, "Pictured Bodies. A Methodical Photo Analysis," *INTER (Interaction, Interview, Interpretation). Bilingual Journal for Qualitative-Interpretive Social Research in Eastern Europe* 4 (2007): 125–141.

Making Histories

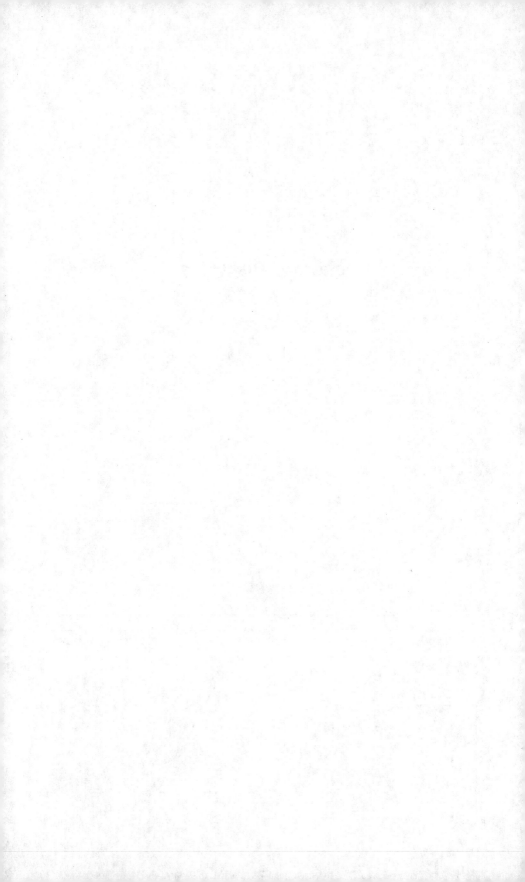

From Propaganda to the Personal: WAVES, Memory, and the "Prick" of Photography

Kathleen M. Ryan

Media and visual studies researcher Kathleen M. Ryan interviewed female navy recruits who served in World War II and asked them about photographs the women had kept from the period as well as propaganda photographs produced by the U.S. Navy. Ryan explores the interplay of values, memories, and images in the women's self-presentation vis-à-vis their public image as it was created by navy photographs, just as Schiebel and Robel's essay considers how German communists used press photographs in their life–story telling, and Payne's essay shows how young Inuit Canadians reconfigured the meanings of government photographs taken in the 1950s. Ryan uses Barthes's notion of the "punctum"—that aspect of a photograph that catches one's eye, that touches one personally, that gets under one's skin—to better understand the meaning gap opened by, on the one hand side, glorious, liberating, oral narratives and, on the other, sometimes mundane photographs. It is the punctum that allows her to establish a link between the past and the present, between the women and history, between the imagetexts and herself. Like other essays in this collection that are explicit about the historian's role and relationships in their interviews and history-making, for Ryan this "punctum" helps her analyze how she participates in the construction of the WAVES' history.

During World War II, the U.S. Navy used photography as both a historical recording device and a propaganda tool. Famed photographer Edward Steichen headed the navy's photography unit, coordinating efforts to present a consistent visual message.[1] Photographs were sent to newsrooms showing naval personnel in training or on the job. The photographs were especially important in shaping public perception of the navy's female recruits, the WAVES (Women Accepted for Volunteer Emergency Service). The navy developed specific goals for its promotion of WAVES, including key publication dates and overall themes, which it distributed to news outlets around the nation.[2] The photographic propaganda was crafted to create the image of women serving as refined, cultured, and elegant.

In contemporary oral histories, individual WAVES have described themselves, and the navy, in ways that echoed the themes portrayed in navy publicity.[3] The women denied any knowledge or remembrance of the publicity campaign. Nonetheless, they saved *individual* navy-created photographs, while claiming not to know that these same photographs were part of the navy's *overall* publicity plans. Even photographs outside of the navy's publicity machine, including snapshots taken of and by individual women, echo and reinforce the navy's publicity goals. This raises the question: did the navy "make" the women, or did the women, in essence, "make" the navy, being drawn to a military branch that already echoed their perceptions of themselves?

The "Prick" of Memory / the "Prick" of the Image

Oral historians investigate how memories of direct experiences, stories from others, and even false recollections become "stuck" in an individual's brain and told as part of a personal life story, where individuals reassess and evaluate their own life experiences.[4] Walter Benjamin divided memory into two complementary parts. *Mémoire involontaire*, the events the individual has experienced indirectly (such as by watching a film, viewing a photograph, or hearing a story told by another), works hand in hand with *mémoire volontaire*, a conscious remembering of actual experience. Benjamin privileged *mémoire involontaire* because he felt its mnemonic partner was fraught with limitations. *Mémoire involontaire*, by contrast, is independent from direct personal experience. It is the afterimage or trace of something that gets stuck in our brain.[5]

Oral history is suffused with *mémoire involontaire*. It litters the stories of the 52 veterans who participated in my project. In their storytelling, the women combined their direct experiences of World War II with memories of mediated images and the stories of others.[6] *Mémoire involontaire* also affects the researcher. It explains how the women's stories remain as an afterimage in my brain, becoming part of my memory, often forgotten, only to be triggered by some unrelated

sensory experience, such as hearing a snippet of music or touching a piece of fabric.[7]

In essence, there is something about the story that "pricks" the listener, allowing it to linger in the brain. Of course, this is not limited to the storytelling process. Visual communications scholars have found something similar in how we understand and remember photographic imagery. They argue that audiences perceive the visual at a different and more basic level than language, and our "ability to hold the image over time, a process described as 'working memory,' is ultimately the basis of extended consciousness."[8] The photograph, an image that only exists through the mediation of a camera and a darkroom, is especially potent. It has the potential to burn itself into an individual's memory, leaving an afterimage that Roland Barthes refers to as the punctum.[9] As with *mémoire involontaire*, the memory of the photograph held in the mind's eye can be more potent than the photograph itself.

The Magazine Photograph

In order to appreciate the attraction of the navy images, it is crucial to understand the intersection between audience and cultural output during the World War II–era. The U.S. government attempted to control media messages through the Office of War Information (OWI). It struggled with two seemingly contradictory messages: "to convey the serious side of the war...(and) to maintain the morale of the public they served."[10] The OWI-developed American propaganda is widely considered to be successful. The oftentimes idealistic messages promoted a view of America holding the moral high ground, assisting allies who held similar beliefs.[11]

The navy worked hand in hand with the OWI to publicize its new female force, which began in August, 1942. By October, 1943, the two copublished a media guide for magazines, newspapers, radio, and newsreels. The booklet outlined recruiting goals and sought to use media coverage to reinforce the navy-constructed identity for the WAVES: an elite group made up of "some of the most attractive, and alert young women of today" who joined "to make their contribution to victory."[12] The women would become leaders "both in military and later in civilian life,"[13] and were praised by the president of the United States. The guide identified times for stepped up publicity, coordinated with navy recruitment goals.

In November and December of 1943, months identified for intensified publicity, photo essays by Lousie Dahl-Wolfe appeared first in the fashion magazine *Harper's Bazaar* and then in *Vogue*. The series of photographs (three in *Harper's* and three in *Vogue*) was taken at the Naval Air Combat Station in Jacksonville, Florida. The essays are remarkable in the artistic way Dahl-Wolfe portrayed the

women, interpreting the navy editorial suggestions in an aesthetically pleasing manner, while at the same time using those images to tell a compelling story about women serving in the navy. The photographs are imbued with punctum.

One, in particular, resonates.[14] An aerographer's mate looks to the sky, peering through a piece of forecasting equipment. The woman is in profile, her head tilted back, highlighted by the rays of the sun. She is in shirtsleeves, leaving her fitted jacket aside. The photo demonstrates that "Dahl-Wolfe knew precisely how to make [a] woman look casual, comfortable, cool, and nonetheless, ineffably chic."[15] The woman in the photo isn't a model, but rather a WAVE on duty. The tilt of her head, her loose hair falling to her collar, is both casual and fashionable at the same time. The woman's skin glows with the light of the sun. Her uniform, lacking the formality of the jacket, appears both supremely comfortable and also classically elegant. The angular lines of the huge machine she peers through accentuate the long, lean lines of her body. She looks up through the machinery, gazing to the heavens. She appears to be a woman supremely in control of her own life.

But it is the small details that draw me to the photograph. Her neatly manicured left hand grabs the weather forecasting machinery, but her pinkie finger trails, in a dainty echo of the etiquette protocol of English high tea. Her right hand, in deep shadows, grasps a thin handle on the machine, creating a visual echo of those same etiquette norms. The imagery reinforces the notion of the WAVES as ladylike or cultured. But at the same time, the woman is challenging traditional notions of what it means to be a "lady." She is going hatless in an era when it was considered proper for both men and women to wear a headcovering while outside; a hat was part of the WAVES uniform. Her curled hair is loose, with a few tendrils caught in the breeze. She seems to be looking up toward an unknown, but optimistic future (perhaps a time after the war ends?). The tilt of her head, the angle of the machine, and the line of her arm all point to the same direction, a spot outside of the upper-left quadrant of the image. The viewer is left to imagine what she sees.

The aerographer's mate, and other women featured in the magazine essays, were those who were perhaps most directly freeing men to fight. Men skilled at shooting from gunnery turrets and piloting planes would be far more useful on the battlefield than in the classroom training others, weather forecasters could be better used on the front lines than stateside. The navy recognized this; by 1944, "the number of WAVES on duty…equaled the number of men it would have taken in peacetime to man ten battleships, ten aircraft carriers, 28 cruisers, and 50 destroyers."[16] In many cases, the women surpassed the men doing the same jobs. As the war progressed, being trained by a woman was a status symbol of sorts, as it was believed that the better and more competent pilots and gunners were trained by women.[17] Despite these advances, the navy was fighting an outside perception that saw military service for women as "unfeminine, regimented

routine, and with a questionable social status."[18] Bilge Yesil contends that the government's World War II propaganda imagery presented idealized images of the woman war worker, which, far from empowering, instead marginalized women's efforts.[19] While on the surface the images seemed to empower women, by encouraging them to take less-than-traditional roles in the workplace, the images also encouraged women "to be feminine, attractive and dependent on men, and idealized the notions of domesticity, home and family."[20] This was reinforced by the nature of the work, which was only temporary, until male workers would return home.

While this reading may be true for some campaigns, the navy's message was more complex. Far from positioning women as secondary to men, the navy's propaganda mission sought to demonstrate that a WAVE "share(d) with our men in uniform the responsibility and honor of contributing directly to the Nation's battle for victory."[21] The navy's message was that the women's work was not only important for the war effort, but would also improve the already-high character and abilities of the women volunteers.

The photograph of the aerographer's mate reflects the self-assuredness of the WAVES, which is manifest in the WAVES' descriptions of their own jobs. "I was assigned an SNJ...I had to take care of the plane," recalled machinist's mate Pat Pierpont.[22] "It was fascinating," said Link trainer Dot Forbes, before describing her job in minute detail.[23] Gunnery instructor Josette Dermody used sound effects to describe how the simulator sounded: "It was kind of an early audio visual arcade."[24] Nowhere in the memories is there any indication that the women felt that they were somehow "secondary" to the war effort. In both the photograph and the women's memories, their work is of utmost importance, absolutely vital to the United States' success in World War II.

The Official Navy Photographs

The navy was a prolific producer of photographs, with tens of thousands of images created by the end of the war.[25] Headed by photographer Edward Steichen, navy efforts focused on "the unifying themes of American patriotism, strength and spirit."[26] The publicity for WAVES began as women entered basic training, known as boot camp. Navy representatives took photographs and wrote news releases about the women as they circulated through, providing information for hometown newspapers.[27] Navy personnel charted where recruits came from and stepped up publicity in service districts where enlistments were declining.

Initially women were only allowed to serve in specific roles (clerical and radio work), but eventually women were able to serve in a wide variety of positions stateside, including "glamorous" jobs working around naval aircraft such as those depicted in the Dahl-Wolfe magazine essay. While on the one hand the

navy attempted to downplay the unusual (aircraft base work), on the other they publicized the same women's work.[28] Pat Pierpont, an aircraft machinist's mate, has an eight-by-ten glossy, black-and-white photograph taken while she was assigned to the Jacksonville Naval Air Station as an aircraft machinist's mate (see Figure 7.1). Pierpont is a tall, slender woman; in the photograph she stands on the runway, dressed in men's slacks and a work shirt, signaling a plane with semaphore flags. Her demeanor in the photograph calls to mind a young Katharine Hepburn, or Dahl-Wolfe's aerographer's mate.

The photo's punctum is tightly linked to Pierpont's stories, cemented in my mind due to mémoire involuntaire. Pierpont never said she came from a well-to-do family, but did talk about growing up in Connecticut (like Hepburn) and attending a boarding school during her high school years. She joined the navy specifically to serve as a machinist's mate. She said she never considered she would be assigned another job. In her storytelling, she constructed the job as different from those held by other WAVES. As a machinist's mate, she was the elite of the elite. "It was limited to how many they could put in aviation machinist's mate school," Pierpont said, explaining that women took aptitude tests to be able to work in the aviation fields.[29]

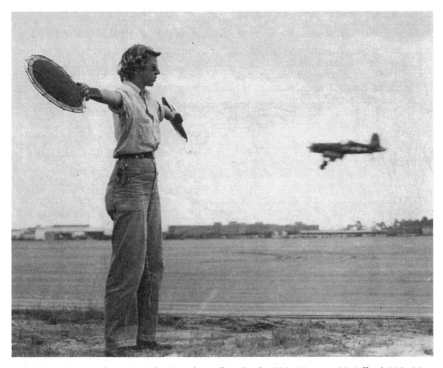

Figure 7.1 "Wave Flagging a Plane," Jacksonville, Florida, U.S. Navy, 1944 (official U.S. Navy photograph, personal collection of Pat Pierpont Graves). Pat Pierpont is the aviation machinist's mate in the photograph.

The details in the photograph reinforce her storytelling. Pierpont, like the aerographer's mate, is working in a man's job on the Jacksonville Naval Air Station. She stands in profile, hard at work using semaphores to signal a plane to the runway. She appears fully competent and capable of her work. But unlike the WAVE in *Harper's Bazaar*, Pierpont isn't glamorous. She is wearing men's pants made of a heavy cotton material; a tangle of keys and what appears to be a utility knife hanging from a metal ring attached to her belt loop. Her shirt isn't a spotless white cotton, but instead is a heavier material in a light color. She stands alongside the runway in a tangle of weeds. A blurred plane is landing in the background, its landing gear extended as it approaches the runway. The plane draws my attention. Its motion contrasts with Pierpont's seeming stillness, though of course as a signaler she would have been in action on the runway.

Pierpont remembered this single photograph, rather than any of the thousands of others the navy created. She brought it out for me to see when discussing her oral history. This illustrates another trend in the project: the women interviewed only recall (and usually saved) publicity when it was specifically about them, from articles about their enlistment to copies of official navy photographs of their work experiences. Other publicity they only vaguely remember. Dorothy Turnbull, for instance, was a WAVE recruiter and in a position to remember WAVE publicity campaigns. She saved numerous photographs taken of various campaigns she staged. She had no memory of any of the national media publicity surrounding the WAVES.

Turnbull, based in southeastern Texas, regularly crafted different approaches to drum up potential enlistees. One of her duties was to walk around downtown areas in her uniform and simply talk to people who asked about it. She made pitches at schools, college campuses, or the local YWCA. Her ploys ranged from the basic (an afternoon tea) to the creative (a Mardi Gras party where women would pull small charms out of a cake to represent the jobs they would hold if they enlisted). One photograph features a group of WAVES in modest bathing suits, gathered around Turnbull, who is wearing a crisp seersucker uniform (see Figure 7.2). The photo is a curious interpretation of the pinup trope. Turnbull and two women (a brunette and a blonde) stand on top of a stage covered in bunting. Two other women kneel in the sand below. Seven identical recruitment posters lean up against the stage while others are held by the kneeling women. The ocean is nowhere to be seen, but the day is breezy, with the wind blowing the women's hair out of place.

But none of these details make up the punctum of the photograph. It is the stark contrasts that tantalize the viewer. The eye first is pulled to the top of the photograph, where Turnbull stands broadly grinning in her uniform, linked arm in arm with two of the swimsuit-clad women. While the two women bookending her look directly at the camera, Turnbull is looking off above the photographer's lens. She's wearing a hat, flesh-toned stockings, and dark colored pumps on a

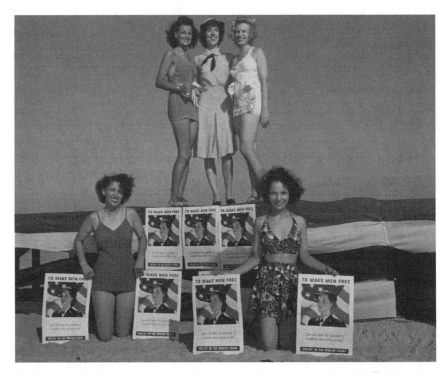

Figure 7.2 WAVES Recruitment Drive, Galveston Beach, Texas, U.S. Navy, *ca.*1944 (official U.S. Navy photograph, personal collection of Dorothy Turnbull Stewart). Dorothy Turnbull is at top center with several unidentified WAVES.

day warm enough to be out in a swimsuit. Her sartorial polish seems almost incongruous with the casual scene pictured. She is a professional standing amid a bevy of pinups.

World War II has been described as the "golden age" of the pinup.[30] They appeared everywhere, from magazines such as the highly sexualized "Varga Girls" of *Esquire*, to drawings of attractive, scantily clothed young women on the noses of planes used in bombing runs.[31] Pinups were understandably popular with men, but women also embraced the image. Maria Elena Buszek argues that women of the era saw the pinup "as an icon of the new, wartime ideals of women's sexuality."[32] Not only did women read magazines like *Esquire* (evidenced through letters to the editor), but they also created do-it-yourself pinup snapshots. The pinups "gave women a language for...sexual self-expression."[33]

The pinup becomes a type of culturally understood myth, which as Barthes notes can both form and transform meanings within a culture.[34] The idea, firmly entrenched within a culture, eventually becomes a sort of shorthand, essentially invisible, reinforcing the construction. In this case, the World War II pinup has two purposes: not only reinforcing traditional notions of woman as a sexual-plaything, but also transforming sexuality into a type of empowerment.[35]

Oral history becomes a way to understand if the navy women embraced—or rejected—the pinup archetype. Turnbull offered an explanation of the thinking behind her photograph:

> They were showing the audience that we had gotten together. They were showing how the women in the navy were still women. And ladies. The whole thing was to let society know that our girls were their girls…They were daughters and sisters.[36]

Her interview makes it clear that the incongruity was a conscious construction. Turnbull, the WAVE recruiter, is shown as an elegant mother hen of sorts, shepherding a group of wholesome women into a classy adventure in the WAVES. This construction dovetails with her description of herself, and her own role in the military. She came from what at the time would have been called a "comfortable" family. Her father was a land developer in the New Orleans area, and a member of several local krewes, regional social clubs that helped put on the city's famous Mardi Gras celebrations. During high school Turnbull rode on one of the Mardi Gras floats as a princess, and was a member of a school sorority. After graduation, she attended Newcomb College, the prestigious women's institute affiliated with Tulane University. After she graduated, Turnbull enlisted in the WAVES, and was assigned to become a recruiter because she was good at talking.

By looking at the photograph, and listening to her interview, it is impossible to imagine this articulate young woman having much trouble convincing four others to appear in their bathing suits. Each looks comfortable and relaxed. But these aren't the empowered, sexually charged poses of the pinup that Buszek describes. Even though the women (except for Turnbull) are in bathing suits, and their hair is mussed, the photograph is of daughters, and sisters, not girlfriends. The women are wholesome and chaste.

With one exception: the brunette kneeling at the lower right. She's the only woman showing a hint of a midriff, wearing a two piece swimsuit with daring décolletage. While the other women are dressed in monochrome prints or a chaste white, her suit is a dark Hawaiian floral. The other swimsuits are each in a similar modest cut; hers has a kicky skirt that is getting caught in the breeze. Her eyes are perky, her smile flirty. She is not just an anonymous face or figure, but rather a desirable woman filling an important wartime role. She is the "tantalizing and wholesome ideal, developed through and sanctioned by radically new roles for women in the public sphere."[37] If she were alone, she might be considered a pinup. But when her pose combined with that of the other women, including the fully clothed Turnbull, the sexuality of the young woman in the Hawaiian-print two-piece suit is tempered. She is desirable not simply because of her attractiveness, but because she is doing an important job. As a result the photograph's hint of sexuality serves not to push boundaries, but rather to reinforce Turnbull's (and

by extension the WAVES') message. The women who joined were the elegant girls next door, not the sexualized (or sexually empowered) pinup. The official navy photograph ultimately toed the party line, and this construction would later be echoed in the women's description of their service.

The Personal Photographs

While all women saved official photographs, those in glamour jobs like Pierpont and Turnbull saved photographs of themselves at work. By contrast, yeomen and storekeepers[38] saved photographs of themselves in military formation. These personal mementos are evidence of the divide between the two groups. Both groups of women embraced the navy's framing that the WAVES were "elite." However, those who did work unusual for women could use their jobs as a manifestation of their elite status. Yeomen and storekeepers, who worked in jobs similar to those women could do in the outside world (secretarial and bookkeeping), used their military identity to differentiate themselves from the general population. They became elite by putting on a uniform and becoming a WAVE.

All of the women, regardless of job, shared one element in describing their military lives. Each described herself as a trailblazer; someone who was doing something unique for the time. Again, how each woman said she blazed a trail is dependent upon her job. Those who worked as aerographers, machinists, link trainers, or gunnery instructors used their work as a way of demonstrating their status as an innovator. Those who held WAVE jobs similar to work readily available to women in the outside world (yeomen, storekeepers) described themselves as being unusual within the military group. They were the first, or only, woman to be placed in a particular situation, or they experienced specific things away from the job that set them apart not only from civilians, but also from the rest of the WAVES. They constructed themselves as different.

Margaret Anderson, a yeoman, directly expressed frustration with her navy assignment. "Unfortunately, I got a paper pushing job," she said.[39] She was based in San Francisco, and was part of a large contingent of women who were tasked with following the paper trail of a ship's orders. But outside the job, Anderson described a world of excitement where she was able to fulfill her dream of being an "adventurist." She lived in an apartment paid for by the navy, and was convinced her first landlady was an enemy agent. "We turned her in to the local authorities," she recalled; her roommates caught the woman rifling through their paperwork.[40] She met Eddie Cantor, a popular entertainer of the era. She attended the peace conference held by the group that was to become the United Nations, witnessing the signing of the U.N. charter. She toured the USS *Missouri* with a group of WAVES, as it was stationed in San Francisco Harbor before heading to the South Pacific. Anderson was a treasure trove of 1940s minutiae.

Yet the photographs reveal little of the punctum evident in her storytelling. While Anderson's richly detailed stories become stuck in the listener's brain (painting equally vivid mental pictures), her corresponding images are much less memorable. The photograph of Anderson standing alongside two fellow WAVES and a young boy is typical of the snapshots she shared with me (see Figure 7.3). The photographer looks up at the quartet, who are posed in front of a leafy oak. It's obviously a warm day, as the women are wearing their summer searsucker uniforms without a jacket. The photograph is remarkable in its ordinariness. Minus the uniforms, and the war headline plastered across the top of the newspaper the little boy holds, the photograph could have been taken any time, any place. It echoes hundreds of thousands of other anonymous snapshots stuffed in shoeboxes around the globe.

Anderson is posed at the right of the image. As I look at her face, with its slightly shy smile, I wonder why she shared this particular photograph with me. Where is the adventurist? Was it the uniform itself that was significant to her, evidence of this huge wartime mobilization? The photograph, unlike the stories, was something concrete that Anderson could reflect upon in the years after her military service. She had no physical evidence of any of the exciting wartime stories she told: no paperwork from a "report to the authorities," no photo with Eddie Cantor or aboard the USS *Missouri*, no program from the U.N. chartering ceremony. The photograph was something Anderson could share with me, tangible proof that she had served in the WAVES. Thus, its punctum is not in the image itself, but in the stories that it only tangentially supports. Without the interview, the photograph would be eminently forgettable.

Other women shared photographs that featured more distinctive images. But like Anderson's, the puntum of the photograph became sharper when it was viewed with the cultural and temporal understanding oral history provides. Merrily Kurtz, for example, brought photographs of her out-of-uniform leisure time on the Hawaiian beaches. She belonged to a group of 4,000 WAVES who served in Hawaii during the waning years of the war. Hawaii was a U.S. territory at the time and so the assignment was technically "overseas." The navy was concerned about the safety of women in the exotic foreign base. One captain recommended building a low fence around the WAVE quarters, supposedly to protect them from men.[41]

But the official concerns contrasted with the unofficial role that developed for the women outside of their workday duties. Louise Wilde, the WAVES commander in Hawaii, told how the women would frequently be invited to socialize at parties as homecoming escorts for men who were returning to port after serving months at sea[42] Some parties were organized as part of the official social events on the military bases (such as dances), but more often there were informal activities like the beach parties seen in Kurtz's photographs. Kurtz's images are relaxed and lack the formality of official navy photographs. In one, Kurtz sits on the sand in a white two-piece bathing suit (see Figure 7.4). A young

Figure 7.3 "Dress Greys," Cedar Falls, IA, *ca.*1944 (courtesy of Margaret Thorngate). Margaret Anderson is at right with two unidentified WAVES and a newspaper boy.

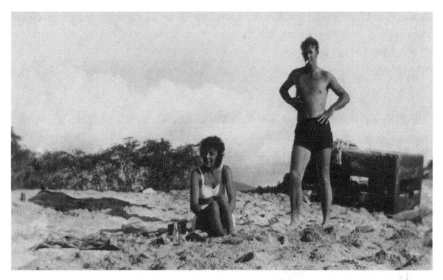

Figure 7.4 Merrily Kurtz and friend, Honolulu, Hawaii, *ca.*1945 (courtesy of Merrily Hewitt).

Marine stands alongside of her in swimming trunks. Beer bottles litter the sand and a large cooler rests nearby on the beach. Initially, when Kurtz showed me the photograph, I compared it to the series of lighthearted films from the 1960s starring Frankie Avalon and Andette Funicello, such as *Beach Blanket Bingo*.

We looked at the photograph and then went on to other stories. But Kurtz felt compelled to return to the photograph—and what it represented—during our conversation. The process of telling her oral history, alongside the personal snapshots from the era, allowed her space for reevaluation:

> I think in a way, this is kind of off the top of my head, that the reason they had us WAVES go to Hawaii...was for us to mix with the fellows that were coming back from overseas. A lot of those fellows had been over there two, three years and longer. A lot of them hadn't seen white women and they didn't really know how to act and react to women. So it kind of, if they did come out and...get used to us again.[43]

The idea that WAVES were doing something beyond their official jobs was something that came "off the top of (her) head." It is only with the wisdom of hindsight that she realizes the benefits their presence had on the men stationed temporarily in Hawaii—helping them to become re-acclimated to "normal" life through non-combat events like beach parties.

The revelation deepens the meaning of the snapshot and helps me zero in on why this particular image becomes wedged in my brain. Kurtz suns on the sand next to a Marine striking what seems to be a bodybuilding pose. A closer

look reveals that Kurtz's posture seems tentative and uncomfortable. Her hands are wrapped under her knees, hiding or protecting her body from the Marine (as well as from the snapshot viewer). The Marine's posturing is fraught with a similar tension. He doesn't seem to know how to hold his hands, which are posed awkwardly next to his body. He appears to be rubbing his belly with one hand, while the other is splayed across his left hip.

Without Kurtz's story, I wouldn't know to look to the Marine's body language. The other small details of the photo, the sand on the beach and the litter of empty bottles, become distractions. The punctum lies in his hands, which demonstrate his difficult transition moving from a fighting man to civilian life. They lack the "comfort" of cradling a gun, the assuredness of having something to hold onto in a (social) situation. It's a revelation that extends beyond the beachfront scene, and to the greater postwar world: he doesn't know what to do outside of war. It is up to a subsection of the WAVES, the elite of the elite as it were, to help him find his way back to "normal" society.

So did the navy "make" the women, or have the women, through carefully cultivated (and curated) personal memories and photographs, crafted a version of the navy that fits their own sense of self? This is a difficult question to answer. The five photographs shown here are a small selection of the thousands of photographs of WAVES produced in and out of the navy during World War II. Similarly, the interviews represent a small cross-section of the 100,000 plus women who served as WAVES. Nonetheless, the images and oral histories reveal consistencies. The stories demonstrate how the women remembered the navy's construction as an "elite" force, and also reveal that they were perhaps drawn to this service branch because of the navy's "reputation." The photographs offer visual evidence of the navy's construction, either as a "glamour girl" or as a modified "pinup" with just a hint of sexuality, but the women's stories, and the associated photographs, complicate this image, revealing women with a strong sense of self. Their work wasn't superficial, but vital to the U.S. war effort.

This study illustrates that when used together, visual communication and oral history can bridge the temporal divide which may exist between the era that the narrator is discussing and the time and place of the oral history interview. Through photographs, the oral historian can better understand specific cultural conditions, such as those that led these World War II–era women to break the traditional boundaries of their time and enlist in the navy. For this cohort, pinup shots, glamorous fashion magazines' photo displays, or even personal photographs are used in later life as tools to reaffirm the value of the work done and the quality of the individual women serving. Through oral history storytelling, the punctum of the photographic evidence is enriched. It is the combined "pricks" of storytelling *and* photography that cause each to remain deeply implanted in our mind's eye, leading to a deeper understanding of the experience and memory of World War II WAVES.

Notes

1. Mame Warren, "Focal Point of the Fleet, U.S. Navy Photographic Activities in World War II," *The Journal of Military History* 69 (October 2005): 1049.
2. *Information Program for the Women's Reserve of the US Navy,* Office of War Information/Bureau of Naval Personnel, October 1943, Jane Barton Papers MC542 Box3 , Folder 3.1 [Loose items from #7F+B10-7F+B12], Schlesinger Library, Radcliffe Institute for Advanced Study, Harvard University.
3. A total of 52 women shared their life stories with the researcher. Interviews were gathered following human subjects protocol.
4. Alessandro Portelli, *The Death of Luigi Trastulli and Other Stories: Form and Meaning in Oral History* (Albany: State University of New York Press, 1990).
5. Walter Benjamin, *Illuminations,* ed. Hannah Arendt and Harry Zohn (New York: Schocken Books, 1969).
6. All but two of the women were members of the group WAVES National, which offered assistance finding participants. They originally came from all corners of the United States.
7. Alessandro Portelli, "Oral History as Genre," in *Narrative and Genre,* ed. Mary Chamberlain and Paul R. Thompson (London; New York: Routeldge 1998), 23–45.
8. Ann Marie Barry, "Perception Theory," in *Handbook of Visual Communication Research: Theory, Methods, and Media,* ed. Ken Smith, Sandra Moriarty, Keith Kenney, and Gretchen Barbatsis (Mahwah, NJ: L. Erlbaum, 2005), 51.
9. Roland Barthes, *Camera Lucida* (New York: Hill and Wang, 1981).
10. Allan M. Winkler, *The Politics of Propaganda: The Office of War Information, 1942–1945* (New Haven: Yale University Press, 1978), 57.
11. Winkler, *The Politics of Propaganda.*
12. Information Program, 2.
13. Information Program, 2.
14. The photograph can be found in the essay "WAVES: Sky Workers with Their Feet on the Ground" in the November 1944 U.S. edition of Harper's Bazaar.
15. Vicki Goldberg, "Louise Dahl-Wolfe," in *Louise Dahl-Wolfe,* ed. Dorothy Twining Globus, Vicki Goldberg, and Nan Richardson (New York: Abrams/Umbrage Editions, 2000), 21.
16. Jean Ebbert and Mary Beth Hall, *Crossed Currents: Navy Women from WWI to Tailhook* (Washington, DC: Brassey's, 1993), 90.
17. Mildred McAfee Horton, "Oral History," in *Recollections of Women Officers who served in the U.S. Navy and the U.S. Coast Guard in World War II,* ed. John Mason and Etta Belle Kitchen (Annapolis, MD: U.S. Naval Institute, 1979), 84.
18. *Information Guide,* 1.
19. Bilge Yesil, "'Who Said this is a Man's War?': Propaganda, Advertising Discourse and the Representation of the Woman War Worker During the Second World War," *Media History* 10, 2 (2004): 113.
20. Yesil, "A Man's War?": 108.
21. *Information Guide,* 5.
22. Pat Pierpont Graves, interview by author, Florence, OR, April 21, 2006. "SNJ" is the Navy designation for a pilot training aircraft used during World War II.

23. Dorothy "Dot" Forbes Enes, interview by author, Ellington, CT, August 18, 2007.

24. Josette Dermody Wingo, interview by author, Oxnard, CA, August 2, 2007.

25. The photographs can be found in the 80-G subject file in the National Archives.

26. Michael Griffin, "The Great War Photographs: Constructing Myths of History and Photojournalism," in *Picturing the Past: Media, History and Photography*, ed. Bonnie Brennen and Hanna Hardt (Urbana and Chicago: University of Illinois Press, 1999), 143.

27. *Navy Service: A Short History of the United States Naval Training School (WR) Bronx, NY*, compiled by the Public Relations Office, USNTS (WR), Elizabeth Reynard Papers, Box2 5V, Schlesinger Library, Radcliffe Institute for Advanced Study, Harvard University, 24.

28. Louise Wilde, "Oral History," in Mason and Kitchen, *Recollections of Women Officers*, 42.

29. Graves, interview.

30. Walt A. Reed, "Pin-Up Art: A Historical Commentary," in *The Great American Pin-Up*, ed. Charles G. Martingette and Louis K. Meisel (Köln: Taschen, 2002), 16.

31. Charles G. Martingette, "The Great American Pin-up," in Martingette and Meisel, *The Great American Pin-Up* , 32.

32. Maria Elena Buszezk, *Pin-up Grrrls: Feminism, Sexuality, Popular Culture* (Durham and London: Duke University Press, 2006), 208.

33. Buszezk, *Pin-up Grrrls*, 207.

34. Roland Barthes, *Mythologies* (New York: Hill and Wang, 1972).

35. Buzak, *Pin-up Grrrls*.

36. Dorothy Turnbull Stewart, interview by author, Salem, OR, April 17, 2007.

37. Buszek, *Pin-up Grrrls*, 187.

38. Secretaries and other office workers are known as "yeomen" in naval parlance; "storekeepers" refers to those who do bookkeeping and inventory work.

39. Margaret Anderson Thorngate, interview by author, Florence, OR, April 21, 2006.

40. Thorngate, interview.

41. Eleanor Grant Rigby, "Oral History," in Mason, and Kitchen, *Recollections of Women Officers*, 35.

42. Wilde, "Oral History," 42.

43. Merrily Kurtz Hewett, interview by author, Portland, OR, March 29, 2007.

Family Photographs as Traces of Americanization

Maris Thompson

Educational researcher Maris Thompson used family photographs and interviews with second-, third-, and fourth-generation German Americans in Illinois, United States, to explore photographic genealogical memories and to consider the memories and postmemories of discrimination during the two world wars as well as the lingering legacy of Americanization: "Oral testimonies and family photographs uniquely highlight how troubling events experienced during the first half of the twentieth century are still very much at work in the stories from these communities." While the oral testimonies revealed memories of anti-German sentiment, language restriction, and the need to keep a "low profile," the photo albums served as more positive anchors of family genesis, helping German American families to ground their identities in assimilation to the American landscape. Such multiplicity in meaning, or gaps between meanings, Thompson writes, are "productive spaces for analysis of social history." These gaps are also significant in the essays by Freund and Thiessen, Thomson, Marles, Mannik, and Tinkler. Like these writers, Thompson highlights the complex and contested uses of photography and personal narrative in dealing with conflicting and painful memories.

It has become apparent that we live and function within a fourth major environment—the symbolic. This environment is composed of the symbolic modes, media, codes, and structures within which we communicate, create cultures, and become socialized. The most pervasive of these modes, and the least understood, is the visual-pictorial.[1]

Concerns over the nature and degree of cultural and linguistic assimilation remain central to historical and contemporary discourses of immigration in the United States. In today's heated debates, the experiences of nineteenth-century European American immigrants are often used as a basis of comparison for the experiences of contemporary immigrants. "Master narratives" of European immigration stress the ease at which these historical immigrant groups willingly adapted culturally and linguistically to their lives in the United States.[2] Yet, these dominant portraits typically obscure critical variations in the Americanization[3] experiences of many European ethnics. Periods of anti-immigrant feeling in the early twentieth century dictated very narrow terms of acceptance for many immigrant groups. One group in particular, the German Americans, experienced targeted periods of anti-German sentiment after which the voluntary basis of identifying ethnically or linguistically was forever altered. The experiences of German Americans offer one example of a European immigrant group whose experience of cultural adaptation was circumscribed by institutional forces of language sanction, and accusations of American disloyalty.

This chapter examines oral testimonies and photographic narratives from second-, third-, and fourth- generation German Americans who came of age in southwestern Illinois in the first half of the twentieth century. During both world wars and the interwar period, many Midwestern German American

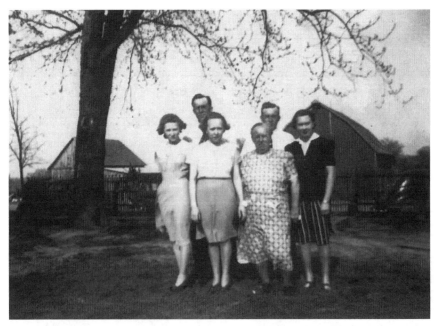

Figure 8.1 Walter Kottmeyer, his mother, and siblings on the family farm in Illinois (Kottmeyer Album).

communities experienced intensive anti-German hostility combined with government-sponsored Americanization efforts to eradicate the German language in schools, churches, and public places.[4] While most historical portraits of German Americans argue that these external pressures to assimilate resulted in the loss of language[5] and ethnic identity,[6] an exploration of the consequences of these rapid cultural changes for later generations remains overlooked. Oral testimonies and family photographs uniquely highlight how troubling events experienced by families during the first half of the twentieth century are still very much at work in the stories from these communities. Through visual and spoken testimonies, we come to understand collective and personal beliefs about the varied experiences of anti-German sentiment, and language loss, and how these beliefs get interpreted, reworked, and communicated to successive generations.

I am interested in how an analysis that juxtaposes visual and oral sources of testimony yields a more complicated picture of social history, particularly in the way these communities make sense of and talk about the past. Like Alessandro Portelli's explanation of inconsistencies in the oral stories of the Italian working class,[7] oral and pictorial testimonies from southwestern Illinois help illuminate divergent storylines of adaptation and loss. While family photographs respond to local "schemes of perception"[8] in representing the genesis of family identity, particularly the desire for upward mobility and cultural assimilation, oral testimonies reveal more painful chapters of anti-German sentiment in these communities. An analysis that articulates these two sources of testimony highlights the complicated nature of social memory for German Americans, and the often delimited terms of assimilation offered to them in the early twentieth century. This analysis also provides the groundwork for an interpretive discussion about the uses of visual and oral sources of evidence used by oral historians in interpreting social history.

Contexts of Anti-German Feeling

A "storm of anti-Germanism" raged in the period leading up to U.S. entry into World War I.[9] Some aspects of anti-German hysteria took on absurd manifestations such as the changing of German-associated words; for example sauerkraut became "liberty cabbage." Other aspects of public hostility were more far reaching, such as the closing of German ethnic societies, the shutdown of German language newspapers, and the abrupt end of German language instruction in schools and churches.[10] Dennis Baron notes German was targeted by the government as a language "to be rooted out,"[11] and many states including Illinois, Nebraska, and Wisconsin passed English Only constitutional amendments for schools, churches, and public places.[12] In Clinton County, Illinois, the area of this study, marriage and funeral records from

many local churches were kept in German from the earliest periods of German settlement until roughly World War I, when all records thereafter were kept in English.[13] For German Americans, "the eradication of one's ancestral language became an essential component of Americanization, and the rite of passage in the Anglo-American fold."[14]

The psychological impact on German American communities of these periods of anti-German hostility and language sanction is difficult to calculate. Many scholars argue that German Americans, faced with such large-scale language eradication and claims of disloyalty, opted for a more "submerged ethnicity"[15] where overt cultural practices were confined to the private sphere. Terrence Wiley is less moderate in his appraisal of these consequences, and notes the German response to this period amounted, essentially, to an "ethnic lobotomy."[16] Others, like Frederick C. Luebke, argue a "cultural amnesia" characterized later generations of German Americans who "spoke almost no German and knew little of German culture."[17] He notes, "the conditions that had promoted ethnic consciousness—large numbers, economic success, public esteem—had been more than offset by the intolerance of the war years, leaving the people for the most part demoralized, lacking in self-confidence, no longer proud of being German."[18] These periods of intensive anti-German feeling and of government-sponsored language eradication provide needed context in making sense of the stories and family albums that are shared in these communities.

Oral and Photographic Sources of Testimony

The following oral history research was part of a longer ethnographic study (2005–2006) that took place in Clinton County, located in southwestern Illinois, 25 miles east of the Mississippi River and the Missouri border. This small, rural county forms the center of a rough circle of German American communities that stretch about thirty miles eastward and twenty miles southward into adjoining communities of southern Illinois.[19] The data from this chapter includes interviews from eight participants who are second, third, and fourth generation German American, ranging in age from 61 to 93 years. Participants also represented different sexes, denominations, and social classes. Roughly half grew up speaking German as children.

After initial interviews with participants, it became clear that the family album played a central role in the telling of the family tale. Participants brought the albums to the interviews or pulled them out in the course of our conversations in family living rooms or kitchens. Given the centrality of the role these artifacts played in these first interviews, I began soliciting family albums and loose photographs for subsequent interviews. I then made copies of the photographs either by xeroxing them, or scanning them into my computer.

Operating on the same assumptions as Richard Chalfen[20] and Michael Lesy,[21] I assumed photographs would serve as tangible artifacts to "jog" memories of place, family identity, and local history as well as contribute to building rapport between interviewer and interviewee. I was interested in the role photographs played in visually organizing family history, and certain beliefs about the past. In particular, I was curious about the role of photographs in the construction of a particular version of the family's experience in America and what role historical periods, technological developments, regional and cultural variation, and social class play in these portraits of family life.

Drawing partly on Chalfen's "photo interview" methodology, I used the photographs as a way to elicit stories, attempting to understand "what people see" in these images, what meanings they attach to them, and what they interpret as significant.[22] I paid attention to the way the participants utilized photos to examine their family histories and which particular photographs elicited narration. I also considered how family photographs and their related narratives worked in relation to oral testimonies of Americanization often in very contradictory ways.

As Marilyn Motz's study of photographic albums from turn-of-the-century Midwestern women demonstrates, albums provided the women a way to examine their pasts, and comment on their social environments. Albums enabled her subjects to represent their lives as they wanted to see them and "as they wished to have them seen by others."[23] The German American family albums chronicled the family in its most idealized moments, what Motz terms, "heightened activity."[24] While cross-cultural differences exist, incidents of death, divorce, and disaster were not typically photographed. The selectivity of photographs allows researchers a way to understand something of the "editorial authority"[25] or "visual rules" that are shaped by larger cultural, and social conventions, what Bourdieu calls "schemes of perception, thought, and appreciation common to the whole group."[26]

While photographs reveal schemes of perception and socially situated meanings, they may also conceal them. Drawing on the work of Roland Barthes,[27] Annette Kuhn,[28] and Marianne Hirsch,[29] I was interested in the ways in which photographs encode ambiguous, and often conflicting messages. In Kuhn's study of her own family photos, she argues memories do not simply spring out of images, but "are generated in a network, an intertext of discourses that shift between past and present, spectator and image...In this network, the image itself figures largely as a trace, a clue: necessary but not sufficient, to the activity of meaning making; always pointing somewhere else."[30] Similarly, Marianne Hirsch considers family photographs as potential sites of resistance. She analyzes the autobiographic work of four writers "to reveal the ruptures and dislocations in the autobiographical and familiar narrative."[31] The writer, Marguerite Duras, contests the autobiographical images taken by her mother, noting the many erasures and omissions of formal portraits: "all of these photographs of

different people, and I've seen many of them, gave practically identical results, the resemblance was stunning."[32] In Duras' analysis, the photograph conceals more than it reveals, promoting "forgetting" or an "erasure of the particular as they reinforce the plenitude of the imaginary, and the external signs of class and institutional allegiance."[33]

In looking at these German family albums, I was struck by the similarity between images that participants shared with me. Key motifs were apparent in the collection of these photographs, that worked in relation to the stories people told about their family migration, settlement, and adaptation. Like the work of Alexander Freund and Angela Thiessen in this volume, precise identification of images (where or when they were taken, who they were taken of) was not always possible, indeed often mattered little to the narratives themselves. Acting as "traces," the narratives traveled beyond the borders of the photographs, and began to encompass larger, allegorical meanings central to the family chronicle. The meanings of these "imagetexts,"[34] relied both on what was remembered in the photos, as well as what was potentially forgotten. These omissions became central to the oral testimonies of Americanization analyzed in the second part of this chapter.

In the following section, I analyze the photographs and photo narratives first followed by the oral testimonies of Americanization. I do so because this order roughly mirrors the conversational development of the interviews that often began with the family photographs, and later moved to more difficult subject matter. Like Freund and Thiessen, I also assumed that elderly participants would feel more comfortable telling stories around photographs, and determining their own direction of the conversation, versus narrating their life history, or responding to open ended questions. This was certainly confirmed in the interviews. However, I also found that participants preferred to start with photographs as these were stories that people *wanted* to tell me about their family history. These were stories people could feel proud of. In contrast, narratives of Americanization were stories of a more troubled nature that involved the experience of being targeted and marked as German immigrants and German speakers. The order of their telling is significant in this respect as well.

Most family albums begin at the beginning, with large, first-generation family portraits. Sepia toned, or black and white images of families in their best dress peer out from posed and formal compositions. Most are taken in portrait studios, and the content of the photographs bears similar affectations; family members sit with hands folded, expressions are often stoic and serious. Mid-late nineteenth century American photographs reflected portraiture traditions of nineteenth century Europe. Props and backdrops such as pillars and draperies resembled elaborate backgrounds of upper class portraits alive in European painting, making these traditions available to anyone able to afford a studio photographer.[35]

In Figure 8.2, Carl and Wilma Schroeder pose in the center of their seven children, with their eldest son directly behind them. Photographs of first families

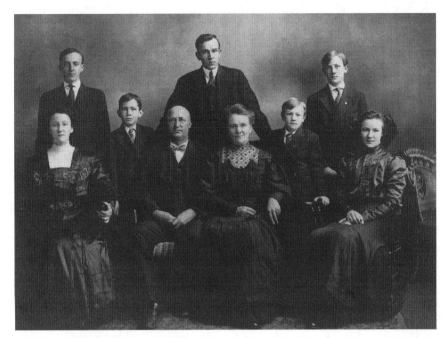

Figure 8.2 Carl and Wilma Schroeder and their seven children (Schroeder and Sander Family Album).

typically prompted participants to share wider contexts to the family story. Participants would frequently begin what I term "origin stories," that concerned a family's story of migration from Germany to the United States. In the following example, after inspecting his own family portrait, Tom Schroeder tells the story of his grandparents journeying to the United States:

> Well, this is the picture of Johan Carl Schroeder. See, he married a Mrs. Johan Carl Schroeder, and so he took her property, her name, and inherited the property then. And his family is here. They had five children. The one we know Johan Carl Schroeder II was born in 1818, and he came over here across the ocean in 1848, and he came to New Orleans, and then came up the Mississippi River, and then they went through the Ohio River, and then they came up the Wabash River to Vincennes, Indiana.[36]

"Origin stories," like this one from Tom Schroeder, often accompanied the first-family photographs, and were usually polished and "worked upon" narrative constructions.[37] These stories were embedded in my photo interviews with participants, and allowed narrators to characterize family members as brave pioneers or legitimate negotiators of interactions with immigration officials. In this particular example, Schroeder's testimony is highly descriptive, with dates and

Figure 8.3 Mersinger Homestead, O'Fallon, Illinois (Kuhn Album).

migration routes serving to chronicle the family's arrival and settlement, much like a historical text. Through photo and story, he provides the raw materials that discursively shape the story of family migration.

Another essential motif that figured prominently in the photo interview was the first-family homestead, or "homeplace." Figure 8.3 shows the Mersinger homestead in the late nineteenth century. A plain, hand-hewn, log cabin stands alone, shadowed by trees. Homeplaces were symbolically important in recounting ancestral migrations and settlement and served as evidence of the family's hardscrabble origins and new American identity. Here, Joe Klostermann considers a photograph of the family homeplace and relates a story about the migration and settlement of his great grandfather who was among the earliest settlers to Germantown, Illinois:

> And most families stayed in this area although one or two of the sons moved to Haste, Kansas. I'm not sure when that took place, but my great grandfather was involved in a lot of things, again. Germantown is the oldest community around here, and I think it was settled in 1826 and he got here eleven years later. And I've read stories of the first people to move along the Kaskaskia River and Shoal Creek. These German people—like I said—why would you want to leave Germany to come to a place like this? The way it was then, the family went into winter without a roof on their house! And they spent three days in bed, because it was so cold, they couldn't do anything.[38]

Photos of the first homestead serve as tangible reminders of the family's humble beginnings. Klostermann marvels at the ability of his family members to withstand a brutal Illinois winter in a partly constructed home, and he generalizes this character trait to the larger population of German immigrants. His rhetorical question, "why would you want to leave Germany to come to a place like this?" allows him to comment both on the bravery of his own family members and of everyone else who migrated to the area. The homeplace photo and narrative work together to evolve the family immigration story. While the image signals the permanence and durability of the first attempts to lay claim to land, the stories around the images allow participants to comment on their ancestors who made this possible and provide reasons for why they were successful.

Another image common in these photographic collections was the family pictured on the family farm. In Figure 8.4, Mary Thorand Chatillon and her children stand in front of their family home with the farm buildings fanning out to the left and right. In similar photos, families stand near chicken coops or pigpens, atop threshing machines or alongside draft horses and plows. The photos are reminiscent of Grant Wood's *American Gothic*, intended to dignify strong Midwestern characters.[39] Like Wood's portrait of American homesteaders, the families in these photos stand nearest to the things they hold most dear. In Figure 8.1, Walter Kottmeyer stands with his mother and siblings on the family farm. Behind them are the modest family home and barn. As I interviewed Walter, he glanced through these images and narrated many

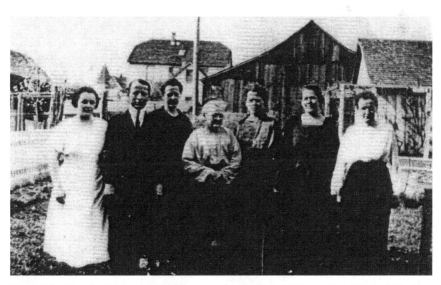

Figure 8.4 The Chatillons *ca.*1939. Left to right: Martha, Julius, Minnie, Marie Thorand Chatillon, Juila (Kuhn), Anna, Adele (Kuhn Album).

stories of his childhood. His details of the daily work of the family farm are
noteworthy:

> Well my dad had a small farm in those days, about one hundred sixty acres, now
> today they are much much bigger than that. He had cows and field hogs and
> chickens and they brought flour from the store. My mother baked bread and
> everything in that line. We had hogs, we'd butcher half a dozen or more hogs
> every year and that was our dinner. We helped milk—I could milk a cow when
> I was six years old! Then we went to school and that was about three and a half
> miles and we walked most of the time.

When I asked if Walter's family ever faced hard times on the farm, he continued
with this:

> I wouldn't say hard times but I know a guy here in this nursing home that told
> me he was from Tennessee and he was a sharecropper, or I guess his parents
> were. And he said there were meals there where they didn't have anything to eat.
> We never came to that point, we always had plenty to eat.[40]

Strong themes of self-sufficiency and the details of daily work are central to
Walter's story of his early childhood on the farm. While he is meticulous in his
details of the gendered work of his parents and, particularly, his own assistance in
butchering and milking as a young boy, Walter is quick to admit that his family
never went hungry. This is where the true meaning of the story rests. By com-
paring the relative solvency of his own family to that of the Tennessee sharecrop-
per, he furthers his own claim to his family's self-sufficiency, despite hard times.
This theme was central to many stories of early childhood that accompanied the
images of farm life. Many participants were quick to remind me that even dur-
ing the Great Depression, when people in nearby towns were unable to procure
basic supplies, farm families were able to provide for themselves. The images and
stories of the family farms testify to the prosperity of these farming families and
the pride with which they remember their early success as new Americans.

Midway through the family albums, images of daily labor and the family
farm give way to smiling younger generations amid more relaxed and candid
moments. These images follow popular discourses of home photography made
possible with the advent of the instamatic camera post World War II. Family
members pose informally in family living rooms, on grassy hillsides, in local res-
taurants. These images of postwar leisure and modernity represent a significant
departure from the austere turn-of-the-century photographs of homeplaces and
family farms. Figure 8.5, captioned "Lazy Summer," is emblematic of this shift
in composition and code. Literally, "Lazy" connotes both leisure and relative

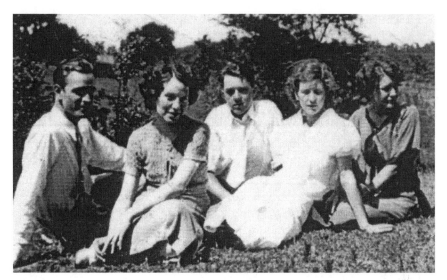

Figure 8.5 "Lazy Summer," 1933 (Witt Album).

inactivity compared to the previous generations' difficult daily work and thrift. In the following example from Dolores Witt Satterfield, she gives context to the captioned photo by sharing the story of her parents' Sunday picnics:

> We went to the farm almost every Sunday. The whole neighborhood came over, there must have been about 15 different guys, they would come from different farms. They seemed to gather there. They would play horseshoes, or we'd get a ball game going, or we'd ride those big plow horses around. And have a little lunch, and just visit. That was a weekly thing, and sometimes through the week. And if the weather was bad, there was a long lane and a lot of times we couldn't make it up the lane if it was muddy, and all full of ruts...But we had a good time.[41]

In Figure 8.6, family members are dressed more formally for a night out. The elegant dress and drinks at the table signal a celebratory atmosphere. Both photographs are emblematic of images taken in the time period following World War II and signal the arrival of the family's youngest generation into modern, middle-class behaviors and sensibilities. In these images, the focus is no longer on representing family homesteads or humble family origins but on picturing casual and sometimes lavish moments of entertainment outside of the home. Dolores' story describes these social gatherings as important spaces of courtship for young unmarried coeds, while the photograph of the Chase Hotel codes a festive, celebratory atmosphere of married couples during a night out in nearby

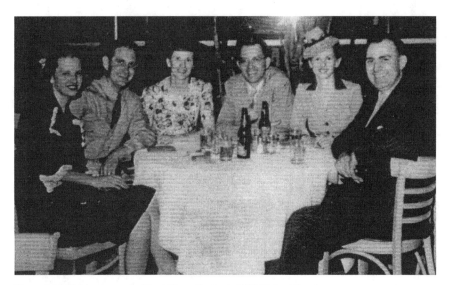

Figure 8.6 Celebrating at the Hotel Chase, St. Louis 1943 (Kuhn Album).

St. Louis. While these images and accompanying stories of leisure and play mirror changes in the wider society, they are particular to representations of the middle class. As cultural historian T.J. Jackson Lears notes, the previous decade's "bourgeois ethos" founded on patterns of compulsive saving, civic responsibility, and rigid self-denial gave way to a new set of values "sanctioning periodic leisure, compulsive spending, apolitical passivity, and an apparently permissive (but subtly coercive) morality of individual fulfillment."[42] These latter images and stories convey new middle-class ideologies and desires for belonging.

Collectively, these family photographs visually order the story of family genesis. Older images of first-generation immigrants are placed adjacent to first-family homesteads or images of families on the farm. These early portraits encode meanings of family unity, of shared possessions and of relative affluence and stability comparative to their lives in Germany. The stories that accompany the images articulate characteristics of the German immigrant identity that families idealize—a stalwart spirit, thrift and hard work, and the ability to provide for the family. Contemporary images of younger generations encode similar messages about the importance of belonging. However, they push beyond this and emphasize belonging to a new set of values—of leisure and personal fulfillment—those of the modern, suburban, post war middle class. While some of these changes in content are attributed to changes in technology and shifting conventions of portraiture, there is also a strategic narrative conveyed through the arrangement of this imagery. Motz argues, "the meaning of the albums arises in large part from the relationship of the photographs to one another, and each photograph itself takes its meaning in part from its juxtaposition with other photographs."[43]

The arrangement of the photos in chronological order forces a particular reading of the images. Mid-century images of middle-class leisure and suburban life work in close articulation to the turn-of-the-century images of immigrant arrivals and domestic livelihood. Their chronological ordering underscores messages of inevitability in the changing family identity. In the German American albums, participants discursively shape a romanticized version of the family chronicle from arrival to the present day and focus on particular images that best cue these readings for later generations.

Oral Testimonies of Anti-German Feeling

Oral testimonies of Americanization present a very different view of the past from those of the family photographs. After the albums were put away, I continued to interview people about the difficult political context of Americanization during world wars I and II. I asked direct questions about these "difficult times" and asked people to remember events that may have been hard for their families or communities. Unlike the family photographs and their accompanying celebratory accounts, stories about Americanization deal with a far darker chapter in German American history. The following examples are just a few of the many stories that were shared about these turbulent times. Principal among them are experiences with language restriction at school and church, the need for immigrant parents to keep a "low profile," and neighborhood experiences with anti-German sentiment.

Roughly half of the participants I interviewed grew up speaking German in their homes. For these residents, the accounts of language loss or language sanction in their families were the most detailed and compelling. Language was offered up as the sine qua non of experiences with Americanization and anti-German feeling. This first example is from Dorothy Becker Cryder, born in 1918 and second-generation German American. Her father, John Becker, was predominantly German speaking during her childhood and his first language figured prominently in stories of trouble for her family. John Becker was an active member of his small Methodist church, which had a German minister and services in German prior to World War I. I asked Dorothy if she knew any stories about the changes in the German services that resulted from the war:

> Well, they didn't have an English minister so that [German language] was the only thing they could have! And see that was what they loved 'cause they spoke German and that's what they loved and then it was taken away because of the war between the Kaiser and America. That's when they started to oust the German ministers because they didn't like the Germans anymore so my dad led a low profile because he could speak German and write German, read German but he never talked you know. People in the States didn't like Germans because

of that war and the Kaiser. So they hated 'em way back then. Well, that seems so far away and you know and stuff but my dad lived it and knew it! You know so he just kept his mouth shut.[44]

Dorothy begins her narrative defensively, noting that the offering of German language services was based on practicality in serving the needs of its majority German-speaking congregation. While she refers to the language sanction and the ousting of German ministers happening in many churches during and following World War I,[45] her appeal is more emotional than factual as she recounts upsetting memories for her community and family. Her father's silencing and her congregation's experience with anti-German rancor are memories that are painful and confusing for Dorothy. Also noteworthy is the time frame of this recollection. Most likely, this event occurred prior to Dorothy's birth in 1918. The story works then as a "generational memory,"[46] passed down from her parents and grandparents; one that still holds great import for her family today.

Language restriction at school also figured prominently in the interviews with early German-speaking residents of Clinton County. People spoke of being punished on the school grounds for speaking German or noted the end of German instruction. In the following interview with Leander "Lindy" Horstmann and his wife, Florida Horstmann (who grew up in the same town and joined us for part of the interview), both shared fond memories of speaking German as children. When I asked if this was common among other families in town, Lindy immediately replied, "Yes" and then Florida, "Oh yeah." Lindy then continued:

In fact we talked more German than English up to—I think I was in the seventh grade maybe in school—when we had a kid move in and all he knew was German and we talked German. At the same time we got a nun who couldn't understand German (laughs), and she forbid anyone on the playground to speak German!

Florida asked, "How well did that go over?" Lindy responds:

Well if you got caught you got a penance! And then I got real jaded. I went back [to work] on a farm, and they had people working for them who didn't know German, strictly English. Ever since that, the English kind of died out—I mean German died out.[47]

Lindy proudly recounts how he spoke more German than English through most of his parochial schooling. The narrative of his seventh-grade year is complicated by two competing events—the arrival of a new student and an English-speaking nun who forbids the speaking of German on the playground. While his memory stresses the utility he found in being able to "talk German" to his new classmate,

he juxtaposes this with his frustration at being prohibited from speaking German on the schoolyard. His laughter at the nun's inability to speak German and her punishment of students who did may indicate the irony he found in his predicament. When Florida asks, "How well did that go over?" she acknowledges the impossibility of this situation given the majority of children were German-speaking. Lindy's response to this policy, which caused him to become "jaded" and quit school, leaves many unanswered questions. What is clear is how he relates his eventual language loss to this initial event in his schooling, and the intensity this memory still holds for him.

In addition to stories of language sanction, stories of citizenship and the confusing nature of German ethnic identity were shared by many participants. In some cases, narrators worked hard to relay attempts by parents or grandparents to become citizens during world wars I and II. Alice Willeke Hall, born in 1912 and second-generation German American, was one of the oldest residents I interviewed. Her memories of the events surrounding her childhood during World War I were detailed and sharp. Many of her stories involved the issue of citizenship for her immigrant father:

> When I was in the first grade, and I remember this very well, my dad applied for his citizenship, and that was a big thing! And my mother was thrilled to death about it. And we had to go to the county seat and as a result he hired a car—which was a big thing in those days! Highway 50 was all dirt and my brother—it was just my brother and I that were there then. And he took me out of school to go over there. And we had to explain that to my brother you know, he was about four or five, something like that. And we got through the rigama-role and everything was fine and my dad said "Now, we're all Americans!" And I can remember to this day my brother said "Well, when are we gonna get the German blood taken out of us and American blood put in?" (laughs) So, we were all happy about that.[48]

Alice's testimony conveys some of the excitement and tension around applying for her father's citizenship from the perspective of a small child. German citizenship presented many problems for first-generation immigrants during the war years making them more vulnerable to anti-German hostility or accusations of disloyalty. Many residents proudly showed me citizenship papers, carefully preserved among the documents in the family albums or framed on living room walls. The stories of citizenship were discursive declarations of allegiance, best exemplified by the words of Alice's father, "Now, we're all Americans!" Yet, it is Alice's retelling of her younger brother's question concerning the confusing nature of this legal shift that deepens the meaning of this story. The figurative association of an American blood transfusion is evidence of something more than a child's musings. Perhaps it conveys something of the shame associated with

the family's German ethnicity and the need to distance or even deny German citizenship during these desperate times. Her father's pride at uniting his family in immigration status also evidences the broader context for protecting his family from perceived hostility.

The last story of Americanization comes from Jean Platt, born in 1926. Her story centered on troubling experiences for Germans in the community at large between the two world wars. When asked about whether she remembered hearing of any negative experiences for neighbors during the war, Jean shared a specific memory of a neighbor who was accused of being a Nazi sympathizer:

> There was one. He had a grocery store here. His name was Raebus. And they always thought that he was a spy for Germany because there was a fire, and he had grocery store, and he had a fire in his apartment, and they said he ran up into the flames to get something, and they figured it was something that would tie him in with this thing that they suspected him of. I was still pretty little but it still made a great impression on me because we only lived a block away.

I then asked her "How did your parents feel about him?" and she responded:

> Well, they said it had never—now my dad always said and he was always so logical—he said it's never been proven, and he said we've always shopped there and we're not going to stop now because of gossip. And he did, he had good meat and everything there you know so, but some people didn't feel that way.[49]

Accusations of Nazi sympathizing were not uncommon for many German Americans during the years leading up to World War II.[50] Jean's story of Mr. Raebus is less significant for its historical specificity than how she remembers this incident and the power of community memory. Her father's belief that this was just gossip, and her family's support of Raebus, stand in contrast to other neighbors who refused to patronize the grocery store. When Jean notes "they always thought he was a spy" and "they thought it would tie him in with this thing," she conveys something of the mob mentality that assumed Raebus' guilt and may have been fuelled by public discourses about German disloyalty. Jean's narrative highlights this larger context of public scrutiny that German Americans negotiated during these difficult years.

Oral testimonies of Americanization reveal troubling memories of language loss and anti-German sentiment in these communities. When residents did speak openly, they shared various strategies for negotiating language restriction in their schools, homes, and public places. The stories afford an opportunity to better understand how people made sense of the changes in their own families and communities that accompanied language sanction and heavy public monitoring. The testimonies also reveal much of the confusion and bitterness that persist in the

generational memories of the children and grandchildren of residents of Clinton County.

Oral testimonies of Americanization contrast greatly with the visual narratives of family photographs. While the photo narratives work to construct storylines of upward mobility and successful adaptation, oral testimonies present differently textured storylines of turbulent acculturation periods accompanied by loss, confusion, and, at times, shame. Oral testimonies trouble the photographic portraits of seamless assimilation and engage listeners in community-wide "matters of contested concern which may not be spoken of, but which must be discussed nonetheless."[51] The stories of Americanization are difficult chapters for German Americans and reveal deep fractures in the visual narratives of untroubled adaptation.

While they may construct conflicting storylines, photographs and oral testimonies from residents of Clinton County are not unrelated projects. Visual narratives with their many omissions present a version of an idealized past that provides needed coherence to communities precisely because of the loss and fragmentation experienced during the Americanization periods. Photographic texts become the "constitutive narrative"[52] that the community requires in retelling aspects of its own history and reflecting back a more logical sense of the past. Oral testimonies of Americanization provide a context for the construction of the predictable and stabilizing family portraits.

The combined use of testimony and photographs in this study helps to amplify the oral historian's understanding of the multiple associations and meanings that this Americanization period holds for these residents. As Hirsch compares her own longing for continuity and coherence during her turbulent adolescence, she notes "I begin to perceive the discontinuities within my own story as illuminating and enabling."[53] So, too, must the oral historian discern the discontinuities between the reading of photo narratives and the reading of oral testimonies as productive spaces for analysis of complex social history. "Reading these texts against one another" opens up new spaces for more nuanced understanding of the multiple forces at play in the lives of acculturating German Americans during a time of intense anti-German feeling. A desire for belonging in a new American landscape is evident in the strict adherence to the codes of family album compositions as well as a desire for reconnection and coherence given the turbulence of this time. In the oral testimonies of language loss and citizenship, we become more aware of the lingering confusion associated with the experiences of Americanization and the frustration these families may have felt as they realized their double bind. To publicly identify with their German ethnicity or language could be seen as unpatriotic and disloyal at a time of heightened paranoia. The oral narratives work together and against the photographs from these communities, opening up spaces of interpretation that consider the multiplicity of experience for these families and the delimited nature

of "voluntary" decisions to assimilate linguistically and culturally. By combining photographic and oral sources of testimony, oral historians may better access a more layered picture of twentieth-century Americanization for German American communities and further demonstrate how this process remains ongoing and incomplete.

Notes

1. Sol Worth, "Toward an Anthropological Politics of Symbolic Forms," in *Reinventing Anthropology*, ed. Dell Hymes (New York: Pantheon, 1969), 335–364.
2. Carola Suárez-Orozco and Marcelo Suárez Orozco, *Children of Immigration* (Cambridge: Harvard University Press, 2001).
3. This definition of Americanization includes both the government-sponsored, coercive programs of forced assimilation aimed at immigrants at the turn of the century through the early 1920s as well as a "particular variant of assimilation by which newcomers or their descendants come to identify themselves as American." Russell A. Kazal, "Revisiting Assimilation: The Rise, Fall, and Reappraisal of a Concept in American Ethnic History," *American Historical Review* 100, 2 (1995): 440.
4. Don Heinrich Tolzmann, *New German-American Studies: Selected Essays* (New York: Peter Lang, 2001).
5. Herbert Kloss, "German-American Language Maintenance Efforts," in *Language Loyalty in the United States*, ed. Joshua Fishman (The Hague: Netherlands: Mouton, 1966), 206–252.
6. Kathleen Neils Conzen, "German-Americans and the Invention of Ethnicity," in *America and the Germans: An Assessment of a Three-Hundred Year History*, ed. Frank Trommler and Joseph McVeigh (Philadelphia: University of Pennsylvania Press, 1985), 139–141.
7. Alessandro Portelli, *The Death of Luigi Trastulli and Other Stories: Form and Meaning in Oral History* (Albany: State University of New York Press, 1991).
8. Pierre Bourdieu, *Photography: A Middle-Brow Art* (Oxford: Polity Press, 1990).
9. Frederick C. Luebke, *Bonds of Loyalty: German Americans and World War I* (Dekalb: Northern Illinois University Press, 1974).
10. Erik Kirschbaum, *The Eradication of German Culture in the United States: 1917–1918* (Stuttgart: Hans-Dieter Heinz, Akademischer Verlag Stuttgart, 1986).
11. Dennis Baron, *The English-Only Question: An Official Language for Americans?* (New Haven, Connecticut: Yale University Press, 1990).
12. Terrence G. Wiley, "The Imposition of World War I Era English-Only Policies and the Fate of German in North America," in *Language and Politics in the United States and Canada: Myths and Realities*, ed. Thomas Ricento and Barbara Burnaby (New Jersey: Lawrence Erlbaum Publishers, 1998), 211–241.
13. Maris Thompson, "They Used German When They Didn't Want Us to Understand: Narratives of Immigration, Ethnicity and Language Loss in Southwestern Illinois" (Ph.D. diss., University of California, Berkeley, 2008).
14. Wiley, "The Imposition of World War I," 224.

15. John F. McClymer, "The Americanization Movement and the Education of the Foreign-Born Adult, 1914–1925," in *American Education and the European Immigrant, 1840–1940*, ed. Bernard J. Weiss (University of Illinois Press, 1982), 96–116.

16. Wiley, "The Imposition of World War I," 231.

17. Luebke, *Bonds of Loyalty,* 329.

18. Luebke, *Bonds of Loyalty,* 329. Luebke's seminal work on the impact of World War I on German Americans argues that German Americans were "trapped in a crisis of loyalty" on the eve of World War I. He argues that World War I cemented tensions that had been long simmering toward German Americans, particularly their interest in maintaining German language and identifying with German culture.

19. For an interesting discussion of the enduring ways that German Americans in the area of Belleville, Illinois maintain subtle cultural distinctions in social interactions with their non German background neighbors, see John M. Coggeshall, " 'One of those Intangibles': The Manifestation of Ethnic Identity in Southwestern Illinois," *Journal of American Folklore,* 99, 392 (1986): 131–150.

20. Richard Chalfen, *Snapshot Versions of Life* (Bowling Green: Bowling Green State University Popular Press, 1987).

21. Michael Lesy, *Time Frames—The Meaning of Family Pictures* (New York: Pantheon Press, 1980).

22. Richard Chalfen, *Turning Leaves: The Photograph Collections of Two Japanese American Families* (Albuquerque: University of New Mexico Press, 1991), 225.

23. Marilyn Motz, "Visual Autobiography: Photograph Albums of Turn-of-the-Century Midwestern Women," *American Quarterly* 41, 1 (1989): 63.

24. Motz, "Visual Autobiography," 66.

25. Julia Hirsch, *Family Photographs: Content, Meaning and Effect* (New York: Oxford University Press, 1981), 13.

26. Bourdieu, *Photography,* 6.

27. Roland Barthes, *Camera Lucida: Reflections on Photography,* trans. Richard Howard (New York: Hill and Wang, 1981).

28. Annette Kuhn, *Family Secrets: Acts of Memory and Imagination* (London: Verso, 1995).

29. Marianne Hirsch, *Family Frames: Photography, Narrative and Postmemory* (Cambridge, MA: Harvard University Press, 1997).

30. Kuhn, *Family Secrets,* 14.

31. Hirsch, *Family Frames,* 192.

32. Hirsch, *Family Frames*, 200.

33. Hirsch, *Family Frames*, 200.

34. Barthes, *Camera Lucida,* 5.

35. Julia Hirsch, *Family Photographs: Content, Meaning, and Effect* (New York: Oxford University Press, 1981).

36. Tom Schroeder, interview by author, Nashville, IL, November 9, 2005.

37. Michael J. Toolan, *Narrative: A Critical Linguistic Introduction* (New York: Routledge, 1988).

38. Joe Klostermann, interview by author, Breese, IL, June 7, 2006.

39. Steven Biel, *American Gothic: A Life of America's Most Famous Painting* (New York: W.W. Norton & Company, Inc., 2005).

40. Walter Kottmeyer, interview by author, Carlyle, IL, November 16, 2005.

41. Dolores Witt Satterfield, interview by author, Trenton, IL, October 27, 2005.

42. T.J. Jackson Lears, "From Salvation to Self-Realization: Advertising and the Therapeutic Roots of the Consumer Culture, 1880–1930," in *The Culture of Consumption: Critical Essays in American History 1880–1930,* ed. Richard Wrightman Fox, and T.J. Jackson Lears (New York: Pantheon Books, 1983), 3.

43. Motz, "Visual Autobiography," 73.

44. Dorothy Becker Cryder, interview by author, Trenton, IL, July 10, 2006.

45. Audrey L. Olson, *St. Louis Germans 1850–1920: The Nature of an Immigrant Community and Its Relation to the Assimilation Process* (New York: Arno Press, 1980).

46. Tamara K. Hareven, "The Search for Generational Memory: Tribal Rites in Industrial Societies," *Deadalus* 107, 4 (1978): 137–149.

47. Leander Horstmann and Florida Horstmann, interview by author, Damiansville, IL, April 9, 2006.

48. Alice Willeke Hall, interview by author, Trenton, IL, October 26, 2005.

49. Jean Platt, interview by author, Carlyle, Illinois, December 16, 2005.

50. Tolzmann, *"Selected Essays,"* 2001.

51. Charlotte Linde, *Working the Past: Narrative and Institutional Memory* (New York: Oxford University Press, 2009), 219.

52. Robert N. Bellah, Richard Madsen, William M. Sullivan, Ann Swidler, and Steven M. Tipton, *Habits of the Heart: Individualism and Commitment in American Life* (New York: Harper & Row, 1985).

53. Hirsch, *Family Frames,* 214.

CHAPTER 9

Family Photographs and Migrant Memories: Representing Women's Lives

Alistair Thomson

The fault lines of migration are at the center of historian Alistair Thomson's study of British migrants to Australia who sent photographs, letters, and audio tapes back home during the 1950s and 1960s. Thomson scanned photographs from his interviewees and then returned to discuss the photographs, now blown up on his laptop computer screen. Like most of the essays in this collection, he uses the productive spaces produced by the juxtaposition of image and narrative to explore photographs' "complex and even contradictory relationship to memory." Behind the smiling photos of immigrant success linger the memories of unhappiness, disappointment, and family conflict. Placing photographs and oral stories next to each other exposes the crevices between myth and reality. Yet, neither the happiness of photos nor the lack of unhappy photos can suppress memories of hardship. Indeed, happy photographs have the power to evoke contradictory memories. Thomson in particular draws our attention—like Mauad in a later essay—to the production history of photographs: "the contemporary photograph is highly selective, influenced by technology...cultural expectations of what to photograph and how to pose, and the social relationships within which photos were taken, disseminated, and discussed." Thus, while the photographs themselves depict smiling faces, their use during the interview may point to past and possibly still reverberating tensions created by social expectations and individual desires.

In April 2000 Phyllis Cave responded to my press appeal for the stories of British migrants who had taken up the postwar assisted passage to Australia but subsequently returned to Britain. She sent a short account of her migration in 1969 with husband Colin and three small children, together with a selection of her "best" photographs from the time. Among the photos was this image (Figure 9.1) that Phyl described as "my husband's family seeing us off at Southampton," shown top left and including the lady in the check coat waving her hand, the man beside her with a child, the three to their left and, in front, Colin's brother with the camera and binoculars.[1]

The excited and anxious faces in this evocative image capture the emotion of farewell, as relatives on shore clutch hold of streamers thrown from the ship to maintain a connection with loved ones until finally rent asunder. We used this photo in publicity for our oral history project about postwar British migration, but it wasn't until I interviewed Phyl in 2006, and she pointed to this picture, that I heard a very different story about leaving Britain. Phyl now explained that in 1969 Auntie Aileen in the check coat had been particularly "nasty" about their emigration and had told Phyl's husband he was "a traitor to your country." The photographic image is not always what it seems; it conceals as much as it reveals and can trigger unexpected stories.[2]

Photographs have a complex and even contradictory relationship to memory. Photos can help us to remember the past more vividly, but in doing so they might filter memory selectively through the images that were created and that have survived. We all have moments of our life that we "remember" not from the

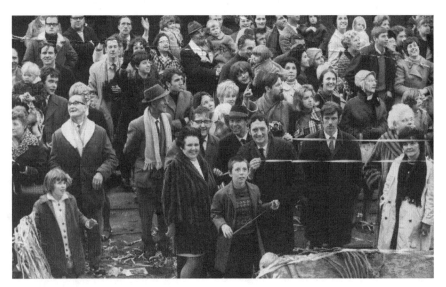

Figure 9.1 "My husband's family seeing us off at Southampton," 1969 (courtesy of Phyl Cave).

event itself but through photos of the event and the stories that are spun around those images. Roland Barthes suggested that the concrete detail of a photograph, imprinted in our mind through repeated use, could block out memory and substitute the image for the event in our remembering.[3] Since the late nineteenth century, and throughout the twentieth century as the photographic image has become an increasingly widespread and potent representation of individual and family life, memory has been organized and shaped in new ways by photography. The photo album and the slide show—and now the digital slide show on Facebook or in an electronic frame—have become the "mnemonic devices" of individual and family history.[4]

And yet while photos might "fix" memories to match the selective image, they can also trigger new remembering and alternative stories, such as Phyl Cave's memory of Auntie Aileen. If photo collections suggest particular, agreed stories about the past, the stories around the images can "open the curtains" of family memory.[5] Photos are "unlocked by storytelling," and "any photograph is a potential *kernel story*, a discrete catalytic reference to a longer story that is teased out and expanded in conversation."[6] And, as family circumstances alter and alternative understandings become available, photo stories can be narrated in new ways. Looking at old family photos "we both construct a fantastic past and set out on a detective trail to find other versions of a 'real' one."[7]

This issue in photographic theory, and the tension between photos fixing or triggering memory, is echoed in debates about memory within oral history. In response to critics concerned about the reliability of memory as an historical source, oral historians have asserted both the durability and veracity of long-term memory.[8] Only a small selection of our myriad short-term memories are consolidated within long-term memory, and this process of selection, and the use of stories to shape memories into coherent and indeed memorable forms and meanings, generates remarkably robust accounts of significant life experiences.[9] And yet, paradoxically, most oral historians now accept Alessandro Portelli's acute insight that memory "is not a passive depository of facts, but an active process of creation of meanings." The changes "wrought by memory...reveal the narrator's effort to make sense of the past and to give a form to their lives, and set the interview and the narrative in their historical context."[10]

This chapter explores the representation of family life and women's role in postwar Australia, and aims to elucidate aspects of the relationship between photographs and remembering and their use in tandem as historical sources. I draw upon examples from my collaborative biographical work with British women who emigrated to Australia in the 1950s and 1960s, who I have interviewed over the past decade, and who have given me access to family photos and letters they sent home to England.[11] These women produced and preserved photographs to create a record of their migration, but they also sent photos home—as set of prints, in photos albums, and even as slide shows with reel-to-reel

recordings as an audio commentary—to picture their Australian experience for families at home. Though photographs had not replaced letters as a means of communication—they were usually sent together in one package—by the mid-twentieth century these posted photo collections had become the preeminent medium for creating and circulating family stories, and perhaps the most influential way in which migrants represented themselves and their experience in Australia.[12]

The family photo collection is a creative space and site of memory. It is a popular autobiographical form in which people combine images and text to represent a version of family life and identity.[13] An idea of what was visually important—according to both personal attitude and wider family and social expectation—influenced the decisions at each stage of the photo story process: what to photograph and in what way; which images to select and to send; how to arrange and juxtapose photos; which words to caption and define the image; and which photos to keep forever. These decisions shaped the photographic narrative and defined family life history in particular ways. It is often difficult to trace the decisions and processes of family photo stories. Archivists working with collections of photograph albums describe the challenge of recovering the missing stories—the "suspended conversations"—through which the photographic images in their care were created and compiled into albums.[14] But in my project we have detailed evidence—not only within the photos but also from contemporary letters and oral history interviews—about the creation, embellishment, and conversation that enlivened and narrated family photos, that gave them stories and made them meaningful.

Historians of family snapshots agree that "illness, depression, painful experiences, inter-personal conflicts, personal disappointments, social failures and dreary settings" usually have no place in the family photo story.[15] An extensive literature about family photography emphasizes the symbiotic relationship between the development from the late nineteenth century of commercial family photography (epitomized by Eastman Kodak) and the development of suburban family life. Families were and are encouraged to take and display photos of family rituals and events, and thus emphasize the success of the nuclear family. Family photos were expected to represent happy families and contented parents, and especially contented mothers. Photography was, in Susan Sontag's words, a "rite of family life" that immortalized the highlights of a successfully integrated unit and asserted particular family identities and aspirations.[16]

Yet family life involves constant change as families separate and re-form, grow and sometimes dislocate, in an evolving and perpetual cycle. Family photographs play a role in dealing with change and creating and articulating new family identities.[17] For migrants this need is especially acute, and their photographic compilations help them to recreate family identities that have been dislocated by displacement and thus play an important role in adjustment.[18] Postwar British

migrant women—who posted the photos and wrote most of the letters—wanted to show relatives in England how they were getting on; or rather, they wanted to show they were getting on well. They wanted to picture themselves as they responded to new circumstances and changed over time, and in so doing to make sense of the experience. Their photos were, above all, about family and about recreating family identity at a turbulent time.

Dorothy Wright and her husband Mike migrated from southern England to Sydney in 1959, with their one-year-old son Nick and Dorothy heavily pregnant with Bridget, who was born just a few months after arrival. Over the next six years, until they returned to England in 1965, Dorothy and Mike created eight photo albums that Dorothy sent to their parents in England for circulation among family and friends (she got the albums back on return to England). Dorothy and Mike had decided that it seemed "a good idea to keep our snaps together in albums to be passed round; saves getting lots printed & keeps a chronological record of us." The albums were a creative collaboration. Mike hand-crafted the albums, and Dorothy produced decorative covers using paint, embroidered patterns, and pictures cut from magazines. Dorothy recalls that "we had great fun doing the covers," and at the time wrote of the "joy" of "choosing the cover & making it all appropriate & beautiful as we can."[19]

Picturing the children was especially important. As Dorothy Wright recalls of the photos they sent to relatives in England, she wanted "to keep in touch and let them see the growing children."[20] About half of the Wright and Cave photos depicted their children, mostly at play in the backyard or on day trips and holidays, and also participating in the ritual events of childhood and family life: birthdays and Christenings, Christmas and starting school, and family parties and reunions. This photographic story portrayed ideal children and an idealized childhood. The joys of youth and parenthood are obvious in images of first steps or first fishing, frolicking under the garden sprinkler or camping in the Australian bush, but little of the challenge of childhood or difficulty of children—some of which is detailed in letters and memories—is apparent in these photographs. There are hints in captions—a 1961 photograph of a sleeping baby Bridget Wright was captioned by her mother, "This is how we like 'em"—but these are mostly playful children in happy families.

One of Dorothy Wright's favorite photos from the family's Australian photo albums (Figure 9.2) depicts Dorothy reading with her two small children on the occasion of Bridget's first birthday in 1961. In the 1961 album Dorothy captioned this photo, "End of a perfect birthday," and Mike's beautifully posed image of a calm and loving mother with her attentive children asserts peace and perfection. Yet we know from Dorothy's letters and our interview that she had a very difficult time as a young mother. Mike was away at his engineering job during the weekdays, and Dorothy was isolated and lonely in the Sydney suburbs, cut off from the support of her family in

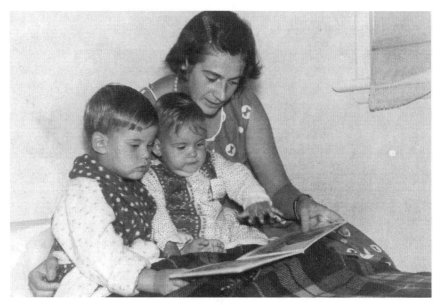

Figure 9.2 "End of a perfect birthday," Sydney, 1961 (courtesy of Dorothy Wright).

England. She was exhausted by the constant round of housework and childcare, and she loathed "the continual 'hampered' feeling" of her life at home with two small children. Armed with that knowledge photos like this are striking for what they conceal as much as reveal about women's experience of family and domestic life.[21] Dorothy wanted to show her family, and herself, that all was well, and yet this moment of peaceful family reading was an exception rather than the rule, a photographic expression of hope as much as a depiction of reality. One of only two photos used more than once in the Wright's eight albums, a copy of this photograph from the 1961 album reappeared the following year among others celebrating Bridget's second birthday. The repetition is evidence of the photo's significance for Dorothy at the time.

Another image (Figure 9.3) from the Wright family albums shows how family photographs are intended to narrate a particular version of family life, yet sometimes contain clues to other meanings and become part of a very different story. Dorothy Wright wanted to show off her Sydney-born baby daughter to her mother back in England, and the album she sent home in mid-1960 included several baby photos, including this one of mother and daughter taken by Mike in June, with Dorothy's jokey caption, "Under our gum tree. 13 weeks old (not the gum tree or Dossie)" ("Dossie" was Dorothy's family nickname).

In the photo Dorothy averts her eyes from the camera, as she does in most of the first baby photos with Bridget; indeed in this first year, by contrast with later years, there are very few photos with Dorothy smiling. There is a hint in

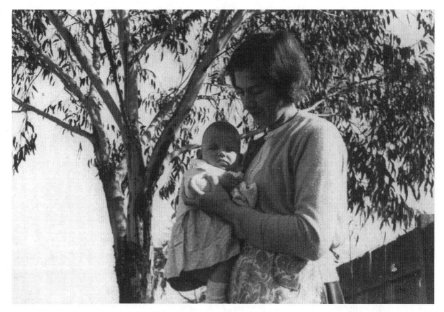

Figure 9.3 "Under our gum tree. 13 weeks old (not the gum tree or Dossie)," Sydney, 1960 (courtesy of Dorothy Wright).

Dorothy's body language that all is not well. But it was several months, and not until the worst was over, before Dorothy could admit in letters to her family that she had been in a miserable state and had reached "screaming point" in the months after Bridget's birth.[22] Years later, Dorothy recalled that she had "a terrible feeling in the pit of my stomach. I cried often, sometimes when I was on my own with the children, and I remember Nicholas at 2 years old trying so hard to comfort me."[23] Maternal depression was not part of the family photo story in 1960, though there are hints beneath the surface of such images. This photo of mother and child speaks to Marianne Hirsch's argument that family "photographs locate themselves precisely in the space of contradiction between the myth of the ideal family and the lived reality of family life."[24]

At the time Dorothy wrote in her letters that she was struggling to meet the expectations of housework and childcare, and concluded that she was "not a good mother" ("what Dr. Spock calls a 'slow mother' who leaves her chores to make sure junior gets the right treatment").[25] She now makes rather different sense of her time as a young mother. In the early 1980s Dorothy, who had left school at 16, went to university as a mature student and was exposed to feminist thinking that explained how young women of her generation had been directed away from further education and careers and into motherhood and domestic life. From this new perspective she looked back on her own inadequate schooling, the disappointment of a teenage ambition to be a farmer, the difficulties of suburban motherhood, and her eventual success as a swimming instructor, and reflected

with some pride, "Thank goodness I did eventually, and even if only in some small way, manage to beat The System!"[26]

Dorothy also gained fresh insights about her postnatal misery when her daughter Bridget was herself pregnant in the 1980s and had "all the latest books about pregnancy." Dorothy read one of these books, and now she "suspected the real cause" of her own unhappiness as a young mother. "Postnatal depression. I read to Mike the symptoms from her book, and said 'Does that remind you of anyone?' 'Yes,' he immediately knew that had been my problem, when such conditions were not spoken of—at least to me. But I battled on."[27]

The self-diagnosis of postnatal depression gave Dorothy an affirming explanation of the unhappiness that is hinted in photos of mother and child in 1960. But of course it can be just as difficult to represent one-self as depressed, whatever the cause, as it is to deal with expectations about being a "good mother." In a recent self-published autobiography Dorothy chose the photograph of maternal bliss at the "End of a Perfect Birthday" to illustrate the chapter about their years in Australia.[28] The image of a successful mother with contented children is still immensely appealing and deeply satisfying. Though Dorothy could write about her postnatal depression and share vivid memories of this difficult period in our interview, the depressed mother was not the image she wanted to represent her life at this time. Women of Dorothy Wright's generation, brought up in the 1930s and 1940s to be mothers and housewives in the 1950s and 1960s, have lived with complex, contradictory, and changing ideals of femininity, none of which, as Bronwyn Davies notes, allow them "to achieve unequivocal success at being a woman."[29] In their remembering, as in their lives, women like Dorothy Wright have negotiated the shifting terrain of women's roles. The photographs and the stories they use to represent their lives capture both the changes and contradictions in women's roles.

Phyllis Cave's photo memories offer another rich example of the dynamic relationships between photography and self-representation, and between image and memory. When Phyl, Colin, and their three children arrived in Sydney in 1969, like many other British migrants they sent home photos that portrayed a beautiful country and wonderful lifestyle, and which asserted the success of their migration. Photos could, quite literally, show off this success, and where letters might be suspected of self-censorship photos offered the illusion of visual authenticity. Four months after arriving in Australia, a letter from Phyl Cave to her parents included a set of negatives depicting their day trips out of Sydney. Among them was this color photo (Figure 9.4) of Colin Cave surveying Palm Beach from the bonnet of a car owned and shared by migrant friends that he drove to work and on weekend day trips.

Phyl's letter explained that "some of these are Palm Beach & some are Jenolan Caves & some Katoomba & Fitzroy Falls... I certainly think we've made the right decision coming here—don't you? I think you'll have to join us later too

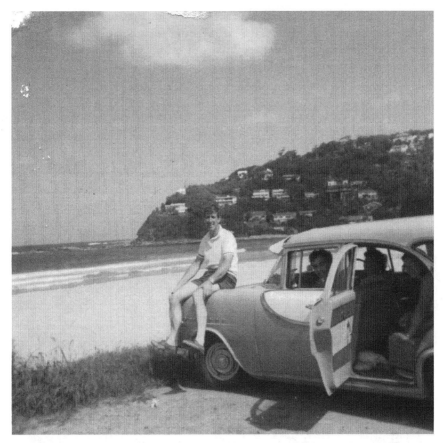

Figure 9.4 The Cave family at Palm Beach, New South Wales, 1970 (courtesy of Phyl Cave).

when we get our own house. I'd love you to see the country. As you can see from the photos it really is very beautiful." Five months later, when Phyl and her family bought their own new home, another set of photos was promised to show off this triumphant achievement. "The house really is super, Mum. I only wish you could see it. We'll take some photos before long & send some."[30]

Buying their own home in Australia was central to the Cave family's migration aspirations. In England, Colin had worked as a farm laborer, and the family lived in rented farm cottages that were "tied" to the job. But farm work was seasonal and unreliable, and every time Colin lost his job the family had to move house. Australia offered the promise of more secure employment and a home of their own. In their first Australian year the Caves lived in a migrant hostel as they saved for a house on the cheapest fringes of outer Sydney. Colin found steady work building cool-rooms for farmers. Phyl, who had taken in piecemeal machine-knitting work in England while she raised three small

children, found her skills in great demand in Australia and took a full-time machine-knitting job. Even so, raising the funds for the home deposit was a real struggle, especially when the children got sick in the unhealthy hostel and Phyl had to stop work. Their home dream looked to be dashed when the man who shared his car and the long drive to work with Colin moved away, and it seemed that Colin, who could not afford a car, would have to give up his job. Out of the blue, the family had a memorable lucky break, and the new home was secured, when Colin won a new Ford Cortina in a lottery. Phyl sent home this photo (Figure 9.5) of herself standing beside the new car, with an ecstatic letter that reported that the car was worth $2,180 ("a bl-dy fortune"), and Colin was "like a cat with two tails." She concluded that "our luck has certainly changed."[31]

In 1970, this photo represented the family's changing fortunes in Australia, and their optimism for the future. In 2000, when Phyl included this image with the set of her "best" migration photos that she sent to our research project, she added a new caption explaining that this was "The car we won and our hut [at the migrant hostel] was the first one at the back by the fence."[32] Phyl's written migration story that accompanied the photos emphasized the importance of the

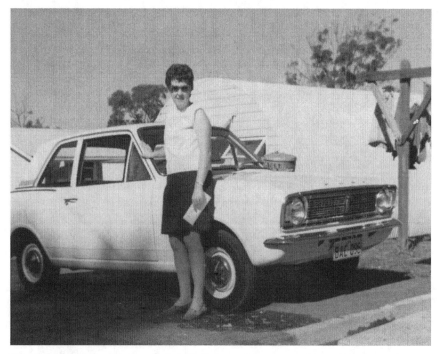

Figure 9.5 Phyl Cave at the migrant hostel with the car Colin won in a lottery, Sydney, 1970 (courtesy of Phyl Cave).

lottery win at a time of financial difficulties while they were living on the hostel and saving for a house, and in our interview six years later at her home on the Isle of Wight she told the same story with great enthusiasm. The day after I interviewed Phyl, I returned with my laptop computer, and we browsed photographs from her collection that I had scanned onto the computer. Tiny Kodak Instamatic images from the 1970s now filled the computer screen in dramatic detail. As Phyl looked at each image they triggered stories that often spiraled off in unexpected directions and enriched my understanding of the photos and the moments they pictured. Phyl used the images to plot her life history but also recounted stories that made meaning beyond the images.

The photo of the lottery car now sparked a very different memory, as Phyl pointed to the envelope in her hand and explained that it contained her first Australian pay check. In 1970, when Phyl sent this photo to relatives in England, including Colin's parents, her letter celebrated the lottery win and the car, but for Phyl the image had another, more intimate meaning that became increasingly significant over time. In England, Colin had not just been unlucky at work, he had lost jobs because he was an unreliable worker who sometimes mixed in the wrong circles. Phyl Cave had been the driving force for the family's emigration, because she wanted to take Colin away from bad influences in England and create a new start for the family. She was determined that she would get a job in Australia so she could guarantee a secure home of their own that was not dependent on Colin. "If I could work, it didn't matter what he did, I was secure, and I could keep the home. That was what was behind that. First, last, and in the middle."[33] This first pay check was thus especially significant, and when Phyl sent the lottery car photo to her own parents—who knew about Colin's troubled work history—she confided in them about its double-meaning.

The discrete presence of Phyl's pay check in this photo echoes the muted presence of Phyl's career in family photographs from their years in Australia, which focus like many migrant collections on family life at home and on weekend excursions. Phyl's letters were more effusive about her burgeoning machine-knitting career. In 1973 she wrote home that she was "in charge of 36 demonstrators in the metropolitan area. I travel from store to store and have driven 7,000 miles since May!...I work at home sometimes as I also supervise the writing of the knitting patterns and it's my job to check them and type them up for the printers & to organize the photography etc. Quite an interesting job and an experience I wouldn't have missed. Next year I have to train girls from all over N.S.W. [the state of New South Wales] It wouldn't matter where I went now I would know someone! I must admit that I am no longer the same person who was tied to the kitchen sink at home, and I certainly would find it very difficult to go back to that again! Australia is a beautiful country."[34]

Phyl's Australian career was cut short in 1976, when she had an unplanned fourth child. More importantly, Colin had lost his job, resented Phyl's success,

and wanted to reassert his preeminent role in the family. He began to complain of homesickness and insisted that Phyl and the children return with him to England. Phyl had been planning childcare so she would restart at work, but now could not imagine life as a single mother and reluctantly agreed to return. Seventeen-year-old Heather, the eldest child, refused to leave Australia and the family went back to England without her. Phyl was heartbroken about the break-up of the family and the loss of her daughter, and bitterly disappointed about the end of her career. Life back in England was difficult. Colin contracted rheumatoid arthritis and never worked again. Phyl's initial success with a wool shop ended with bankruptcy in the recession of the early 1990s and the loss of their home. In 1995 she and Colin separated, and he died a few years later.

When Phyl now looks back on her life, the years in Australia, and especially her tremendously successful though short-lived career, are the highlight. In our interview, and when we looked over her old photos, Phyl emphasized the skill and success of her Australian working life. A picture of Heather in their Sydney backyard triggered a story about the dress she is wearing, which Phyl had made and which she used at work to demonstrate the clothes you could create on a knitting machine. The front corner lights of Phyl's company car peak out from the edge of a sunlit and smiling photo of Phyl and Colin watering the new rose bushes in their Sydney garden, and prompted a story about learning to drive (despite Colin's skepticism) so that she could supervise her team of knitting-machine demonstrators. This 1973 color publicity shot (Figure 9.6) of Phyl working as a knitting-machine demonstrator for Lemair Helvetia reminded Phyl that she she had knitted the jumper and skirt she was wearing, and that her smile was a new set of dentures because "I'd had all my top teeth out the day before." It then sparked a detailed account of the skills of pattern-making and sales demonstration.

Phyl can't recall if she sent this image home in 1973; she may have felt awkward about showing off in a photo. But in 2000 she sent me this photo clipped to the 1973 letter that exclaimed that she was "no longer the same person who was tied to the kitchen sink at home." She now captioned the image, "Phyl Sydney Wide." Sydney Wide was the name of the discount shop where she was demonstrating the machine, but the caption also evokes the many miles across metropolitan Sydney that Phyl traveled for work, and a potent memory of expansive opportunities in her Australian years. In 2000, and even more emphatically during our interview in 2006, Phyl was quite clear that this photo of her at work best matched the sentiments of the 1973 letter, and that her Australian career was the time of her life.[35]

Photos provide rich visual evidence about the migration experience: about places visited, houses built, and domestic appliances bought, and about domestic life and family rituals. They are also evidence about the subjective meaning of experience and the ways in which migrants made sense of the new country

Figure 9.6 "Phyl Sydney Wide," 1973 (courtesy of Phyl Cave).

and new lives. But the contemporary photographic record is highly selective, influenced by technology (e.g., in the 1960s most family photos were taken outside because of poor quality flash), cultural expectations of what to photograph and how to pose, and the social relationships within which photos

were taken, disseminated, and discussed. British migrants mostly produced and preserved photos that showed the happy family thriving in an exotic land of opportunity.

Contemporary letters provide valuable evidence about the technology and use of family photos, and hints about their selective representation, though letters were sometimes also self-censored to present a positive picture. Memories—such as Phyl Cave's account of the lottery car or Dorothy Wright's recollection of sub-urban motherhood—can help us to read beneath the surface of the photograph and explore more complex and even contradictory meanings. Recorded memo-ries can explain the purpose and process of photographic self-presentation, with its emphases and silences, and enable a more critical reading of photographs as historical evidence.

The evidence of memory also shows how the meaning and use of photos changes over time. As Julia Hirsch concludes, family photographs "do not change, only the stories we tell about them do."[36] Memory is, indeed, an "active process of creation of meanings"; our memory stories do change with shifting circumstances and new understandings. Bankruptcy and divorce in England ensured that Phyl Cave's stellar Australian career became the centerpiece of her life story and a pos-itive identity in later years. Exposure to feminist ideas and new theories about maternity and depression helped Dorothy Wright reinterpret her experience as a young mother.

But if there is an overlay of shifting social attitudes and identities that we use to make new sense and stories of our lives, then there is also a psychic under-lay of personal experience and meaning, with some sharp or jagged edges, that reverberates through our life and stories. Life story–telling often involves the creation of personal coherence, but it is not always possible to create a past that we can live with. In remembering we strive, not always successfully, to compose an account that makes reasonably comfortable sense of those jagged edges.[37] For example, motherhood was not always easy for women like Dorothy Wright and Phyl Cave. Dorothy was caught between the expectations of motherhood and a desire for self-fulfillment, and her recollections and use of photos from that time resonate with that tension. Phyl Cave's memory is still seared by the separa-tion from daughter Heather in 1977. Torn between her child and her husband, between guilt and responsibility, between a life of fulfillment in Australia and a bleak future back in England—and with her energy and confidence drained by the effort of caring for a new baby—she made an excruciating decision. Though Phyl now lays part of the blame upon her jealous and controlling ex-husband, she still feels acute guilt and regret for leaving Heather. Her mixed feelings of pain and responsibility—and indeed the difficulty of taking responsibility—are evoked in her oral account of departure from Sydney and the repeated and dis-tancing reference to herself in the second person. "I would've *loved* to have turned round and gone [back from the airport], but you just didn't do it. You just got

on. You just do it on automatic pilot almost, you go numb, and you do what you have to do."[38]

There are very few photos of the Cave family's final, painful year in Australia, and none of their leaving and separation from Heather. Experiences like this are too difficult, and feel inappropriate, for photography. Yet memory is not necessarily silenced or expunged by this absence of images. Photos offer starting points for memory stories, and their creation and use may well consolidate memories of photographed events and consign some un-photographed events to oblivion. But significant moments linger in memory, regardless of image. In later life they may take on new meanings and contribute to a reinterpretation of both the life story and the photographic record.

Notes

1. Lani Russell (my research associate), record of a telephone conversation with Phyl Cave, April 27, 2000; Phyl Cave, letter to Lani Russell, April 30, 2000. The oral history interviews with Phyl Cave and Dorothy Wright (conducted by Alistair Thomson on the Isle of Wight in 2006), and copies of their letters, photographs, and unpublished manuscripts, are in the British Australian Migration Collection, Mass Observation Archive, University of Sussex Special Collections (Brighton, England). Phyl Cave and Dorothy Wright granted permission for use of their words and photos in this chapter, and they have read and commented on this chapter.
2. Cave, interview.
3. Ronald Barthes, quoted in Marianne Hirsch, *Family Frames: Photography, Narrative and Postmemory* (Cambridge, Massachusetts: Harvard University Press, 1997), 20. See also Geoffrey Batchen, *Forget Me Not. Photography & Remembrance* (Amsterdam: Van Gogh Museum and New York: Princeton Architectural Press, 2004), 30–31.
4. Henry M. Sayre, quoted in Martha Langford, *Suspended Conversations: The Afterlife of Memory in Photographic Albums* (Montreal and Kingston: McGill-Queens University Press, 2001), 5.
5. Hirsch, *Family Frames*, 107.
6. Langford, *Suspended Conversations*, 124.
7. Patricia Holland, "Introduction," in *Family Snaps: The Meanings of Domestic Photography*, ed. Jo Spence and Patricia Holland (London: Virago, 1991), 13–14.
8. Alice M. Hoffman and Howard S. Hoffman, "Memory Theory: Personal and Social," in *Handbook of Oral History*, ed. Thomas L. Charlton, Lois E. Myers, and Rebecca Sharpless (Lanham MD: Altamira Press, 2006), 277–278; Alistair Thomson, "Memory and Remembering in Oral History," in *The Oxford Handbook to Oral History*, ed. Donald A. Ritchie (New York: Oxford University Press, 2011), 77–95.
9. Ulric Neisser, "Memory With a Grain of Salt," in *Memory: An Anthology*, ed. Harriet Harvey Wood and A.S. Byatt (London: Chatto & Windus, 2008), 88.

10. Alessandro Portelli, "What Makes Oral History Different," in *The Oral History Reader*, ed. Robert Perks and Alistair Thomson (London: Routledge, 2nd edition, 2006, first published in 1979), 37–38.

11. For this project see, Alistair Thomson, *Moving Stories: An Intimate History of Four Women Across Two Countries* (Manchester: Manchester: Manchester University Press, and Sydney, UNSW Press, 2011). On postwar British migration to Australia see A. James Hammerton and Alistair Thomson, *Ten pound Poms: Australia's Invisible Migrants* (Manchester: Manchester University Press, 2005).

12. Ken Plummer, *Documents of Life 2: An Invitation to Critical Humanism* (London: Sage 2001), 59.

13. See Martha Langford, "Speaking the Album: An Application of the Oral-photographic Framework," in *Locating Memory: Photographic Acts*, ed. Annette Kuhn and Kirsten Emiko McAllister (Berghahn Books: New York, 2006), 223–246; Marjorie L. McLellan, *Six Generations Here: A Farm Family Remembers* (Madison: State Historical Society of Wisconsin, 1997); and Annette Kuhn, "Remembrance," in *Family Snaps*, ed. Spence and Holland, 17–25.

14. Langford, *Suspended Conversations*.

15. Richard Chalfen, *Snapshot Versions of Life* (Bowling Green, Ohio: Bowling Green State University Press, 1987), 99.

16. Susan Sontag, quoted in Langford, *Suspended Conversations*, 36. See also Kuhn, "Remembrance," 23; McLellan, *Six Generations Here*, 75.

17. Martha Langford (in *Suspended Conversations*, 99) develops this argument using Tamara Hareven's pioneering oral history research on family cycles.

18. See Hirsch, *Family Frames*, 222.

19. Wright, letters to Mummy, March 3, 1960; to Alistair Thomson, April 8, 2001; to Mummy, March 16, 1961. Each album grouped photographs in rough chronological order; photos on a particular event or theme were often grouped together across several pages. The first five home-made albums were larger and included several photos per page. The last few albums were bought rather than made, probably because by the mid-1960s the Wrights had more money to spend and factory-manager Mike had less time to make albums; two of these albums were smaller and fitted just two photos per page. All the Wright album photos are black and white prints, some developed commercially, some in the later years printed by Mike, and they are affixed to the page by photo corners. Most have white borders and are 5 by 3.5 inches, though in later years Mike enlarged some prints—usually portraits—so that they filled a whole page. Just occasionally an image was cut with scissors to focus on one aspect of the original. Both Mike and Dorothy were involved in the selection and arrangement of albums. Dorothy chose most of the ephemera that were pasted in amongst the photos: menus and ship plans from the voyage; tickets from a Sydney show; cartoons from Australian newspapers and magazines; cuttings from brochures about scenic trips; and magazine photos of Aboriginals in the outback. In places Dorothy added her own humorous ink-drawings of evocative scenes. Perhaps most importantly, it was Dorothy who wrote all the capitalized captions that make sense of the images (she also wrote each of the letters that described and explained the photos). The overall effect is a mixed-media smorgasbord of imagery and text picturing a migrant family's experiences and perceptions of Australia.

20. Wright, interview.
21. Wright, letter to Mummy, March 16, 1961.
22. Wright, letter to Mummy, November 1, 1960.
23. Wright, "I was a £10 Pom," unpublished manuscript, 2000.
24. Hirsch, *Family Frames*, 8.
25. Wright, letter to Mummy, March 2, 1961.
26. Dorothy Wright, *One Ship Drives East And Another West* (Isle of Wight: Fernlea Publications, 2008), 165–169.
27. Wright, "I was a £10 Pom."
28. Wright, *One Ship Drives East And Another West*, 165–169.
29. Bronwyn Davies, "Women's Subjectivity and Feminist Stories," in *Investigating Subjectivity: Research on Lived Experience*, ed. C. Ellis and M.G. Flaherty (London: Sage, 1992), 55.
30. Cave, letters to Mum and Dad, April 10, 1970 and November 10, 1970.
31. Cave, letter to Mum and Dad, April 10, 1970.
32. Cave, letter to Lani Russell, April 30, 2000.
33. Cave, interview.
34. Cave, letter to Patricia and Peter Cave, December 16, 1973.
35. Cave, letter to Patricia and Peter Cave, December 16, 1973. On the "time of my life" as a theme in return migrant memories, see Hammerton and Thomson, *Ten pound Poms*, 316–323.
36. Julia Hirsch, *Family Photographs—Content, Meaning and Effects* (New York: Oxford University Press, 1981), 5.
37. For oral historians' approaches to the "composure" of memory and its psychic underlay and social overlay, see Michael Roper, "Re-remembering the Soldier Heroes: The Psychic and Social Construction of Memory in Personal Narratives of the Great War," *History Workshop Journal* 50 (Autumn 2000): 181–204; Penny Summerfield, "Culture and Composure: Creating Narratives of the Gendered Self in Oral History Interviews," *Cultural and Social History* 1, 1 (2004): 65–93; Alistair Thomson, *Anzac Memories: Living With the Legend* (Melbourne, Oxford University Press, 1994). See also Charlotte Linde, *Life Stories: The Creation of Coherence* (New York, Oxford University Press, 1993).
38. Cave, interview.

From Witness to Participant: Making Subversive Documentary

Al Bersch and Leslie Grant

Folklorist Al Bersch and photographer Leslie Grant argue that the presentation of oral history and photographs as evidence of "authentic" experience of hardship and oppression does "more to maintain existing conditions than...to promote social change," because these representations deflect attention from systemic oppression and imply that oppression is an individual's personal misfortune. They discuss three art projects that use oral history and photographs in diverse ways and that provide alternative approaches that nevertheless accept the possibility of saying something meaningful about experience. In their own art practice, Bersch and Grant, with sound artist Nina Pessin-Whedbee, use photographs and oral narratives to challenge our understanding of historical representation. In the project Sugar House, Grant and Pessin-Whedbee worked with former workers at a closed-down sugar refinery to assemble diverse materials that they "treated as collage elements rather than revelatory mediums." History, as a result of such a process, is not conclusive but open to multiple readings. Bersch and Grant question the possibility of documentary as a social practice and seek to "undermine expectations for authority and truth in oral histories and photographs." This approach reflects on the "documentary turn" in oral history and photography by questioning the fundamental claims of both as documentary practices. Bersch and Grant's work speaks most directly to the essays by Marles and Mauad, who similarly investigate the documentary claims of oral histories and photographs. Like Payne, Marles, and Schiebel and Robel,

Bersch and Grant undermine the seemingly fixed boundary between public and private photography, in their case by publicly exhibiting private pictures.

As documentary forms, both photography and oral history have historically been used as evidence of an authentic social reality or cultural truth. Photographic documentaries often provide viewers with a sense of "witnessing" an event. Oral histories can likewise be presented as testimony. As witness or as testimony, these forms imply a credibility of experience whereby the event of documentation is transparent, and the artifact (be that a photograph or a recording) is simply a carrier by which the subject can communicate directly and without interference. The perception of inherent truth of documentary media, however, obscures how their meaning is created rather than revealed.

In this chapter we take the position, following Victor Burgin and others, that documentary forms such as photography and oral history are constructions of, rather than, windows to reality, and that the meanings produced through these forms are subject to change and interpretation.[1] Stuart Hall writes, "meaning does not inhere *in* things, in the world. It is constructed, produced." He explains, "if meaning is the result, not of something fixed out there, in nature, but of our social, cultural and linguistic conventions, then meaning can never be *finally* fixed."[2] This acknowledgment of the constructed nature of meaning opens up the possibility for documentary, ethnographic, and artistic practices that move beyond historical evidence and instead encourage ongoing, democratic interpretations of everyday life. Through a discussion of three critical documentary projects, we aim to reposition the documentary effect from fixed revelation to progressive story-telling, enabling a more complex and reflexive interpretation that takes into account multiple viewpoints and changes over time.

Photographic Meanings

In order to imagine a new model for documentary practice, we will first look to how conventional documentary photographs and oral histories create meaning. Photographs present facts about our world, but they do not give us the meaning of such facts. The information in an image only becomes meaningful to us based on interpretation using prior cultural knowledge, not through the discovery of the inherent meaning. Yet photographs function as communicative tools by delivering a completed message to the viewer rather than asking for interpretation. Both the mechanical nature of the camera, which creates the illusion of an objective view, and the coherence and stability of the photographic frame, present the viewer with the semblance of an organized and fixed reality. Abigail Solomon-Godeau writes, "While natural vision and perception have no vanishing point, are binocular, unbounded, in constant motion, and marked by a loss of clarity in the periphery, the camera image, like the Renaissance painting,

offers a static, uniform field in which orthogonals converge at a single vanishing point."[3] Such a system allows the spectator a visual mastery over the scene, and is tied to the functioning of ideology by offering up a fixed, unchanging world to the viewer. Perspective, and the languages of science, rationality, and balance it employs, brings with it the effects of power subtly wielded. With this supposed neutrality photographs convince us of their factual nature, and in doing so tell us with authority about our world rather than admitting to the contingent and shifting meanings that are possible.

If photographs are seen as an index of natural truth, then what they picture becomes naturalized. Allen Sekula acknowledges this process as being one of domination: "The worldliness of photography is the outcome, not of any immanent universality of meaning, but of a project of global dominion." He explains, "It almost goes without saying that photography emerged and proliferated as a mode of communication within the larger context of a capitalist world order ... ultimately to unify the globe in a single system of commodity production and exchange."[4] John Berger and Jean Mohr echo this radical claim, insisting that "we are surrounded by photographic images which constitute a global system of misinformation: the system known as publicity, proliferating consumerist lies."[5] They see the camera as implicated in this institutionalized fakery, and the resulting photographs as promoting the falsehoods continually churned out by capitalism in order to maintain its dominant position. In the age of Photoshop we know that all images are potentially manipulated, but at the same time we cannot escape the reinforcement of dominant cultural tropes photographs help to uphold.

Documentary Traditions: Witness and Testimony

An illustration of photography's ability to work in the interest of a powerful elite, even as its practitioners are hailed as social activists, can be found in the work of Farm Security Administration (FSA) photographers (often considered the pioneers of modern documentary practice). A coherent documentary rhetoric and style was established in the United States during the decades between the two world wars out of the desire to make sense of social experience, particularly during the Depression.[6] During this time, the FSA, headed by Roy Stryker, sent its employees into the field with specific instructions on how and what to capture with the lens, solidifying a deliberate documentary style.[7] The resulting photographs were propaganda aimed at eliciting support for the farm securities aid programs, and changed the rhetoric of documentary from the supposed cold presentation of facts to an appeal of emotion. Such a humanist approach, which persists to this day in the work of photographers such as Sebastião Salgado and Steve McCurry, helped the viewer to identify with the subject of the image, and presented the "other" classes as misfortunate and worthy of compassion. As Solomon-Godeau explains, "the victims of the

Depression were to be judged as the deserving poor, and thus the claim for redress hinged on individual misfortune rather than on systematic failure in the political, economic, and social spheres."[8] We agree with Solomon-Godeau that documentary projects operating in this vein, even those attempting to bring awareness to oppression, do more to maintain existing conditions than they do to promote social change.

As with the FSA photographs, testimony using personal experience as evidence of hardship or oppression may in fact direct attention away from the systematic contexts for those experiences—contexts that also shape how the experiences are interpreted. Norman Denzin argues that the feminist "standpoint epistemologies" of Dorothy Smith and Patricia Hill Collins, among others, "falter at the moment when they aspire to be successor sciences—subjugated standpoints" that generate more accurate, objective accounts of the world. "This stance," he writes, "hopelessly entangles the project in the dominant patriarchal discourse on science."[9] Joan Scott likewise discusses the consequences of positing experiential accounts of difference as uncontestable evidence against dominant historical narratives. Such attempts at alternative histories, she argues, take categories of difference for granted and thus run the risk of reinforcing rather than undermining the social systems that rely on such categories. "The evidence of experience," she writes, "then becomes evidence for the fact of difference, rather than a way of exploring how difference is established, how it operates, how and in what ways it constitutes subjects who see and act in the world." Rather than attempt to revise sexist, racist, and heterosexist versions of history by adding the voices of "others," Scott urges historians of difference to analyze how knowledge is produced, and subjects are formed. "Experience," she writes, "is at once always already an interpretation, *and* something that needs to be interpreted. What counts as experience is neither self-evident nor straightforward; it is always contested and always therefore political. The study of experience, therefore, must call into question its originary status in historical explanation."[10]

In thinking about oral history and photography together, we have a chance to reconsider authenticity and objective recording as goals for ethnographic research. Rather than prescribe a new correct methodology, we want to explore examples of alternative documentary forms and social practices that examine, rather than obscure, the production of meaning in their work. Toward this end, we have gathered examples of alternative documentarians who use oral histories and photography to collectively open up meaning produced by their works. From reenactments where participants engage with the past in the context of the present to narrative collages that seek out ambiguity, to collaborative projects created by multiple authors with multiple perspectives, these works break down boundaries between distinct modes of knowing, address assumptions about who gets to tell the story, and question the authority of the author and photographer as well as the supposed authenticity of first-person narrative.

Surname Viet Given Name Nam

In Trinh T. Minh-ha's 1989 film *Surname Viet Given Name Nam*,[11] Trinh reinterprets a set of ethnographic interviews of Vietnamese women, conducted in the 1970s. The ethnographer behind the original texts, Mai Thu Van,[12] gathered the material on her travels throughout Vietnam on what might have been "an autobiographical quest for origins and self-knowledge."[13] In Trinh's reenactments of the interviews, staged by Vietnamese-born women currently living in the United States, she questions the truth value of the oral history form. She uses her filming style to gradually expose this restaging. First she films in a conventional talking heads style and then gradually moves to different camera angles and movements. The camera pans up and down and around, illustrating how the act of filming the interview is an intersubjective process. We are so used to seeing a talking head that we are not actually aware of the framing of the subject. In contrast, when the camera shows just a portion of an actor/interviewee's mouth and her hands, it turns the viewers into active participants; we are forced to imagine what the rest of her looks like. Also, there are a lot of blank walls in the film: either the interviewees are sitting off to the side of a partially lit wall, or pacing in front of it, moving beyond the camera's frame at times. Being drawn to look at that wall causes audiences to engage with what was not there, or with what could not be captured by her image and her words. In these ways, the framing itself is a refusal to definitively know the subjects of the film.

Trinh also calls into question the authenticity of the testimonial text through collage technique. She weaves the testimonies with overlapping folk songs, voice-over commentaries, and historical texts, and she layers historical and archival film and still photographs alongside written text from the Mai interviews. Photographs of refugees, women working, political rallies, and women interacting with men are combined and layered with various texts, creating a range of possible considerations rather than one overarching theme. The end result is a film with layers of meaning organized in a way that refuses to arrive at conclusions.

Translation, which in *Surname Viet Given Name Nam* is wedded to interpretation, is also layered. Rather than totally disregarding more "traditional" ways of doing ethnography or anthropology, Trinh incorporates challenges to these practices into her filming process. In the first "interview" sections, she does not let us take the act of translation for granted. At times the subtitle is off screen, as is the woman speaking. The interviews were conducted in Vietnamese, translated into French, and spoken in English by women with discernable Vietnamese accents. The words spoken in English do not exactly line up with the subtitled text, so that there is never any one cultural truth that can be uncovered from so many layers of interpretation. One woman says in her interview, "I am willing to talk, but you should not have doubts about my words. There is the image of the

woman and there is her reality. Sometimes the two do not go well together!"[14] She reminds us that simply engaging in a conversation about anything, much less something as complex as womanhood or war, is a translation in itself. Trinh rejects mainstream anthropological approaches to uncovering traditions and customs, but what's more, she does not reject the fact that people's interpretations and invocation of traditions and customs—their contextual uses—are still some part of the stuff that makes up our cultural identities.

Denzin contrasts Trinh's approach to interpretive ethnography with the standpoint texts discussed in the previous section. While these texts struggle to be "objective and partial, critical, embodied, and situated at the same time,"[15] for Trinh, distinctions between subjectivity and objectivity are mute. "Trinh," he writes, "seeks to undo the entire realist ethnographic project that is connected to such terms as lived experience, authenticity, verisimilitude, truth, knowledge, facts, and fictions."[16] Recognizing that truth is "produced, induced, and extended according to the regime of power,"[17] Trinh makes a strong argument for "the fight against 'realism.'" Not as "a denial of reality and of meaning, but rather a determination to keep meaning creative, hence to challenge the fixity of realism as a style and an arrested form of representation."[18] In *Surname Viet Given Name Nam*, the creative production of meaning, through reenactment and collage, helps the viewer to imagine multiple, interconnected situations and narratives.

The only conclusion Trinh may state too strongly occurs when she interviews the women actors as themselves, on the topic of what it is like to participate in the making of the film. The revelation that they are Vietnamese immigrants in the United States who were acting as refugees in South Vietnam is crucial to what we have been talking about—translation and interpretation decentering a single, set narrative. But it feels like these new interviews give too many answers. The filming style changes. It is more straightforward, brightly lit, centered on the women in a 'real-life' context—on a back porch, for example, or a restaurant. This new set of interviews falls back on assumptions of reality—they seem to reveal the "true story" behind the ambiguous and interpretive first half of the film. But while they could have found a way to keep reminding us that even "playing themselves" there is some translation involved, the problem of the second set of interviews is also indicative of the impossibility of completely and totally resolving the need for artist and viewer to look for and discover some truth in the documentary.[19]

"Ruralismo" Revisited

In October 2009, an exhibit titled "'Ruralismo' Revisited: Multimedia Artefacts from Richmond, Indiana's Rowntree Records"[20] at Traditional Arts Indiana's Center for Folk Traditions in Nashville, Indiana, challenged conventional definitions of "tradition," and refused clear distinctions between ethnographer,

subject, and audience. The exhibit featured audio, visual, and material artifacts from the experimental home recording collective Rowntree Records, working in Richmond, Indiana during the early 2000s.

"'Ruralismo' Revisited," a project by Joseph O'Connell, is as experimental as the music of the Rowntree collective itself. It is difficult to nail down its genre—is it a documentary? An oral history project? Or perhaps another creation by Rowntree projects. Recorded audio interviews are at times more musical than text-based, more playful than informative. This is the strength of the installation. Because it operates simultaneously within the frameworks of performance and folklore exhibit, it requires audiences to reconsider disciplinary boundaries around different modes of communication.

The exhibit fills one room of the museum, accessed via an internal glass door. The open floor plan is divided visually by two support columns, which subtly orient visitors towards a left-to-right path through the exhibit space, following multiple intertwined narratives in both audio and visual form. There is a drum set in the corner, mix tapes and records pinned to the wall, and collaged panels containing Rowntree ephemera are displayed along another wall (Figure 10.1). An audio device and headphones rests on a column in the center of the room, as a listening station with randomly mixed sections of a self-recorded interviews from Rowntree participants. Next to the drum set, a small speaker emits an ambient mix of music and texts, pulled from disparate collections of various Rowntree members.

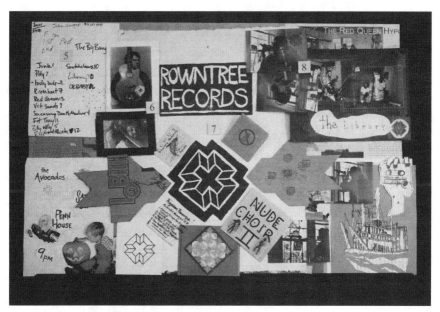

Figure 10.1 A collage of Rowntree Records' materials, including show flyers, photographs, album covers (courtesy of Joseph O'Connell).

O'Connell presents the materials more as artifacts than as evidence. An intentionally slap-dash and do-it-yourself aesthetic highlights their subjectivity and reminds the viewer of the Rowntree member/collector who has saved these things. The photographs, artifacts, texts, and audio are like bits and fragments saved in a shoebox, held together by collective and personal memories.

Supplementing the exhibit artifacts, official-looking museum placards tell, in first-person narration, of O'Connell's developing musical relationship with Jason Henn, an imaginative home recordist from Richmond, Indiana. While still in middle school, Henn secretly "began misusing a karaoke machine to make tape recordings in the attic of his parents' house...attributing them to a band called Tipe, and sharing them with his classmate Andy Stout on 'Industry Release Tuesdays.'"[21] As the Tipe bandleader, he assumed the role of King Elder, one of his many fictional characters and "the displaced ruler of an obscure island nation, forced into Richmond factory work by a cruel turn of the global economy" (see Figure 10.2).[22]

In the context of the museum exhibit, Henn's playful exploration of identity frames the larger context of Rowntree Records, whose members documented and remixed their musical experiments to reflect a constant reworking of cultural identity among a fringe group made up of both student transplants and Richmond locals. O'Connell's own shifting identity between ethnographer and group member is present in the text, where his voice comes through the writing as an ambiguous participant-observer and a self-conscious exhibit director. He explains how he selected and arranged materials according to his own vision yet within the tradition of the group's constant experimentation—through audio mixing and playback—with collective self-image. "'Ruralismo' Revisited can be thought of as a personal 'monitor mix,'" he writes, "a balancing and filtering of playback elements that, to my ear, sounds like Rowntree Records. Others might notice my fingerprints on the faders."[23]

O'Connell's "monitor mix" exhibit concept comes through notably in the presentation of audio elements in the exhibit. Echoing the collage of visual artifacts, the audio interviews, sounds, and music are randomly mixed and overlaid so that listeners hear multiple voices instead of one clear narrative. One might hear, for instance, over the sound of someone hitting what sounds like a xylophone, Henn's response to O'Connell's interview request, "Okay Joe, I've tried recording this a bunch of times, and I think I'm going to just live with whatever comes of this take, right now. I hope this is still useful to you 'cause your message said that you needed it in about a week and it's been about a week, so I hope this is arriving in time."[24] Following this statement, a voice explains how to adjust the knobs on a home recording device, and then, suddenly: "I remember, particularly, the 'pam' knob."[25] Heard side by side with answering machine messages, the sound of a coin in a washing machine, and improvisations with echo-effects, the

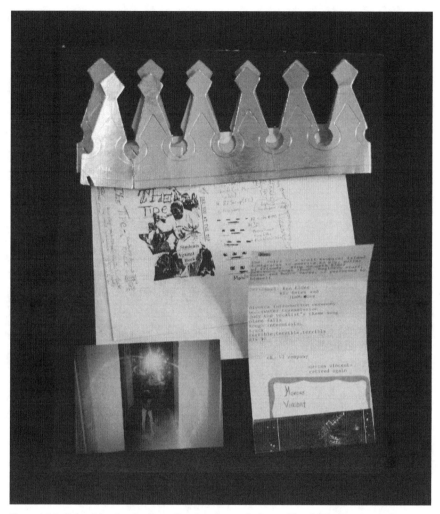

Figure 10.2 Materials related to Jason Henn's ambiguously fictional band "The Tipe," including a tape cover and the crown worn by bandleader character King Elder (courtesy of Joseph O'Connell).

interview segments reflect delight in the accidental and unexplainable; to make their point, they undercut their legibility.

Sugar House

In our projects with workers in resource extraction industries (salt mining, forestry, sugar refining, fishing), we attempt to undermine expectations for authority and truth in oral histories and photographs. Our aim is to explore how and why identities are created and maintained, and ultimately to help create new

and different identities or realities. Rather than acting as authorities who reveal the true situation, however banal or horrific, in our practice, we—Al Bersch and Leslie Grant—and Nina Pessin-Whedbee attempt to build stories that seek multiple interpretations, and require active listening and creativity on the part of participants and audiences alike.

Using a methodology based on collaboration rather than a solo practice, site-specificity rather than universalized claims, and participatory, multifaceted research rather than official histories, the project *Sugar House* combines photographs, both ours and donated family snapshots, oral histories, personal maps, and archival materials ranging from ID badges to hand-written notes, to tell complex stories about our chosen subject. These forms all have latent histories that impose a structure and expectation for a certain kind of narrative, usually one that benefits the powerful at the expense of the marginalized. In *Sugar House*, we seek to reveal these forces and disrupt them by creating multiple possibilities for narrative threads that subvert the authorial power of representational media.

Sugar House, exhibited as a multimedia installation of photographs, collected objects, and audio, and existing as a website (http://www.sugarhouseproject. com/), focuses on the former employees of the Domino Sugar Refinery and the surrounding neighborhood in Williamsburg, Brooklyn. The refinery closed in 2004 after over 100 years in operation, and was one of the last businesses to leave the once-crowded, working-class, industrial area that has rapidly gentrified and become a high-rent residential neighborhood. The end of an era, for sure, and also the end of well-paid employment for the mostly long-term employees who had worked there for 15, 20, or 30 years.

For a year between 2008 and 2009, Grant and Pessin-Whedbee collaborated with a dozen or so former employees of Domino Sugar to gather materials and create the project, according to each worker's interest and time.[26] Our first step was to take a formal portrait photograph in locations chosen by the employees. For example, Bob Shelton always played handball at the local Williamsburg courts, and requested to have his portrait made there. Eddie Lopez grew up in Red Hook, and we traveled there with him to visit his old apartment building and took photographs on the waterfront nearby (Figure 10.3). Errol Anderson asked to be photographed in front of the Mechanics Hall, an organization similar to the Freemasons, of which he was a respected member. Other employees were photographed at their homes, or in front of the refinery. The portraits were useful not just for the stories they told to the viewer, but as a process that opened up a working relationship between us and the subjects. Their concreteness provided a departure point for less visible and defined conversations and stories to unfold. We then asked people to contribute their own personal snapshots to the project, and received many photo albums from which we curated images of work and workers at the refinery or at leisure (Figure 10.4). We included many different sources of photography in the project—personal, amateur, professional,

Figure 10.3 Eddie Lopez on the waterfront in Red Hook, Brooklyn, where he grew up (courtesy of Leslie Grant and Nina Pessin-Whedbee). From *Sugar House*, 2009.

Figure 10.4 A Domino Sugar employee baseball game in Williamsburg, Brooklyn, mid 1990s (courtesy of Allen Wade, former Domino Sugar employee). From *Sugar House*, 2009.

portraiture, corporate—to undermine any possibility of a single overriding perspective, author, or narrative.

We also collected memorabilia and research materials from the employees and the Brooklyn Historical Society, such as historical photographs, company newsletters, and newspaper articles about the refinery and about sugar production in general. Including these objects engages the project with ideas about art-making and ethnographic study. Similar to our photographic strategy, our use of a mixed collection of materials from many different sources and positions, with many different weights of meaning, enables these materials to be treated as collage elements rather than revelatory mediums. We choose to raise questions and create profound juxtapositions rather than tell a conclusive history about the people who worked at Domino in particular, and sugar production in general.[27]

An integral aspect of the project was to present personal views of Domino Sugar and the neighborhood, so we invited participants to draw maps and narrate stories about working at the refinery and living or hanging out in Williamsburg. These hand-made maps navigate disparate lived experience, including one map detailing how a certain machine used in sugar production worked, another of bars where employees used to drink together, and one of a bike route to work (Figure 10.5). In addition to the maps, we made audio recordings of people

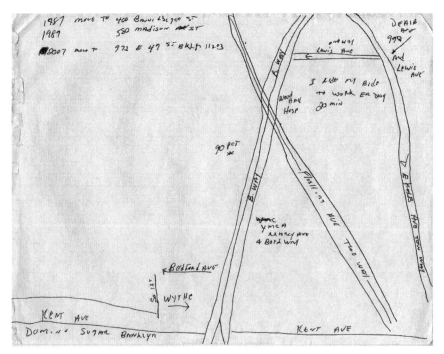

Figure 10.5 Map drawn by Bob Shelton, former Domino Sugar employee, showing his bicycle route to work through Brooklyn. From *Sugar House*, 2009.

talking about their experiences, and we combined these stories with other oral texts into a single, multifaceted audio piece. The audio recordings for *Sugar House* worked along similar lines as the visual materials discussed above, in that they included different categories of information, such as personal narrative and literature, and governmental or advertising texts read aloud by the refinery workers and by Grant and Pessin-Whedbee. For example, we used text from the introduction of Richard Braughtigan's *Watermelon Sugar*, an advertisement for household sugar from the 1930s, parts of oral histories recorded during the project, and a section of *Moby Dick* by Herman Melville among others. By including these various sources of information, we wanted to make it a challenge for listeners to be able to categorize different types of knowledge so as to disrupt the dichotomies of fact/fiction, personal/official, poetic/explanatory. As such, a reading of an advertisement for the sugar industry becomes a poem, and a description of whiteness from *Moby Dick* becomes a personal history.

Sugar House was exhibited in *There Goes the Neighborhood* at the Museum of Contemporary Art in Cleveland, OH in June 2009. The installation aimed to tie the different media of the project together in one space. It consisted of large-scale prints depicting our photographs, donated snapshots, and hand-drawn maps (scanned and reprinted), two vitrines presenting the objects and textual materials we collected from the employees and historical archives, the audio piece that could be listened to on headphones at three stations, and a map drawn by artist Leah Beeferman of her imaginings about how the sugar refinery looked and operated (she had never been there). As a viewer one could listen to the audio while looking at any of these three other media, which created the opportunity to make connections between the historical texts, personal maps, portraits, and imaginings that the project includes.

In its many forms, from photography to archival materials and to audio recordings, *Sugar House* meshed together official and vernacular texts, and like *"Ruralismo" Revisited*, included voices and interactions of the researchers alongside those of the "studied." The combination not only of different voices, but different types of materials, undermines a tendency to assign a specific, authentic position to the speaker. In conventional documentaries, such as Milton Rogovin and Michael Frisch's *Portraits in Steel*,[28] the visual and textual information interact together to provide corroborating evidence. Oral histories and photographs are used side by side to reinforce the representation of both visual and experiential reality. In *Portraits in Steel*, for example, the workers' words narrate the portraits, which in turn provide an illustration of the written history. The stories presented are often complicated and uncomfortable, but they always tell a singular, fixed story. That singular story reveals hardships and creates sympathy in the viewer, but it does not leave room for ambiguities and takes the authenticity of first-person narrative for granted. In contrast, the collage-style presentation of text and image in *Sugar House,* situates both the producer and subject as complicit in

the story-telling that documentary ultimately accomplishes. Such an approach acknowledges the many, and often contradictory, narratives that go into the formation of self and group, and therefore makes plain the constructed and contingent nature of both representation and identity. Documentary practice is recast as a collaboration between photographer and subject, and the dichotomies of professional/amateur and outsider/insider begin to disintegrate. The effect is a poetic reading of multiple points of view that have the ability to tell a complex and contradictory set of stories about Domino, rather than an attempt at reconstructing a singular, totalizing, and expected story about labor and the closing of the plant. With this layered narrative, the audience can translate myriad threads into their own idea of what that lived experience was like, and what its potential meanings might be in a broader cultural sense.

This chapter explores alternative interpretations and uses of photography and oral history that subvert assumptions of authority and open up new possibilities for exchange between subjects, audiences, and researchers, both in the ways they are recorded, and in their exhibition or presentation. Through shifting documentary's emphasis on reproducing reality to opening meaning, other, more democratic ways of knowing may emerge so that that the world can be thought of in alternate ways, and historically marginalized peoples can create their own new cultural identities. Hal Foster, in the conclusion to his essay "(Post)Modern Polemics," asks what is lost by severing, or tampering with, that "clean line" leading from the subject in front of the camera—or microphone—to the reader or listener. "For many," he writes, "this is indeed a great loss—and may lead to narcissistic laments about the end of art, of culture, of the West. But for others, precisely for Others, this is no great loss at all."[29]

When film restages ethnographic texts with actors, when a museum exhibit purposefully distorts and overlays interviews to the point of humorous confusion, when *Moby Dick* reads as oral history, documentary may lose credibility with those in power. What it gains, however, is the crucial possibility for alternative ways of understanding our world and each other. If we puncture or tear away the façade of the document, the witness, the testimony, and revel in their complexity, then we come closer to a changing, progressive knowledge about our social reality.

Notes

1. Victor Burgin, *Thinking Photography* (London: The MacMillan Press, 1982), 144–146. Burgin explains (144), "whatever specificity might be attributed to photography at the level of the 'image' is inextricably caught up within the specificity of the social acts which intend that image and its meanings"; Stuart Hall, *Representation: Cultural Representation and Signifying Practices* (London: The Open University and Sage Hill Publications, 1997); Allan Sekula, "The Traffic in Photographs,"

in: *Photography Against the Grain: Essays and Photoworks 1973–1983.* (Halifax Nova Scotia: Nova Scotia College Press, 1984), 80, 96.

2. Hall, *Representation*, 23–24.

3. Abigail Solomon-Godeau, *Photography at the Dock: Essays on Photographic History, Institutions and Practices* (Minneapolis: University of Minnesota Press, 1991), 180–181.

4. Sekula, "The Traffic in Photographs," 144.

5. John Berger and Jean Mohr, *Another Way of Telling* (New York: Pantheon Books, 1982), 96.

6. John Tagg, *The Burden of Representation* (Amherst: The University of Massachusetts Press, 1988), 8.

7. Solomon-Godeau, *Photography at the Dock*, 178.

8. Solomon-Godeau, *Photography at the Dock*, 179.

9. Norman K. Denzin, *Interpretive Ethnography* (Thousand Oaks: Sage Publications, 1997), 86.

10. Joan W. Scott, "The Evidence of Experience," *Critical Inquiry* 17, 4 (Summer, 1991): 797.

11. Trinh T. Minh-ha, Director, *Surname Viet Given Name Nam*, 1989.

12. Mai Thu Van, *Viêtnam : un peuple, des voix* (Paris: P. Horay, 1983).

13. Katherine Gracki, "True Lies: Staging the Ethnographic Interview, in Trinh T. Minh-ha's Surname Viet, Given Name Nam (1989)," *Pacific Coast Philology* 36 (2001): 48–63.

14. Trinh T. Minh-ha, Framer Framed (New York: Routledge, 1992), 62.

15. Denzin, *Interpretive Ethnography*, 86.

16. Denzin, *Interpretive Ethnography*, 74.

17. Trinh T. Minh-ha, *When the Moon Waxes Red: Representation, Gender, and Cultural Politics* (New York: Routledge, 1991), 30.

18. Minh-ha, *When the Moon Waxes Red*, 164.

19. The writing in the chapter section about Trinh T. Minh-ha's film *Surname Viet Given Name Nam* was based on a conversation between Al Bersch and Nina Pessin-Whedbee in January 2008.

20. "'Ruralismo' Revisited: Multimedia Artefacts from Richmond, Indiana's Rowntree Records," Center for Folk Traditions. 46 Gould Street East in Nashville, IN 47448. October 14, 2009.

21. Joseph O'Connell, "'Ruralismo' Revisited" exhibit text, 2009.

22. O'Connell, "'Ruralismo' Revisited."

23. O'Connell, "'Ruralismo' Revisited."

24. Jason Henn Interview, "'Ruralismo' Revisited."

25. Henn, "'Ruralismo' Revisited," 2009.

26. Grant and Pessin-Whedbee also collaborated with slowLab founder Carolyn Strauss, who helped to instigate and explore the conceptual framework for the project and aided in securing funding and exhibition opportunities.

27. For a discussion of art-making and ethnography, see Hal Foster, "The Artist as Ethnographer," in *The Return of the Real* (Cambridge: MIT Press, 1996).

28. Milton Rogovin and Michael H. Frisch, *Portraits in Steel* (Ithaca: Cornell University Press, 1993).

29. Hal Foster, "(Post)Modern Polemics," *New German Critique* 33 (1984): 78.

Photographs from *The Shoebox*

Janet Elizabeth Marles

Audio-visual producer and filmmaker Janet Elizabeth Marles created a history of her mother's (and her own) search for family roots by constructing a website that can be explored in multiple directions and that reflects "the fragmentary nature of Heather's memory story." Heather was born in Australia and was 72 years old when she received a shoebox full of mementos from her childhood. This led her on a search through archives, cemeteries, and memorials around the world. Marles's essay and her website take us on Heather's "journey of discovery," demonstrating, along the way, the fragile and fragmentary nature of memory and the power of narrative to assemble such fragments into a whole. Like Wilton in an earlier essay, Marles considers the therapeutic potential of life story work. Photographs were at the center of this exploration, used both to document the past and to help remembering. Marles brings the perspective of the documentarian. Her website is an example of Bersch and Grant's proposal, in an earlier essay, to look for alternative ways of presenting documentary that undercut authenticity by refusing, in Marles' case, linearity. Like Bersch and Grant, Marles does not wish to reject the veracity of her narrator's lived experience. The website presents elements of a life story, but the website visitor is also given the opportunity to put them together in different ways. While print publications have been a dominant medium for oral historians to publish their research, Marles' interactive website, like Bersch and Grant's exhibition of photographs and oral narratives (also accessible online), showcases the multimedia documentary opportunities for oral history and photography used in tandem to produce histories that are not conclusive but instead are open to multiple readings.

In November 2005 my mother Heather and I traveled to her birthplace, a small rural town named Nhill in the wheat-belt of the Wimmera, a region near the border of the Australian states of Victoria and South Australia. It was a trip of discovery that had begun in 2002 when Heather, at the age of 72, was given a shoebox of documents. This shoebox had been stored in a shed in the Wimmera for over half a century. Its contents answered many questions for Heather about her childhood. She had little knowledge of her parents or her extended family, because she had been orphaned in 1941 at just ten years of age.

With the discovery of the shoebox, Heather began a quest to uncover more of her family history and to meet relatives long lost to her. Our trip to the Wimmera was the beginning of these journeys that have taken Heather to the Victorian State archives, historical societies, cemeteries, the Australian War Memorial archives, the World War I battlefields of France and Belgium, and key localities from her childhood. Historian Anna Haebich describes this type of travel as genealogical tourism with "off the beaten track" destinations "where travelers seek emotional, personal and even spiritual contact with the past, as well as museums and archives where they search for genealogical and historical facts to embellish their memories."[1]

I have accompanied Heather on many of these journeys and have recorded our conversations and her reactions as she uncovered fragments of her history. We have also discovered an unexpectedly rich collection of family photographs, many of which Heather had not previously seen. These photographs stimulated Heather's memories about significant events of her childhood; memories she articulates with surprising accuracy.

With the combined rich resources of Heather's recorded memories, the information gleaned from the documents in the 60-year-old shoebox, research from historical archives, and our visits to key locations, I produced a web-based biographical history documentary of Heather's unique story titled *The Shoebox*[2] and created an interactive online architecture to mirror its content.

The narrative structure of *The Shoebox* is designed to accentuate the fragmentary nature of Heather's memory story. As users explore each 360-degree panoramic scene they are prompted to access embedded clips within each scene. Once viewed these embedded fragments build on a timeline that can be played, after a specific cue, as a "traditional" linear documentary narrative with scripted beginning, middle, and end.

Naming this story-telling structure *memoradic narrative*, I designed it to mimic the process of autobiographical memory recall whereby a recollection is accessed as numerous small memory packages stored throughout the brain that are combined into a comprehensive narrative by the person remembering, and then presented to another as a continuous (personal) story. Engel explains autobiographical memory as a reconstructive process where "one creates the memory at the moment one needs it, rather than merely pulling out an intact

item, image or story. This suggests that each time we say or imagine something from our past we are putting it together from bits and pieces that may have, until now, been stored separately."[3]

There are over 60 still photographs in *The Shoebox*. Some were taken by myself as Heather and I uncovered her story, others are scans of old documents found in the shoebox; the majority, however, came from Heather's family's own photographic collections ca. 1915 to 1955. Selecting just six of these photographs, this chapter explores the relationship between image and memory in Heather's narrative, and the use of images and oral testimony in digital history making.

Return to Abdullah Park

On our genealogical journey of discovery in November 2005 Heather and I visited the homestead where Heather had lived as a child. Named Abdullah Park,[4] after a famous Arabian racehorse, the property is a 50-acre horse stud located at Moolap four miles (approximately 7 kilometers) southeast of the Victorian coastal city of Geelong in southern Australia.

Heather's family—her father Donald, mother Clara, and two older sisters Gwendoline and Marjory—moved to Abdullah Park from the Wimmera in July 1937, when Heather was six years of age. Eleven weeks later Heather's father Donald was killed when his car hit an electric tram. Tragedy struck the family again just three-and-one-half-years afterwards when the girls' mother died from an unknown illness.

Heather said:

> We were up in the Wimmera,
> up on the South Australian border and my father,
> there weren't any boys in our family,
> I was the third girl,
> and when Gwen got to be 14 he wanted her to go to high school and there was
> no local high school,
> so he made the decision to move to Geelong,
> and that was how he bought Abdullah Park.
> It was only fifty acres but it was a horse stud,
> a Mrs. Gibb owned it,
> and her husband had been killed in a jumping accident.

Heather thinks this picture of their home (Figure 11.1) was taken around the time of her father's funeral in early September 1937. The photograph shows one portion of the Abdullah Park homestead from the entrance driveway. To the

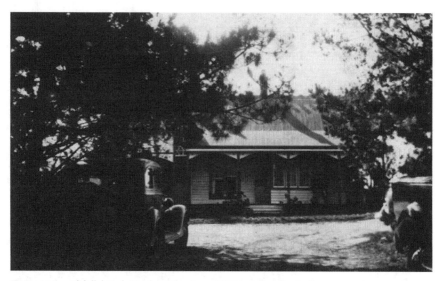

Figure 11.1 *Abdullah Park,* Moolap, Victoria, *ca.*1937 (private collection).

left and right of the driveway two Ford cars are just visible. Donald was driving a similar vehicle when he was killed.

In preparation for our visit to Abdullah Park Heather communicated with the current owner, who agreed we could visit. The family who bought the property after Heather's mother Clara's tragic death in 1941 had lived at Abdullah Park for over 60 years and had made few changes. The current owner had completely opened up the back of the house and renovated the kitchen; however, the front of the house was untouched. The lounge, bathroom, and bedrooms were all as they had been when Heather was a child.

Although in need of some repairs, Abdullah Park is still grand and beautiful. There are lovely stained glass windows throughout the house, ornate plaster ceilings, and fireplaces in the bedrooms as well as the lounge. When Heather lived here from 1937 to 1941, the long gravel drive from the road to the house was lined on both sides with stately pine trees. These are now gone. However, the stables and the men's quarters at the back of the house remain.

Our visit lasted two hours. The current owner was interested in the history of the property and Heather's handful of family photographs. It was invaluable for me to be present as documentary witness and emotional supporter as Heather relived events and recalled small details of the life she had lived here, as the memories of the young girl flooded back.

At Abdullah Park Heather remembered the crossed peacock feathers above the fireplace in the lounge. Superstition said they brought bad luck. Losing both parents in less than four years, Heather is inclined to agree. She remembered lying in bed and being able to just reach, with her foot, the light switch,

which hung as a long string from the center of the room. For a country girl this was luxury. She remembered the towel fight she and her sister Marjory had in the bathroom and her father's World War I uniform that hung in the cupboard behind the bathroom door. She remembered one rare occasion when she and her mother were home alone, they made toffee on the wood stove; it boiled over and spilt all over the stove. She remembered her mother on the hall telephone the night her father was killed. She remembered her mother went to hospital and never came home.

Heather said:

> But I must tell you about my father buying the property from Mrs. Gibb,
> she said there was 50 acres there and he sent the surveyors out and they said
> there was only 48,
> they argued about the price and finally my father said,
> being a betting man and so was she 'cause they were horsey people,
> he said I'll toss you for it.
> Marjory tells me they went out onto the footpath and they tossed.
> Now having been a child of seven when he died they always told me he won
> the toss,
> but the truth might be somewhat quite different.[5]

This story of Donald tossing a coin to settle a dispute is the type of characterization history documentary-makers relish when portraying people long deceased. Within this small vignette a larrikin[6] recklessness suited to the persona of a returned Australian soldier is accentuated. Heather has told this anecdote a number of times, and I used her voice-over interview relating this tale with a video reenactment of a tossed coin superimposed over Figure 11.1 as an embedded media clip in *The Shoebox*. I have also written an audio documentary dramatizing one part of Heather's story, titled *Everything Changes*, which uses this coin-tossing anecdote as the opening scene because of the insight it provides into the character of Heather's father.[7]

My Father

Heather's father's involvement in World War I and the injuries he sustained on the front line are a constant thread in Heather's recollections of him. Her family photographic album includes six photographs of Donald Neil McDonald as a private with the First Australian Imperial Force (AIF). Some of these photographs were taken in a studio near the Seymour military training camp, north of Melbourne, Australia, in 1915 before Donald was shipped out to the battlefields of France and Belgium.

Figure 11.2 is of particular interest because both Donald and his brother James are present in the back row of this photograph. The brothers signed up for active service together in Melbourne on July 20, 1915. James, aged 26, is on the left, and Donald, aged 21, is on the right. Although assigned to different battalions the brothers sailed together on the troopship *Afric* on January 5, 1916, for training in Egypt before they were transferred to the trenches in France.[8]

Both James and Donald fought in the battle of Pozieres, and both brothers were wounded in action; Donald on July 26, 1916 with a gunshot wound to his left leg and James the following day with a wound to his back. Two months later James received a severe gunshot wound to his leg, which left him in hospital in England for 11 months, before he was shipped home in July 1917.

Donald remained on the frontline and was wounded a second time with a gunshot wound to his face in the battle for the Hindenburg Line. He was hospitalized with this injury and suffering from shock on May 8, 1917. His third injury, received in the battle of Anzac Ridge in Belgium on October 4, 1917, was a severe gunshot wound to his face and right eye. On this occasion Donald was left wounded on the battlefield for two days before he was retrieved and sent to hospital.

Both James and Donald made it home to Australia, yet both were severely disabled by the war. Donald lost the sight of his right eye. Coincidently, James died from complications of sugar diabetes just eight weeks before Donald was killed in the car accident on September 9, 1937. Donald's war service disability, particularly his blind right eye, were major contributors to his fatal accident.[9]

Heather said:

My father had five brothers,
two of them,
Dad and his brother Jim went to the War and
they both died young...
My father,
he'd been very badly knocked around in the War,
he was blind in one eye,
he'd had two head injuries and a bad leg injury
and he was shipped home in January of 1918 because he had just gone through so
 many injuries and [even after Heather was born in 1930, 12 years later] he was
 still going back to the military hospital from time to time for treatment.[10]

My Mother

Less than four years after Donald's death, Heather's mother Clara was taken to hospital suffering from an unknown illness. Even today Heather does not know the real cause of her mother's death.

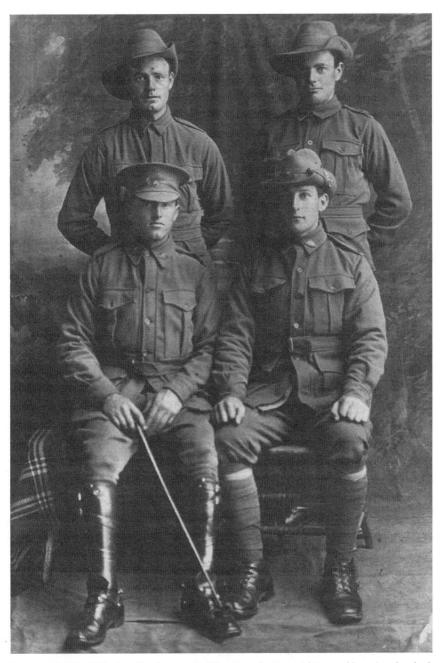

Figure 11.2 World War I studio photograph of First Australian Imperial Force soldiers, (standing back row left to right) Privates James and Donald McDonald, (seated front row) unknown Officer and Private, Seymour military training camp, Victoria, Australia, *ca.*1915 (private collection).

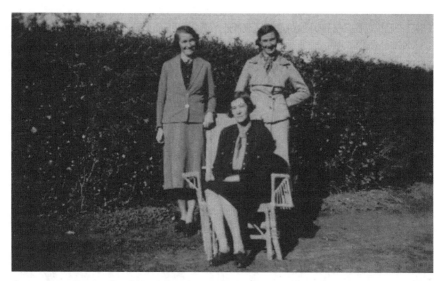

Figure 11.3 Clara McDonald (seated) with sisters Addie and Mabel (standing), *Abdullah Park, ca.*1941 (private collection).

Figure 11.3 shows Clara seated in the garden of Abdullah Park in about 1941. Standing behind are her two eldest sisters. Addie is on the left, and Mabel is on the right. Both sisters are more than five years older than Clara, yet in Figure 11.3 she looks to be considerably older than her sisters. This photograph is a clear indication of how ill Clara had become before she died.

Heather said:

> My mother was the youngest of six girls in a row,
> she was a lovely person...
> she had those soft brown eyes
> they're not heavy brown eyes,
> they're a lighter brown eye,
> but they're kind,
> very kind looking eyes...
> she was only a young woman [when she died],
> she was only 42 and she hadn't had a history of ill health.
> She'd been perfectly well,
> and the only thing I know is,
> I don't remember but people have said,
> that she got very thin and,
> I think now on reflection that she had undiagnosed diabetes which if
> neglected causes kidney failure and,

I think that that's very clear because she had never had ill health,
 until,
a few months before she died.
Yeah.
Yeah.
But why someone didn't pick it up,
I don't know,
I mean she went to doctors,
they,
it just seemed to be,
medical mismanagement as far as I'm concerned,
and why her friends and family didn't say,
you know, "Are you sure you're well?"
or whether when she got to the hospital,
she was four weeks in the hospital,
but perhaps the care wasn't adequate there.
She might not have gone in as desperately ill,
Ahh,
but we'll never know.[11]

When their mother died in May 1941, Heather and her sisters were placed under the guardianship of their father's older brother, Uncle Jock, a stock and station agent, who lived with the rest of the extended family 250 miles (400 kilometers) away in the Wimmera. Uncle Jock did not want the girls to be separated and made the decision to board them in Geelong. It was wartime and accommodation was very scarce so the girls moved from place to place. For Heather, the youngest, it was to be a dozen boarding houses in ten years.

"The Day We Left"

One of the key photographs from Heather's childhood depicts three girls in overcoats and hats lined up for the photographer, eldest to youngest, left to right. In front of them is a small terrier dog also looking directly at the photographer. On the left side of the photograph is a trimmed hedge; on the right is a portion of the house showing a veranda. Behind the girls the viewer can just make out a utility truck, which is packed with belongings.

Heather said:

That's us,
down the side of the house,
the day we left.[12]

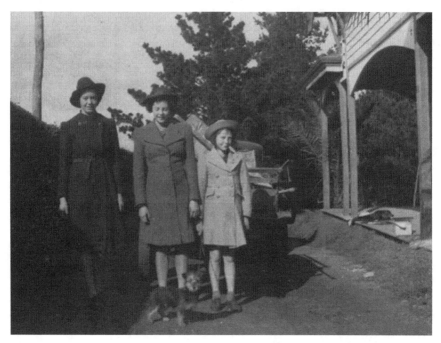

Figure 11.4 (left to right) Gwendoline, Marjory, Heather, and Pongo the dog (in foreground), *Abdullah Park,* August 10, 1941 (private collection).

Figure 11.4 was taken on August 10, 1941. Heather is the youngest of the girls. To her right is her sister Marjory aged 14, next to Marjory is her eldest sister Gwendoline aged 17. The girls are leaving their home Abdullah Park. It was 12 weeks after their mother died in hospital and the girls became orphans.

Heather said:

> That was the age I was when we left Abdullah Park.
> We went into Geelong.
> That's the age and size I was,
> so,
> it wasn't long,
> we were only in that house for four years,
> and,
> and,
> only for two months,
> my father was there with us.[13]

As the girls' legal guardian Uncle Jock managed their parents' leased wheat-farm in the Wimmera, which provided the girls with the funds for their lodgings.

It was Uncle Jock who stored the documents in the shoebox that would eventually be given to Heather in 2002.

Heather said:

Well the Shoebox was 50 years old,

it was longer than that it was 60 years old,

and it had been in a cupboard in a garage in Kaniva belonging to my Guardian who had died in 1961.

And he had been the executor of my mother's estate and so when his business closed down all the documents and records that you're required to keep by law were put in a cupboard in a shed behind his son's house,

who has subsequently died as well.

So there was a long time where this stuff had just been kept and stored until it became evident that there were white ants in the shed.

And surprisingly I was in the country town,

which I'd hardly ever been in,

only on very rare occasions the very day that they found the shoebox.

And so they rang me and they said.

"Oh we've got this box and it's got all about your family in it."

And so I said "well Oh that'll be good I'll, I'll come and get it this afternoon because I'm going to be over that way,"

and they couldn't wait,

they came round,

jumped in the car and came straight round and presented me with the shoebox.

And in it I found copies of all of the documents that had related to my parents and their properties and the costs,

all of the costs involved over the period of time,

from when I was 11 until I was 21.

Which was very valuable information...

We paid 30 bob[14] a week each,

and for that we got all our meals and all our washing and ironing done.

Inside the shoebox Heather also discovered account books, check butts, letters, legal documents, the wills of both her parents, probate documents filed at the time of their deaths, purchase documents for the Moolap property Abdullah Park and documents concerning land taxes and Donald's horse breeding activities.

These documents are all dry fiscal records ca.1922 to 1950, yet to Heather these records are a tangible link to her long deceased parents. As Margaret Gibson[15] explains in her book on memory and mourning, "for the bereaved, objects can transpose into quasi-subjects, moving into that now vacant bereft place." Heather's access to the contents of the shoebox enabled her to touch and

scrutinize items used and written by her parents over 60 years before and gives her valuable insight into the way they lived. One check butt made out for 20 pounds to Gwendoline is dated July 31, 1941. It has Uncle Jock's poignant notation, "advance to carry on." This check was written ten weeks after Clara's death.

Figure 11.5 was also taken "the day we left" Abdullah Park. It is three days after Heather's eleventh birthday. She is holding one of her pet cats. Another cat stands in the foreground.

Heather said:

> We couldn't take our cats with us to Mrs. Pearse's [in Geelong].
> They stayed with the place [Abdullah Park].
> Pongo, our little dog, went to a farm.
> We were very upset.
> We loved our animals.

After the girls moved Heather continued to attend the local school along with the children whose family bought Abdullah Park, yet she recalls with some surprise never talking to these children about Abdullah Park and never even inquiring about the cats they had left behind when they moved in with Mrs. Pearse in Geelong.

A Dozen Homes in Ten Years

The societal and family opinion of the era was that the girls should not dwell on their regrettable situation, neither should they view themselves as unfortunate victims, rather, they should "fit in and not break the rules of the house[16]."

Heather said:

> When we left Mrs. Pearse and went to live with Mrs. Cameron she,
> oh well we went to a Mrs. Young.
> She was in Garden Street,
> she was a young woman,
> and she was a widow with a seven-year-old child,
> and I would have been 12,
> I think and,
> she was a very unhappy woman and,
> she'd actually been,
> her father had been a relative by marriage to one of my mother's sisters,
> Anyway we had a pretty tempestuous time with her,
> she was one of these nothing out of place,
> and the first time,

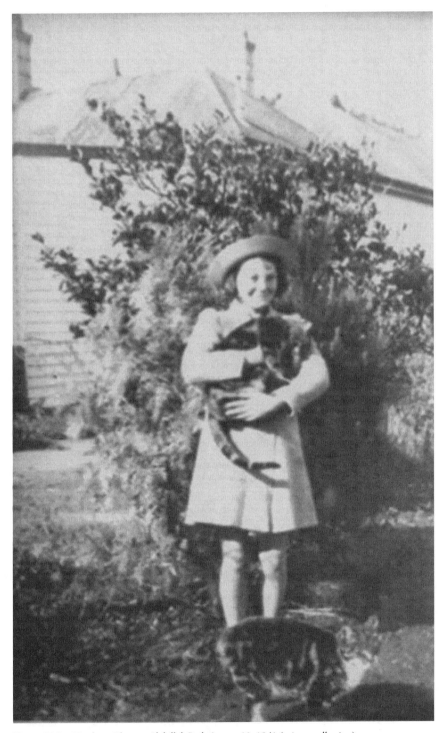

Figure 11.5 Heather with cats, *Abdullah Park,* August 10, 1941 (private collection).

got up Monday morning went to school,
Marjory and I used to share a double bed in one of the rooms,
and we came home everything was thrown out the window.
Regardless of the weather.
Out the window.
Anything that's left around that's where it goes.
She was only in her thirties this woman but by golly she was tough.
Anyway came Christmas time and we went up to our family in the
 Wimmera and we still paid,
my Uncle always paid our board through our family estate,
and he always paid to keep the rooms vacant,
so that we had somewhere to come back to,
and she apparently had all her relatives come down from Shepparton for
 the Christmas holidays.
Anyway Ahh,
some period of time later she sent a writ to Uncle Jock and said he hadn't
 paid our board while we were away on holidays.
And he found some sort of a letter that she had written saying that she'd
 had relatives staying,
so they went to court.
She sued him,
and he got on the train and came down to Geelong and fought the case,
didn't tell us a thing about it
until after it was all over.

Autobiographical Memory

Old photographs have the ability to transport people to eras long past. An example of this is one very small, grainy photograph from Heather's family's collection, which shows a family group dressed in overcoats and hats on a boardwalk next to a windy beach *circa* 1934. It is labeled "McDs Victor Harbour."

No one is posing for the photographer, who appears to have hurriedly snapped a candid family holiday picture. The photograph is overexposed and badly composed, the horizon line rises wildly to the right, and the family group is crowded into the bottom left-hand corner of the frame with their legs cut off. Yet for Heather, who is the smallest child in the picture, this unremarkable photograph opens up a torrent of stories and emotions.

Heather says:

My mother must have been a bit of a photographer.
She seems to have taken most of the pictures.

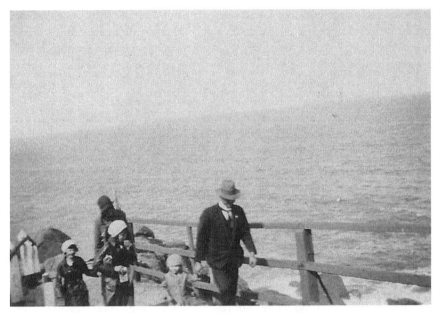

Figure 11.6 "McD's Victor Harbour," believed to be taken September 10, 1933, Gwendoline's tenth birthday. Heather, the youngest, is three years old (private collection).

> I'd never seen these until Andrew [Gwendoline's son] sent them [in 2008]
> See this one.
> That's my father...
> and look...
> he's holding my hand.

Heather's autobiographical memory recall triggered by the documents in the shoebox and the family photographs is a mixture of semantic memory (facts about one's self such as one's date of birth) and episodic memory (experiences of one's life such as recollections of one's eighth birthday party),[17] as well as clarification, analysis, and reflection. Although her recollections reveal some slight errors, the essence of Heather's memory is remarkably accurate. She remembers quite clearly explanations she was given at the time of events as well as situations she experienced first hand.

The accuracy of Heather's memory recall is surprising given her youth when these events occurred and her advanced years when interviewed. Heather's memories of her father were encoded before she was seven years of age, an age according to Eacott and Crawley when children's memories rarely survive into adulthood.[18] Further, her memories of her mother were encoded when she was still just ten years old. In addition, over 60 years lapsed between Heather being orphaned and her receiving the shoebox.

Memory researchers Engel and McNally have found that while it is true that early childhood memories are easily forgotten, and memories do fade, as people grow older; it is also true that extreme situations or circumstances of heightened emotions can crystallize memories enabling them to remain vivid and clear from early childhood until old age.[19] According to McNally, there are six elements at work enabling stressful memories to be encoded strongly: emotional arousal while encoding; distinctiveness of the event; degree of surprise experienced; perceived personal relevance; directly experiencing the event; and rehearsal of the reception context. The perceived importance of an event combined with the degree of surprise determines the emotional intensity of the response. The more emotion experienced the more likely the person will revisit the memory, the process of rehearsal, which in turn, strengthens the memory for the event. In addition, personally experiencing an event, and the distinctiveness of the event, both ensure the memory is tagged as a unique experience warranting special processing in the long-term memory.

Heather's autobiographical memories, which were laid down in extreme situations of heightened personal emotions, fulfill all six of McNally's categories, ensuring her recollections from childhood are strong, vivid memories that are "surprisingly accurate."[20] Heather's family photographs also provide a vehicle for Heather to relive and retell experiences represented in the photographs, thus aiding the process of repetition and rehearsal, which in turn cements her childhood memories.

Memoradic Narrative: *The Shoebox*

With the rich collection of Heather's family's photographs and Heather's excellent memory recall, I set about making an interactive online history documentary of her story. It is a story that would commonly be made as a documentary film, but I wanted to explore the potential for the online platform to reveal this narrative in a way that would reflect its content. Accentuating the fragmented way Heather discovered her history, *The Shoebox* reveals tiny pieces of Heather's memory/story as the user/viewer interactively accesses them. When viewed, these fragments fall into their unique positions on the timeline. Once three fragments have entered the timeline the timeline itself becomes active and can be played as a traditional linear narrative.

The Shoebox combines two narrative structures: an interactive nonlinear structure, and a linear structure. The nonlinear sections require the user/viewer to interactively engage with the media by navigating to small pieces of story content. This interaction in turn creates another story space, a linear story that translates the fragments of this biographical tale into a narrative the user/viewer can sit back and absorb as one would with a traditional documentary film.

The interactive architecture of *The Shoebox* compels the user to access small fragments of memory/story (video clips, animated stills, audio) whilst navigating within 360-degree panoramic scenes. As the user accesses each memory fragment embedded in the panoramic scenes, an icon representing the visited clip falls into a designated position on a timeline at the base of the viewing screen. Once three embedded media clips have been accessed, the timeline is cued to fill up with the remaining icons, and the user may choose either to continue exploring the 360-degree panoramic scenes for additional embedded media clips, or the user can play a complete linear documentary video of animated still photographs and video clip reenactments accompanied by themed music, voice-over narration, and extracts from Heather's oral interviews. This traditional linear narrative tells Heather's story with a scripted beginning, middle, and end that the user/viewer passively observes. In comparison, the interactive component requires the user to interactively participate in the discovery of the story fragments.

This story-telling architecture combining nonlinear and linear narrative structures also mimics the process of autobiographical memory recall whereby fragments of memory stored in different parts of the brain are accessed and joined together into a comprehensive narrative. I define this story-telling architecture as *memoradic narrative*. In *The Shoebox*, the memory fragments stored in

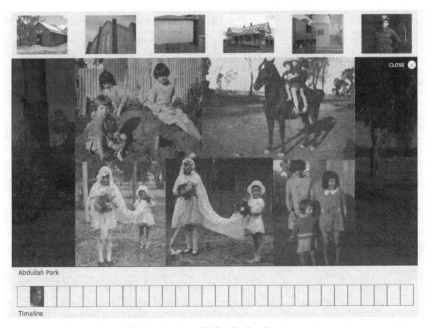

Figure 11.7 Screen shot in black and white of *The Shoebox* showing six interactive panoramic icons on top of the central viewing frame, which displays an embedded media clip from the "Abdullah Park" 360-degree panoramic scene. The timeline (center bottom) shows one embedded media clip has already been accessed. The timeline linear movie is not yet active and cannot be played.

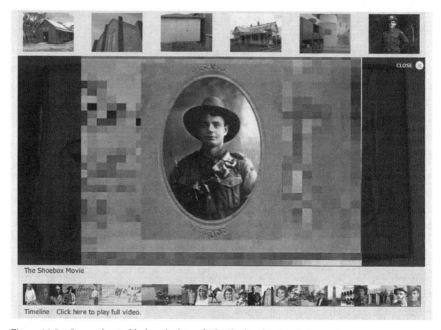

Figure 11.8 Screen shot in black and white of *The Shoebox* showing six interactive panoramic icons on top of the central viewing frame, which displays a frame from the timeline linear movie "The Shoebox Movie." The timeline (center bottom) is filled with all embedded media clip icons and is active.

the database are accessed and joined together into a comprehensive narrative on the timeline.

Researchers such as Engel and Freed have found that memory is an amalgamation of activities that utilize a number of sites and cognitive processes in the brain, and these processes are much more complicated, more fragmented and more subjective than we are inclined to presume.[21] Whilst we tend to think of the process of memory as being similar to recording and playing back a scene in the same way a video camera operates, it is in fact more akin to the processes of capture, storage, and retrieval that a hypermedia platform such as *The Shoebox* employs.[22]

Autobiographical memory pieces together these "bits and pieces" to construct a type of narrative by which the rememberer communicates experiences. With this in mind McNally claims the following:

> Even when we garble the details about the past, we often get the essence right. Memory for the gist of many experiences is retained with essential fidelity, and this is especially true for events having personal, emotional significance. The paradox of memory lies in its "fragile power."[23] Although subject to distortion, memory usually serves us well. It provides the core of personal identity and the foundation of cognition.[24]

Or, to put it another way, our autobiographical memory, whilst a reconstructive process, open to change and variation, is often "surprisingly accurate."[25]

Heather's ability to remember in remarkable detail key events of her childhood is both surprising and fascinating. The personal and shocking nature of Heather's childhood aided her to create memories that remain remarkably vivid and enduring. Some of these memories have been stimulated as Heather and I sorted through her family's collection of photographs. The photographs serve a valuable role in enabling Heather to relive and retell the events of her childhood and in the process enrich and strengthen her memories of childhood. In addition, the quality and nature of these family photographs give *The Shoebox* a depth and texture that complement Heather's oral interviews.

Notes

1. Anna Haebich, "A Long Way Back: Reflections of a Genealogical Tourist," in *Griffith Review* 6, "Our Global Face" (2004), 181–193.
2. Janet Marles, *The Shoebox*, www.memoradicnarrative.com (2010).
3. Susan Engel, *Context is Everything: The Nature of Memory* (New York: W.H. Freeman and Company, 1999), 6.
4. The sign on the front gate of the property reads "Abdallah Park"; however, the sale documents from 1937 refer to the property as "Abdullah Park." Heather believes "Abdullah" is the correct spelling.
5. Interview with Heather, September 2004.
6. Larrikin in the Australian vernacular describes someone who is antiauthoritarian, a risk taker, and free-spirited.
7. Marles, *Everything Changes*, www.memoradicnarrative.com/extras.html.
8. Australian War Memorial, War Service Records of AIF Private 3561 Donald Neil McDonald and AIF Private 3591 James McDonald, cross-referenced with 8th and 24th Battalion Field Diaries; National Archives of Australia Online Resources, "A.I.F. Service Personnel War Records," http://naa12.naa.gov.au/scripts/ResearcherScreen.asp, accessed 2006–2008; and Australia War Memorial Online Archives, "A.I.F. First World War Field Diaries," http://www.awm.gov.au/diaries/ww1/diary.asp?diary=82, accessed 2006-2008.
9. Public Records Office of Victoria, "Coroner's Inquest #1288, Donald Neil McDonald, Geelong, 6th October 1937."
10. Interview with Heather, September 2004.
11. Interview with Heather, May 2005.
12. Interview with Heather, September 2004.
13. Interview with Heather, June 2008.
14. Prior to 1971 Australia used British currency—pound, shilling, and pence. A "bob" was vernacular for one shilling. A shilling was equivalent to 12 pence and 20 shillings made a pound.
15. Margaret Gibson, *Objects of the Dead: Mourning and Memory in Everyday Life*, (Melbourne: Melbourne University Press, 2008), 47–79.

16. Interview with Heather, May 2005.

17. Richard, J. McNally, *Remembering Trauma* (Cambridge Massachusetts: The Belknap Press of Harvard University Press, 2003), 35.

18. M.J. Eacott and R.A. Crawley cited in McNally, *Remembering Trauma*, 44.

19. Engel, *Context is Everything: The Nature of Memory* 5–51, and McNally, *Remembering Trauma*, 39–77.

20. The description "surprisingly accurate" is an expression used by researchers of memory: Engel, *Context is Everything: The Nature of Memory*, 3, and McNally, *Remembering Trauma*, 39.

21. Engel, *Context is Everything*, 4, and Michael Freed, "Is human memory similar to the RAM in a PC?," http://madsci.wustl.edu/posts/archives/mar97/852177186. Ns.r.html, (1997), 1, accessed August 30, 2005.

22. McNally, *Remembering Trauma*, 28.

23. Daniel Schacter, cited in McNally, *Remembering Trauma*, 39.

24. McNally, *Remembering Trauma*, 39.

25. See note 20.

Committed Eye: Photographs, Oral Sources, and Historical Narrative

Ana Maria Mauad

Historian Ana Maria Mauad argues that political engagement is "a form of authorship," which may be found in the work of Brazilian photographer Milton Guran. His press photos of the military dictatorship in Brazil are evidence of a commitment to truth—the photographer's "committed eye"—that also reflects a political stance. Guran's photographs and Mauad's interviews with him hark back to the idea that images shaped the social consciousness and memory of the twentieth century: as Mauad writes, "the photographic experience of the twentieth century redefined the forms of access to historical events and their registration in the social memory." Guran's photographs took on a life of their own, shaping collective memory in ways unanticipated and perhaps even unintended by the photographer. Mauad's essay takes us away from the focus on the individual to questions about the role of photographs in societies and about the stories of the photographs that we tell collectively. Like many other contributors to this volume, Mauad draws on phenomenological studies of photography to explore photography's "capacity...to organize the meanings of contemporary history." Like Marles and Bersch and Grant, Mauad forces us quite insistently to investigate the creative aspects of oral history and to consider in greater detail (oral) history as documentary posing and performance. And like Schiebel and Robel, Mauad demonstrates that it is tricky business to define a photograph as a personal or family photo. Guran's press photographs may well have entered private family albums, once again undermining the photographer's documentary role.

During the course of the twentieth century, the practice of photography transformed events into scenes, experiences into memories, and captured human life with a single movement, the pressing of a button. What is this history made of images?

The experience of photographers, alert to the heat of events, in battlefields, political arenas, and public places, defines the spaces of this history.[1] Aware of being the "eye of history," the engaged photojournalist became an agent of political action and social practice. This chapter discusses the capacity of this social practice to organize the meanings of contemporary history. It argues that engaged photojournalism gives form to human actions through images. Images of the political world have become fundamental records of historical events. They are not, however, simply reproductions of reality. Rather, photographs make history.

I focus on the early career as a photojournalist of Brazilian photographer and anthropologist Milton Guran, and on his political coverage between 1978 and 1984.[2] Through this case study, the chapter investigates the experience of public photography that is committed to a cause, namely the movements for the redemocratization of Brazilian society.[3] That political process had its beginnings in 1978–1979 with struggles for amnesty, the return of political exiles, the creation of the Workers Party (PT), and the rebirth of social movements, including the student movement.

For some time I have been developing projects on the role of photojournalists in the production of meanings in contemporary history. I have conceptualized photojournalists as both privileged witnesses of events and cultural mediators in the production of representations of these events. More generally, I have also explored the circuits of production, circulation, and consumption of photographs in twentieth-century Brazil.[4]

Milton Guran's career helps us to reflect on the relationship between photography and history. For this study I conducted four thematic interviews in 2009 in addition to drawing on archival documents and six of Guran's photographs from the late 1970s to the mid-1980s.[5] In this chapter, I analyze Guran's political engagement as a form of authorship.[6]

Photographic Experience and Engagement as Historical Authorship

The multiplication of different ways of taking pictures during the course of the twentieth century testifies to a significant change in a regime of visuality that is related to the uses and functions of photography, including the processes of photographic production and circulation. This change was accompanied by changes in society and culture that were often advanced by social and political movements

such as the workers' movements, feminist demands for sexual equality, civil rights struggles, and postcolonial movements.

All of these social changes were captured by professional photographers alert to the importance of the events taking place. Their images make up a catalogue from which arose a history redefined by the instrument of representation: the photographic camera. In this visual history, the place of production, the agencies of production of the image (the family, the state, and the press) and the subject of the narrative (the photographs), share with the historical profession the task of imagining the nation and establishing the places of its memory. For the English historian Benedict Anderson, the capitalist press played a fundamental role in the creation of the nation as an imagined community of the modern world.[7] Thus, the photographic experience of the twentieth century redefined forms of access to historical events and their registration in social memory to the extent that we can tell the story of the twentieth-century through its images.

Brazil during the 1970s

In 1964, a civilian-military coup d'état established a dictatorial regime in Brazil that lasted for almost 30 years. The regime limited civil liberties, imposed curfews, forced political parties and unions underground, censored the means of communication and the arts in general, ferociously persecuted the opponents of the regime, and exiled thousands of Brazilians.

This was a hard blow to the young Brazilian democracy that had aspired to a more autonomous position in international relations during the cold war, dialoguing with countries behind the iron curtain and recognizing new leaders in Latin America, such as Ernesto Che Guevara. Internally, social reforms had been discussed, with a large project of agrarian reform and a limit on profits that multinational companies sent out of the country. The turbulent political situation had been accompanied by a similarly tumultuous cultural scene, marked by the movements of new cinema and the theatre of the oppressed, and popular forms of culture with broad youth participation. A new political culture had been forged in the public spaces of the large cities. All of this came to a sudden stop with the military coup that was supported by the government of the United States. The 1968 Institutional Act No.5 shut down the National Congress and intensified the regime of exclusion.[8]

Milton Guran was just coming of age during these political and cultural upheavals. He remembered:

> In 1968, I was 19 going on 20. I was 20 at the end of 1968 and I was a law student, but I did the university entrance exam for Communications in the middle of the year and started to study Communications in the second semester

of 1968 and, because of my participation in an assembly which discussed the invasion of Czechoslovakia, I was led to the student movement, the political struggle, detention, and exile.[9]

The life course of Milton Roberto Monteiro Ribeiro—the given name of Milton Guran—blends into the history of Brazil. Little by little, Milton Ribeiro became Milton Guran, professional photojournalist, committed to the consolidation of the profession of press photographer. Due to his activism in the student's movement during the late 1960s he was imprisoned for a period and after that he decided to leave the country:

Exiled in Paris I met a group of friends interested in photography who were centered around the photographer Alécio de Andrade...so, then, I saw these guys working with photography, contact sheets, and from this I discovered that photography was a language and I began to experience this possibility of dialogue with the visual world which was photography. I came back to Brazil in 1972; I had already worked as a trainee in various places, before going abroad, in order to obtain my registration as a professional journalist....[10]

Between 1972 and 1973 I was trying to find my feet, it was only from 1973 that I took up a professional life as a photographer. So, I remained a freelance from 1973 to 1978. Between 1977 and 1978 I went to live in Barbacena, a small town in Minas Gerais, and the opportunity came up to start a local newspaper, but the fact is that the April 1977 Packet came, and the climate changed. That is to say, General Geisel changed the climate and it became very strange, really very strange. The police were back in the streets again. It seemed, in this way, a revival of the times of General Medici. And then I became very frightened by this and, really, I was very marked by my imprisonment and by the interrogation, as had to be the case, I wasn't prepared to face something like this. Then I really didn't know where to go and I had the idea of going to Brasília, to my father's house, which was something everyone had the right to do, and it was there in Brasilia...arriving there I got a job at the *Jornal do Brasília* to cover politics and I found myself right in the National Congress in the middle of 1978, when General Geisel started the slow and gradual political relaxation.[11]

The six photographs that make up the sequence chosen for analysis were produced between 1978 and 1982. Those photos were highlighted by Guran, during our first interview, as an example of the kind of work he used to do as an independent photojournalist working at an agency organized by independent photographers in Brasília: *Agil Fotojornalismo*. In the following interviews those images oriented the process of recollection and took an important role in framing his photographic experience. They cover personalities, places,

and situations that marked the end of the dictatorial regime in Brazil. Since the last years of the 1970s, due to the international oil crisis, the internal disputes among the military high command, and the pressure of organized social movements, which in spite of the repression maintained resistance throughout the dictatorship, a political relaxation had begun of which the first big step was the creation of the Brazilian Committee for Amnesty in 1978. In this new moment of political development, independent photography played an important role.

Agents and Agencies of the Photographic Experience in Brazil

From the end of the 1970s, a new generation of Brazilian photographers began to develop a new attitude to the practice of photography. These photographers were also responsible for the formation of independent photographic agencies in Brazil that aimed to cover political events and social movements that were not on the agenda of the corporate press, because their social dissent was against dictatorship.[12] This was a generation made up of young people in their 20s who assumed the right and the duty to be eyewitnesses (of the history) of their times. Thus, armed with their cameras, they engaged in social struggles, and in an authorial gesture produced a history in images. Guran said at the time, in 1982: "The greatest truth is that we are learning. What is more and more important is that the production of the independent photographic memory constitutes a cultural asset, and we have to organize to guarantee this cultural asset."[13]

In Brazil, the movement of independent photographic agencies was also organized around the struggles for photographic credits, and the definition of copyright as it applied to press photography and social documentation in general. Milton Guran's career as a photographic reporter became consolidated within the movement of the agencies when *Agil Fotojornalismo* was established in 1980. Guran recalled:

> So, it was exactly between 1979 and 1980, with the great commotion which was occurring in Brazilian society, which resulted in the return of the unions, and I participated actively in the return of the unions in Brasilia. We founded the photographer's union of Brasília. I participated in the foundation, was on the first executive committee, from 1978 to 1980...*Agil* was created, among this great agitation. It rose up in the movement of the independent agencies which proposed creating instruments for us, the reporters, to be able to produce our own agendas, and put the information in the market. There was a lot of discussion; above all in the Rio-São Paulo-Brasília axis...It was a fight for professionalization, for professional recognition, and for recognition, also, for

photography as a language committed to the construction of historical events. That was already something we were aware of at the time...[14]

The story was happening in front of us and nobody said anything, and nobody wanted to publish it. They said, "but they don't publish because there aren't any photos —." So, for you to have photographic coverage of these social movements, this has a cost. Someone has to pay for this. This money has to come from somewhere. So you have to take a boring and bad photo, which pays, to spend money on the ABC strike, for example. At *Agil*, which was in Brasilia, we documented all the opposition movements to the military regime. We photographed the movements for the amnesty, the reconstruction of the UNE (National Union of Students), the formation of the Workers' Party (PT), the agrarian question in Brazil. *Agil* had correspondents in all the states of Brazil, photographing land conflicts. All this we documented, it fell to us at *Agil* to take these photos."[15]

According to Guran's testimony, the work among the independent agencies defined a new profile for press photographers, who stopped being mere members of staff and became agents of their own work.

In journalism, the photographer was a guy who didn't have a degree. The photographic reporter in the decades of the 1950s and 1960s, apart from some honorable exceptions, was a person who really limited himself to making a register of the literal transcription of that which the reporter told him to do. He was a film operator: the one who sells his labor and gives [away] all copyright, the outline and the content of his work. So, it is evident that the photographic reporter, as a producer of information, didn't carry much weight. This was reflected in the structure of the newspaper itself. You had editors of everything but not for photography. You started having picture editors in the 1980s, in some very special newspapers...[16]

Agil was founded precisely for the purpose of creating an efficient instrument for the photographer—an instrument of organization in the profession which permitted us to document the reality following a broader theme, which was not on the agenda. Behind the creation of a photographic agency there was the discussion about whom the image produced belonged to...to the photographer, obviously.[17]

When asked about the reasons that led his generation to adopt photography as a means of public expression, Guran permits himself consideration of his tastes and interests, which precisely expresses his membership of a social group.

There is a watershed that is not at all scientific. It might even seem a joke, but it is absolutely true. It is *Blow-up*, the film by Antonioni, in which the photographer

appears surrounded by glamour. This film is from 1968. The film would mark the entrance of the middle class into the photographic scene—the middle class, the higher middle class, photography as a consumer product which creates wealth, the photographer as the person capable of making an artistic reading of the visible world. This had already been happening since the postwar years. That is to say, the postwar is 1945 to 20 years afterwards, the generation that at the time was 20 became enchanted with photography. It was the postwar generation that implemented photography, this free and artistic reading of the world, as a possibility of intellectual, commercial realization, and so on. The Magnum agency and other international photographic agencies placed intelligent photojournalism on the agenda. Then, in the 1970s, we saw the middle classes enter photography en masse, both through universities and outside universities. So, the profile of the photographic reporter really changed in the big cities. I belong to this generation which had a different general culture, which came from a different environment, had a different cultural background, carrying a greater symbolic capital in the area of culture, and which passed through the universities"[18]

A History Made with Images

The Committed Eye—The Images and Their Stories

During his recollection Milton Guran configured a historical analysis for his personal experience. His memory work was led by the photographs that he had taken and the feelings that had motivated his work as an independent photojournalist, but his present political position also influenced a critical approach to the past:

> At that time, I was covering the National Congress, more precisely the transition from General Geisel to General Figueiredo. It was the moment at which, pressured by civil society which was reorganizing, the military regime began that slow and gradual loosening by General Geisel. It was when the amnesty was negotiated, the next president was negotiated, in fact, a reorganization of a national judicial order was negotiated, which ended up in the Constituent Assembly. The photographs of this time reflect, above all, the critical vision of a left-wing reporter, a reporter against the regime, who held a frankly critical position in relation to the regime, and in relation to the pantomime of power, the way in which power presents itself in its arrogance, in its absolutism, in all its dictatorial weight.[19]

These words associated with the sequence of photographs chosen for our analysis reveal the critical and involved perception of a committed eye. The memory

of the process of producing these images reveals attitudes and positions that corroborate the argument that political engagement is a form of authorship that is founded on its own historical condition. Thus, photographic authorship is understood as the result of an engaged social practice that is defined according to three elements: first, the idea of the witness, which is characterized by the presence of the photographer at the scene of the events (a witness whose presence impacts upon the scene) as well as by the relations that are established with the political field; second, his or her vision of the world, or even the way in which he or she interprets what is seen according to his or her political culture; and, finally, the ability to operate the photographic instrument—which includes the set of strategies that range from the choice of camera, film, and so on to the capacity to select the scene that synthesizes an idea.

The analysis of the sequence of the six photographs taken by Guran begins with the denunciation of the theater of power, in the mannered pose of a right-wing senator, Petrônio Portela (Figure 12.1), and then moves to the generals in the corral (Figure 12.2), to the soldier on guard (Figure 12.3), the mothers searching for their "disappeared" children (Figure 12.4), the crowds who received Arraes (Figure 12.5), before concluding with the photograph of Tancredo and Ulisses [Figure 12.6]. This set of images composes a narrative that projects the past into the present in a visual interpretation of recent Brazilian history.

> So we can highlight one photo [Figure 12.1], which is a photo that doesn't say much to people today. This photo shows the president of the Federal Senate, who is the president of the National Congress, talking to journalists, the most important political reporters of the *Folha de São Paulo*, the *Jornal do Brasil*, the *Estado de São Paulo*, the *Correio Brasiliense*, the *Jornal de Brasília*, basically, to the press which represented the conscience of the nation. The press are seated and the president of the Senate is standing, with one foot on top of a coffee table, giving a "one man show," representing a theater of what was political life. This man, Petrônio Portela, was, as they said at the time, the civilian alternative to succeed Geisel…This photograph makes a parallel with one of the generals [Figure 12.2] who are at a ceremony in the General Army Barracks, the Duque de Caxias Palace, where everything is very organized, where there is even a cordon marking a special VIP space for the generals. So there is a cordon, with a sign in front on which is written "Generals." Behind this sign, there are the generals, who are waiting for the ceremony like first grade students waiting for the Flag Day ceremony, something like that—joking about. It was a difficult photograph to take because the pressure on the press is very great—we are always put in an unfavorable position. It was taken using a zoom lens, and is even a bit shaky, but it is a photo which has a content which carries a lot of weight in this context…

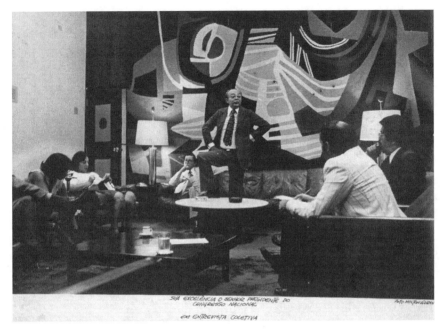

Figure 12.1 Petrônio Portela, Federal Senate, Brasília, 1978 (Milton Guran).

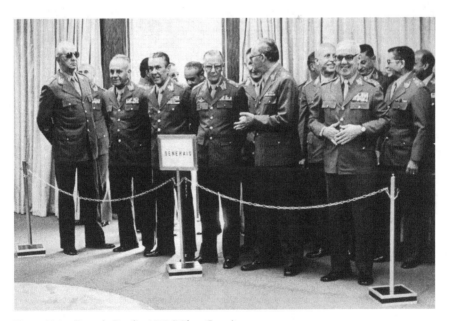

Figure 12.2 Generals, Brasília, 1979 (Milton Guran).

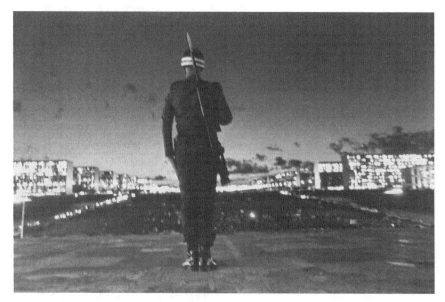

Figure 12.3 Esplanada, Brasília, 1979 (Milton Guran).

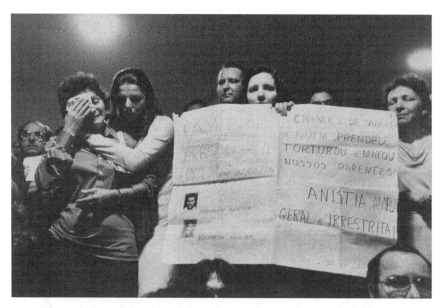

Figure 12.4 Amnesty Movement, National Congress, Brasília, 1978 (Milton Guran).

Another photo which I think is worth highlighting is the photo of Tancredo with Ulisses [Figure 12.6]. The two are seated at a meeting of the amnesty committee, and Tancredo is there with that look of Tancredo and Ulisses is talking, talking with that way of his, and he turns to the side and says, "Isn't

Figure 12.5 Return of Miguel Arraes, Recife, PE, 1979 (Milton Guran).

Figure 12.6 Federal Deputies, Ulysses Guimarães and Tancredo Neves, Brasília, 1982 (Milton Guran).

that right, Tancredo?" And Tancredo inclines his head to his side with that look of Tancredo, and Tancredo's head rests on Ulisses's hand, as if to illustrate that famous phrase "ecce homo" (this is the man). And in fact, Ulisses, as the man of the direct elections, ended up taming and paving the way for Tancredo to be the

great man of the indirect elections, the president who never assumed the post and put in place, no more no less than the ex-president of the PDS, which was the successor to Arena, the party of the military regime.

While this was happening, the soldier guards the Esplanade of the Ministries [Figure 12.3], at the top of the National Congress—a photograph taken without a tripod, not on the agenda. I was simply going away, after a day's work, when I saw the soldier and said to myself, this will make a photo. So, I bent down, held my breath and took the photo—it is a type of archive photo which says much more about the situation of the country as a whole than some specific news situation—than an event created by the pantomime of power to become news…

There are two more photos I want to comment on: the first is a photo [Figure 12.4], which in my opinion is horrific, of the mothers of militants who had disappeared, holding placards, in the Green Room of the National Congress demanding amnesty and the investigation of crimes of repression. And—it happened very quickly, they came into the Congress with the help of some deputies of the opposition to the military regime, they opened those placards and the television, obviously, extending the limits of permitted coverage, threw the light sources in their faces and started to film. And then I clicked away with that very harsh light, really dramatic, and the photo also carries the drama of this moment. It is a photo that touches me deeply—.[20] Lastly, we have an allegory of the political movement that was installed in the country from this said redemocratization. It is a photo [Figure 12.5] taken at the rally for Arraes, on his return from exile, in Recife. Arraes was received by millions of people, who are in the background with their arms in the air, shouting "Arraes is there," drag him here—and in the foreground there is a poster with the face of Arraes, torn—a poster thatannounced this demonstration, where the face of the leader appears crumpled in the foreground against this multitude, speaking to nothing. This crowd shouts to nothing because the politicians and the political class gave them nothing.[21]

All of these photographs were published in different vehicles of the mainstream and alternative press. The photograph of Ulisses and Tancredo gained notoriety because it was used, not at the time of its production, but two years later, in an editorial by Mino Carta, a liberal journalist and editor during the 1980s of the Brazilian magazine *Isto é*, to symbolize the struggle for direct and free elections.

When asked about his interpretation of the photographs, Guran paused to reflect on the photographic act. In his reflection he clearly shows both the complexity of the experience acquired by the photographer during his career, as well as the strict relationship between seeing and knowing, or acknowledging the visible world. This connection is made possible by a regime of visuality in which the

photograph is not only a technique of observation, but also a form of expression and production of social meaning.

> I think that a brief reflection on the photographic act is fitting here, because what happens with the photographic act is the following: it goes beyond reason; beyond in the sense that it goes faster and independent of reason. A photographer is a photographer because the instrument of dialogue that he or she has is not the word. It is not rationality but the eye, visual astuteness; it is the perception of this magical dimension where the image is written. So, this is the reality—the photographer records things that he has not perceived completely, but he has an intuition. This intuition is what ensures a good record, even because the photographer does not photograph what he sees, nobody photographs what they see, you photograph what you foresee, what you guess, because what you see has already happened. It isn't a photo any longer. You have to anticipate or unfold from life to get the photo. This is true, but it is also true that when you photograph, you decide, or your forefinger decides, based on all that you are.[22]

Photography is revealed through Milton Guran's memories as a visual language whose expressive form is supported by the capacity to transform ideas into scenes and to synthesize the multiple moments of social experience in the instantaneous authorial movement of pressing a button.

> And so you ask me, "What did you think at the time that you took these photos?" Nothing! At the time that I took the photo I didn't think of anything! Really, but this means the following, I thought of everything that I was already thinking of. I was in front of the president of the National Congress doing this pantomime and thinking [Figure 12.1] "Guys, I don't believe this. It can't be true." Do you understand? It couldn't be true but it was. I said to myself "Ah, but this I have to get," you know what I mean?
>
> So, I was passing the top of the National Congress. Sometimes I used to go past there. At the top there was always a soldier, but one day things were different, one day a light hit the soldier. There was a haze. I don't know what it was, there was a breeze which spread out the clouds, and something happened [Figure 12.3]. That soldier, his helmet shone more, he had a broad chest, I don't know. His rifle was held in a different way. But then, that figure, the way that he was, instead of being a little further to the right, he was a little more to the left, so the light from the twentieth floor reflected onto his bayonet, something like that. At that moment something was produced—artistically, photographically—which I felt inside myself and made me take that photograph.[23]
>
> The photograph is a very fleeting moment, and the photograph, to be good, strong, it needs to be absolutely representative, not only of the physical, descriptive fact, but of the emotional charge that involves that fact. In the case of the

photograph of the mothers searching for their lost children [Figure 12.4], I am completely inside the photograph, in direct connection with what it shows, in complete unanimity with what I am seeing and experiencing. I was one of the "disappeared" for ten days. I was arrested and disappeared. Only I am a "disappeared" who came back. I did not suffer terminal tortures, terminal murders—all torture is murder, but some are terminal. I did not suffer these terminal tortures, and I came back. But I am emotionally, existentially connected to this that is there. And so we come back to the story of Cartier-Bresson, who says, in the philosophy of Herrigel's *Zen in the Art of Archery*, that to photograph is to put into line the mind, the heart, and the eye—the mind that perceives all of this, the eye that gives it form, and the heart which is completely inside the scene. I am inside this; I am this portrait; I am this woman who cries; I am this man transformed into a mask; I am these people; I am this story. I think that the photograph translates this. José Medeiros used to say that we photograph what we see, and that we see what we are. That is me.[24]

The shot of Tancredo is another example. Ulisses did that many times, that gesture. I saw him making that gesture, and I said this is good [Figure 12.6]. I got it. I got it two or four, three years before Tancredo was the candidate for the indirect elections.

It is obvious that anyone with my background inside the Palácio Duque de Caxias, in full army control, seeing a peripatetic scene of some generals in an enclosure labeled "Generals," playing around like children, would take that photograph [Figure 12.2]. I, who was at the Military College, who grew up inside that little fence. Ha! I can't let that go. So, what am I thinking? It wasn't necessary to think, it was enough to be. Because being, the thoughts come together.[25]

More than twenty years have passed since I made the interviews, and during this period Guran became a well-known visual anthropologist, with a PhD at École des Hautes Études, and experience working with African descendents from former Brazilian slaves that had returned to the West African coast republics and also with Brazilian Indians Nations.[26] Nowadays working as an academic he still keeps the same vivacity that inspired him, as an independent photojournalist, to defend the political role played by photographs in representing social processes through images. Either in the past or at the present time, his political position is to apply his knowledge and ability with the photographic medium on behalf of the society he is working for.

The history revealed by Milton Guran's images, and the process of remembering taking the photographs, is inspired by another type of writing history, the history of representations. What is important to this mode of writing history is less the proof of what really happened, and more the relationship the historical subject establishes with the world that surrounds him or her—a relation measured by feelings, sensations, and expectations.

Notes

1. David Levi Strauss, *Between The Eyes. Essays On Photography And Politics* (New York: Aperture, 2003).
2. The complete analysis of Milton Guran's career can be found in Ana Maria Mauad, "Milton Guran, a fotografia em três tempos," *Revista Studium*, http://www.studium.iar.unicamp.br/28/01.html
3. Eric Hobsbawm, *On History* (London: New Press, 1998).
4. This research activity is recorded in Memória e Mídias, by the research group of CNPq—Laboratório de História Oral e Imagem—UFF. www.historia.uff.br/labhoi.
5. Interviews carried out with Milton Guran by Ana Maria Mauad on the following dates: March 5, 2009 (60 minutes); August 17, 2009 (90 minutes); September 3, 2009 (60 minutes); and September 8, 2009 (30 minutes), belonging to the archive of the Laboratory of Oral History and Images (Laboratório de História Oral e Imagem) of the Universidade Federal Fluminense (www.historia.uff.br/labhoi). The extracts of the interviews cited are identified with the initials of the interviewee—MG—followed by the date of the interview.
6. Jue de Paume, ed., *Le statut de l'auteur dans l'image documentaire: signature du neutre*, "Document 3" (Paris: Éditions du Jeu de Paume, 2006).
7. Benedict Anderson, *Imagined Communities* (London: Verso, 1998).
8. For further reading on the subject see Daniel Aaro Reis, Marcelo Ridenti, and Rodrigo Patto Motta, *O Golpe e a Ditadura Militar: 40 Anos Depois (1964–2004)* (Bauru: EDUSC, 2004).
9. MG, August 17, 2009.
10. Alécio de Andrade became a photographer at the beginning of the 1960s. He settled in Paris in 1965 and was the correspondent photojournalist for the magazine *Manchete* (1966 to 1970). In 1964, he received a grant from the French government to study at the Institut des Hautes Études Cinématographiques. From 1970 to 1976 he was an associate member of the Magnum photo agency.
11. MG, August 17, 2009. "The April Package" was the name given by the press at the time to the set of measures imposed by the then president General Ernesto Geisel, who, among other measures, temporarily closed the National Congress. General Geisel presided over Brazil between 1969 and 1974 and was responsible for the period of greatest repression by the Brazilian dictatorship. It was also the period of the "economic miracle," when the external debt guaranteed the accelerated development of the country.
12. *Ciclo de Palestras sobre fotografia*, 1. Rio de Janeiro, October 27 to December 29, 1982; in particular the testimonies of Nair Benedicto, Assis Hoffmann, Milton Guran, and Zeka Araújo.
13. Statement by Milton Guran in *Ciclo de Palestras sobre fotografia*, 1. Rio de Janeiro, October 27 to December 29, 1982, 153.
14. MG, August 17, 2009.
15. MG, September 3, 2009. ABC is the acronym for the three industrial cities: Santo André, São Bernardo, and São Caetano, located in the interior of the State of São Paulo, where the multinational industries set up plants including automobile factories. In this manufacturing complex the new unions arose, a movement in

favor of workers' rights that called a wave of strikes during 1979 led by the recent President of Brazil Luiz Inácio Lula da Silva.

16. MG, August 17, 2009.
17. MG, September 3, 2009.
18. MG, September 8, 2009.
19. MG, March 5, 2009.
20. MG, March 5, 2009.
21. MG, September 8, 2009. Miguel Arraes (1916 to 2005) was a politician from the northeast, a member of the Brazilian Socialist Party. He was the governor of the state of Pernambuco at the time of the military coup, was impeached and exiled, as during his government he supported grassroot reforms and was implementing agrarian reform in Pernambuco, which was dominated by large landowners.
22. MG, March 5, 2009.
23. MG, March 5, 2009.
24. MG, September 8, 2009. José Araújo de Medeiros (1921 to 1990) was a documentary maker, and one of the masters of photojournalism of the twentieth century in Brazil. In 1957, he published the book *Candomblé*, the first photographic record of this religion in Brazil, and in 1962, with Flávio Damm, founded the photographic agency— Image. He also achieved success as director of photography of classics of modern Brazilian cinema and was a lecturer at the cinema school of Santo Antonio de los Baños, in Cuba, at the end of the 1980s.
25. MG, March 5, 2009.
26. Milton Guran, *Agudás: Os brasileiros do Benim* (Rio de Janeiro: Nova Fronteira, 2000).

Contributors

Al Bersch (University of Oregon) and **Leslie Grant** (Parsons The New School For Design) make the same work together. They are interchangeable components of a collaborative team. They are friends, photographers, folklorists, storytellers, non-ethnographers, and relationally minded aestheticists involved in social reality. Their work, past and present, involves collaborating with people working in fishing, sugar manufacturing, forestry, salt-mining, and renovation industries.

Alexander Freund is associate professor of History and holds the Chair in German-Canadian Studies at the University of Winnipeg. He published *Aufbrüche nach dem Zusammenbruch*, a history of German migration to North America after World War II and edited a forthcoming essay collection on German-Canadian Studies (University of Toronto Press). He is the codirector of the University of Winnipeg's Oral History Centre, copresident of the Canadian Oral History Association, and coeditor of the Association's journal, *Oral History Forum d'histoire orale*. He is a former Council Member of the International Oral History Association.

Lynda Mannik, Ph.D., teaches in the Social Anthropology Department at York University. She is the author of *Canadian Indian Cowboys in Australia: Representation, Rodeo and the RCMP at the Royal Easter Show, 1939* (University of Calgary Press, 2006). Her book in-process, titled *Photography, Memory and Refugee Identity: the Voyage of the S.S. Walnut, 1948*, focuses on the circulation and use of the *Walnut* collection over the past 60 years. She is currently beginning research that will focus on media portrayals of other refugee groups who have arrived on Canadian shores by boat in the twentieth and twenty-first centuries, with an emphasis on the social role of photographs as they are entangled with memories.

Janet Elizabeth Marles is a senior lecturer in Profession Communication and the Media at the Universiti Brunei Darussalam, and an adjunct research fellow with the School of Humanities, Griffith University, Australia. Her chapter in this book arises from her doctoral research exploring the conflation of nonlinear and linear narrative and her biographical online documentary project. These seemingly disparate narrative structures come together through a computational platform to deliver the story in a way that echoes its content. This work stems

from an extensive career as an editorial photographer, audio-visual producer, and short-form filmmaker.

Ana Maria Mauad, Ph.D. in Social History, is associate professor in the History Department of Federal Fluminense University, since 1992 researcher in the Laboratory of Oral History and Image (www.historia.uff.br/labhoi), and since 1996 at the National Council of Research (CNPq-Brasil). She specializes in the theory and methodology of history and in the fields of oral history and visual culture. Further information at http://lattes.cnpq.br/5456423540789233.

Carol Payne, Ph.D., is a photo studies scholar at Carleton University, in the art history unit of the School for Studies in Art and Culture, and is an affiliate of the university's Public History program. She has written on the National Film Board of Canada's Still Photography Division, nineteenth- and early twentieth-century U.S. photography, and contemporary photo-based art. She has two forthcoming books: a monograph on the NFB's Still Photography Division and a collected volume of essays on photo studies in Canada, which she coedited with Andrea Kunard. Since 2005, she has collaborated with the Inuit training program, Nunavut Sivuniksavut, on the oral history project described here. This research has been supported generously by grants from the Social Sciences and Humanities Research Council of Canada.

Yvonne Robel, M.A., was from 2008 research associate at the University of Bremen Department of Cultural Studies in a research project on the political activity, sanctions, and imprisonment experienced by people of two generations between 1945 and 1968 in East and West Germany. She is a doctoral student in the Department of Cultural Studies; the title of her dissertation is "Genocide and Responsibility. Discourses in German Politics since 1989."

Kathleen M. Ryan, Ph.D., is an associate professor at Miami University in Oxford, OH, United States. Her research deals in visual communication, oral history, and media studies. Her work has been published in several academic journals, including *Journal for Cultural Research* ("Transparent and Mysterious: On Collection, the Photograph, and Tomio Seike") and *Oral History Review* ("'I Didn't Do Anything Important': A Pragmatist Analysis of the Oral History Interview"). She has presented on her oral history research at international academic conferences, received several grants for the WAVES project, and is currently working on a PBS documentary film in connection with this research, tentatively entitled *Homefront Heroines: The WAVES of World War II*. Prior to her academic career, she was an award-winning television network news producer.

Martina Schiebel, Ph.D., was from 2008 research associate at the University of Bremen Department Cultural Studies and project director of an ongoing study on the political activity, sanctions, and imprisonment experienced by people of two generations between 1945 and 1968 in East and West Germany. As a

sociologist, she works in the fields of interpretative social research methods and methodologies, historical sociology, cultural history, cultural sociology, and political biographies.

Angela Thiessen, B.A., B.Ed., studied German and Education in Winnipeg, Canada and Bamberg, Germany. She teaches German and Canadian History as part of the German-English Bilingual Program in the River East Transcona School Division in Winnipeg, Canada.

Maris Thompson, Ph.D. is an assistant professor of Education at California State University, Chico, where she teaches courses in literacy development, multicultural education, and curriculum and instruction. Her research focuses on adolescent literacy and identity, immigration and schooling, and narrative theory. She received her Ph.D. in education from the University of California, Berkeley.

Alistair Thomson is a Professor of History at Monash University in Australia. He co-edited the British journal *Oral History* from 1991 to 2007, and was President of the International Oral History Association from 2006 to 2008. His oral history publications include: *Anzac Memories: Living With the Legend* (Oxford University Press, 1994), *The Oral History Reader* (Routledge, 1998 and 2006, with Robert Perks), *Ten Pound Poms: Australia's Invisible Migrants* (Manchester University Press, 2005, with Jim Hammerton), and *Moving Stories: an intimate history of four women across two countries* (Manchester University Press and UNSW Press , 2011).

Penny Tinkler is a senior lecturer in Sociology at the University of Manchester, UK. She has written extensively on the history of girlhood, including *Constructing Girlhood: popular magazines for girls growing up in England, 1920–50* (Taylor & Francis, 1995), and on the feminization of smoking, including *Smoke Signals: Women, Smoking and Visual Culture in Britain 1880–1980* (Berg, 2006). Penny is now researching the history of photographic practices and writing a book on methods entitled, *Photography in Historical and Social Research*, to be published by Sage.

Janis Wilton is an associate professor in History at the University of New England, Armidale, Australia. An active oral and public historian for over 30 years, her recent research publications and projects include *Golden Threads: The Chinese in Regional NSW,* 2004 (a book, traveling exhibition, and website); *Different Sights: Immigrants in New England,* 2009 (a book and online database); *Maitland Jewish Cemetery,* 2010 (a book and online database); and a growing number of articles on oral history and remembering objects. She is a former Council Member, vice president, and president of the International Oral History Association; Trustee of the Historic Houses Trust of NSW; and member of the National Committee of the Oral History Association of Australia.

Index

Printed in the United States of America